DATE DUE

MAR 0 6 2000		
APR 2 2 2000	NOV 0 7 2002	
APR 1 8 2000	NOV 1 0 2003	
JUL 0 8 2000	DEC 1 8 2004	
JUN 2 6 2000		
AUG 1 4 2000		
JUL 3 1 2000		
OCT 0 3 2000		
NOV 18 2001		
JUL 01 2000		
MAR 1 9 2002		
APR 2 0 2002		
APR 0 5 2002		
MAR 0 7 2003		
MAR 0 6 2003		
GAYLORD		PRINTED IN U.S.A.

Art Center College of Design
Library
1700 Lida Street
Pasadena, Calif. 91103

MODERNISM'S HISTORY

When philosophy paints its grey in grey,
then a shape of life has grown old.
By philosophy's grey in grey it cannot
be rejuvenated but only understood.
The owl of Minerva spreads its wings
only with the falling of the dusk.

Hegel

MODERNISM'S HISTORY

A study in twentieth-century art and ideas

BERNARD SMITH

Yale University Press

NEW HAVEN AND LONDON · 1998

For Maggi

Designed by Faith Brabenec Hart
Printed in England at the St Edmundsbury Press

Library of Congress Cataloging-in-Publication Data

Smith, Bernard. 1916–
 Modernism's history: a study in twentieth-century art and
ideas / Bernard Smith.
 p. cm.
 Includes bibliographical references and index.
 ISBN 0-300-07392-5 (h/b)
 1. Modernism (Art) 2. Postmodernism. 3. Art, Modern–20th
century. I. Title.
N6494.M64S65 1998
709'.04–dc21 98-5856
 CIP

Preface and acknowledgements

When writing this book I had two main objectives in mind. First, to present a new approach to understanding the history of architecture, sculpture and painting during the course of the present century, one different from that which has become conventional; that is to say, as a series of avant-garde movements from Post-Impressionism to Postmodernism. Second, to present a general survey of the history in the light of this new approach, one that may be of interest to readers seeking an introduction to twentieth-century art and that also gives due regard to art as a cultural activity deeply embedded in other social, religious and intellectual activities while subject to pressures from the fields of economics, politics and ideology. Although individual achievement is not neglected, emphasis is placed upon the societal nexus within which achievement takes place.

Most of my earlier work as an historian has been based upon archival research. This book, by its very nature, could not be of that kind. It had to address a great amount of specialist history and criticism written during the past forty or so years, work that has greatly changed the way we now view the art of the twentieth century. I have sought to present a general picture that emerges, it seems to me, from this specialised work. Other historians may come to see it differently. This is but one endeavour to present a long-term view of the art of the present century as it now draws to a close.

It would not have been possible to write the book without drawing upon the work of many specialists. Because of the vast range of relevant material it is not possible to provide a general bibliography. But I must acknowledge here those whose work I found particularly helpful. I owe them all considerable debt but must list them only by name here for the sake of brevity. Their relevant publications are contained in the footnotes and in the References at the back of the book: Dawn Ades, Erich Auerbach, Esme Berman, Franz Boas, Albert Boime, Pierre Bourdieu, John Bowlt, Matthew Cullerne Bown, Emily Braun, Norma Broude, Norman Bryson, Peter Burger, Mark Cheetham, James Clifford, Belisario Contreras, Richard Cork, Jonathan Crary, Mary Garrard,

Clifford Geertz, Tom Gibbons, Robert Goldwater, Ernst Gombrich, Camilla Gray, Christopher Green, Clement Greenburg, Serge Guilbaut, Ihab Hassan, Linda Henderson, Berthold Hinz, Margaret Iverson, Martin Jay, Wendy Kaplan, Joseph Kosuth, Rosalind Krauss, Michael Leja, Kim Levin, George Levitine, Jack Lindsay, Christina Lodder, Alice Marquis, Tsutomu Mizusawa, Margaret Olin, Toshiharu Omuka, Fred Orton, Harold Osborne, Otto Pächt, Ronald Paulson, Michael Podro, Christine Poggi, Alex Potts, John Richardson, J. Thomas Rimer, Sixten Ringbom, Harold Rosenberg, John Rosenfield, William Rubin, Steven Sack, Irving Sandler, Martica Sawin, Kenneth Silver, Terry Smith, Virginia Spate, Leo Steinberg, George Stocking, Suji Takashina, Maurice Tuchman, Steven Watson, Jeffrey Weiss, Peg Weiss, Iain Boyd Whyte and Richard Wollheim.

I am also much indebted to Jaynie Anderson, Peter Beilharz, Ian McLean and Humphrey McQueen, who were gracious enough to read first drafts of some of the early chapters. Toshiharu Omuka and Haruo Arikawa kindly read the text of my section on Japanese art in Chapter 12, and Michael Godby, the section on art in South Africa, in the same chapter. John Nicoll's interest was a constant support, and Faith Hart worked tirelessly upon the manuscript to provide it with a clean bill of health not only in matters of fact and reference but also in clarity.

Maggi sustained me during the three years in which I was writing the book; Kate Challis collected books and copies of articles for me from the University of Melbourne Library where its courteous librarians were unfailingly helpful – as were those of the Art Library of the State Library of Victoria.

I also acknowledge with gratitude the award, in 1993, of a four year Category A grant by the Literature Board of the Australia Council which made it possible for me to embark upon the project.

Contents

Introduction

In 1906 Virginia Woolf, aged twenty-four, together with her sister Vanessa, her brothers Thoby and Adrian, and a few friends, paid her first visit to Greece. On donkeys with some Greek boys to escort them they ascended Mount Pentelicus – from which the marbles for the Parthenon and the statues of Phidias had once been quarried. Blessed by fine autumn weather, the little party were in high spirits. Virginia, a short time later on returning to England, assembled her recollections of that day in a memorable and piercingly imaginative account.

> They had seen Marathon and Salamis, and Athens would have been theirs too had not a cloud caressed it; at any rate they felt themselves charged on each side by tremendous presences. And to prove themselves duly inspired, they not only shared their wine flask with the escort of dirty Greek peasant boys but condescended so far as to address them in their own tongue as Plato would have spoken it had Plato learned Greek at Harrow. Whether they were just or not shall be left for others to decide; but the fact that Greek words spoken on Greek soil were misunderstood by Greeks destroyed at one blow the whole population of Greece, both men and women and children. At such a crisis one word came aptly to their lips; a word that Sophocles might have spoken, and that Plato would have sanctioned; they were 'barbarians'. To denounce them thus was not only to discharge a duty on behalf of the dead but to declare the rightful inheritors, and for some minutes the marble quarries of Pentelicus thundered the news to all who might sleep beneath their rocks or haunt their caverns. The spurious people was convicted; the dusky garrulous race, loose of lip and unstable of purpose, who had parodied the speech and pilfered the name of the great for so long, was caught and convicted.[1]

Shortly afterwards the little party rested on a grassy shoulder of the mountain and the young men discussed, in an appropriately melancholic and nostalgic vein, the departed glory of Greece of which

[1] Woolf 1987; Woolf 1989. See also Rosenbaum 1994, pp. 189–90.

they alone, graduates of Cambridge, were the true guardians. Then suddenly:

> The little bushes creaked and bent, and a great brown form surged out of them, his head obscured by the bundle of dried wood that he carried on his shoulders. At first there was some hope that he might be a fine specimen of the European bear, but a second glance proved that he was only a monk discharging the humble duties of the monastery near by. He did not see the six Englishmen till he was close up to them, and then their presence made him stand erect and gaze as though startled against his will from pleasant meditations. So they saw that he was large and finely made, and had the nose and brow of a Greek statue. It was true that he wore a beard and his hair was long, and there was every reason to think him both dirty and illiterate. But as he stood there, suspended, with open eyes, a fantastic – a pathetic – hope shot through the minds of some who saw him that his was one of those original figures which, dipped in the crude earth, have resisted time, and recall the first days and the unobliterated type: there might be such a thing as Man. But . . . All that the brown monk said however was καλησπέρα which is good evening, and it was odd that he addressed the gentleman who had been the first to proclaim the doom of his race. And as he returned the salutation, rising to do so and taking the pipe from his lips, the conviction was his that he spoke as a Greek to a Greek and if Cambridge disavowed the relationship the slopes of Pentelicus and the olive groves of Mendeli confirmed it.[2]

Virginia's brothers and their young friends may be forgiven their hubris, exercised so naturally in the presence of humble muleteers, Greeks incapable of speaking Greek. For were they not the scions of an empire upon which the sun had not yet set, and of a culture that had taken ancient Greece to be its own a century before they came to Pentelicus to pay it homage. Only Virginia, among that little party, was sensitive enough to savour the irony enacted before her eyes, an irony in which she too was to play a leading part. For the centuries-old conviction that Greece had provided Europe with a timeless model for its literary and visual culture was then already under serious challenge. In 1906 Picasso, then of an age of Virginia's brothers, was about to begin his masterpiece, *Les Demoiselles d'Avignon*, after which the supremacy of Greek models for the visual arts would give way to the supremacy of those whom

[2] Woolf 1987.

the Greeks called 'barbarians', and Virginia Woolf would herself explore her creativity as a writer against the grain of the realistic tradition that had been seminal since Homer.

Nevertheless the Greek tradition, the Greek supremacy that Virginia's brothers leapt involuntarily to defend as an integral part of their own culture, has continued to find its defenders all through the present century: Erich Auerbach for one, Ernst Gombrich for another – both Jews, and both given to the defence of a humanist, international ideal of civilisation rather than Herder's celebration of national and regional cultures.

Auerbach was forced to leave his position as Professor of Romance Languages at Marburg University in 1935, after the National Socialists came to power in Germany, and took up a position in the Istanbul State University of Turkey. There between 1942 and 1945 he worked on his great book *Mimesis: The Representation of Reality in Western Literature*, not published until 1953. He begins with Homer and ends with Woolf: an excerpt from the *Odyssey* about the scar of Ulysses, and a section from *To the Lighthouse* respectively. Between them he traces the varied fortunes of the realist tradition through three thousand years of its history with citations from Petronius, Tacitus, Gregory of Tours, the *Chanson de Roland*, Dante, Boccaccio, Rabelais, Montaigne, Cervantes, Voltaire, Stendhal, and others. He ends his book on a sad note. He admires Woolf's writing: 'One of the few books of this type which are filled with good and genuine love but also, in its feminine way, with irony, amorphous sadness, and doubt of life'. Indeed he finds the 'stream of consciousness' techniques, of which her work is representative, indicative of the end of a long tradition. Everything had become so fragmented. The emphasis was now on the 'random occurrence, to exploit it not in the service of a planned continuity of action but in itself'. This was its strength, for it concerned the elementary things that all had in common. Yet Auerbach feared for the simplification, the flattening out, implicit in the process. 'The strata of societies and their different ways of life have become inextricably mixed. There are no longer any exotic peoples . . . Beneath the conflicts and also through them, an economic and cultural levelling process is taking place. It is still a long way to a common life of mankind on earth, but the goal begins to be visible.' Auerbach is at once hopeful and fearful for the future of human culture. He had good reason to be while writing his book during the years that Hitler dominated Europe and millions of his people were being exterminated. Ernst Gombrich's great work *Art and Illusion* was published in 1959, six years after *Mimesis*. It too sought to

reconstitute the relevance of the Greek tradition, in this instance the visual tradition (of naturalism to Auerbach's realism), for the modern world. Both writers, faced with similar developments in modern culture came to similar conclusions. It was a problem of interpretation. Auerbach, commenting on *To the Lighthouse*, noted that 'even the most painstaking analysis can hardly emerge with anything more than an appreciation of the multiple enmeshment of the motifs but with nothing of the purpose and meaning of the work itself . . . We never come to learn what Mrs Ramsay's situation really is.'[3] And Gombrich, commenting upon an *Abstraction* by Jacques Villon, decided that 'there is no possible test by which we can decide which reading to adopt. The example reminds us of one of the intrinsic problems of abstract art that are all too rarely discussed: its overt ambiguity.'[4]

Such views placed the masterly texts of Auerbach and Gombrich, both estranged from their originary culture by National Socialism, in a puzzling position. For the Third Reich itself also believed that it was defending the classical tradition by exterminating all signs of the modernism that concerned both scholars, what it was pleased to call Degenerate art.

However, in the field of culture, we need to remind ourselves that one contradiction folds over and feeds constantly into others. By the time that Auerbach and Gombrich published, in the 1950s, the dominance of the formalist tradition in western European culture, of which their works were powerful, though eminently civilised, critiques, had peaked and almost run its course. Signs of what is now called, inelegantly, Postmodernism were already floating in the intellectual air.

In this study I shall seek to trace the sources and outline the history of the formalism that gave Auerbach and Gombrich unease. From the viewpoint of the late 1990s it is now possible to see that what they then viewed as modern is now no longer so. We live, or so we are informed on all sides, in a postmodern age. I shall question that view and ask whether that which is still regarded as 'modern art' in our culture should now be so called. In my view it is now a part of history, part of a major period style that I shall call the Formalesque (a coinage I shall discuss shortly). This will have the advantage of placing it in an historical perspective and distancing it more objectively from Modernity. Because with the advent of so-called Postmodernism, formalism tends to be used as a fall guy to explain, if not to celebrate, the 'postmodern' condition. Now that

[3] Auerbach 1953, pp. 551–52.
[4] Gombrich 1960, p. 286.

we have come to the end of the dominance of the Formalesque, it is time that we viewed its achievements with greater objectivity. For they are central to twentieth-century culture. Although its immanent drive was towards abstraction, the tensions that the Formalesque set up between form and content led to the creation of the characteristic masterpieces of the late ninetenth and early twentieth centuries. As Meyer Schapiro wrote in 1937 when it was coming most seriously under attack:[5] 'It bears within itself at almost every point the mark of the changing material and psychological conditions surrounding modern culture.'[6] I would agree that it bore the characteristic mark of Modernity but would contend that it also masked its wounds, its central anxieties.

Auerbach traced the course of realism in literature through three millennia, and Gombrich has done something similar for the visual arts. The object of this study is more modest, though testing enough. It is to trace the course between *c.* 1890 and *c.* 1960 of the suppression of the realist/naturalist tradition by formalism, and the dialectical interactions in the visual arts of architecture, sculpture and painting brought into play in the process. In my view the sources of the drive towards formalism, and ultimately towards abstraction, lie deep in the historical conditions of the nineteenth century when Europe was colonial master of the world, and the style-cycle, which is still called Modernism, was fully formed within that ethos, that is to say, of the period between *c.* 1890 and the Great War of 1914–18, when the nineteenth century came to an end substantially – if not chronologically. I shall suggest, as I said earlier, that this style-cycle be called the Formalesque and that it may be conveniently divided into an early, avant-garde, Formalesque (*c.* 1890–*c.* 1915), a mid-Formalesque (*c.* 1916–*c.* 1945), and a late or high Formalesque (*c.* 1945–*c.* 1960). Admittedly, these divisions, like all historical periodisations, are a convenience, but they are an inescapable convenience. There is, of course, a strong sense in which history is a seamless web, if it is thought of as the abyss of time past, but the discipline of art history cannot be sustained without periodisations. The time has come to periodise the twentieth century. If it is to survive as a distinct discipline, art history will have to retain confidence in its capacity to create those generic period styles which have served it so well in the past: Romanesque, Gothic, Baroque, Rococo, and so forth. This, of course, is not to say that period styles serve all the needs of art

[5] e.g. in the German exhibitions that year of *Entarte Kunst* (Degenerate Art).
[6] Meyer Schapiro, 'Nature of Abstract Art'; reprinted in Schapiro 1978, p. 202.

history. They are comparatively useless, for example, in close re-
search, such as investigating the art of a place, an artefact, or an
individual artist's *oeuvre*. But we need distanced[7] views as well as
close-up ones, wide-angled perspectives as well as meticulous in-
vestigations. This is particularly so for twentieth-century art where
so much detailed work has been published in recent years. The time
has come to see it from a broader viewpoint. This is imperative if we
are to bring the art of the world, as distinct from the arts of Europe
and the United States of America, into a coherent *spatial* focus.
Anthropologists find it useful, if not indispensable, to establish
(despite the infinite degree of diversity entailed among the objects
so classified) broad regional, stylistic classifications of the artefacts
of say Polynesia, Melanesia and Australia. They are adopted with-
out reference to the individual artists who have produced the arts.
In order to get the twentieth century into a workable focus we need
a synthetic view, a view as it were that might see European art from
indigenous Polynesian, Melanesian or Australian viewpoints – an
'art history without names view', once again, by means of which it
should be possible to distinguish the twentieth-century wood from
its trees, not only Picasso but the spatial and temporal style-cycle
that his work inhabits. For there is surely such a thing as the 'colour
of time', as Wölfflin[8] and Spate[9] have put it, both in their own
contexts, a dominant colour that is nevertheless susceptible to an
infinite range of tints and tones that may take on also the shades of
subordinate colours until such time as it changes into another do-
minant hue. That period styles are intrinsic to historical discourse is
revealed by the present popularity of the 'Postmodern' to describe
so much of the philosophy, sociology, art and culture of the last
third of the present century. For it is indeed an ostensible generic
style despite the intrinsic contradictions and diversities it innocently
embraces. My reservations to the term 'Postmodernism' are seman-
tic, not substantive. I see it rather as the final efflorescence of a
twentieth-century modernism that had been growing in opposition
to the Formalesque since the Great War of 1914–18. Support for
seeing the Formalesque as a period style and not as a sequence of
distinct avant-garde movements comes from an artist who perhaps
more than any other marks in his work and thought a major
qualitative and stylistic break with the Formalesque. In 1961[10]

[7] On the importance of a 'distanced' view for the appreciation of aesthetic phe-
nomena, see Bullough 1957.

[8] In speaking of Rubens, Wölfflin 1929, p. 9.

[9] In speaking of Monet, Spate 1992.

[10] The date is significant, for it is from the 1960s that we may witness on all sides the
dominance of the Formalesque style collapsing.

Marcel Duchamp (1887–1968), speaking at a symposium at the Philadelphia Museum College of Art, said, 'I believe that to try and guess what will happen tomorrow, we must *group* . . . the 'isms. . . the 'isms which have followed one another during the last century, at the rate of one new 'ism about every fifteen years' (my emphasis).[11]

But why is the style-cycle of which Duchamp speaks still called modern though it came effectively to an end in the early 1960s – at the time he was speaking? I think that the answer is at heart a psychological one. So much emotional investment, so much critical advocacy, so much marketing expertise has been put into promoting the avant-garde moment of late nineteenth-century art that we dare not stop calling it modern. Ihab Hassan put the matter succinctly when he wrote, 'does Modernism stretch merely to stretch out our lives?'[12] Can we possibly bear to think that our own blockbustering moderns, our Monets and our van Goghs, are now no longer modern?

To see now what has been called modern, as a period style and described as Formalesque, implies a distanced view, and there may be some small advantage, despite the obvious disadvantages, of being an Australian art historian who has specialised in Australia and the Pacific, writing from Melbourne about European and Eurusan[13] art in the twentieth century. This might be described as an antipodean point of view in the sense that antipodes is not a place but a relationship, in this case a spatial and cultural relationship between north and south. I shall be writing therefore with Europe as my antipodes, seeing it from a distance and yet seeing it also as part of myself, my cognitive space and my culture.

According to Frederic Jameson, one of the major problems anyone has in assessing coherently the nature of Postmodernism is the impossibility of distantiating its presence because, as he puts it cryptically, our 'postmodern bodies are bereft of spatial coordinates'.[14] That may well be so if one is writing from Paris, London, New York or even North Carolina. But when one writes from the margins one is struck by the *uneven* spatial nature of Modernity and

[11] Duchamp 1975, p. 28.

[12] Hassan 1987, p. 26.

[13] For a discussion of this coinage, see ch. 10, p. 255.

[14] Jameson 1984. That Jameson is thinking of temporal as well as spatial distancing is suggested by his context. 'What the burden of our preceding demonstration suggests . . . is that distance in general including "critical distance" in particular has very precisely been abolished in the new space of postmodernism. We are submerged in its henceforth filled and suffused volumes to the point where our now postmodern bodies are bereft of spatial coordinates and practically (let alone theoretically) incapable of distanciation' (p. 87).

the modernisations of the cultures embraced by it. Historical disjunctions may look quite different from differing spatial view-points. The paradigmatic break that so many theorists now broadly agree occurred during the 1960s and divides the modern from the 'postmodern' may seem little more than a dimple on the cheek of time from Australia. On the other hand the break that occurred during the Great War of 1914–18 can look like a deep wound in all that Auerbach and Gombrich admired.

So to get a timely focus on things we need to rehabilitate the concept of period style, an invaluable working tool that has been put under a cloud in recent years by the so-called new art historians. But nothing is new for long, and the durability of nov-elty decreases inversely as Modernity intensifies.

If art historians continue to find it convenient to use the concept of period style to describe art from say the Geometric Greek style of the tenth century BC to Art Nouveau and Art Deco, why cannot we use the concept to describe the art of the late nineteenth and early twentieth century as it ceases to be modern? I think we must, and I have coined the term 'Formalesque' to describe it; that is to say, an avant-garde style created during the late nineteenth century that gradually attained an imperial dominance during the first half of the twentieth century. But why Formalesque rather than formalist, the usual term to describe the central role of form in the aesthetics of the style? Because 'Formalesque' will have the advantage of allowing such terms as 'formalist' and 'formalism' to act out their conventional normative functions. To take an obvious example. The façade of the early Renaissance Pazzi Chapel (1429) in Florence is much more formalist in its conception than the late Gothic of the arcades of the Doge's Palace in Venice (after 1424). The fact that 'formalist' and 'formalism' are bound still to be used in their nor-mative mode will allow the term 'Formalesque' to be used in a strictly chronological sense to describe the period style. The ety-mology of 'art nouveau' affords us an interesting comparison. Originally it meant, literally, 'the new art'. Today it refers to a style of the late nineteenth century; and in my reading it is one of the substyles that contributed to the formation of the Formalesque.

For this essay in historical reconstruction I have adopted a modi-fied Hegelian view, not a metaphysical but a pragmatic Hegelianism that will view change as a process determined by a continuing dialectic, a persistent interrogation of the dominant by the sub-dominant and the suppressed. It seems to me that a pragmatic Hegelianism can still serve as a better tool to confront the problems faced by the historian traversing broad tracks of twentieth-century

time than, say, poststructuralism or postcolonialism. These more fashionable discourses tend to fracture brutally along hard binary alternatives such as nationality, identity and alterity. They do not allow for the more intricate ebbings and flowings of history, the sublime play of its oppositions, to move freely enough in order to write it in a fashion that is not a disguised polemic.

Since art historians continue to find the period style concept useful for all the other periods that they study, there is no reason why it cannot be applied also to our own so-called modern period, *when that period becomes no longer modern.* To refuse to do this is to abnegate the independence of art history as a discipline and allow its peculiar insights to become dissolved into social, political, cultural or psycho-sociological history. Discourse between disciplines is not only desirable, it is essential, but the individual identities of disciplines need to be preserved to achieve positive results. Cross-fertilisation obviously is not possible if there is nothing that is native and individual to the discipline to cross with other disciplines.

There were significant modes of art and theory that opposed the Formalesque, but in their very opposition they were inflected by its dominance. It is for this reason that, in my view, we may classify, in a generic sense, *all* the arts produced during the time under discussion as modes of the Formalesque, in the same broad way that we may classify all art produced during the supremacy of the Baroque styles as modes of Baroque.[15]

The twentieth century also witnessed a dramatic, dialectical interaction between two fundamental types of visual mimesis that had been active in European culture, institutionally, since the fifteenth century. I am using the term 'mimesis' in a manner similar to Michael Taussig when he describes it as 'the nature that culture uses to create a second nature',[16] the faculty that provides the crucial link between the biological and the social, as the rhythm of the heartbeat is imitated in the rhythm of dance. The two types of *visual* mimesis I have in mind may be described as the mimesis common to craft (that I prefer to call art in the general sense) and the mimesis common to the 'high' arts of Renaissance and post-Renaissance painting and sculpture. Craft mimesis, broadly speaking, imitates other craft whether that craft consists primarily of abstract patterning as in, say, basketry, or imagery, such as Byzantine icons or the effigies of a shaman. The mimesis of high art (that

[15] Consider for example how in his definitive study, Wittkower (1958) embraces the style-cycle of the period covered by means of a dual Baroque system: an early, high and late Baroque, and an early, high and late Baroque classicism.

[16] Taussig 1993, p. xiii.

I prefer to call art in the special sense), since at least the Greek art of the sixth century BC, seeks to imitate the natural world even though, in so doing, it also imitates similar artefacts seeking to imitate the natural world.

Of course both the imitation characteristic of art in the general sense, such as the copying of previously existing arrowheads by the skills developed in producing arrowheads, and that imitation characteristic of art in the special sense, copying nature itself, such as the body of a woman in the *Venus de Willendorf*, reach back into immemorial time. Moreover in ancient times no distinction was made between the two modes. Both were performed by craftsmen. It is the theoretical distinction, and the institutionalisation of that distinction, that will concern us here. Perhaps it first emerges in theory in Aristotle. In the *Nichomachean Ethics* he refers to what I call art in the general sense when he writes:

> art is nothing more or less than a productive quality exercised in combination with true reason. The business of every art is to bring something into existence and the practice of an art involves the study of how to bring into existence something which is capable of having such an existence and has its efficient cause in the maker and not in itself. This condition must be present, because the arts are not concerned with things that exist or come into existence from necessity or according to Nature.[17]

In this sense Aristotle is defining art in a very general way, not altogether dissimilar from the way in which Karl Popper distinguishes a 'third world' as the products of the human mind, as distinct from a 'first', or physical world, and a 'second', or world of experience.[18]

But in the *Poetics* Aristotle, writing of tragedy, describes the 'objects of imitation' as 'men in action and these men must be either of a higher or lower type . . . [W]e must represent men either as better than in real life, or as worse, or as they are. Polygnotus depicted men as nobler than they are, Pauson as less noble, Dionysius drew them true to life.' It is clear that in this case he is speaking about the imitation of nature not, as the earlier quote implies, the imitation of previously existing human productions.[19]

This distinction was first institutionalised in Europe in the writings of Alberti in the fifteenth century[20] and the consequent

[17] Quoted from Tatarkiewicz 1970, p. 156 (trans. J. A. K. Thompson).

[18] See Popper 1972, pp. 106–28 et al.

[19] Tatarkiewicz 1970, p. 157 (trans. S. H. Butcher).

[20] In his treatises on painting, sculpture and architecture: *De pictura* (1435), *De statua* (c. 1435) and *De re aedificotoria* (c. 1452).

creation of academies of art (as distinct from craft guilds) in the sixteenth century. Of course, we may remind ourselves, it was institutionalised much earlier in China.[21] But that is another story.

If we are to appreciate how the Formalesque style emerged as a period style we must view it from a distance as a dialectical inter-action between art in the general sense, and art in the special sense as it developed in Europe since the Renaissance. It will be shown that the significant formative elements in the creation of the style, at the level of both theory and practice, drew heavily upon art in the general sense as it was customarily created beyond the limits of Europe. Such a view is obscured if artistic activity in Europe is construed from a close-up view as a series of avant-garde move-ments from, say, Impressionism to Minimalism.

From a distance, twentieth-century European art may be seen as a modern theatre, as a highly coloured, strobe-lit proscenium, set for a dialectical interaction between these two types of mimesis: an Aristotelian mimesis of art in the general sense (or artefactual mimesis), and an Albertian, institutionalised mimesis of art in the special sense (or naturalistic mimesis). However, the very process of interaction developed an anti-mimetic dynamic, a drive towards a universalising abstraction, which was immanent within the Formalesque style – a style itself, the sources of which were gener-ated during the nineteenth century (to 1914) as the result of an interaction between Europe and the arts of a world over which it then exercised a global suzerainty. To trace the causes, creation, institutionalisation, hegemony and decline of this art as it was gradually fashioned into an imperial culture constitutes the central theme of this book.

It will involve making a fundamental distinction between Modernity and its modernisms. Modernity is a slab of history and like history has no meaningful end – that was Hegel's error.[22] Modernity is neither aware of its nature nor conscious of its trajec-tory. Driven by science, technology and instrumental rationality, it constructs its Brazilias by befouling and violating Mother Earth and has been doing so for some considerable time now.

The concept of Modernity cannot be confined to capitalism or the so-called West. During the present century we have experi-enced fascist modes of Modernity in Germany, Italy, Spain and Japan, and socialist modes of Modernity as central state systems in the former Soviet Union and modern China. In such cases the

[21] During the Tang Dynasty (AD 618–907) when the emperor Xuanzong (AD 712–56) established the Hanlin Academy.

[22] And in Karl Popper's view, Marx's also. But it is questionable whether Marx held a teleological view of history.

political field develops dominance over the economic and financial fields; and these modes of Modernity have shown themselves to be just as threatening to the natural environment as capitalism and even more disastrous to civic polity.

Modernisms are critiques of Modernity. They draw upon the archaic, the classic, the exotic and the 'primitive' to develop their critiques. Modernism does not feel at home in Modernity. Its creative drive is constructed from components drawn from an idealised past or a utopianised future, not from Modernity's present, which it finds banal or life-threatening. Yet each modernist critique of Modernity invariably fails. During its creative avant-garde moment it seeks to make Modernity endurable, liveable. As its energy wanes its traces may be discerned in Modernity. For Modernism's critique is not sustained; it folds over into a celebration of Modernity. It begins with its Picassos and ends with its Warhols tirelessly repeating themselves. Then hopefully, but not inevitably, a renewed avant-garde may appear again, perhaps as the strange child of cultural imperialism, and in another part of the globe.

Part One

THE RISE OF THE FORMALESQUE

1 Modernity and its modernisms

MODERNITY

Conventional accounts tell us that modernism begins within the context of Symbolism during the late nineteenth century. Then follows stories of the achievements of, say, Frank Lloyd Wright, Cézanne and Brancusi, as pioneers of modern architecture, painting and sculpture respectively. However, in recent years historians have become increasingly impatient with such avant-garde accounts written in the form of biographical narratives. Yet the mode persists. For with the growth of secularism within the culture of Modernity, art has steadily replaced religion as society's social comforter. Fine art's heroes replace the martyrs of the Church militant. The typical art monograph sacralises modernism's martyrology.

But what is Modernity? No matter how convincingly a specialist may distinguish a period from that which precedes it, another, working across the disjunction and using different thematised material, will have little difficulty revealing traditional elements of say law, ethics, economy or politics that effectively span the alleged break. That has been accomplished repeatedly, as in the transition from the ancient to the medieval world during the third and fourth centuries of our era, and from the medieval to the modern world during the fifteenth century. This is not to say that we may abandon the search for disjunctions in writing history but that we should appreciate that they are grounded in particular kinds of history, such as economic, legal, moral or religious history, not in 'general' history. Historical disjunctions are perspectival not epistemological.

How then shall we view the problem of Modernity? For Anthony Giddens,[1] it refers to 'modes of social life or organisation which emerged in Europe from about the seventeenth century onwards'. That seems about a century too late for me. For on Giddens's own account of the matter he rightly cites capitalism, industrialism and the nation-state as three constituent components of Modernity. But there are strong grounds for asserting that capitalism and the

[1] Giddens 1991, p. 1.

nation-state were both going concerns by the end of the sixteenth century, whereas industrialism is not fully under way until the second half of the eighteenth century. Of course the seventeenth century is the century of Descartes and there is wide agreement even today with Hegel's description of him as 'the father of modern philosophy', and that with him we witness a sharp break between traditional and modern thought. But therein lies the danger of using one historical discourse as a metonym for history in general. Yet the fact of the matter is that when we invent or assume *major* periodisations we are involved with general history – what Lyotard has called metanarratives. The concept of Modernity – or Postmodernity for that matter – implies a metanarrative.

I have no problem with that. Metanarratives will be written long after Lyotard is dead, long after my generation have ceased to indulge their *fin-de-millénnium* anxieties. Such narratives are not written to be taken on trust but to be criticised. That is what history is about. Attempts to discourage the writing of such narratives is a futile form of intellectual censorship, a *trahison des clercs*.

But if we find ourselves involved in the problem of periodisation it will be prudent to take those moments in history (in this case European history) where multiple disjunctions appear to intersect more or less simultaneously, where the specialist discourses, whether economic, social, political, philosophical, appear to converge and tell a more or less similar tale, one that many generations of historians have found to be convenient and credible in writing their own specialist narratives. For this reason I prefer to place the beginnings of Modernity in Europe to the fifteenth and sixteenth centuries with the Renaissance and Reformation.

Modernity is still with us. The only discourses surely that take the notion of Postmodernity literally are those apocalyptic cults that name a day for the end of the world and when their prophecies fail consume themselves in their own eschatological passions. For the purposes of this study we may ignore the notion of a Postmodernity. But it will be desirable to make a clear distinction between Modernity and modernism.

MODERNISM

Modernism is a critique of Modernity – the concept used to cover the general history of modern times. But history has no conceivable *end*. It is not teleological. That was the central mistake made, among others, by Hegel and perhaps by Marx. Given that Modernity

emerged in Europe during the fifteenth and sixteenth centuries, the art that emerged with it may appropriately be described as modern art, an art that became the first of the modernisms of Modernity. It was the modern art of those times that first separated art from craft, aligned it with the innovative proto-science of the Renaissance, and turned it into a reflexive form of production that recuperated the past, as a standard, while also developing an inbuilt capacity for constant change. The first researches into the laws of perspective made it possible for artists, with the aid of proportion theory and chiaroscuro, to develop new modes and standards of naturalism beyond the naturalism already achieved during Greek and Roman antiquity. Should we not then describe the generations of Brunelleschi, Alberti and Leonardo as the first modernists, the modernists of their time? It is generally agreed that within the courts of the Renaissance princes a new conception of the artist as distinct from the craftsman, as a person of both intellect and skill, emerged and gained for the artist a degree of independence not previously achieved. And with Vasari, a generation later, Michelangelo became the first modern hero of art, an artist equal to a saint. In the end it worried him greatly:

> Now I know well that it was a fantasy
> That made me think art could be made into
> An idol or a king. Though all men do
> This, they do it half-unwillingly.

Of course there are enormous differences between the innovative artists of the Renaissance and the avant-garde of the later nineteenth-century; it is the business of art history to distinguish such differences. But we must be alert also to the long-term affinities that bind generations. After the fifteenth century European art evolves according to principles different from those that govern change in the crafts, in art in the general sense. And it will not be possible to unravel the strands that link European art with its imperial effects throughout the world without realising the radical significance of the break with art in the general sense that took place in the fifteenth century and the emergence of this new art in the special sense that came to be known eventually in the nineteenth century as 'fine art'. Looked at long-term it was a further development in the idea of mimesis that had begun in the Greek art of the sixth century BC. Instead of imitating other artefacts, the normal practice of craft, art sought to imitate nature. That became a major theoretical concern once again during the fifteenth century and continued to be so until the end of the nineteenth century.

From the fifteenth to the eighteenth century historical change in the arts of architecture, sculpture and painting was characterised by intermittent and yet fairly continuous stylistic disjunctions in response to both immanent and external effects. During the past century, modern European art history has often been written in the form of chapters, along the following lines: Early Renaissance (*c.* 1300–*c.* 1450), Renaissance (*c.* 1450–*c.* 1500), High Renaissance (*c.* 1500–20), Mannerism (*c.* 1520–1600), Early Baroque (*c.* 1600–20), High Baroque (*c.* 1625–75), Late Baroque and Rococo (*c.* 1675–1750), Neo-classicism and Romanticism (*c.* 1750–*c.* 1850), Naturalism and Realism (*c.* 1850–80), Impressionism and Post-Impressionism (*c.* 1870–1920), Modernism (*c.* 1890–1960), Postmodernism (*c.* 1960–). It is true that the beginnings and ends of these phases are often disputed, but there is general agreement about their convenience; indeed it would now seem inconceivable that the history of European art could be written ignoring them.[2]

However, it will be noted that whereas from the fifteenth to the late eighteenth century historians have been content to work within the single chronological labels – Renaissance, Mannerist and Baroque – a break occurs during the eighteenth century. Thenceforth there is less certainty about the dominant style of the period; a tendency has developed to adopt two stylistic labels, running more or less in tandem: late Baroque with Rococo, Neo-classicism with Romanticism, Naturalism with Realism, Impressionism with Post-Impressionism. Change continues to occur but now reveals itself as a kind of dialectical confrontation between two styles of art in the special sense. There is also less confidence about where the chronological disjunctions occur and a greater sense of overlap between the period styles as one diminishes and the other takes its place. It may be noted too that whereas it is feasible to view the course of development from the fifteenth to the late eighteenth century as embracing the arts of architecture, sculpture and painting with virtually equal relevance, from the late eighteenth century onwards the stylistic labels fit painting and sculpture better than they do architecture. For can we speak with confidence about romantic, realistic or impressionist architecture, except in metaphor?

These differences between the pre- and post-eighteenth-century situation serve to draw attention to the major break that occurred during the eighteenth century, one much more profound than the

[2] I have adopted the commencing and terminating dates proposed for these styles by the relevant contributors to *The Dictionary of Art*, London, Macmillan, 1996 (Dictionary 1996). The fact that they are *circa* in all cases must be stressed.

stylistic changes between the fifteenth and the eighteenth century. Although an increasing degree of autonomy may be observed developing in European art from the fifteenth century down to the present time, that is not to say that its course was unaffected by influences external to the realm of art. External influences were always present, but never more so than during the late eighteenth century, a time when a dynamic bourgeois culture based on capitalist enterprise began to replace a feudal aristocracy whose wealth and power were grounded in the hereditary ownership of landed property. It is of course also the Age of the Enlightenment and the Industrial Revolution. Indeed the cultural disruption of European society at this time was so great that for many historians and sociologists it is the later eighteenth century that marks the true beginnings of Modernity. But that view ignores the origins of mercantile capital, of the nation-state and nationalism, and of those seminal concepts of freedom and individualism all of which have their source in the fifteenth and sixteenth centuries.

Prior to the major break announced by the Enlightenment, an homology may be discerned from the fifteenth century onwards between the economy of merchant capital and the dynamic of the new art harnessed to science, and a new respect for the individual artist, despite the fact that the great bulk of the productive wealth of Europe was still drawn from a feudality of aristocratic land-owners and peasant proprietors based on agriculture and the raising of cattle. The new art is but one aspect of the new world arising in mercantile cities in opposition to the feudal world it will eventually replace.

If European art is dynamic – which is not to say that it is progressive but that it is in a condition of constant change – from the fifteenth century onwards, we might well ask what drives it? That is to say, what drives it in a fashion distinct from that which drives the technology of craft, of art in the general sense, as it continued to be practised both within and beyond Europe? Now three necessary, but not sufficient, conditions for this innovative dynamism appear to be its increasing reliance upon science, technology and the market. Science began to utilise art for its own needs; technology developed new graphic means of reproducing representations that greatly spread the use and influence of art; the market transformed art increasingly into a product to be sold rather than used directly or commissioned. All three factors privileged the need for an art that like capitalism itself was in a constant state of change. Post-Renaissance artists gradually internalised the social need for this new dynamic art. It came eventually to be described –

with an unwitting touch of innovative blasphemy – as 'creative' activity.[3]

THE AVANT-GARDE

Should we call those artists whose work helped to effect the stylistic changes between the various phases of Renaissance, Mannerist and Baroque art an avant-garde? The term, as we noted, is normally used to describe the innovative artists of the nineteenth and twentieth centuries. But if European art became dynamic from the fifteenth century, may we not extend the usage back to that time? Because the stylistic changes were certainly effected by gifted individuals, may we not therefore call, say, Brunelleschi, Leonardo, Michelangelo, Caravaggio, Rembrandt and Watteau avant-garde?

It was the Comte de Saint-Simon (1760–1825) who coined the phrase 'avant-garde' around 1803.[4] It would consist of a union of industrialists, scientists, engineers and artists who would challenge the values of feudal society and develop new attitudes and institutions compatible with the new phase of Modernity made possible as a result of the political ascendancy of the bourgeoisie. But that, surely, was what advanced scientists, artists and engineers had been engaged in since the fifteenth century. Saint-Simon was all for Modernity:

> the artists, the men of imagination, will lead the way in that great undertaking; they will proclaim the future of mankind; they will bring back the golden age from the past to enrich future generations; they will inspire society with enthusiasm for the increase of its well-being by laying before it a tempting picture of a new prosperity, by making it feel that all members of society will soon share in the enjoyments which, up to now, have been the prerogatives of a very small class; they will hymn the benefits of civilization.[5]

But paradoxically the first artistic avant-garde of the nineteenth century turned Saint-Simon's idea on its head. It emerged, influenced by Saint-Simon, as the group known as the Barbus, the bearded ones, out of Jacques-Louis David's studio, with Maurice

[3] It may be noted that the *New Shorter Oxford English Dictionary* (1993) gives the late fifteenth century for the first usages of the word both of 'having the quality of creating' and 'showing imagination as well as routine skill'.

[4] In his *Lettres d'un habitant de Genève à ses contemporains*. See Saint-Simon 1976, pp. 65–81, and Rose 1988, special suppl., pp. 23–24.

[5] From his essay 'On the Social Organisation', in Saint-Simon 1976, p. 233.

Quay (*c.* 1779–1804) as its leader. Quay dressed like an ancient Greek and was called by his friends Agamemnon. He advocated that all but a few of the archaic Greek sculptures should be preserved, the remainder of the masterpieces of the museums should be destroyed.[6] They were interested, as Saint-Simon himself had put it, in bringing back the golden age but not seriously in advancing Modernity.

Thus it was that the first avant-garde among artists of the nineteenth century revealed itself as an archaistic reversal of Modernity's values not, as Saint-Simon hoped and worked for, as an advocate of Modernity. But is this not all rather *déja vu*? Was not Leonardo an avant-gardist in Saint-Simon's sense, an innovative scientist, engineer and artist for his time, and did he not, like Quay, advocate the need for a return to Classical antiquity for the best models? We may recall that when Leonardo visited Pavia in 1490 and saw the Roman equestrian statue known as the *Regisole*, he wrote in admiration, 'the imitation of antique work is more praiseworthy than those of the moderns'.[7] To be a modernist one turned to the ancients.

As it began so it has continued. There is a paradox at the heart of all modernisms that is not present in the structure of Modernity itself. Modernity is unilinear, basing its ontology upon the idea of progress, and with its eye always on the immediate future. Modernisms are the antitypes of Modernity. Perhaps that is what Walter Benjamin (1892–1940) meant when, inspired by a painting of Klee, he envisioned History as an angel with its face turned to the past, and Progress as the storm 'blowing from Paradise' that turns the past into a pile of debris.[8]

So were Europe's first modern artists a fifteenth-century avant-garde? The concept is a nineteenth-century one and if we apply it to earlier centuries we run the risk of developing an anachronistic hermeneutic. But the risk is worth taking because the concept now possesses a powerful normative as well as historic function. If European art since the fifteenth century has been a dynamic mode of production, then the nature of its prime movers becomes a matter of paramount interest. The *New Shorter Oxford English Dictionary* (1993) lends its support to this strategy by defining 'avant-garde' normatively as 'the pioneering or innovative writers, artists, etc., in a particular period'. Though we may still agree that there are many differences between the 'pioneering and innovative' artists of

[6] Levitine 1978.
[7] Quoted from Kemp 1981, p. 204.
[8] Benjamin 1973, pp. 259–60.

the fifteenth and nineteenth centuries, it is to the fifteenth that we must look for Europe's first avant-garde: artists who pursued their new practices in the face of conservative opposition bound to traditional craft practices.

Given this position we may then take note of artists and groups of artists occupying avant-garde positions at every major stylist disjunction from *c.* 1420 to *c.* 1750, from early Renaissance to late Baroque. We may also see fit to describe these artists not only as an avant-garde but as the modernists of their day. Implicitly, of course, we have long done so, describing the history of European art since the Renaissance, broadly speaking, as the history of modern art. Modernity and modernism are such central concepts in the description of contemporary society that they are unlikely to become obsolete in the foreseeable future.

Let us return, for a moment, to the pre-eighteenth-century avant-garde, to those artists who introduced dynamic change into the craft-based production cycle. What moved these movers? Change is observable in their personal styles from the beginning. An early Donatello is readily distinguishable from a late one; an early Titian from a late Titian. But at the points of disjunction between, say, High Renaissance and Mannerist art, a *period* change is also discernible. How may we explain such changes?

GENERATIONAL CHANGE

Ernst Gombrich has offered an insightful explanation which is often ignored – perhaps because of its very simplicity.

Men such as Michelangelo and Raphael, Titian and Leonardo, had actually done everything that former generations had tried to do. No problem of draughtsmanship seemed too difficult for them, no subject-matter too complicated. They had shown how to combine beauty and harmony with correctness, and had even surpassed – so it was said – the most renowned statues of Greek and Roman antiquity. For a boy who wanted one day to become a great painter himself, this general opinion was perhaps not altogether pleasant to listen to. However much he may have admired the wonderful works of the great living masters, he must have wondered whether it was true that nothing remained to be done because everything art could possibly do had been achieved. Some appeared to accept this idea as inevitable, and studied to learn what Michelangelo had learned, and to imitate

his manner as best they could. Michelangelo had loved to draw nudes in complicated attitudes – well, if that was the right thing to do, they would copy his nudes, and put them into their pictures whether they fitted or not . . . But not all young artists of that period were so foolish . . . Many, indeed, doubted whether art could ever come to a standstill, whether it was not possible after all, to surpass the famous masters of the former generation, if not in their handling of human forms, then, perhaps, in some other respect. Some wanted to outdo them in the matter of invention. They wanted to paint pictures full of significance and wisdom – such wisdom indeed, that it should remain obscure, save to the most learned scholars. Their works almost resemble picture puzzles which cannot be solved save by those who know what the scholars of the time believed to be the true meaning of Egyptian hieroglyphics, and of many half-forgotten ancient writers. Others, again, wanted to attract attention by making their works less natural, less obvious, less simple and harmonious than the works of the great masters.[9]

And Heinrich Wölfflin (1864–1945), years before, put the issue in a somewhat similar fashion, linking individual change with generational change:

The history of generations does not proceed differently from the history of the individual. If a great individual like Titian incorporates perfectly new possibilities in his ultimate style, we can certainly say a new feeling demanded this new style. But these new possibilities of style first appeared for him because he had already left so many old possibilities behind him. No human personality, however mighty, would have sufficed to enable him to conceive these forms if he had not previously been over the ground which incorporated the necessary preliminary stages.[10]

For both Gombrich and Wölfflin, change is also *generational* change. The achievements of one generation lie heavy upon that which succeeds it.

Yet Gombrich would not offer it as a sufficient explanation for the move from Renaissance to Mannerist art, nor would he, as Wölfflin does, assume that 'a new feeling demanded' the change from High Renaissance to Baroque, but rather would present generational change as but one crucial factor endemic to an art

[9] Gombrich 1955 (7th edn), p. 266. For an interesting discussion of Marx's use of the concept of generational change, see Kitching 1988, pp. 44–45.
[10] Wölfflin [1929], p. 230.

which, since the fifteenth century, is constituted, and reconstitutes itself, by radical change. The demand for change, the very nature of art in the special sense as distinct from craft, insists upon change, thus closing out the art of the recent past as models to be simply copied. No doubt generational change affects craftspersons also, but not with the same insistence. It is a factor bound up with the cult of the creative individual as a genius, the beginnings of which are to be found in the fifteenth century.

Norman Bryson has shown how David and his generation sought to cope with this problem, crucial to modern art, of appropriating the past, in their case the art of Roman antiquity and the recent past of French painting, in their symbolic production of the new art: 'the painting's apprehension of its precursors unfolds through a figure of irony, by which one does not necessarily mean that the precursors are mocked; only that the productions are suspended within a logically higher set, within an image which presents itself . . . as a container of other images, rather than as independent content'.[11]

The problems that thus faced the French Neo-classicists set the scene for nineteenth-century art in Europe. A sequence of nineteenth-century 'modernisms' driven in part by generational discontent preceded the major stylistic disjunction which began in the 1890s and is still called 'the modern movement' today. Each of the nineteenth-century modernisms was accompanied by bursts of polemical criticism during which a new generation of artists sought to displace its predecessors. We need only to recall the furore that accompanied the performance of Hugo's *Hernani* in 1830 that signified the triumph in France of Romanticism over Neo-classicism; and thirty years later the triumph of the Parnassians, grouped around Lecont de Lisle (1818–1894), over Romanticism; which was in turn supplanted, some twenty or so years later by the Symbolists. Or consider the element of rivalry between J.-A.-D. Ingres (1780–1867) and Eugène Delacroix (1798–1863) or, for that matter, between Richard Wilson (1714–1803) and John Constable (1776–1837) – as much a generational difference as a conflict between classicism and romanticism.[12] All this is common knowledge, but it would be naive to correlate artistic generations overly with natural

[11] Bryson 1984, p. 35. A parallel view in the field of literature has been developed by W. Jackson Bate in Bate 1971 and by Harold Bloom in Bloom 1973.

[12] Romanticism, essentially of literary origin, is of doubtful value as a periodising style in the visual arts; despite the unquestioned influence of romanticism on the visual arts, it is not possible to describe a 'romantic' style visually. See Barrell 1986, pp. 223ff.

generations. Although the pressure exerted by a new generation is ever present, other factors may advance or retard artistic change. For example, the polemical campaign which A. Welby Pugin (1812–1852), as champion of the Gothic Revival in Britain with his *Contrasts* (1836), led against Neo-classical architecture may be seen as a generational change at one level, despite his good relations with his employer, Sir Charles Barry (1795–1860).[13] But it represents also a major change in European taste, important not only in Britain but also in France and Germany, and persisted for several generations as the states of northern Europe sought to define their own cultural identities increasingly in Gothic terms. It was a taste distinct from the long-sustained hegemony of Italian classicism grounded in European culture's alleged identity with the architecture and sculpture of Greek and Roman antiquity. The taste for Gothic, particularly in ecclesiastical and collegiate architecture, is not effectively challenged until the emergence in the late nineteenth century of the formalist architecture, institutionalised as the International Style, and still called Modernist today. In the case then of Pugin, both generational and national factors are present in his avant-garde advocacy of a major stylistic change in British architecture.

Likewise the undoubted generational conflict present between Ingres and Delacroix and less obviously between Wilson and Constable, a change roughly intersecting with the classicism/romanticism divide, may have been fortified by the collapse, during the 1820s and 1830s, of the camera obscura as a model for the status of the observer, as Jonathan Crary has argued, and the consequent development of a colour-directed naturalism that faced towards Impressionism.[14]

On the other hand, towards the end of the nineteenth century, the 'artistic' generations crowd upon the natural generations as we move from Impressionism, to Neo-Impressionism, Fauvism and Cubism, all in less than forty years. The oedipal pressures of the natural generations are ever-present there also but now telescoped by market forces. For with the growth of capitalism's marketing techniques, change, as an index of fashion, presses with increasing weight upon avant-garde innovations. Here the study of market-driven changes in substyles tends to obscure the long-term trends operating within contemporary art.

[13] On Pugin's relations with Barry, see Clark 1962, pp. 128–32.
[14] Crary 1988, pp. 29–44.

THE AUTONOMY AND INSTITUTIONALISATION
OF ART

Given that the dynamic condition of European art and literature
creates an endemic situation of increasing anxiety in which the past
is not viewed simply as so many events in a series over and done
with but normatively as both an atemporal valuing system and
something to be confronted and annexed, the whole process
delimits a field within Modernity in which art becomes increasingly
autonomous. Yet it remains an imperfect autonomy threatened at
all times by economic, technological, national and other factors
external to its realm. In this respect Peter Burger's concept of the
historic avant-garde (the avant-garde that erupts with Dada)
becomes problematic. For is not the avant-garde always historic,
not only during the 1920s? Historic, that is, in Bürger's own sense:
that art as an institution must be challenged in order for art to
change, yet historic in its very dependence upon the past to effect
that change. Certainly, Pugin did not possess the same conception
of art as an institution as, say, Duchamp did, yet he mocked classi-
cal architecture as apt for the modern world as ruthlessly as
Duchamp sought to mock the idea of the artist as a special kind of
person inhabiting an autonomous, sacralised realm. Yet both drew
upon the art of the past for their ironic challenge: Pugin upon
classicism, Duchamp upon industrial art, or art in the general sense.
It is usually forgotten that some anonymous artist-designer de-
signed Duchamp's ready-mades. Art as an institution, pace Bürger,
did not suddenly become visible in the 1920s, first witnessed by his
so-called historic avant-garde. It had been emerging in Europe
since 1600 with the formation of the early academies of art when
dissent from the authority of the medieval guilds became a driving
force behind change. And as it began so it continued. For example,
Caravaggio's innovations are made in the face of 'the very different
cultural traditions of late Mannerist Rome'.[15]

Viewed in this way the concept of the avant-garde is better
understood as a metaphor for *generational* change in 'fine' art,
which by its implicit nature is dynamic, rather than a metaphor for
a small group of talented individuals networking for artistic reform
against philistine majorities during the nineteenth and early twen-
tieth centuries. Jeffrey Weiss has argued convincingly that some of
the leading figures that Bürger cites as master critics of art as an
institution, such as Pablo Picasso (1881–1973) and Duchamp, were

[15] John Gash in Dictionary 1996, vol. 5, p. 703.

in practice deeply involved with the art institutions of both advanced and popular art during the years immediately prior to World War I. Weiss shows that it is confusing to regard such artists as occupying a position of advanced theoretical opposition to art as an institution. They were of it and very much in it, not in docile approval, but in a dialectical interplay with an institution upon which they depended. It took the form of 'verbal play, parody, irony and the practical joke, strategies . . . exploited by these two artists [Picasso and Duchamp] in direct conjunction with the diffi-cult reception of modernism in general'.[16] So it is with all avant-gardes. Precisely because the modern art world possesses a high degree of autonomy within civil society, modern professional artists *qua* artists *cannot* act outside of it. Today, Duchamp and Warhol are two of its most celebrated heroes, sacralised in countless mono-graphs. Indeed Clement Greenberg, writing in 1940, saw the avant-garde as defenders of art as an autonomous institution, 'the embodiment of art's instinct of self-preservation'.[17]

We have then here three factors that are influential in defining an emergent modernism in contrast to the Modernity within and against which it operates. First, a generational change that begins to operate about every twenty-five years, but may be advanced or delayed by social factors; for generational change, like adolescence, is, at bottom, a biological factor.[18] Second, under the conditions of Modernity, the presence of a free market for art that regulates and absorbs avant-garde innovations, normalising them, folding them over into the conditions and conventions of Modernity. Third, the presence of new art institutions themselves, such as the academies of the sixteenth century or the Museum of Modern Art, New York, in the twentieth, established to safeguard the autonomy of art and its recently won innovations within Modernity itself.

Let us return to Peter Bürger for a moment, for he does make a point of considerable significance. For him aestheticism, the advanced art of the late nineteenth century, represents the end of an era not the beginning of one. It is not, in his view, to Baudelaire, Cézanne, Gauguin, Brancusi and the like that we must look for the true beginnings of a modernism peculiar to the twentieth century, but to Dada and Surrealism, to Duchamp and Schwitters, to film and montage, to the *papier-collé* of Braque and Picasso. This, obvi-ously, is not to say that the poems of Baudelaire and the paintings

[16] Weiss 1994, p. xvii.

[17] 'Towards a Newer Laocoon', in Greenberg 1986, vol. 1, p. 28.

[18] On this controversial point, see, above all, Freeman 1983.

of Cézanne and their innovative epigones are of less *aesthetic* signifi-
cance but that from the viewpoint of the late twentieth century
their art is best understood as a late nineteenth-century achieve-
ment, the culmination in both theory and practice of positions that
had been developing for over a century, since Hogarth and Kant,
Schelling, Turner and Riegl.

2 The theoretical sources of the Formalesque

The emergence of the Formalesque as a period style is basically the story of the reduction of the concept of style to that of form under the over-arching conditions of cultural imperialism. It is manifest in the desire to create a universal art with an authentic European look, a formal art that might be globally negotiable among all the heterogeneous cultures of the world. It is also, to a large degree, the historiography of art history and modern aesthetics.

I have called this style-cycle the Formalesque because quality centred upon style – style understood as form. Art history and, to an even larger extent, art criticism were predicated mainly, until the 1960s, upon the concept of style. But the concept, in the visual arts, contains an inherent ambiguity. Style embraces both that which may be shown and that which may be inferred; that which may be seen to be so, and that which may be meant to be so; in other words form and meaning. Art history has oscillated between the inherent tensions within the concept: style as meaning, style as form. In the visual arts visual analysis and interpretation involve an unavoidable entanglement between word and image.

It is there from the beginning, from the Latin *stilus*, a sharp-pointed instrument for writing on a wax tablet, thus providing both the means and the result, production and reception, from which it comes to be used to describe rhetorical modes in classical oratory, and from which in turn Pliny (AD *c.* 23–79) applies the concept to the visual arts in writing the history of ancient Greek bronze sculpture to distinguish, for example, the 'style' of Polyclitus from that of Lysippos in terms of human movement and proportion. Peculiar to Polyclitus 'is the device by which his statues step forward with one leg ... [and] are squarely built and seem almost to be made of a uniform pattern', whereas Lysippos did much 'to advance the art of sculpture in bronze by his careful treatment of the hair, and by making the head smaller and the body more slender ... thus imparting to his figures an appearance of greater height'.[1]

In Pliny visual analysis of this kind is incidental, but his comments on style reveal the rudiments of a history of art as

[1] Pliny, *Natural History*, xxxiv.55.61; quoted in Jones 1895, pp. 126, 196.

progressive and dynamic, distinct somewhat from craft, at least in its emerging capacity to represent proportion and movement. However, such records as Pliny's only account for the 'progress' towards a greater naturalism in the art of ancient Greece between the fifth and fourth centuries BC. After that, art was felt to have declined. There is no sense of stylistic change after the 'ideal' forms have been attained. This is also true of Giorgio Vasari (1511–1574) writing on Italian art from its earliest times down to his own day. After the ideal attained in the art of Michelangelo, the rest of the story is a decline into a condition of stasis or maniera: 'these arts [i.e. architecture, sculpture and painting] resemble nature as shown in our human bodies; and have their birth, growth, age and death'.[2] It was not until the eighteenth century with Johann Winckelmann (1717–1768) that any concept of art continuously changing in response to both social and immanent change (i.e. within the logic of its own development) develops beyond the notion of successive *technical* innovations leading to the perfection of naturalism in proportion, movement and expression. The change first appears, as Alex Potts has convincingly argued, when Winckelmann, in his *History of Ancient Art*, distinguished between a high and a beautiful style in classical Greek sculpture. 'The key difference . . . is one between a certain hardness and angularity of contour in the high style and a flowing gracefulness of contour in the beautiful style'.[3] Winckelmann was not arguing that the beautiful style was of a finer quality or had reached a higher peak of perfection than the high style, or vice versa. He was seeking to describe two modes of excellence. This distinction opened out the possibility of an art history that developed a concept of style that escaped the organic analogy and the naturalistic imperatives that dominated the conceptual framings of Pliny and Vasari. Rather than use a biological analogy to explain the distinction he makes between the high and beautiful styles of Greek sculpture, Winckelmann uses a *social* analogy drawn from law:

> With such severe ideas of beauty [i.e. the high style], art began to be great, as well-ordered states thrive with severe laws; and the figures were simple, like the manners and men of the age. The immediate successors of the great lawgivers in art did not however proceed as Solon did with the laws of Draco, they did not depart from their rules; but as the strictest laws become more

[2] Vasari 1963, vol. 1, p. 18.
[3] Potts 1994, p. 68.

useful and acceptable through a temperate interpretation of them, so the latter sought to bring nearer to nature the lofty beauties which, in the statues of their great masters, were like abstract ideas of nature, and forms modelled upon a system; and in this way they attained greater variety. This is the sense in which we are to understand the grace introduced by the masters of the beautiful style into their works.[4]

The analogy suggested the possibility of a *social* history of art and also implied a strong element of relative autonomy in the dynamic development of art as a social institution.

Winckelmann's distinction between the high and beautiful styles also reveals the persisting ambiguity within the concept of visual style itself that we noted earlier. Whereas such descriptions as 'angularity of contour' and 'flowing gracefulness of contour' are the products of visual observation, phrases such as 'pure harmony and grandeur' and 'variety and diversity of expression' are descriptions of *affect*, of the viewer's personal response to what has been seen rather than relatively neutral descriptions of the visible. The aporia at the heart of Winckelmann's concept of the high and the beautiful styles was exacerbated by the fact that not only was the high style (as Potts points out) a kind of limbo between Winckelmann's concepts of the archaic and beautiful styles in Greek sculpture, it was not based upon empirical analysis. Indeed no original evidence existed then (and little exists today) that enabled him to provide an empirical analysis of the style.[5] In consequence the high style in Greek sculpture remained rather like a Platonic Idea, hidden from reality. And so it has remained largely to this day, a demanding yet invisible ideal for Eurocentred valuing.

One way out of the problem implicit in Winckelmann's concept of style had already been indicated by William Hogarth (1697–1764) over a decade before the appearance of the *History of Ancient Art*. Hogarth reduced aesthetic value to a question of visual form. It is probably the first attempt to advance a purely formalist aesthetic. 'I shall endeavour to show', he wrote, 'what the principles are in nature, by which we are directed to call the forms of some bodies beautiful, others ugly; some graceful, and others the reverse; by considering more minutely than has hitherto been done, the nature

4 Winckelmann 1881, vol. 2, p. 135.
5 The one group that Winckelmann regarded as 'indisputable works of the grand style' (Winckelmann 1881, vol. 2, p. 132) were in fact Roman copies of Niobe and her daughters which he believed to have been either by Skopas or an exact copy of a Skopaic original (see Haskell & Penny 1981, p. 274).

of those lines, and their different combinations, which serve to raise in the mind the ideas of all the variety of forms imaginable.'[6]

Hogarth argued that the two-dimensional waving 'line of beauty' and the three-dimensional serpentine 'line of grace', when mixed judiciously with one another and with plain lines in opposition to them, could provide the mind with all that it needed to apprehend the beauty and grace offered by works of art. After much theoretical elaboration it was such a formalist aesthetic that came to dominate the modernism of the late nineteenth and early twentieth centuries.

One line of its descent may be traced through the discourse developed by the German historians of art during the nineteenth century. They became increasingly aware that the visual arts, though a relatively autonomous activity, nevertheless issued from society.[7] However, by the end of the century their intensely dialectical discourse came down, for all practical purposes, in favour of a formalist aesthetic.

Essential to formalism was the realisation that art was a quasi-autonomous activity operating within the social realm. From an economic viewpoint this was but another case of the division of labour stimulated by the rise of the bourgeoisie and the development of industrial society. Art was work of a special kind, a kind of creative or spiritual labour, to be distinguished from mundane work. The fine arts were to be distinguished from the 'useful' arts. One of the first to do so was Charles Batteux (1713–1780), who, in his *Les Beaux-arts réduits à un seul principe* (1747), divided them into useful and beautiful arts, the latter of which comprised sculpture, painting, music and poetry, with architecture (and eloquence) combining beauty and utility. A supportive distinction, the idea of 'disinterested valuation', had been developed somewhat earlier in English thought during the seventeenth century by Ralph Cudworth (1617–1688) and the Cambridge Platonists in opposition to Thomas Hobbes (1588–1679), who had argued that both religion and morality were grounded in 'enlightened self-interest'. It entered aesthetic thought in the writings of Anthony Cooper, 3rd Earl of Shaftesbury (1671–1713), and Francis Hutcheson (1694–1746). Shaftesbury contrasted 'disinterested attention' with 'any

[6] Hogarth 1955, p. 21.

[7] As Michael Podro has put it: 'If a writer diminishes the sense of context in his concern for the irreducibility or autonomy of art, he moves towards formalism. If he diminishes the sense of irreducibility in order to keep a firm hand on extra-artistic facts, he runs the risk of treating art as if it were the trace or symptom of those other facts. The critical historians were constantly treading a tightrope between the two' (Podro 1982, p. xx).

desire to use or possess or otherwise manipulate the object of attention'.[8]

The 'disinterested attitude' eventually became a guiding principle of formalist aesthetics after it was developed by Kant (1724–1804), in his *Critique of Aesthetic Judgement* (1790), as one of the central principles of his highly influential philosophical system. Kant recast Shaftesbury's notion of 'disinterest' into the logic of his own metaphysics, moving it from psychology to phenomenology. Aesthetics had been first developed as a philosophical concept some forty years before by Alexander Baumgarten (1714–1762) in his *Aesthetica* (1750–58), in which he adopted the Greek *aisthetikos*, denoting sensory perception, as the section of philosophy treating of sensuous experience; just as truth was the aim of knowledge, and good the aim of volition, so the perception of beauty was the aim of sensuous knowledge. Aesthetics, Baumgarten said, is 'the sister of logic',[9] a 'feminine analogue of reason at the lower level of sensational life'.[10]

Kant recast Baumgarten and Shaftesbury. His critique of judgement, the realm of the aesthetic, formed a middle term between understanding and reason. Aesthetic judgements (the judgements of taste) are to be distinguished from judgements concerning the pleasure, utility or goodness that things or actions provide. They are personal, disinterested and universal – and cannot be logically refuted. They form a class of their own. Because the judgement of taste is subjective, it can only address itself to the form of the object. Should it address itself to content, to subject matter or to emotions evoked by the object, the 'disinterest' essential to the judgement of taste will be compromised by pleasure, or desire. Kant puts it in this way: that which 'distinguish[es] a judgement of taste from all cognitive judgements, will of itself suffice for a deduction of this strange faculty, provided we abstract at the outset from all content of the judgement, viz. from the feeling of pleasure, and merely compare the aesthetic form with the form of objective judgements as prescribed by logic'.[11]

Kant's views exercised a powerful long-term influence upon the formation of the Formalesque style. Although he was not a formalist in the manner of most of his later epigones, such as Roger Fry and Clement Greenberg, his aesthetic encouraged the development of formalist theory throughout the nineteenth century and its

[8] Osborne 1968, p. 99.
[9] Quoted in Eagleton 1990, p. 16.
[10] *ibid.*
[11] Kant 1952, p. 136.

dominance during the first half of the twentieth. In discussing the art of landscape gardening, Kant writes: 'No matter how heterogeneous . . . may be the craft involved in all this decoration . . . still the judgement of taste . . . is determined . . . only upon the forms (without regard to any end) as they present themselves to the eye.'[12] Or again, when speaking of arts such as opera that combine the virtues of several arts: 'Still in all fine art the essential element consists in the form which is final for observation and for estimating . . . The matter of Sensation (charm or emotion) is not essential.'[13] For Kant, the *formative* arts are architecture, sculpture and painting, as distinct from poetry, rhetoric and music. 'Among the formative arts I would give the palm to *painting* . . . because it is the art of design and, as such, the groundwork of all the other formative arts.'[14] Kant's perception of painting as design was indeed prophetic, for it was, as we shall see later, through the arts of design, as exemplified in the decorative arts, rather than through the naturalistic painting and sculpture so popular during the nineteenth century, that increasing stress was laid upon form during the later years of the century.

Although his aesthetic was a formalist one, Kant was not an aesthete. His view of fine art also contains a powerful moral component.[15] But the overall effect of his *Critique* laid greater emphasis than ever before upon form in the practice of fine art. For example, although Friedrich von Schiller (1759–1805) differs in several respects in his aesthetic from Kant, most notably in the constitutive role he gives to art as play, he was deeply influenced by Kant's stress upon form. 'In a truly successful work of art, the contents should effect nothing, the form everything, for only through the form is the whole man affected . . . [I]t is only from form that true aesthetic freedom can be looked for.'[16]

Kant's aesthetic prescribed one way of viewing art and nature and proscribed other ways. It was the first fully theorised *receptionist* aesthetic. But it also contributed powerfully to the constitution of fine art as an autonomous social realm. 'Taste lays claim simply to autonomy. To make the judgements of others the determining ground of one's own would be heteronomy.'[17] Fine art, unlike handicraft, was free. Fine art can only be a success 'as play' (here

[12] *ibid.*, p. 188.
[13] *ibid.*, pp. 190–91:
[14] *ibid.*, p. 196.
[15] On this point, see Crowther 1993, pp. 56ff., and Bell-Villada 1996, pp. 21 et al.
[16] Schiller 1967.
[17] Kant 1952, p. 137.

he follows Schiller), whereas handicraft 'on its own account is disagreeable'.[18]

Kant's aesthetic, grounded in the German idealism of his time, thus constructed immanent possibilities for the practice of a cultural imperialism that could embrace phenomenally and universalise not only the heterogeneous arts and crafts of all tribes and nations but even the global diversity of nature itself within the universal play of aesthetic cognition.

In this connection it is of interest that, despite the categorical stress on the disinterested character of aesthetic judgement, Kant does allow interest to creep in by the back door. Although disinterest is a determining ground for aesthetic judgement, he adds that 'it does not follow that . . . an interest cannot enter into combination with it'.[19] But this interest will be 'indirect', an 'inclination proper to the nature of human beings', an 'empirical interest'[20] existing only in society rather than upon determinate a priori grounds.

[I]f we admit that the impulse to society is natural to mankind, and that the suitability for and the propensity towards . . . *sociability* is a property essential to the requirements of man as a creature intended for society, and one, therefore, that belongs to *humanity*, it is inevitable that we should look upon taste in the light of a faculty for estimating whatever enables us to communicate even our *feeling* to every one else, and hence as a means of promoting that upon which the inclinations of everyone is set . . . Further a regard to universal communicability is a thing which everyone expects and requires from everyone else, just as if it were a part of an original compact dictated by humanity itself. And thus, no doubt at first only charms, e.g. colours for painting oneself (roucou among the Caribs and cinnabar among the Iroquois) or flowers, sea-shells, beautifully coloured feathers, then, in the course of time, also beautiful forms (as in canoes, wearing apparel, etc.) which convey no gratification, i.e. delight of enjoyment, become a moment in society and attract a considerable interest. Eventually, when civilisation has reached its height, it makes this work of communication almost the main business of refined inclination, and the entire value of sensations is placed in the degree to which they permit of universal communication. At this stage, then, even where the pleasure which each

[18] *ibid.*, p. 164.
[19] *ibid.*, p. 154.
[20] *ibid.*, p. 155.

one has in an object is but insignificant and possesses of itself
no conspicuous interest, still the idea of its universal communi-
cability almost indefinitely augments its value.[21]

There were many moments in European society (which Kant
equated with civilisation) when the painted faces of indigenes and
artifacts such as Polynesian canoes attracted 'considerable interest'.
Kant's aesthetic unwittingly sets in place a powerful justification for
a European imperial project by means of which the arts and crafts
of indigenous peoples became the object of the playful cognition of
aesthetic judgement – which when 'universally communicated'
greatly augmented both their aesthetic and financial value. In other
words, his aesthetic helped to prepare the transformation of the
cultural particulars of indigenous artefacts into the universalising
aesthetic formalism of marketable commodities.

That is, in one sense, the negative side of the Kantian aesthetic.
But there is also a positive side. His stress upon disinterest, play and
form are inextricably interwoven with the concept of the *sensus
communis*, the Enlightenment belief in a common humanity, indeed
in the grounding concept of the human for all social and cultural
interrelationships. It is because we do *not* want to consume the
specific content of the art work (to desire or possess it) but only to
take a disinterested delight in it, that delight for Kant must be
formal; in their *form* art works achieve universality. Here lay the
potential for a global view of art that ignored specific content while
admiring a 'universalised' form. From that universalist position, in
the fullness of time, would develop 'primitive' art museums in all
parts of the 'advanced' world. But it also held out the distant
promise and potential of a *non-possessive*, global perspective on
world art.

In theorising genius Kant also developed another concept at the
heart of the Formalesque. Genius is a natural endowment and the
'innate productive faculty of the artist' by means of which 'nature
gives the rule to art'.[22] Originality implies that there can be no fixed
techniques or conventions. But this does not mean that there are
no rules at all. Fine art, unlike craft, is not produced by following
conventions. It is the practising artist, working in the ever-changing
situation of fine art, who provides the rules. He does this by provid-
ing exemplary models for artists who come after him. However,
Kant does not address the contradiction here involved; for, if it is
genius that produces original fine art and the gift of genius proceeds
from nature rather than art, are those later 'fine' artists who take

[21] *ibid.*, pp. 155–56.
[22] *ibid.*, p. 168.

the genius's rules as exemplary also geniuses themselves, or are they just craftsmen? His argument implies a regress of art into craft. Here we may glimpse a distant echo of the melancholy which will rise constantly from Hegel to Adorno as modernists contemplate the future prospects of the ever-changing art of their own day, as innovations are folded over into mere celebrations of Modernity, their Duchamps into Warhols.

Yet even such a melancholy view of Kant's idea of genius still provides a powerful explanatory concept for writing a history of fine art that is determined by 'creative' individuals. It offers an interesting parallel to Thomas Kuhn's account of the history of science as the product of successive paradigms originated by highly talented scientists that are subsequently refined by the technicians of science,[23] and may also be compared with Griselda Pollock's view of avant-gardism as a kind of 'game play' involving reference, deference and difference.[24] For Kant's genius, by its natural talent, produces 'different' work, refers it to an existing body of work, and tests it against models (as Kant puts it) 'not for *imitation* but for *following*'.[25]

Friedrich Schelling (1775–1854) developed Kant's concept of genius. The 'innate mental aptitude' by means of which Kant's genius 'gives the rule to art' becomes with him an unconscious drive within the artist's ego. Art begins as a conscious activity but its result contains unconscious activity also, and it is this that constitutes the 'genius' component in art practice. Schelling put it this way: 'The ego . . . must begin with consciousness (subjectively) and end in the unconscious, or *objectively*; the ego is conscious as regards production, unconscious as regards the product . . . The . . . product is none other than the product of genius or, since genius is possible only in art, the *product of art*.'[26]

All artists, Schelling pointed out, were 'involuntarily impelled to the creation of their works'. It was an irrepressible impulse containing a contradiction, an apparently 'free' activity yet incurred involuntarily. 'Consequently it can only be the contradiction between the conscious and the unconscious in free action that sets the artistic impulse into motion.'[27]

[I]f art is brought to completion by two thoroughly different activities, then genius is neither the one nor the other but that

[23] Kuhn 1962.

[24] Pollock 1992, pp. 12ff.

[25] Kant 1952, p. 171.

[26] Schelling, *System of Transcendental Idealism* (1800); quoted in Simpson 1984, pp. 120, 122.

[27] Simpson 1984, p. 123.

which is above both. If we must seek in one of these two
activities, namely conscious activity, for what is usually called
art, but which is merely one part of art, namely the part that is
practised with consciousness, deliberation and reflection, which
can also be taught and learned, received from others, and
attained by one's own practice, then, on the other hand, we
must seek in the unconscious, which also enters into art, for that
in art which cannot be learned, cannot be attained by practice or
in any other way, but only can be inborn by the free gift of
nature, and which is what we may call in one the *poetry* [*Poesie*]
in art.[28]

Schelling was responsible, more than anyone else, for the concept
of the unconscious entering the Romantic discourse. Both Schiller
and Goethe followed him.[29] He gave the Kantian concept of genius
a dynamic turn. This too may be seen as a generational change.
Kant is a brilliant son of the Enlightenment and his taste (to the
extent that he possessed taste rather than wrote about it) is neo-
classical. Schelling, born some forty years after Kant, belongs to the
first generation of Romantics and more than any other philosopher
provided them with a transcendental philosophy and ideology that
befitted their aspirations.

So we find Schelling inverting several of Kant's central ideas.
The aesthetic is now no longer the judgement of taste centered
upon form, it is the vehicle of self-consciousness, the objective
demonstration of philosophical thought. 'If aesthetic intuition is
only intellectual intuition become objective, then it is evident that
art is the sole true and eternal organon as well as document of
philosophy, which sets forth in ever fresh forms what philosophy
cannot represent outwardly, namely, the unconscious in action
and production and its original identity with the conscious.'[30] The
idea of form ceases to be central to the judgement of taste, it
becomes instead a shaping of the vital energy of nature which not
merely forms but also transforms all things. The static idea of form
is transfigured into formative energy. Form is given a central place
not only in the reception, as in Kant, but in the production of art.

Schelling, by stressing that creativity resided in the unconscious
component of artistic production, diminished Kant's concept of
genius as the provider of the 'ruler' of art. He also subtly diminished
the significance of craft and technique, the conscious components

[28] *ibid.*
[29] See Abrams 1953, pp. 210–11.
[30] Simpson 1984, p. 129.

of artistic production. This left the way clear for a cult of genius to develop, best described as *geni'usism*, which finally divorced the idea of genius utterly from that of craft skill. Schelling is the forefather of Duchamp and Conceptual Art.

No philosopher ever gave so high a place to art as Schelling did. 'Philosophy, to be sure, reaches the highest level, but it brings only, as it were, a fragment of man to this point. Art brings *the whole man*, as he is, to that point, namely to a knowledge of the highest of all, and on this rests the eternal difference and the miracle of art.'[31]

What is relevant to us here is that Kant's aesthetic was basically a reception aesthetic born of his taste and generation; Schelling's, a producer's aesthetic that placed the artist above community and the moral order. Romantic freedom was driven from within, an involuntary and therefore paradoxical freedom.

[I]t excludes not only affinity with everything that is merely sensuous enjoyment . . . or with the useful [he is with Kant here] . . . but even affinity with everything that belongs to morality. Indeed, it leaves far below it science itself, which in view of its disinterestedness borders most closely upon art, merely because it is always directed to a goal beyond itself and in the end must itself serve as a means for the highest, i.e. art.[32]

The ideas we have been considering thus established two poles of the Formalesque aesthetic: form, centred upon the beholder; genius, centred upon the practising artist. They continued to provide the character and defence of Formalesque theory. Form became a dominant figure in Formalesque thought as it embraced an increasing diversity of artistic products drawn from diverse cultures; the concept of genius became the basic defence for the autonomous practice of art over against the limiting demands of society. On this matter Schelling sounded a prophetic note:

[T]he art world must . . . be thought of as a single great whole, and presents in all of its individual products only the one infinite . . . For if aesthetic production proceeds from freedom, and if the opposition of conscious and unconscious activity is absolute precisely for freedom, then there exists really only a single absolute work of art, which can to be sure exist in entirely different exemplars but which yet is only one, even though it should not yet exist in its most original form.[33]

[31] *ibid.*, p. 130.
[32] Schelling, *System of Transcendental Idealism*; quoted in Simpson 1984, p. 126.
[33] *ibid.*, pp. 128–29.

It was an idealist way of describing the immanence within artistic production. Praxis makes perfect.

Hegel doubted whether art should be placed upon quite so high a pinnacle. Art at its best was, for Hegel, a thing of the past. Nevertheless he seems to have been influenced in the development of his aesthetics by much of Schelling's thinking. For example, Schelling in his *Concerning the Relation of the Plastic Arts to Nature* (1807) argues that it is the art of the sculpture of the ancients that provides the perfect balance between the forces of nature and the forces of the soul, whereas the painting of modern times makes 'the soul itself into the suffering organ of higher revelations'. 'Raphael takes possession of serene Olympus and leads us with him away from the earth into the concourse of the gods . . . He is no longer a painter, he is a philosopher.'[34] It is not difficult to see here a foreshadowing of the grand theme of Hegel's *Aesthetics*. Hegel turns Schelling on his head. For Hegel, art reaches its pinnacle with the sculpture of ancient Greece (he follows Winckelmann in this), but then loses its perfectly sensuous balance in the romantic art of Christianity. For Hegel, the art of his own day was (in a sense he foreshadows Theodor Adorno and Max Horkheimer here) a thing of the past. Modern art must defer to Philosophy where the Absolute Spirit had taken up residence – in Hegel's own Idealism.

Because sensuous material was a necessary condition for fine art, Hegel regarded its *content* as decisive: 'For it is the content which, as in all human work, so also in art is decisive.'[35] In its history fine art expressed its content by evolving forms by means of which it sought the ideal: in the symbolic form of Egyptian art; the classic form of Greek art; the romantic form of Christian art. Art had attained its ideal form in Greece as the sensuous presence of the Idea. In Hegel the formal element in art is not only given a dynamic subjectivity, as in Schelling, it is historicised. Broadly following Winckelmann's typology for Greek sculpture, he extends it to the history of art in general. So Egyptian architecture is taken to exemplify the severe style, Greek sculpture the beautiful style and European painting the pleasing style.[36] He thus conceived a morphology of style readily adaptable later to the empathic formalism of Wölfflin.

Hegel envisaged art as the reflection of a culture and its religion – as revealed in art's sensuous, material content. He had no conception of art's *autonomous* development. This move was taken up by his pupil Karl Schnaase (1798–1875). Schnaase paid close attention

[34] Quoted from Simpson 1984, pp. 155, 156.
[35] Hegel 1975, vol. 1, p. 611.
[36] *ibid.*, vol. 2, pp. 615–20.

to the specific forms that art evolved and transformed. He noted, for example, that the development of domed vaulting in Byzantine architecture led to less use of the straight entablature of classical architecture, that Byzantine capitals no longer flaunted delicate Corinthian calyces but were reduced to simple but stable cubic forms.[37] This way of interpreting works of art involved releasing them 'from contextual functions and contingent meanings'.[38] But for Schnaase the development of art's autonomy is relative. He agreed with Hegel that art developed in consort with religion. Like body and mind they are complementary yet in opposition and develop separately. In some periods religion dominates, in other periods art.

Significantly, German thinkers from Winckelmann to Schnaase in discussing the visual arts addressed their thought, explicitly or implicitly, to fine art and more particularly to sculpture and painting. Craft and industrial art, art in the general sense, was either categorically banished from the charmed circle or ignored. For Hegel, for example, art, which for him is fine art, begins emphatically with architecture 'Those beginnings which are simple and natural in the sense of being crude have nothing to do with art and beauty . . . Beauty, as a work of the spirit, requires . . . even for its beginnings a developed technique.'[39]

It is not surprising that it was left to an architect, Gottfried Semper (1803–1879), to take account of craft when addressing the problem of style. For the notions of disinterestedness and uselessness which the aesthetics of Kant and his epigones privileged do not fit comfortably with architecture. Batteux, we have noted, defined it as a category that combined art with utility. The very idea of a 'useful' fine art remained equivocal in German aesthetic thought.

Semper's view of style was grounded in the concept of an archetype or *Urform* which was itself derived from the foundational crafts of all humankind. These were of four kinds: textiles, pottery, carpentry and wall construction. The techniques basic to these four crafts were the source of the motifs and symbols of the visual arts and could be adapted to new functions and different materials. For Semper, style was an assortment of motifs and ways of treating certain materials. It is a materialistic theory of style and helped to connect fine art with the problems of design, suggesting new possibilities for a conjunction of the problematics of art in the special sense and art in the general sense.

[37] Schnaase, *Geschichte der bildenden Kunste*, vol. 3, p. 297; quoted in Podro 1982, p. 37.
[38] Podro 1982, p. 40.
[39] Hegel 1975, vol. 2, p. 615.

In his *Style in the Technical and Tectonic Arts (Der Stijl)* (1860–63) Semper sought to create a new theory of style that embraced form and meaning, starting from an analysis of basic craft techniques. In textiles, for example, he was interested in the designs that emerge from the techniques essential to creating seams, knots, bands and wreaths. The traditional employment of such techniques results in the creation of symbolic motifs. Semper believed, for example, that the use of a wreath on the neck of a painted pot with the leaves pointing alternately up and down symbolised its use for pouring liquids in and out. Similarly, he explained architectural symbolism in terms of the building techniques employed. He was interested in the ways traces of such techniques could be retained when transferred from one material to another, as in the move from wood to stone in Greek temple architecture. He was also interested in body ornament and its relation to the psychology of identity. Pendant earrings emphasize by contrast the neck's curve and contribute to poise; 'the brave red Indian will hold his shoulders more proudly when wearing his decorative head-dress'.[40] Semper, as Michael Podro insists (in retrieving Semper's reputation from a popularly held belief that his design theory was grounded in a technical determinism), clearly distinguished between the '*causal conditions of production* and the meaning' that flowed from 'those conditions'.[41]

What is of interest to us here is the way that discourse about form is in Semper rescued from its preoccupation with the body (in a mimetic sense) from Winckelmann to Schnaase, based as these earlier men were in the naturalistic assumptions that dominated the arts of sculpture and painting. Semper's theory of style, based on craft techniques, issues instead in a theory of abstract design that bore a relationship to the body in a social rather than a biologically mimetic sense. It thus opened out aesthetic theory to the abstract implications of handicraft and industrial design.

Semper showed how from craft techniques stylistic motifs could develop that in turn could be perceived as metaphors. He was concerned with the way in which traditional forms retain the trace of, and *re-present*, earlier structural forms. Meaning was realised in and through form. But in the transformation of motifs from their origin, the *Urmotiv*, as Semper called it, could be lost, as the Greeks lost the meaning of the acanthus when it was transformed into stone. 'The Greek imagination could only have come into existence

[40] Quoted from Podro 1982, p. 48.
[41] Podro 1982, p. 52.

on the humus of long dead and decayed earlier conditions and strange imported motifs the original meaning of which was no longer known'.[42]

In Semper's view, good taste, like good sense, meant taking what is relevant and integrating it with what one is doing. 'Even the most striking features of your prototype must be left out if they will confuse your work.'[43] This was Modernity rather than modernism speaking. The past was a foreign country to exploit, not to idealise. Although Semper was interested in the implications of borrowing motifs from the classic and European past, it is clear that his approval of adaptation by transformation and omission could be relevant to contemporary contexts, both spatial and imperial. A generation later Picasso and his contemporaries were to appropriate the forms of African sculpture while ignoring, as Semper recommended, their specific cultural contexts.

Semper himself played a pioneering role in this imperialising process. Born in Hamburg in 1803, he taught architecture in Dresden, but becoming involved in the Revolution of 1848 fled as a refugee to Britain where he assisted in the organisation of the Great Exhibition of 1851 under Sir Henry Cole, there being invited to arrange the Danish, Swedish, Egyptian and Canadian sections of the Exhibition. As a result of his experiences in England, Semper became one of the first to widen the discourse of art theory from its preoccupation with fine art out into the problematics of craft and industrial design. During the second half of the nineteenth century the discourse ceased to be confined to European high art and its classical exemplars, developing into one imperial in its scope as art and artefacts from all parts of the world were assembled at South Kensington. As is well known, the Great Exhibition stimulated the organisation of similar exhibitions throughout Europe and its colonies until the outbreak of World War II. They became trade and industrial bonanzas designed by Europe's nation-states on a global scale to advertise both their own manufactures and the crafts of their colonial and indigenous, colonised cultures. The Great Exhibition also stimulated the establishment in Europe of a new kind of art museum, which sought to embrace, on a global scale, the craftwork, both sacred and secular, of the indigenous peoples of Europe's multifarious colonies. In Vienna the Oesterreichische Museum für Kunst und Industrie was established in 1864, the Kunstgewerbemuseum in Berlin in 1867, the Industrie-Museum in

[42] Semper, *Die vier Elemente der Baukunst*, p. 52; quoted in Podro 1982, p. 54.
[43] *Der Stil*, vol. 1, p. 362; quoted in Podro 1982, p. 53.

Cologne in 1868, and in Hamburg the Museum für Kunst und Gewerbe in 1869. The Great Exhibition also stimulated the growth of new schools of applied art throughout Europe and eventually the whole of the colonised world.

What overall effect did all this have on the development of the Formalesque style? The discourse, under the impact of industrialism, of which the Great Exhibition and its diverse epigones were perhaps the most visible symbol, was now addressed increasingly to stylistic problems arising from the use of handicrafts in an age given over increasingly to industrial production. Applied and industrial design turned increasingly to the traditional crafts and away from the anthropomorphic sculpture of classical Greece for its exemplars. Models were now to be found not in the Aegean but in Europe's far-flung colonies. The traditional applied designs to be found in non-European countries in textiles, leatherwork, glass, wood and other handicrafts revealed little or no interest in perspective, the classically proportioned human figure, or landscape-naturalism. These were the special concerns of European high art. Consequently art theory and art history began to pay increasing attention during the second half of the nineteenth century to abstract and semi-abstract design as it was determined by its relationship to techniques employed and materials used. This, as we have noted, was Semper's special interest. But there was also the history of design motifs and symbols as such, as they were transferred from one material to another and from one culture to another throughout the course of history. This became the particular concern of Alois Riegl (1858–1905).

Significantly, it was in one of the new museums of applied art, the Oesterreichische Museum für Kunst und Industrie of Vienna, that Riegl began his research. The museum, like the Victoria and Albert Museum, had been established in order to foster 'a new awareness of the laws of design among manufacturers and among the public'.[44] He was placed in charge of one of the greatest collections of oriental rugs in the world, and his first book, *Altorientalische Teppiche* (1891), was devoted to their study. As a student he had studied the persistence of Roman law in medieval charters and had related it to the study of medieval calendar illuminations. So the first problem to occupy his mind was the relationship between oriental and classical ornament. His careful visual analysis of the material in his care convinced him that the Islamic arabesque motif was nothing else than the classical scroll ornament in an

[44] Gombrich 1979, p. 180.

orientalised form. Once again all intellectual roads led back to Rome – or, in this case, Athens.

It was the first time that a major art historian had turned from the study of European art and/or the art of classical antiquity to study craftwork of non-European origin. In the same year that Riegl published his work on oriental rugs, W. H. Goodyear, Keeper of the Egyptian Collection of the Brooklyn Museum, published his *Grammar of the Lotus*. It set out to prove that the ubiquitous Egyptian lotus motif had spread widely in the Near East and had infiltrated early Greek art. What Riegl and Goodyear had done in fact was to trace the spread of design motifs in the wake of the expansion of the Egyptian and Grecian empires. Theirs were among the first professional studies in cultural imperialism, though they did not focus their attention on the imperial implications of their material. They were working within a European context that they took for granted. For European imperialism was then at the height of its global power, and social Darwinism privileged diffusionist theories of culture. In his *Children of the Sun*, the British archaeologist W. J. Perry (1868–1949), a younger contemporary of Riegl, sought to prove that the greater part of human culture itself – agriculture, pottery, basketry, domestic animals, houses and towns – first developed in Egypt and subsequently spread around the world. It was not the most convincing essay in cultural imperialism, but it did make many points that could not be readily ignored. In his *Stilfragen* (stylistic questions) (1893) Riegl argued that over five thousand years of plant ornament could be read from the times of ancient Egypt and Mesopotamia to ancient Greece and Rome and thence to Byzantium and Islamic decoration and that all could be 'explained in terms of an internal or organic evolution, as a relatively autonomous development'.[45]

Although he admired Semper's work, Riegl was critical of those of his followers for whom decorative forms were entirely the product of technique and material. There was a strong determinist component in his argument. Individual artists could make an impression on the history of style only if their innovations corresponded to 'the stylistic situation in a particular historical moment'.[46] Since it was *only* artists, in a broad sense, who contributed to a changing design situation anyway, there was something circular about his argument. He called this dialogue between the artist and the historical moment in which he lived the *Kunstwollen*.

[45] Pächt 1963, p. 189.
[46] *ibid.*

Otto Pächt has noted that a literal interpretation, 'that which wills art', is also the best because it preserves the ambiguity within the concept itself. That is to say, does the artist act freely or passively in response to the historical moment or *Zeitgeist*?[47]

In his great work *Spätrömische Kunstindustrie* (1901) Riegl argued that late Roman art was not a decadent style as was widely believed but a new style indicating a change of intention, a new *Kunstwollen* for a new time. Proof of that, he believed, could be found in the aesthetic ideas of St Augustine. He was also convinced that the *Kunstwollen* 'manifests itself equally well in all the different artistic spheres: painting, sculpture, architecture, and the minor arts'.[48] Towards the end of his life he made a close study of the seventeenth-century Dutch group portrait. Since this included masterpieces by Hals and Rembrandt, it inevitably raised the question: to what extent did individual genius contribute to the genre? Riegl's answer was unequivocal. 'Geniuses do not stand outside their national tradition, they are an integral part of it.'[49]

Out of his work came the important conclusion that while art does develop, the nature of the development is constantly changing and each stage should be treated as of equal value. That in fact is what most art historians assume today in their professional practice. But Riegl's views, catching the spirit of his time, possessed some unpleasant implications. 'Each great [historical] phase corresponds to a particular racial disposition . . . Each race plays a prescribed role and retires when its part is done.'[50] His writing lent itself to racial readings, such as that given to them by the pro-Nazi art historian Hans Sedlmayer (1896–1984), when he wrote an introduction to Riegl's collected essays in 1927.

Consequently Riegl's great contribution to art history has been subject to prolonged controversy. What appears to have been largely overlooked until recently is the fact that, apart from his late work on the Dutch group portrait, all of Riegl's findings are based upon a craft rather than a fine art tradition. He brought the craft tradition to the attention of historians and revealed that, like fine art, it too was subject to change and transformation but in a different way.[51] We have already noted that after the fifteenth cen-

[47] Margaret Iverson has argued persuasively that Riegl's *Kunstwollen* does not seek to establish a single-point perspective for art history but is mindful of the fact that all art historians participate in a 'contemporary *Kunstwollen*' (Iverson 1993, p. 165).

[48] Pächt 1992, p. 191.

[49] *ibid.*

[50] Meyer Schapiro; quoted in Gombrich 1960, p. 19.

[51] See Iverson 1993, pp. 7 et al.

tury, European art, under the burgeoning influences of science and the market, begins to become dynamic and subject to generational changing by successive avant-gardes. But the craft traditions that Riegl investigated did not possess avant-gardes. Change occurred by the handing down of skills and techniques, interaction with other craft traditions, and the challenge of external factors such as imperial penetration and domination.[52]

The tendency, by this time dominant in German thought, to explain style in terms of form was greatly augmented by the appearance, in the same year as Riegl's *Stilfragen*, of a small book entitled *The Problem of Form in the Figurative Arts* (1893) by the sculptor Adolf von Hildebrand (1847–1921). It was widely read. Riegl's work at that time and the theories he had developed were, as we have seen, based upon the study of oriental and classical ornament. Hildebrand, a Neo-classical sculptor, developed a formal approach to figurative sculpture and painting, the heartland of mimetic naturalism. Like Riegl he appealed to the psychology of perception:

> Sculpture and painting are, indeed, imitative inasmuch as they are based on a study of Nature . . . But if these problems and no others are solved, . . . if the artist's work claims attention merely on these grounds, it can never attain a self-sufficiency apart from Nature. To gain such self-sufficiency the artist must raise the imitative part of the work to a higher plane, and the method by which he accomplishes this I should like to call the Architectonic Method . . . [O]ur perception enables us to realize a unity of form lacking in objects themselves as they appear in Nature . . . Through architectonic development . . . sculpture and painting emerge from the sphere of mere naturalism into the realm of true art . . . What the artist has to grapple with is a problem of visual manifestation solely . . . spatial perception, namely his faculties of sight and touch . . . The idea which informs the artist's creation is one thing, the process of creation is another . . . The idea of form which we may obtain is but one facet of the whole; one which we have abstracted for comparison of our different visual perceptions.[53]

Art should be architectonic, like architecture, the only fine art that a priori did not set out to copy nature. To be architectonic was to be formalist.

[52] On Riegl, see also Olin 1992.
[53] Hildebrand 1932, p. 11.

Hildebrand was a friend of the philosopher Konrad Fiedler (1841–1895), who maintained close friendships with many German painters. For Fiedler, the artist's vision of the world differed from that of ordinary folk. It was fundamentally perceptual not conceptual, and the work of art was a direct expression of the artist's perceptional gift, his capacity for transforming his perception into concrete material form. In this sense the artist's vision differed from that of the scientist and philosopher for whom experience was a means towards the elaboration of conceptual thought. The artist's ordered perception in a concrete work became 'the visual counterpart of the development of conceptual knowledge'.[54] For Fiedler, art was an autonomous exercise that was not essentially concerned with imitating or reflecting nature and the artist was a special kind of 'perceptive' individual. Thus both Hildebrand and Fiedler stressed the view that artistic form possessed an autonomy not related to normal perception, the purpose of the latter being to identify and distinguish objects and their relationships in a three-dimensional world. Hildebrand also made a significant distinction between classical sculpture and painting; the former being based on tactile, the latter upon purely visual sensations. Wölfflin drew on this distinction in developing his highly influential analysis of the stylistic distinction between High Renaissance and Baroque art.

In his *Renaissance and Baroque* (1888), *Classic Art* (1899) and *Principles of Art History* (1915) Wölfflin developed for the first time a coherent and systematic view of the formal development of art history. The effect of his work for the institutionalisation of the Formalesque style both in criticism and history during the first half of the twentieth century was unparalleled. As Herbert Read put it, 'he found art criticism a subjective chaos and left it a science'.[55] His analyses combined the tradition of German philosophical psychology with an evolutionary interpretation of the transformation of art as developed by Semper and Riegl. The five pairs of concepts by which he distinguished High Renaissance art from that of the Baroque – from linear to painterly form, from plane to recessional form, from closed to open form, from multiplicity to unity, and from an absolute to a relative clarity of the subject – became a staple of art history courses during the first half of the twentieth century throughout the world.

Wölfflin grappled with one of the problems central to art

[54] Podro 1982, p. 111. On Fiedler, see also Listowel 1933, pp. 111–12.
[55] Quoted from the article on Wölfflin in *The Oxford Dictionary of Art*, 1988.

criticism and art history, the relationship between description and interpretation in visual analysis – between pointing to what can be shown to be there, and inferring meaning from what appears to be there. He developed what Michael Podro has described as 'interpretive seeing'. It became 'the most sensitising factor in the critical procedure of *Renaissance and Baroque'*.[56]

Wölfflin's 'interpretive seeing' developed from his interest in the theory of empathy (*einfühlung*), which may be traced back to J. G. Herder (1744–1803)[57] and perhaps to the early romantic J. G. Hamann (1730–1788). It was developed as a psychological theory of aesthetic apprehension first by F. T. Vischer (1807–1887) and his son Robert (1847–1933) and then more fully by the psychologist Theodor Lipps (1851–1914). The theory asserted that aesthetic appreciation consisted in the self-projection of the feelings of the observer into the art object. Such appreciation was not the product of the association of former feelings or memory – as in the psychology of Archibald Alison (1757–1839) – but happened involuntarily and instantaneously. Thus in the appreciation of, for example, a line in a work of art we apprehend it, so it was said, as 'a movement, a stretching and expanding, a bending or a smooth gliding'.[58] Empathy attached to content as well as to form and resided in the art object itself; it was not a subjective projection of the viewer but was induced unconsciously by the object. Thus in music, we do not respond simply to the melodic form but to the calm or passion, the sensations of peace or longing induced by the music. Such responses were aesthetic – in that they were contemplative and disinterested in Kant's sense – and also holistic arising from the apprehension of the unified work.

Wölfflin developed empathic theory into an effective mode of 'interpretative seeing'. His visual analysis is shot through with bodily metaphors, what we see is what we feel as a function of our corporeal existence. Some of his general remarks on architecture in *The Principles of Art History* are typical: 'the column rises, in the wall, living forces are at work, the dome swells upwards, and the humblest curve in the decoration has its share of movement, now more languid, now more lively'.[59] All this is nothing less than the anthropomorphising of inanimate architectural components, yet they do carry a profound evaluative quality. And in this case it is essentially an appreciation of architectural form rather than of content or

[56] Podro 1982, p. 103.
[57] Herder, *Kalligone*; see 'The Theory of Einfühlung', in Listowel 1933, pp. 51–82.
[58] Listowel 1933, p. 70.
[59] Wölfflin [1929], p. 63.

meaning. In Wölfflin, formal analysis and the formal appreciation of art in its development attain fulfilment after a century or more of development since Winckelmann.

Towards the end of his career Wölfflin put it in this way:

> The history of forms never stands still. There are times of accelerated impulse and times of slow imaginative activity, but even then an ornament continually repeated will gradually alter its physiognomy. Nothing retains its effect. What seems living today is not quite living completely tomorrow. This process is not to be explained negatively by the theory of the palling of interest and a consequent necessity of a stimulation of interest, but positively also by the fact that every form lives on, begetting, and every style calls to a new one. We see that clearly in the history of decoration and architecture. But even in the history of representative art, the effect of picture on picture as a factor in style is much more important than what comes directly from the imitation of nature. Pictorial imitation developed from decoration – the design as representation once arose from ornament – and the after-effects of this relation have affected the whole of art history.[60]

Wölfflin here endows empathic theory with a determinist and autonomous vitality. Form creates its own history transcending the intention of the individual artist.

This brief survey of German aesthetic thought from Winckelmann to Wöllflin provides a basis for estimating its contribution to the basic aesthetic concepts and assumptions that prevailed during the advent and subsequent hegemony of the Formalesque style in Europe and its cultural colonies from *c.* 1890 to *c.* 1960. In sum: the emergence in Winckelmann of a concept of style freed from the organic analogy of growth and decline that had previously prevailed, a style that was relatively autonomous yet responded to social change and culminates in the writings of Riegl and Wölfflin; the theoretical distinction between the high and useful arts in the work of Batteux, Kant and their successors; the emergence of a formalist aesthetic in the work of Kant, Schiller and later thinkers; the theorisation of the classical concept of genius, and the associated concept of unconscious creative activity in Schelling, Schiller and Goethe; the growing interest in 'folk', 'primitive' and 'oriental' art in Semper and Riegl.

It is significant that these very concepts provide the bases for the

[60] *ibid.*, p. 230.

attitudes, predispositions and critical temper of the Formalesque style as a whole. In other words the style that became the imperial style of Modernity after 1920 was determined theoretically by ideas that came to fruition during the nineteenth century. All of the major critics associated with the triumph of the Formalesque, from 1890 to 1960, such as Roger Fry, Clive Bell and Clement Greenberg, supported and developed in their own ways these fundamental concepts. This is one significant reason why it is best considered a late nineteenth-century style. Although many of these concepts were challenged almost from the time they were first expressed, it is not until the 1960s that they ceased to dominate modern aesthetic thought and art theory.

Lastly we must ask again – what has all this to do with cultural imperialism? There are obviously two ways of approaching our subject: from the centre or the periphery. Here I have chosen to begin at the centre; we shall turn to the periphery of empire later. Why the centre is so significant is that it is here that the grounding concepts of cultural imperialism were given their theoretical weight, power and respectability. It is here that the aesthetic universalisms were moulded into powerful instruments that could be applied to the very notion of art in any part of the globe, irrespective of cultural difference, in order to separate art from craft, classical man from primitive man, fine art from kitsch, and here where artefacts from any part of the world might be, at the behest of European desire, fetishistically transformed into fine art, for the markets and museums of Europe and its colonies.

3 Exotic sources of the Formalesque

FORM AND THE EXOTIC

Accounts of the development of the Formalesque never fail to take account of the influence of African sculpture on the art of the young Picasso and his generation. But the influence of exotic art (art in the general sense) from beyond Europe is rarely investigated fully in *general* histories of European art. Consider the change that took place in the use of the surface of paintings as planes for the creation of an illusory three-dimensional world. This return to the pictorial surface is, as is well known, a feature of the work of Manet and others of his generation. Clement Greenberg, the most influential art critic of the late Formalesque, put it in this way in 1940: 'The picture plane itself grows shallower and shallower, flattening out and pressing together the fictive planes of depth until they meet as one upon the real and material plane which is the actual surface of the canvas.'[1] Twenty-two years later he put it in more general terms: 'By now it has been established, it would seem, that the irreducible essence of pictorial art consists in but two constitutive conventions or norms: flatness and the delimitation of flatness; and that the observance of merely these two norms is enough to create an object which can be experienced as a picture.'[2] It was Manet who, according to Greenberg, took the first vital step: 'Manet was the first painter in our tradition to flatten foreground and middle ground objects systematically, and bring the background forward to lock their outlines in by sharp color contrasts.'[3]

We need not question the important modifications that Manet – and Courbet before him – made in the practice of painting as an art of illusion. But Greenberg's influential comments have developed into the conventional wisdom that 'modernist' painting, that is to

[1] 'Towards a Newer Laocoon', in Greenberg 1986, vol. 1, p. 35.
[2] 'After Abstract Expressionism', in Greenberg 1986, vol. 4, p. 131 (originally published in *Art International*, 25 Oct. 1962).
[3] 'Cézanne: Gateway to Contemporary Painting', in Greenberg 1986, vol. 3, p. 114 (originally published in *American Mercury*, June 1952).

say the Formalesque style, begins with Manet as its Christ and Courbet as his Baptist.[4]

There is indeed a disjunction in *technical* practice between the time of Delacroix and Manet when painters gradually moved away from chiaroscuro and favoured *values*, in which 'every seemingly insignificant dab of colour, representing light and shade, as well as the most significant, must keep its place and hold its true relation to all the other dabs'.[5] But it is not to the changing processes in the technical methods taught in the mid-nineteenth-century French academies that we must look if we want to locate the *significant* disjunction between painting as a window framing a pictorial illusion and painting as a material, autonomous, aesthetic object.

It is to the Enlightenment and the rediscovery of Greek antiquity that we must defer.[6] It was from ancient Greek painting that Europe constructed its first modern primitivism. We must be clear about this. Obviously, the art of ancient Greece was never at any time a European art. Geographically, ancient Greece straddled the Hellespont, partly in Europe partly in Asia. During the eighteenth century Greece was under the control of the Ottoman Empire, and had been since the fifteenth century. Politically and culturally modern Greece was, during the Enlightenment, a part of the Orient. Europe took little interest in modern Greek culture until the protracted nineteenth-century struggle for Greek independence, not successfully completed until the establishment of the modern Greek republic in 1924 and the modern Turkish state in the same year. Even then it was the European half of ancient Greece that ceded from Turkish rule, Anatolia becoming part of modern Turkey. In the eighteenth century European artists possessed little interest in the culture of modern Greece. It was Greek antiquity – the culture of Plato and Aristotle, Phidias and Praxiteles – that impassioned them. Modern Greeks, in their view, were the decadent survivors of a noble civilisation, a civilisation that during the second half of the eighteenth century Europe sought to appropriate

[4] 'He [Courbet] put his century so completely into his art that he practically forced his successor, Manet, to turn toward the future before he was quite ready.' Review of an Exhibition of Gustave Courbet, *The Nation* (8 Jan. 1949); quoted in Greenberg 1986, vol. 2, p. 276.

[5] Boime 1971, p. 152. Boime discusses Manet's considerable technical debt to his teacher, Couture.

[6] David Clarke has pointed out that 'attempts to find pre-modern or exotic examples of a concern with flatness are ahistorical. Byzantine panels or Japanese woodblocks are not produced within the same discourse' (Clarke 1992, p. 81). Quite so. The attempt made here is not to assume such a discourse in the so-called exotic arts but to trace the emergence of the discourse within Western exoticism, that is to say primitivism.

to its own. It was a view, as we have seen, still held by Virginia
Woolf's brothers and their friends when they visited Greece in
1906. It was the second chapter in a protracted cultural usurpation,
following Charlemagne's appropriation of the art of Rome to the
nascent civilisation of young Europe a thousand years before.

That is the political aspect of the matter, and it is relevant to
any understanding of Europe's first primitivism. The art of the
Renaissance with its discovery of linear perspective and the art
of chiaroscuro had, with the aid of its knowledge of Classical art,
developed a mimetic naturalism that was unique. No other civilisa-
tion possessed such an art. The gradual working out of the visual
implications of that naturalism is probably the most important
aspect of the history of European art from the fifteenth to the
nineteenth century. It is the history of art envisaged as the repre-
sentation of perception.[7] But it was not only that. Interwoven with
its history as a development of perceptional vision is the history of
European art as a history of visual signs, as Norman Bryson has
convincingly attested.[8]

From the Renaissance until the Enlightenment this dialectical
interchange between percept and sign was pursued largely within
the traditional genres of history painting, portraiture and the deco-
rative arts, under the overarching hegemony of naturalism. This
is not to say that naturalistic art was little more than a static
relationship between the artist and the external world, a purely
transhistorical situation. Naturalism *per se* was also historically
impelled socially by the changing demands placed upon the artist
by virtue not only of the nature of the subject matter and materials
but also by the part played by naturalistic art in the service of
European science and technology. Yet it was the dynamic nature of
fine art, of art in the special sense, that instituted an imperative, as
we have noted, for the artist to move beyond the work of previous
generations in order to achieve mastery. Tradition, the past body of
art, consistently closed out the *immediate* past. The *archaistic move* is
endemic to art in the special sense.

With this in mind we may return to the question of art's
autonomy and painting's return to the pictorial surface. The basic
influences appear to be non-European and only emerge in strength
during the Enlightenment when, particularly in the fields of history
painting and the decorative arts, the ongoing pursuit of naturalism

[7] The classic text is of course Gombrich 1960.
[8] Bryson 1983.

begins to be countervailed by archaistic and primitivistic moves that increasingly invoke craft-based exemplars from beyond Europe: *archaistic*, when the source was *perceived* as belonging to one's own cultural past, as Europe perceived the art of Rome and Greece to be; *primitivistic*, when the source was perceived as exotic.

A key figure in these moves is the English sculptor John Flaxman (1755–1826). During his seven years' stay in Italy (1787–94) Flaxman produced sets of drawings to illustrate the *Iliad* and *Odyssey* (both 1793), and Aeschylus (1795) based on his extensive knowledge of Greek vase painting. They were engraved by Tomasso Piroli and immediately aroused widespread interest throughout Europe. Goethe (1749–1832) and Schlegel (1767–1845) wrote enthusiastically about them, and the students of David's atelier around Maurice Quay were fascinated by them. In 1805, editions of Flaxman's work were published simultaneously in Rome, Hamburg, Paris, London and Leipzig. These drawings were published without an accompanying text, nothing more than captions being used for each illustration, and deliberately avoided chiaroscuro and all modes of shading. They were appreciated as works of art in their own right, not as book illustrations, and were seen by a generation being educated to admire ancient Greek art by Winckelmann as a radical move towards a two-dimensional treatment of the pictorial surface. The early romantic German painter Otto Runge (1777–1810), when he saw them, exclaimed, 'My God, I have never seen this kind of thing before in my life: the drawings on Etruscan vases completely pale by comparison.'[9] It is not without significance that Flaxman was, like Hildebrand after him, a sculptor specialising in bas-relief, an art which required close attention to the precise delimitation of spatial planes within the narrow confines of an illusory frontal surface and its material background. In Flaxman's drawings the illusory and actual surfaces are closely integrated. We have reached a moment in European art when its tradition is bidding farewell to the deep perspectives of the High Baroque and returning to the surface – the normal practice, of course, in the crafted paintings universal in Europe prior to the fifteenth century.[10]

Flaxman's drawings 'caused an immediate sensation and were copied and pirated all over Europe'.[11] They were regarded as revolutionary because there was a widespread feeling that the visual

[9] Quoted in Irwin 1979, p. 81.
[10] On the revolutionary significance of Flaxman's linear style, see Rosenblum 1976.
[11] David Bindman, 'Flaxman', in Dictionary 1996, vol. 11, p. 163.

tradition that had prevailed from Renaissance to Baroque was exhausted. Interest was extending towards Asian and European medieval art. It is there that we must look for the moves that brought the pictorial surface back into prominence as a material fact instead of a window opening onto an illusory space. This interest is coeval with the growing interest in craft, exemplified by Semper and Riegl, as a key to the history of art.

In his detailed examination of David's *The Intervention of the Sabine Women* (1795–99), Bryson has noted the artist's indebtedness to Flaxman's drawing *The Trojans Seize the Slain* (1793) for the purity of the outline of his figures and the flattened space. As Bryson whimsically puts it: 'this is a painting of assemblage, collage'.[12] For a dynamic art tradition is a hard taskmaster, continuously blocking paths to the recent past. Ingres, David's pupil, goes back to van Eyck in composing *Bonaparte as First Consul* (1804), where the floor is 'raked at an unnaturally steep angle', and in the view of Liège Cathedral 'the architectural edges have been flattened out'.[13] Bryson's penetrating analysis of the plethora of influences that Ingres brought to bear upon his *Imperial Portrait of Napoleon* (1806) shows the archaistic drift of things as the artist works through the European tradition for his influences. 'Antiquity, Byzantium, the Dark Ages, the Carolingian Empire, the Northern Middle Ages, the High Renaissance or Age of Raphael: the painting is like a speeded up film of Western art from Phidias to Raphael in ten seconds'.[14] This built-in imperative of a dynamic art for continuous change, in order to appropriate tradition and establish its own contemporary authenticity, virtually exhausts the European naturalistic tradition by the early years of the nineteenth century, forcing artists to look elsewhere.

There is, however, an exception – the important exception of landscape painting. Throughout the nineteenth century, landscape still had much post-Renaissance scientific work to do for the bur-geoning sciences of botany, geology, meteorology and the regional description of the earth's surface in general.[15] But as the century progressed, landscape painters moved increasingly away from such particularities towards those universal problems confronting them in the portrayal of natural light – as distinct from controlled studio light. Turner and Monet are here the relevant masters. They set a trend that moved colour from the depiction of natural particulari-

[12] Bryson 1984, p. 95.
[13] *ibid.*, pp. 102–03.
[14] *ibid.*, p. 112.
[15] I discuss some of these issues in Smith 1985.

ties to the rendering of universal light effects – thus stimulating an immanent drive towards abstract art.[16]

A new interest in the Orient, driven by imperialism, emerges on all sides from the early years of the nineteenth century. French imperial policy in North Africa effectively began in 1830 with the conquest of Algiers followed by the occupation of the country. In 1881 the French occupied Tunisia and in 1912 established the French protectorate of Morocco. Imperial policy gave increased access to the non-European arts and crafts to which European artists increasingly had recourse. Islamic art was not, of course, an art of representational illusion. It confined itself, for theological reasons, to design and decoration. This art did much to encourage the enflattening processes in nineteenth-century European painting.

The effect was first experienced most powerfully in the European decorative arts. It is already present in the Rococo, in the adornment of hotels, hunting lodges and *maisons de plaisance*, wherein the highly elaborate rocaille framing, the lightly coloured textures, and the tendency of figuration to spread widely over foregrounds, together with the increased use of grotesque ornament and its interplay of figural and decorative detail, all tend to flatten the pictorial surface. In such cases the decorative use of the exotic played a crucial role, as manifest particularly in Chinoiserie. Roger Benjamin has noted that Watteau's designs for such framing surrounds were called 'arabesques'.[17] This enflattening process is already present in Baroque tapestry based on exotic subject matter such as the Gobelins *Anciennes Indes* (1687–1730).[18]

Ernst Gombrich has drawn attention to the fact that in the early Middle Ages 'Romanesque painting tends to be flat, emphasising the plane . . . In the decorative borders, however, the illusionistic devices of Hellenistic painting live on.'[19] In the Rococo the reverse occurs: the decorative borders, stimulated by exotic interests, encroach increasingly upon the naturalistic heartland of Rococo art and begin to exercise an enflattening effect upon the illusionist centre itself.

[16] cf. Kenneth Clark's statement about Turner's landscapes that 'take their point of departure' from his *Norham Castle: Sunrise* (c. 1835): 'These landscapes are almost as abstract colouristically as a great piece of architecture is abstract formally' (Clark 1949, p. 107); and W. J. T. Mitchell's comment that 'Perhaps abstraction, the international and imperial style of the twentieth century, is best understood as carrying out the task of landscape by other means' (Mitchell 1994, p. 20).

[17] Benjamin 1993, p. 298.

[18] Smith 1992, p. 23.

[19] Gombrich 1979, p. 204.

One of the weaknesses of Edward Said's impressive *Orientalism* (1978) is that because of its overwhelming stress upon the static nature of the European perception of Asia it is possible to read it through without gaining any feeling for the immense influence that Asia exercised upon Europe itself in, among other things, the decorative arts.

Neo-classicism, like the Rococo, tends to dispense with the deep space of the Baroque. In history painting, action takes place increasingly within an enclosed foreground space and across the picture plane. Landscape tends to be reduced to a backdrop.

The interaction in painting between the support as an illusory space and a material reality was at bottom an interaction between mimetic naturalism and artefactual mimesis. During the nineteenth century this interaction was played out most intensely between the fine arts, which served the genres of history painting, portraiture and landscape painting, and the decorative arts, which served the varied needs of architectural practice. It was from the latter that the exotic impact on Europe's fine art, largely from Asia and northern Africa, mostly came. In the earlier decades of the century the distinction between fine and decorative art was firmly maintained, but they converged increasingly towards the end of the century.

The story begins, if it begins anywhere, with Napoleon's invasion of Egypt in 1798. As a result of the work of the savants he took with him, twenty-three volumes of the *Description de l'Egypt* were published between 1809 and 1820. They gave an impact to decorative art that persisted throughout the century. All patterns upon walls and floors, it came increasingly to be accepted, should be flat, avoiding modelling and shading. The younger Pugin commended Turkish rugs because 'they have no shadow in their pattern'.[20]

With the decline of the Ottoman Empire, Greece and the Near East in the early years of the century became more readily accessible to European travellers. In 1833 the young architect Owen Jones (1809–1874), after a traditional visit to Italy, pressed on to Greece, Egypt and Turkey. Enchanted by Arabic ornament, he made a visit to Granada in 1834, from which issued his great work on the Alhambra (1842–45). Thereafter his life follows a pattern similar to that of Semper. He gained an appointment as a superintendent of work at the Great Exhibition of 1851 and a year later designed the Egyptian, Greek, Roman and Alhambra courts. His *Grammar of Ornament* (1856) flowed from this personal involvement and

[20] Quoted in *ibid.*, p. 34.

reached nine editions by 1910, exercising a profound influence upon Victorian taste during the second half of the century.

The book is a classic example of the dialectics of cultural imperialism. On the one hand Jones reveals a supreme confidence in assessing the aesthetic value of non-European culture. He ranges across the art of 'savage tribes' (mainly Polynesian and Maori), then Egypt, Assyria, Persia, Greece, Rome, Byzantium, Arabia, Turkey, Moorish Spain, India and China. The imperial span of his taste encouraged a highly formalist approach and was spurred by primitivism: 'If we would return to a more healthy condition we must even be as little children or savages, we must get out of the acquired and artificial and return to and develop natural instincts.'[21] For Jones even though ancient Greek art 'carried to a perfection pure form to a point which has never been equalled', it 'lacked symbolism'.[22] This amazing statement may be compared with Picasso's later comment that African sculpture was '*raissonable*'. By contrast, in 'the conception of pure form' the Chinese were 'even behind the New Zealanders', and they were 'totally unimaginative'. But Jones, unlike Said, also noted the impact that colonies make upon the centre of empire. 'Rome had given her peculiar art [for which Jones had no high regard] to the numerous foreign peoples under her sway; it is no less certain that the *hybrid* art of her provinces had powerfully reacted on the centre of civilisation' (my italics).[23] And if quality in the centre did not hold in Roman times, Jones had even less confidence that it was holding in the Europe of his own day. In his opinion the Islamic contributions to the Great Exhibition far excelled those from Europe where everywhere was 'to be observed an entire absence of any common principle in the application of art to manufacture'.[24] And it had all happened before. 'The Byzantine school of ornament strongly imposes on all the early works of central and even Western Europe which are generically called Romanesque.'[25] For Jones the Byzantine school of ornament, like all other ornament, is an entirely formal, implicitly secular practice. To treat art as decorative involved the extrusion of its cultural content. In the positivistic climate of the later nineteenth century, to be 'decorative' was considered a positive aesthetic value. The pioneering masters of the Formalesque, Gauguin and Matisse, for example, desired their art to be seen as decorative. But this

[21] Jones 1856, p. 16.
[22] *ibid.*, p. 32.
[23] *ibid.*, p. 51.
[24] *ibid.*, p. 77.
[25] *ibid.*, p. 53.

involved a conflation of high art and decorative art, systems of value that were held to be separate and distinct for most of the century. It was in part a matter of social status. But towards the end of the century under the impact of William Morris, the Arts and Crafts Movement and Art Nouveau, a good deal of convergence began to occur. During the many days he spent in the South Kensington Museum, Morris would certainly have poured over Jones's *Grammar of Ornament*.[26]

A parallel development took place in France. In 1869 Émil Prisse d'Avennes (1807–1879), one among the second wave of French savants to reside in Egypt, published the first volume of *L'Art arabe d'après les monuments du Kaire* (1869–77). By means of magnificent colour lithographic plates, it brought the complex geometric patterning of Islamic art to a wider audience. Then in 1873 the architect Jules Bourgoin (1838–1907) published his *Les Arts arabes et le trait général de l'art arabe*. Bourgoin invited Viollet-le-Duc to write a preface which concluded with the statement: 'Graphic arts have their own philosophy; we must understand how to go deeper than what is apparent in form; we must analyse the creative principles; this is the only method which will enable us, in turn, to be creative.'[27] Bourgoin sought to provide such an analysis. He warned that in considering Arabic art it was necessary

> to disregard the rather defined idea we have of art itself . . . Our aesthetic is wholly inappropriate in these concerns, and it would be a mistake to attempt to apply it . . . The Orient is the native soil of all art, as it is of all religion . . . Taking the word art in its abstract sense, we could consider Arabic art as a decorative system based entirely on order and geometric form, borrowing little or nothing, from the observation of nature; that is to say an art complete in itself, deprived of natural symbolism and idealist significance. The inspiration is abstract and in the execution the plastic has no place.[28]

Bourgoin argued that the geometry upon which this art was grounded was of particular relevance to the new industrial age; 'all that pertains to industry in arts, crafts and architecture includes the application of functional geometry [which] also plays a part in the purely technical aspect of the art of design'.[29] And he went further, arguing that the kind of geometry 'which pertains to art in the

[26] See Lindsay 1975, p. 117.
[27] D'Avennes 1989, pp. 13–14.
[28] *ibid.*, pp. 13–14.
[29] *ibid.*, p. 16.

realm of arts and crafts, and of architecture, that is to say essentially in form and decoration, depends on an entirely different geometry which we may term aesthetic geometry', the kind of geometry that provides 'the theory of forms,' and 'essentially includes all that pertains to order and form as viewed in their purely abstract sense . . . [T]his means that aesthetic geometry, in evidence as much in art as in nature, attains the stature of a real art form, as it serves to translate by means of geometric figures the precise conditions of order, proportion and harmony which make up the specific nature of form in any given artistic endeavour.'[30] 'Art sets in motion the creation of a spectacle for the eyes; whether the basic elements are great or small in number is unimportant . . . In this way the geometric basis in Moorish interlace can be reduced to two principal forms: the square and its derivative figures, and the hexagon and its derivatives.'[31] Here Bourgoin provides us with an aesthetic *in vitro* that will be taken up during the next century in practice by Mondrian and in theory by Greenberg. But it took some time for its full effect to move from the decorative to the fine arts. Prisse d'Avennes began publishing his *L'Art arabe*, the year Ingres died, and Bourgoin his notions about aesthetic geometry a few years later.

After Ingres, a growing interest in the detailed portrayal of oriental fabrics of intricate design appears in high art, thus bringing the signifying systems of paintings increasingly to the surface. Industrial production tended to transform painting from a representational to an artefactual role. Industrial society, as is well known, had need of artists differently trained to design its manufactures. Hence the establishment of the Victoria and Albert Museum as a place of instruction. Design became more significant than perspective and chiaroscuro. Though both remained a stock-in-trade of academic training, they became increasingly vestigial in practical art education. According to George-Albert Aurier, the critical champion of Symbolism, one of the five special requirements of Symbolist painting was that it should be decorative 'as the Egyptians . . . the Greeks and the Primitives understood it'.[32]

In France the romantic generation of Delacroix contributed towards the trend back to the surface as a result of their growing interest in colour and decreasing interest in 'depth' painting. Jonathan Crary argues that the dominant optical model which determined concepts of vision from the sixteenth to the end of the

[30] *ibid.*, pp. 16–17.
[31] *ibid.*, p. 18.
[32] Goldwater 1979, p. 184.

eighteenth century collapsed quite suddenly during the 1820s and 1830s. Until that time painting, grounded in Albertian and Cartesian models of geometric perspectivalism and monocular vision, ignored the physiology of the eye. Vision was modelled on the camera obscura. But with the publication of Goethe's *Theory of Colours* (1810), a new subjective theory of vision begins to subvert the optical geometry that prevailed in pictorial construction. Goethe's study of the retinal afterimage led to an increased interest in vision as a physiological experience. Johannes Müller's *Comparative Physiology of the Visual Sense* (1826) established just how subjective vision could be. Sensations of colour and light could be produced whenever the retina was excited by mechanical influences such as a blow, electricity, narcotics, or the stimulation of the blood. This restoration of vision to its source in the body, as a result of the work of physiologists like Helmholtz and chemists like Chevreul, shifted the interest of artists away from traditional academic practices based on drawing and chiaroscuro to a renewed interest in colour.[33] Delacroix visited Morocco in the winter of 1832. The light was so bright that he feared for his eyes. 'I am rather worried about my eyes', he wrote; 'Although the sun has not reached its full strength, its brightness and the reflections from the houses, which all of them are whitewashed, tire me excessively'. In March he was at Meknes: 'Patches of white over the whole hill. Shapes of all sorts, white always dominant.' At which René Huyghe commented, 'He experienced delights which were still as fresh as ever, a century later, for Matisse and for modern art.'[34] Artists who chose to work in tropical and sub-tropical regions had reason to know that the eye was a fragile bodily organ, not a camera obscura.

This new realisation of the significance of the subjectivity of vision induced the avant-garde artists of the nineteenth century to take a new interest in colour and less interest in three-dimensional illusion. It is notably so in the landscape sketches and paintings of the late Turner and the Impressionists wherein, despite the continued interest in paintings as records of visual experience, the recording of retinal impressions brought the *visual* effect of painting closer to the material surface.

Interest in 'pre-Raphaelite' art became intertwined with influences from the Near East. John Sweetman has compared John Frederick Lewis's *The Reception* (1873) with a fifteenth-century

[33] Crary 1988, p. 42.
[34] Huyghe 1963, pp. 267–69.

Herat miniature, noting the tendency towards flattening out the picture plane by the stress on horizontals and verticals, the silhouetting of small-scale figures and the search for light-filled canvasses. Even though Lewis still composes his interior spaces according to an Albertian perspective, a distinct flattening effect appears in his paintings that was noted by contemporary critics.[35] Many other 'Orientalist' painters of the time might be cited for similar reasons. By virtue of their interest in decorative detail, light-filled lattices, and intricately designed fabrics, the overall visual effect brought such paintings increasingly to the treatment of surfaces. The 'miniaturesque' treatment of detail invited, indeed demanded, that the viewer engage in a close-up view of surface effects. This is accompanied by an increased independence of foregrounded, pictorial motifs. No longer mere compositional tropes, they provide a 'materiality' to painting in sharp contrast to the illusionistic depths of High Baroque.

This trend towards flatness was enhanced by the return of the Nazarenes and the Pre-Raphaelites to fresco painting. The Nazarenes were inspired by the writings of Schlegel, who after his visit to Paris in 1802 turned away from his early admiration for classical antiquity to a new romantic fascination with early Italian, German and Netherlandish masters before Raphael. A massive technical change from Baroque illusionism was advocated:

> No confused massive groupings, but few individual figures, finished with . . . care and diligence . . . the human form; stern and serious figures, sharply outlined and standing out from the canvas; no contrast of effects, produced by blending chiaroscuro and murky gloom and cast shadows, but pure proportions and masses of colour in distinct intervals; draperies and contours that appear to belong to the figures, and are as simple and unsophisticated as they . . . that childlike tenderness and simplicity which I tend to consider as the original characteristic of the human race.[36]

Schlegel's turn from a Neo-classical primitivism to an archaism grounded in a preference for the art of medieval Christendom was developed in practice by the Lukasbrüder in Rome between 1809 and 1818.[37] In Franz Pforr's painting *The Entry of the Emperor Rudolf*

[35] e.g. a *Times* reviewer of Lewis's *The Hareem* noted a 'Chinese flatness parallel to that of Western medieval painting'; quoted in Sweetman 1987, p. 135.

[36] Quoted from Andrews 1964, pp. 17–18. From Schlegel's periodical *Europa* (Frankfurt) 1 (1803–05), p. 1.

[37] Its original members were Overbeck, Pforr, Vogel, Wintergerst, Sutter and Hottinger, all former members of the Akademie der Bildenden Kunste of Vienna.

of Hapsburg into Basle in 1273 (1810), the dramatic illusionism and atmospheric gloom of Baroque chiaroscuro are rejected in favour of a naive, primitive style inspired by the woodcuts of Sebastian Munster's *Cosmography* (1564). Nineteenth-century pictorial primitivism is here seen to be moving from its exotic roots in Greek antiquity towards a newly found romantic admiration for European art at that critical moment when it began its long march towards the naturalism of Impressionism. John Ruskin (1819–1900) was caught up in the dilemma thus produced between his own passion for naturalism and his admiration for the Italian primitives. On the one hand he detested the way that Flaxman drew stones as mere outlines with no modelling – in his drawings to illustrate Dante (1793).[38] Stones were integral to landscape and Ruskin was the great champion of naturalistic landscape. But on the other hand Ruskin possessed a profound admiration for the formal values of Pre-Raphaelite painting with their roots in Giotto.

Giotto had been hailed as the original source of European naturalistic painting from the fifteenth century onwards by such authorities as Boccaccio, Ghiberti, Leonardo and Vasari. But for Ruskin, Giotto was more than a mere beginning; he preferred his work to so much that came after it, and for formal rather than naturalistic reasons. 'His lines', he wrote, 'are always firm, but they are never fine . . . his handling is much broader than that of contemporary painters . . . invariably massing his hues in large fields, limiting them firmly, and then filling them with subtle gradation. He had the Venetian fondness for bars and stripes.'[39] Ruskin praised Giotto's work because it was decorative and subservient to the architecture which enclosed it and he responded profoundly to Giotto's purity of colour and his comparative lack of chiaroscuro. 'Wherever chiaroscuro enters colour must lose some of its brilliancy.'[40] And to legitimate the exotic roots of Giotto's art he endowed it with a quasi-mythological genealogy in a Greco-Etruscan antiquity.[41]

Ruskin delighted in pure colour because it recalled for him the colours of medieval manuscripts and stained glass, and the brilliance of Indian shawls and Chinese vases 'and other semi-civilised

[38] 'The chief incapacity in the modern work [Flaxman's] is not, however, so much in its outline, though that is wrong enough, as in its total absence of any effect to mark the surface roundings' (Ruskin 1903–12, vol. 6, p. 372).

[39] *ibid.*, vol. 24, pp. 35–36.

[40] *ibid.*, p. 37. See also Ruskin's formal comments on the art of the Giotteschi in general in his review of Lord Lindsay's *The History of Christian Art* (in vol. 12, pp. 221–22).

[41] Ruskin 1903–12, vol. 15, p. 345.

nations' that 'colour better than we do'.[42] There is therefore something profoundly contradictory about Ruskin's enormous influence upon nineteenth-century taste. On the one hand he championed the naturalistic landscape as a revelation of God's kingdom; on the other he preferred Giotto and the Giotteschi to the developed naturalism of Renaissance, and post-Renaissance art. He was, of course, both an original inspirer of, and the major critical force behind, the Pre-Raphaelite Brethren. To some extent this contradiction between naturalism and formalism was resolved by his admiration for the light and colour of Turner's work. In the end both enthusiasms pointed in the direction of a Formalesque style – to be achieved through the investigation of pure colour – and in his case for spiritual not secular reasons. In this way he opened a path followed by the colour painters of the Formalesque.

Fresco painting encouraged painting with pure hues on white grounds. The Nazarenes and Pre-Raphaelites popularised 'true' fresco which required quick, skilled work that left no room for indecision and corrections, since the work had to be completed before the allocated area of wet plaster had dried. Because fresco endured best in warm dry climates it was always more popular in the Mediterranean countries than in the North. But the renewed interest in fresco stimulated by the Pre-Raphaelites encouraged the practice of painting in oils on white grounds. William Holman Hunt (1827–1910) recorded that when still a student at the Academy, while copying *The Blind Fiddler* (1825) by David Wilkie, one of the Visitors pointed out to him that Wilkie had used a fresco-like technique, painting his local colour into the wet white ground and finishing each part of the painting piece by piece like the old fresco painters. 'This', said Hunt, 'was a revelation to me.' He then began to study the fresco techniques of the Quattrocento. It became a part of his normal practice.

Oil painting technique in the nineteenth-century French academies differed. For the *ébauche*, or underpainting, 'earth colours dominated because of their solidity'. It was put down 'in three divisions: one for the light areas, another for the shadows, the last for the *demi-teintes*'.[43] Manet, studying in Couture's studio, continued to learn such techniques, but his teacher taught him to drag the same tone across the *ébauche* surface, 'thus bringing into play the tone of the underpainting'. 'Manet went a step further and eliminated the reddish-brown *ébauche*, and closed the gap between

[42] *ibid.*, vol. 3, p. 123.
[43] Boime 1971, p. 37.

the most brilliant light and the darkest shadow.'[44] Thus it was,
as Greenberg pointed out, that Manet eventually 'eschewed
underpainting and worked from light to dark instead of the other
way about, as was the academic practice'.[45] In this way Manet
achieved a countervailing lightness in his canvasses that had
already been resuscitated with the revival of fresco techniques by
the Nazarenes and Pre-Raphaelites. We may conclude then that the
'flattening' of the pictorial surface from a window onto an illusion
to the materiality of an autonomous surface has a history that
should be traced in detail from the High Baroque to Matisse and
beyond. It is not merely a matter of mid-century technical changes
in French painting. It is to be located rather in a conjunction of
exotic influences, mainly from Asia, operating through decorative
art and the growing interest in the fresco techniques of Pre-
Raphaelite painting.

[44] *ibid.*, p. 72.
[45] Greenberg 1986, vol. 1, p. 233.

4 Occult and 'primitive' sources of the Formalesque

The emergence of the Formalesque style was also enhanced by a significant change in *content* that began to affect architecture, sculpture and painting towards the end of the nineteenth century. Darwinian evolutionism and the cry it called forth from Nietzsche that God was dead not only challenged the iconographical power of the whole corpus of Christian art, it also contained a veiled threat to naturalism itself. The Incarnation, God made flesh, was central to Christian belief. To question it was ultimately to question the ontology of naturalism. If an incarnate God did not fashion the material universe, from whence issued the *visible* forms of nature? The *contentual* roots of that *abstract* art, which began to emerge in the high art of Europe prior to World War I, took its origin not in the aesthetics of Kant, the discourse of nineteenth-century art historians, or the moves towards the flatness and materiality of the pictorial surface that developed out of the sundry practices of industrial designers, or Neo-classical, Orientalist and Pre-Raphaelite painters whose effects we have been surveying. It developed from an Enlightenment interest in comparative religion, from an increased conviction that Christianity was only one religion among many and that all religions had much in common. The ultimate origins of such interests are immemorial, lost in speculations about the very nature of spirituality, with sources both within and beyond Europe – in the cabbala, alchemical discourse, the Egyptian mysteries, and much else. Indeed it has often been viewed as an alternative, hermetic tradition that, during the proud post-Renaissance centuries, paralleled, underlay and sought to subvert the dominance of the classical hegemony.[1]

However, in our particular context the occult first appears in its modern secular form during the Enlightenment in the writings of Charles François Dupuis (1742–1809), a member of the French Academy and minister of education during the first Republic, and of Richard Payne Knight (1750–1824). Depuis was a mathematician who became interested in star-clusters and their zodiacal names. He came to the conclusion that the zodiac was a rural

[1] On the hermetic tradition, see Yates 1964.

calendar for the people who invented it, its signs indicating the
appropriate seasonal, agricultural labours. He sought to establish
the precise place and time in which the constellation of Capricorn
must have risen with the sun at the summer solstice and with the
spring equinox under Libra. He finally decided that this coincidence
of time, place and constellation occurred in Upper Egypt, about
fifteen or sixteen thousand years before his own time. So he
ascribed the invention of the zodiac to the people of Upper Egypt or
Ethiopia. On the basis of these deductions he established his
mythological system, and described the theogony and theology of
the ancients. It is said that it was because of Dupuis's belief that the
origin of mythology was to be found in Upper Egypt that Napoleon
organised an expedition there in 1798. Dupuis published his *Origine
de tous les cultes, ou la Religion universelle* in three volumes in 1794.[2] It
explained mythology in dualistic terms: heaven and earth, sun and
moon, male and female deities, together with a matter–mind spirit
trinity (as evidenced in triune gods). Christianity was, for Dupuis,
a latter-day imitation of earlier religions.[3] Madame Blavatsky, a
founder of the Theosophical Society, derived much of her informa-
tion from Dupuis for her first major publication, *Isis Unveiled*
(1877), as did many others who later wrote on theosophy and
spiritualism, even though they disagreed with the rationalistic and
materialistic premises upon which his work was based.

Payne Knight was the heir to a fortune from an ironworks in
Shropshire. He made several visits to Italy, and befriended Sir
William Hamilton, the British envoy to Naples. In 1786 Payne
Knight published *An Account of the Worship of Priapus, and its connec-
tion with the Mystic Theology of the Ancients* and, privately, *An Inquiry
into the Symbolic Language of Ancient Art and Mythology* (1818). Like
Dupuis, he postulated a syncretic view of ancient religions stressing
that the gods were personifications of nature symbolised by male/
female, heaven/earth dualities, and he noted similarities between
European and Asian myths and symbols. He derived the Egyptian
lotus from Hinduism, and equated the Isis and Osiris myth with the
Greek pantheon and their Near Eastern and Indian counterparts.[4]
It must be stressed, however, that both Dupuis and Payne Knight
wrote in the rational spirit of Enlightenment thought. They did not
themselves believe in the occult mysteries.

It is to the alchemical/mystical/spiritualist strand within Euro-
pean thought – to Plotinus (*c.* 203–*c.* 270) the philosopher;

[2] See entry in *Encyclopaedia Britannica*, 9th edn, vol. 7, pp. 550–51.
[3] Weisberger 1986, p. 64.
[4] Welsh 1986, p. 64.

Paracelsus (1493–1541), the Swiss alchemist and physician; Jacob Boehme (1574–1624), the German theosophist; and Emmanuel Swedenborg (1688–1772), the Swedish scientist and mystic – that we must turn for the original sources of modern Spiritualism, the first of the occult cults to inspire Formalesque artists. However, its *modern* revival may be traced to the experiences of the two young Fox sisters who, in their isolated farmhouse in New York State, are reported to have heard, in March 1848, the rappings of the spirit of a murdered pedlar. With their mother they established themselves as successful mediums with huge followings in New York City. Spiritualist circles and seances grew rapidly along the Atlantic seaboard, spread westward across the States then eastward into Europe during the 1850s and 1860s. The romantic imagination took sympathetically to the new spiritual enthusiasm.

Conventional accounts of the history of modern painting still credit Wassily Kandinsky (1866–1944) with the production, around 1910, of the first modern abstract paintings. However, recent research[5] has shown that abstract paintings were produced by Spiritualists in seance during the nineteenth century. Much of this work is of a high quality and it is pointless to separate it from art in the special sense by such categories as 'art autre', 'art brut', 'outsider art', as if it were produced isolated from the 'fine art tradition', for the ambition of the Formalesque aesthetic was to embrace all such art beyond that tradition. When Kandinsky painted his first abstract paintings, most of Europe's high art community would then have regarded his work as beyond the pale of their art in the special sense. Somewhat earlier, we may recall, William Blake was considered by most of the artists of his day to be mad.

Europe's first artists to embrace abstract art were Spiritualists. It was a form of *transcendental abstraction*. When Mrs Hayden, a professional medium from Boston, arrived in Europe in 1852, Spiritualism spread like wildfire, particularly in the form of a mania for table turning.[6] It was the first of the modern occult movements to inspire abstract art. Spirit drawings were not uncommon during the second half of the nineteenth century. As Gibbons suggests, 'Although such paintings were often "symbolic" in the emblematic sense, or more directly representational, it is quite possible that many completely abstract works were produced.'[7] When W. M. Wilkinson held classes in spirit drawings in 1858 he found that

[5] It began with Sixten Ringbom's seminal article, Ringbom 1966, pp. 386–418.

[6] See article on Spiritualism, *Encyclopaedia Britannica*, 9th edn, vol. 22, pp. 404–07.

[7] Gibbons 1988, p. 37.

many students began 'generally first in spiral forms'.[8] Victor Hugo's involvement with Spiritualism began after the death of his daughter in 1843. But his abstract paintings on paper, of the 1850s (though he read Swedenborg), may have been influenced from American sources. Hugo's paintings take the form of mandalas and images of the human eye fused with images of the planets.[9]

In 1871 Georgiana Houghton's exhibition of 155 *Spirit Drawings in Watercolours*, at the New British Gallery in Old Bond Street, London, ran for four months and was given wide publicity. Six years before, she had submitted some abstract spiritual works to the Royal Academy Exhibition of 1865. Although 'Accepted', they were not hung. Georgiana had been trained as an artist but gave up 'secular' painting 'through grief at the death of her younger sister' in 1851.[10] Like Hugo too she was probably influenced by the popular interest in Spiritualism emanating from the United States, for she did not begin her spirit drawings until 1859, holding weekly receptions at her home at which she showed her work. Later in life she became involved with spiritual photography. Holman Hunt is recorded as having been present at one of her seances. Georgiana published *Evenings at Home in Spiritual Seance* in two volumes (1881–82), *Chronicles of the Photographs of Spiritual Beings* (1882) and the catalogue of her 1871 exhibition. Two of the spiritual portraits in her exhibition were of Cromwell Varley and his wife. Cromwell was the second cousin of John Varley Jnr (1850–1933), a prominent theosophist and uncle of W. B. Yeats. John Varley Jnr was the grandson of John Varley (1778–1842), the astrologer and landscape painter for whom William Blake drew his famous 'visionary' heads. Interestingly enough, it was Varley's grandson, Varley Jnr, who drew the illustrations to Besant and Leadbeater's *Thought-Forms* (1905), which have been shown to be the source for the earliest visionary paintings of Kandinsky and Mondrian.[11] We thus have a direct link between Swedenborg, Blake, the Varley circle, Georgiana Houghton and the first abstract paintings of the early Formalesque.

The Swedish artist Hilma af Klint (1862–1944), like Georgiana Houghton, was a professional portrait and landscape painter before

[8] *ibid.*

[9] Tuchman 1986, p. 32.

[10] Gibbons 1988, p. 35. My brief account of Houghton's work is indebted to this article.

[11] Ringbom 1966, p. 404. The illustrations to *Thought-Forms* were made by 'a Mr John Varley, a Mr Prince and Miss MacFarlane according to instructions of the clairvoyant authors'. Varley had been one of Madame Blavatsky's early students.

she turned to abstract art under the influence of Spiritualism. With four other woman she formed a Spiritualist group during the 1890s which received messages from spiritual leaders by means of a psychograph recorder. The 'leaders', known as Amiel, Ananda, Gregor and Georg, inspired the group to draw automatically. In 1894 Edvard Munch, who was himself interested in alchemy and Swedenborg, exhibited a number of his works, including *The Kiss* and *The Scream* in Hilma's studio at the Royal Academy of Fine Arts in Stockholm. Hilma read Blavatsky, Besant and other theosophists, and in 1906 began to explore spiritual abstraction in her work. The year before, she promised Amiel 'that she would devote one year to painting a message for mankind',[12] and in 1907 painted ten large panels representing the four ages of man. In 1908 she met Rudolph Steiner (1861–1925), who did not appreciate the nature of her work, for he eschewed painting dictated by the dead or by supernatural leaders. Greatly discouraged, Georgiana gave up spiritual painting for four years. 'Earlier she had been a direct tool, and her hand had been guided. Now she saw and heard visions and worked inspired by them; as a medium she simply received the message and then painted it.'[13]

Spiritualism became a source of inspiration for František Kupka (1871–1957) and Giacomo Balla (1871–1958), and it influenced the content of other Formalesque artists. But Spiritualism attracted dubious characters, and the resulting scandals detracted from its influence. For many, theosophy came to offer a more attractive occult alternative. It opposed Spiritualism. 'We assert that the spirits of the dead cannot return to earth.'[14] The Theosophical Society, established in 1875 by Helena P. Blavatsky (1831–1891) and Colonel Henry Steel Olcott (1832–1907), became the most influential body promoting occult teaching of modern times. Unlike Spiritualism, whose roots were derived largely from within the European tradition, theosophy borrowed deeply from Asian religion and literature, from Brahminical, Buddhist and Zoroastrian teachings. It set out, as Blavatsky put it, 'to form the nucleus of a Universal Brotherhood of Humanity without distinction of race, colour or creed.'[15] Its teachings were syncretic and universalist, deriving from the western occult traditions – hermeticism, gnosticism, neo-Platonism – the Orient, and some aspects of modern Spiritualism.

[12] Fant 1986, p. 156.
[13] *ibid.*, p. 158.
[14] Blavatsky 1987, p. 27.
[15] *ibid.*, p. 39.

Theosophy became the most powerful ideological doctrine influencing the first generation of Formalesque artists and continued to be highly influential during the hegemony of the style throughout the first half of the twentieth century. However, for some Europeans, Americans and European colonials interested in the occult and the possibility of a universal religion, the emphasis that theosophy put upon Asian religions and philosophies was repugnant. They were attracted more to the anthroposophy (or spiritual science) of Rudolph Steiner, who had joined the Theosophical Society in 1902 and became the dominant figure in its German lodge. Becoming increasingly disenchanted with its leaders, Annie Besant (1847–1943) and Charles Leadbeater (1847–1934), Steiner founded the Anthroposophical Society in 1912. He had made a special study of Goethe in his youth and Steiner's 'spiritual science' became a syncretic religion like theosophy which mingled Goethean concepts with esoteric Christianity, Rosicrucianism and some of the teachings of theosophy, such as karma and reincarnation.

Piet Mondrian (1872–1944) became interested in theosophy around 1899, and read Édouard Schuré's *Les Grands Initiés esquisse de l'histoire secrète des religions* (1889), a book which more than any other exercised an enormous impact upon the French Symbolist circles of the 1890s and had reached its hundredth printing by 1927.[16] In 1909 Mondrian joined the Theosophical Society, his intensely theosophical phase lasting until about 1917.[17] Theosophy is at the intellectual roots of Mondrian's Neo-plasticism, the idea of which he took from M. H. J. Schoenmaekers, a Dutch theosophist and close friend.

Schoenmaekers, like Steiner, sought to transform theosophy into a spiritual science. Aware that clairvoyants frequently observed geometric configurations in their trance-like states, Schoenmaekers equated such states to Plato's opinion, expressed through the mouth of Socrates in the *Philebus*, that universal beauty was best visualised as 'something straight, or round, and the surfaces and solids which a lathe, or a carpenter's rule and square, produces from the straight and the round'.[18] Such views inspired Mondrian to seek an art 'where form and colour are expressed as a unity in the rectangular plane'. An Asian-inspired religious system thus provided Mondrian with both a formal and contentual justification for an art that privileged a return to the pictorial surface. For him art became the means through which we can know the universal

[16] Welsh 1986, p. 68.
[17] Ringbom 1966, p. 414.
[18] Plato 1961, p. 1132.

and contemplate it in plastic form.[19] In the transcendental, neo-Platonic purity that he sought for art, Mondrian cultivated, implicitly, a culturally imperialist project. Later in life, in 1937 in *Plastic Art and Pure Plastic Art*, he affirmed that all art was evolving towards abstraction. 'We need not try to foresee that future; we need only to take our place in the development of human culture, a development which has made non-figurative art supreme. It has always been only one struggle, of only one real art; to create universal beauty. This points the way for both present and future. We need only continue and develop what already exists.'[20] Mondrian's art and ideas, as is well known, became enormously influential in art, design and architecture throughout the present century. If Hilton Hotels are alike throughout the world they owe their self-admiring simulacra, in no small measure, to Piet Mondrian.

As noted earlier, the conventional wisdom of art history still credits Kandinsky and Kupka[21] with having produced the first non-objective or abstract paintings. For example, E. H. Gombrich in the fifteenth edition of his authoritative *The Story of Art* (1989) writes, 'It appears that the first artist to do this [i.e. "exhibit a painting without any recognisable object"] was the Russian painter Wassily Kandinsky.' But such a statement, as we have noted, can only be sustained if we confine the definition of painting to the high art tradition of Europe since the Quattrocento, and even then it is on shaky ground. For as we have seen, Georgiana Houghton exhibited non-objective paintings in Bond Street, London, as early as 1871 and Kandinsky's inspiration towards abstraction springs from similar spiritualistic sources. In his seminal essay 'Art in the Epoch of the Great Spiritual', Ringbom has demonstrated how Kandinsky's earliest abstract paintings were profoundly influenced by the ideas and the illustrations contained in Annie Besant and C. W. Leadbeater's *Thought Forms* (1901) and Leadbeater's *Man Visible and Invisible* (1902), two of the leaders of the Theosophical Society. Kandinsky became deeply interested in theosophy though he did not, like Mondrian, become a member of the Society. He was drawn more to the ideas of Rudolph Steiner because of Steiner's deep interest in Goethe's aesthetics and colour theory, and attended many of Steiner's lectures. Steiner wrote that for Goethe 'Art, religion and science are inseparable, and the artist brings down

[19] Mondrian, *The New Plastic in Painting*, 1917; see Mondrian 1986.

[20] Quoted from Harrison & Wood 1992, p. 370; originally published in *Circle-International: Survey of Constructive Art*, ed. J. L. Martin, B. Nicholson and N. Gabo, London, 1937.

[21] On Kupka's contribution to abstract art, see Anna Moszynska, 'Abstract Art', in Dictionary 1996, vol. 1, p. 73.

the Divine to earth, not by letting the Divine flow into the world, but by raising the world into the sphere of Divinity. This is the cosmic mission of the artist.'[22]

However, Kandinsky's intellectual roots are diverse. He completed his essay *Concerning the Spiritual in Art* (1913) towards the end of 1910, the same year in which he painted his first abstract watercolour. The book has its sources deeply in German romantic philosophy with its perennial interest in the distinction between the spiritual and the material and also owes much to Steiner and theosophy. In moving towards an abstract art he sought to apprehend the vibrations that theosophists believed constituted the auras of persons and material things. As he put it: 'A work of art is born of the artist in a mysterious and secret way. Detached from him it acquires an autonomous life, becomes an entity . . . It exists and has power to create spiritual atmosphere; and from this internal standpoint alone can one judge whether it is a good work of art or bad. If its form is "poor", it is too weak to call forth spiritual vibration.'[23]

Kandinsky's approach to art was fortified by his early training. At Moscow University he had studied anthropology and in 1888 was elected to membership of the Russian Imperial Society of Friends of Natural History, Anthropology and Ethnography. The following summer, commissioned by the Society, he completed an ethnographical investigation of the Zyrian peoples in eastern regions of the Vologda province of western Siberia. Later he recorded his reactions at first walking into one of the great, richly decorated, wooden houses of the Zyrians as a 'miracle': 'It was an experience that would have long-lasting reverberations not only in his art, but in his whole attitude towards the arts.'[24]

Later that year he published his findings.[25] One of the matters that particularly interested him was what he called *dvoeverie* (or double faith), the interweaving among the Zyrians of their pagan beliefs with Christianity. Peg Weiss has argued convincingly that this syncretism of Christianity and pagan faith, gained as a student, entered deeply into Kandinsky's own belief in the artist's vocation. The image of St George, which he chose for the cover of *Der Blaue Reiter* almanac, became something of a persona for him, and he painted its image many times during his life. St George, though a Christian saint, was endowed in Russia with shamanistic powers. April 23, the saint's feast day, was also an important day in the

[22] Ringbom 1966, p. 391.
[23] Kandinsky 1955, p. 74.
[24] Weiss 1990, p. 294.
[25] Kandinsky 1889, pp. 102–10.

agricultural calendar, celebrated with pagan rites as well as Christian ritual.[26] The Siberian shaman was himself a rider and his duty was to heal. As a student of Russian ethnography Kandinsky was widely read in the literature of shamanism. The shaman was an all-knowing man, an intercessor possessing supernatural powers who could heal both physically and psychically, solve social problems, foretell the future and assure good hunting.[27] The Russian shaman communicated with the heavenly powers by leaving his body in a trance-like state. He usually possessed a drum which was transformed into a magic horse during his trance, and on it he could fly above the mountains or descend into the underworld.[28] Weiss has shown how such themes play a central role in Kandinsky's symbolic vocabulary in paintings often regarded as abstract.

Kandinsky envisaged himself as an artist shaman who by his art could help rid the world of its materialism. In the Blaue Reiter almanac, and their exhibitions, he and Franz Marc promoted a wider conception of art. The exhibitions included not only contemporary work, but also examples of Egyptian and oriental art, folk art, child art and amateur art. Kandinsky borrowed a number of ethnographic artefacts from the Staatliches Museum für Völkerkunde, Munich, for the almanac. After attending a concert by Arnold Schoenberg (1874–1951) in January 1911 he became increasingly interested in synaesthesia. His *Impression III – Concert* records his experience of a Schoenberg concert. To the extent that it was inherently abstract, music, he believed, might serve as a model for the new painting of the era of the 'great spiritual'. 'In this respect,' he wrote, 'painting has caught up with music, and both assume an ever-increasing tendency to create "absolute", i.e. completely "objective" works that, like works of nature, come into existence "of their own accord" as the product of natural laws, as independent beings.'[29]

In the work of Kandinsky then prior to World War I, we see a convergence of many powerful ideas that had been developing throughout the previous century: the growing interest in non-European art expressed as a mode of primitivism, the Wagnerian interest in synaesthesia, the role of the artist in modern society as a shaman who can help to heal the sicknesses of modern material life. Yet Kandinsky did not reject realism. He found a place in his schema for a 'great realism' that he found expressed in the work of

[26] Weiss 1995, pp. 95–96 et al.
[27] Weiss 1990, p. 309.
[28] *ibid.*, p. 310.
[29] Quoted in Zweite 1989, notes to pl. 33.

Henri Rousseau and the paintings of Schoenberg. 'Great realism' for
him embodied 'the content of the work . . . by means of the simple
"inartistic" rendering of the simple hard object.'[30] In other words a
naive realism. But the path of his work led far from the naturalism
of the academies. In this regard both the formal and contentual
grounds of his art were being largely driven by forces external to
high European culture.

I have considered Mondrian and Kandinsky in some detail
because they probably exercised the most powerful influence on
the immanent tendency within the Formalesque towards non-
figural representation. But many of their contemporaries also came
under the influence of theosophy, most notably František Kupka,
the first twentieth-century artist, it has been said, to exhibit 'fully
developed non-figurative paintings when he showed his *Amorpha*
paintings in the Salon d'Automne of 1912'.[31] For a time he was, like
Georgiana Houghton, a medium, read Blavatsky and Steiner and
was associated with the group of 'intellectual' Cubists, including
Apollinaire, Gris and Gleizes, that met at Jacques Villon's studio at
Puteaux.[32] Spate has suggested that Kupka, like Kandinsky, might
have been directly influenced by the illustrations in Besant and
Leadbeater's *Thought Forms*.[33]

The Belgian sculptor–painter George Vantongerloo (1886–1965),
with Mondrian and van Doesburg a member of the De Stijl group,
was influenced by the Dutch theosophist Schoenmaekers, who,
like Steiner, developed a 'Christianised' version of theosophy
which he called 'Christosophy'. Vantongerloo's Neo-plasticism was
even more strictly and complexly mathematically based than
Mondrian's. In his *L'Art et son avenir* he advocated an art of harmo-
nious relations which would embody spiritual values correspond-
ing to human needs. The art of Hans (Jean) Arp (1886–1966), the
German painter, sculptor and poet, affords a sharp contrast to that
of Vantongerloo, yet he too was deeply influenced by the occult.
Arp knew Kandinsky, exhibited with the Blaue Reiter, was deeply
versed in the writings of Boehme from childhood and read the
mystic to the Dada group that gathered in the Café Voltaire, Zurich,
during World War I. Arp too became a theosophist, but it would
appear that Boehme was the ultimate source of his concept of
concrete art which he expressed in biomorphic forms grounded in
a two-foci ellipse, a fluid oval, symbolic of generation.[34] Johannes

[30] Quoted in *ibid.*, p. 43.
[31] Spate 1979, p. 85.
[32] *ibid.*, p. 131.
[33] *ibid.*
[34] Watts 1986, pp. 239–55.

Itten (1888–1967), who taught at the Bauhaus from 1919 to 1923, became interested in theosophy after he met Walter Gropius's first wife, Alma Mahler, a theosophist since 1914. He read Besant and Leadbeater's *Thought Forms*, Indian philosophy, and the cabbala and espoused the views of the Mazdaznan sect which insisted on meditation and vegetarianism. His endeavour to insist upon its practices among the students of the Bauhaus led to his resignation.[35]

In addition to the impact of Spiritualism, Theosophy and Anthroposophy on the content of the Formalesque style, a predominantly occult belief in the existence of a fourth dimension promoted the abstract/formal aspects of the style. The occultism of the belief must be distinguished from Einstein's Special Theory of Relativity, which did not become widely known to artists and the general public until it was scientifically verified in 1919.[36] For Einstein, the fourth dimension was time. This was not the view popularised as a result of the occultation of the concept. Oddly enough, however, like theosophy, it has its ultimate origins in rational thought. In 1829 the Russian mathematician Nikolai Ivanovitch Lobachevsky (1792–1856) demonstrated that a non-Euclidean geometry was logically possible – that whereas Euclid postulated that only one line can be drawn through a point in a plane parallel to a given line in that plane, in a non-Euclidean geometry an infinite number of lines may be so drawn. Then in 1854, independent of Lobachevsky, the German mathematician Bernhard Riemann (1826–1866) distinguished between unbounded and infinite space and demonstrated that upon the surface of a sphere no line can be drawn parallel to a given line, and furthermore that on an irregularly shaped surface no figure could be moved without changing its shape.[37] In 1868 the Italian mathematician Eugenio Beltrami (1835–1900), in developing his theory of spatial curvature, proposed his 'pseudo-sphere' as an example of non-Euclidean geometry. These developments together with the work of A. F. Möbius (1790–1868) made possible the creation of n-dimensional geometry and the logical concept of a fourth (spatial) dimension. But mathematical concepts were one thing; the problem of *visualising* a fourth dimension in a three-dimensional world quite another. It led to notions of hypercubes and hypersolids as published by W. I. Stringham in 1880. Although it was obviously not possible to represent a fourth spatial dimension

[35] Long 1986, pp. 210–12.
[36] This has been established beyond doubt by Linda Dalrymple Henderson (1971, p. 417). See also Gibbons 1981, pp. 130–47.
[37] Henderson 1983, p. 5.

convincingly upon a two-dimensional surface, its 'advocates . . . took great comfort in the analogy of a flat, two-dimensional world of beings unaware of the third dimension'.[38]

As early as 1754 the idea of time as the fourth dimension had been suggested by d'Alembert in his article in the *Encyclopedie*. The German mathematical physicist Herman Minkowski (1864–1909) had suggested that space and time should be thought of as comprising a single four-dimensional continuum, space-time, a concept that later became essential to the conception of Einstein's Special Theory of Relativity. H. G. Wells used the concept of space-time in his science fiction tale *The Time Machine* in 1895. But it was *not* time as space that fascinated popular thought during the later nineteenth and earlier twentieth century and promoted the *popular* reception of Cubism, it was the concept of a fourth *spatial* dimension.

It emerged into popular thought as the result of a continuing debate in France during the 1880s and 1890s as to the nature of geometric axioms. Kant in his *Critique of Pure Reason* (1781) had argued that geometric axioms must be synthetic a priori judgements: synthetic because their predicates are not (like analytic judgements) contained in their subjects, and a priori because they are not derived from experience. However, the mathematical development of n-dimensional geometry challenged Kant's belief. Hermann von Helmholtz (1821–1894) argued, on the contrary, that the human mind could represent a non-Euclidean space to itself, citing the example of Beltrami's pseudo-sphere – that our knowledge of space like all knowledge was empirical. During the 1880s and 1890s controversy raged widely between the supporters of Kant and Helmholtz. It was eventually settled for all practical purposes by Henri Poincaré (1854–1912), who theorised that geometric axioms were neither a priori nor empirical: they were conventional.

Such, briefly, outlines the scientific discussion. However, it became common talk and controversial only when it converged with spiritualistic practices. The occult sources of the fourth dimension have been traced back as far as Henry More, the Cambridge Platonist, who in his *Enchridion Metaphysicum* (1671) postulated that 'besides those THREE dimensions which belong to all extended things a FOURTH also is to be admitted which belongs properly to SPIRITS'.[39] But its modern revival was strongly promoted by Stewart and Tait's

[38] *ibid.*, p. 9.
[39] Cited in Gibbons 1981, p. 134.

The Unseen Universe, a book reprinted numerous times between 1875 and 1883. In its fourth printing of 1876 it stated that 'Just as points are the terminations of lines, lines the boundaries of surfaces, and surfaces the boundaries of portions of space of three dimensions: so we may suppose our (essentially three-dimensional) matter to be the mere skin or boundary of an Unseen whose matter has *four* dimensions.'[40] Two years later J. C. F. Zöllner, a Leipzig astronomer, published an article, 'On Space of Four Dimensions', in the *Quarterly Journal of Science* in which he supported Henry Slade, an American Spiritualist. Slade untied knotted cords that had been sealed together without ever touching the cords and extracted a coin from a sealed box. This, asserted Zöllner, was evidence of the existence of a fourth dimension and that in his clairvoyant condition 'Slade's soul was . . . so far raised in the fourth dimension, that the contents of the [sealed, opaque] box in front of him were visible in particular detail'.[41]

In 1884 Edwin Abbott's highly popular novel *Flatland: A Romance of Many Dimensions* gave the fourth dimension further publicity. A literary genre which Henderson has called 'hyperspace philosophy' emerged which relied much upon Plato's 'Idea', Kant's 'thing-in-itself' and elements taken from theosophy. The most prolific exponent of hyperspace philosophy was Charles Howard Hinton. In his *A New Era of Thought* (1888) he claimed that the best way of glimpsing the reality of the fourth dimension was by 'casting out self', which might be achieved by concentrated study of an arrangement of objects. Hinton suggested concentrating on multicoloured cubes in order to visualise the four-dimensional hypercube, which he called 'tesseract'. 'Mental painting', he assured his readers, was an aid to such visualising:

> putting definite colours in definite positions, not with our hands on paper but with our minds in thought, so that we can recall, alter, and view complicated arrangements of colour existing in thought with the same ease that we can paint on canvas . . . The artist is not conscious of the thought process he goes through. For our purpose it is necessary that the manipulation of colour and form which the artist goes through unconsciously, should become a conscious power, and that, at whatever sacrifice to

[40] *ibid.*, p. 135. Balfour Stewart was Professor of Natural Philosophy at Owens College, Manchester; and Peter Guthrie Tait, Professor of Natural Philosophy at Edinburgh.

[41] J. C. F. Zöllner, *Transcendental Physics*, Boston, 1881, pp. 147–48; quoted in Gibbons 1981, p. 136.

immediate beauty, the art of mental painting should exist beside our more unconscious art.[42]

Hinton's was a conceptual art *avant la lettre*.

Blavatsky, who was jealous about the claims of other occult sciences, rejected fourth dimensionalism, but Leadbeater, in his *The Other Side of Death* (1903), translated into French in 1910,[43] related Hinton's concepts to his notion of 'astral vision'. In preparing his lecture 'The Astral Plane' in 1894 for the London Lodge of the Theosophical Society, he discovered that 'sight on [the astral] plane is a faculty very different from and much more extended than physical vision. An object is seen, as it were, from all sides at once, the inside of a solid being as plainly open to view as the outside.'[44]

The Parisian newspaper *Le Theosophe* in March 1911 published an article, 'L'Esprit et l'espace: la quatrième dimension', which discussed the work of Hinton, Lobachevsky and Poincaré. It was in this climate of intellectual discussion that Apollinaire in 1912,[45] in one of his earliest comments on the Cubists, asserted that:

> today's scientists have gone beyond the three dimensions of Euclidean geometry. Painters have, therefore, very naturally been led to a preoccupation with those new dimensions of space that are collectively designated, in the language of modern studios, by the term *fourth dimension*.
>
> Without entering into mathematical explanations pertaining to another field, and confining myself to plastic representation as I see it, I would say that in the plastic arts the fourth dimension is generated by the three known dimensions: it represents the immensity of space externalised in all directions at a given moment. It is space itself, or the dimension of infinity; it is what gives objects plasticity. It gives them their just proportion in a given work, whereas in Greek art, for example, a kind of mechanical rhythm is constantly destroying proportion.
>
> Greek art had a purely human conception of beauty . . . The art of the new painters takes the infinite universe as its ideal, and it is to the fourth dimension alone that we owe this new measure of perfection that allows the artist to give objects the proportions appropriate to the degree of plasticity he wishes them to atttain.[46]

[42] *A New Era of Thought*, 1888, pp. 86–87; quoted in Henderson 1983, p. 29.
[43] *L'Autre Côte de la mort*, Paris, Éditions Théosophiques, 1910.
[44] Tillett 1982, p. 57.
[45] 'Les Peintures moderne', *Les Soirées de Paris*, no. 3 (April 1912).
[46] Apollinaire 1972, pp. 222–23.

Some months later Gleizes and Metzinger in their essay *Du cubisme* (1912) stated that 'If we wished to tie the painter's space to a particular geometry, we should have to refer it to the non-Euclidean scientists; we should have to study, at some length, certain of Rieman's theorems.'[47] Graphic material supported the intellectual link between Cubism and the fourth dimension. In 1903 Esprit Jouffret published his *Traité élémentaire de géométrie à quatre dimensions* in which he illustrated 'sixteen fundamental octa-hedrons' by which he sought to project, by analytical geometry, four-dimensional figures on to the flat page. Some striking parallels may be drawn between Jouffret's illustrations, as Henderson has indicated, and Picasso's Cubist paintings of 1910, such as his *Portrait of Ambrose Vollard*.

But this is not to say that Picasso and Braque were influenced by Jouffret. Their Cubism has its own sources in Cézanne, and African sculpture. But it does reveal the climate of intellectual thought in France within which Cubism emerged publicly and was promoted. One of Picasso's convivial friends at the Bateau Lavoir was Maurice Princet, a mathematician and actuary who arranged occasional sales of the artist's work. He is said to have discussed non-Euclidean geometry and possibly the fourth dimension as a member of the Bateau Lavoir *bande*. Both Picasso and Braque denied that Princet had any influence on their art.[48] Picasso, who associated with anarchists in Barcelona and later joined the French Communist Party out of admiration for its part in the Resistance, was not one to take to occult notions readily. We may accept the comment of John Richardson, the leading authority on the life of Picasso, when he writes: 'The two of them (that is Picasso and Braque) would always be adamanant that neither the fourth dimension nor any other mathematical theory had played any role in the development of cubism – *their* cubism.'[49] But many of his contemporaries did take the fourth dimension seriously, not only Apollinaire, but the so-called Salon Cubists, Gleizes and Metzinger, together with Camoin, Max Weber, Roger de La Fresnaye, Mercereau, Raynal and Larianov.[50] Moreover, according to Cecily Mackworth, the biographer of Apollinaire, 'Apollinaire as well as Picasso and Max Jacob had frequented [the Sar Peladan] in their Montmartre days', and Peladan 'had been momentarily interested in cubism'.[51] Josephin

[47] Quoted from Harrison & Wood 1992, p. 190.
[48] Richardson 1991, p. 506n26.
[49] *ibid.*, vol. 2, p. 120.
[50] Henderson 1983, pp. 59–63.
[51] Mackworth, *Guillaume Apollinaire and the Cubist Life*, London, 1961, p. 126; quoted in Gibbons 1981, p. 147.

Peladan (1858–1918) was the critic and Symbolist who organised the Salon de la Rose + Croix (1892–97) and sought to unite the occult with Catholicism. One of the aims of the Salon was to 'ruin realism'.[52] What is relevant to our present context is that Cubism was an achievement attained within an intellectual and spiritual climate that favoured the fourth dimension in its occult mode. It achieved aesthetically what Hinton and Leadbeater sought for intellectually.

The Cubist moment was unquestionably the most creative moment in the evolution of the Formalesque style, but it was essentially a creation of the nineteenth century, the century that ended in 1914. It did not, in its original creative form, survive World War I. What survived from Cubism played a highly significant role in the institutionalisation of the Formalesque in the period between the wars. The modernisms of the twentieth-century developed as oppositional styles confronting an increasingly hegemonised Formalesque.

The occult, grounded in the hope for and belief in a universal religion, provided innovatory *content* to an art that might have otherwise been dismissed as 'decorative'. The literal meaning of occult is 'hidden' and the content of visual art influenced by occult beliefs was by its intent hidden. Abstract art influenced by occult meaning was not normally meant to be disclosed.

PRIMITIVISM AND THE ORIENT

The renewed interest in the folk arts of Europe and the arts and crafts of indigenous non-Europeans also endowed European art with a renewed *formal* vitality. European art had, of course, always drawn upon the exotic. All art is of hybrid origin. If it may be said to begin anywhere, European art begins around the court of Charles the Great, King of the Franks (771–814). Frankish art consisted of gold, silver and bronze work and, after the Franks conversion to Christianity, carved stone monuments; that is, craft, art in the general sense. Around this indigenous art, Charlemagne, for essentially political and religious reasons, constructed a powerful and imposing hybrid art, drawing upon the art of the Roman Empire, Byzantium and Irish Christianity – all *exotic* to the nomadic Franks. And as it began, so it continued. Throughout its history European art has drawn upon the exotic, largely from Asia until the

[52] Quoted in the article on Peladon in Dictionary 1996, vol. 24, p. 333.

fifteenth century and then, with the opening of the sea routes to America, India, China and the Pacific, upon the arts and crafts of the world at large. But the very nascence of Europe's imperial art was the creation of Charlemagne's court; there it developed a capacity to absorb and transform exotic arts into a syncretism adapted to the political and religious needs of a new European polity. Panofsky called it Europe's first Renascence. It was also Europe's first essay in cultural imperialism.

However, after 1400 when Europe created a new kind of art – an art in the special sense, with the invention of linear perspective and chiaroscuro – it depended far less upon continuous exotic renourishment. True, exotic elements were absorbed on its margins, but they did not materially affect its dynamically powerful naturalism until a crisis in the depiction of perception manifested itself within Impressionism. Thereafter European art began once again to draw as heavily upon the exotic as did Charlemagne's court around 800.

It is pointless to draw a firm distinction between the occult and the exotic. The occult itself springs largely from exotic sources, sources that have been folded over into the European tradition from ancient to modern times. Theosophy drew deeply upon the Egyptian mysteries and the religions of the Indian sub-continent. India occupied a crucial place in the development of German romanticism during the nineteenth century. As Wilhelm Halbfass has put it, 'The very idea of India assumed mythical proportions; the turn towards India became the quest for the true depths of our own being, a search for the original, infant state of the human race, for the lost paradise of all religions and philosophies.'[53] It represented the 'spirit of infancy' in Schelling's 'On Myths, Historical Legends and Philosophies of the Most Ancient World' (1793).

Hegel felt that the Schlegels placed too high a regard upon Indian art; for him the infancy of Indian art was formless and negative. Yet he conceded that because of its 'foreign nationality', it had 'something strange about [it] for us' and possessed a content which outsoared its foreignness and was 'common to all mankind'. Only by 'the prejudice of theory' could it 'be stamped as products of a barbarous bad taste'. 'This general recognition of works of art which lie outside the circle and forms which were the principal basis for the abstractions of theory has in the first place led to the recognition of a special kind of art – Romantic Art.'[54]

[53] Halbfass 1988, pp. 72–73.
[54] Hegel 1975, vol. 1, p. 20.

PAUL GAUGUIN

Towards the end of the century the exotic and occult began to converge in the art of Paul Gauguin (1848–1903), the first artist of whom it might be said that he was self-consciously Formalesque and stands on the threshold of abstract art, the immanent destination of the style. Mark Cheetham has demonstrated how Gauguin rejected the eye of perception for the eye of memory.[55] He stresses that Gauguin possessed powerful intellectual interests that are seriously underplayed in conventional accounts of his life; and that as early as 1888 he had begun, in the company of his friends Bernard, Sérusier and Schuffenecker, to come under the influence of the Platonic and Plotinian concept of anamnesis, that doctrine of the memory of a pre-natal state in which the soul exists and gains its ideas. Perhaps Gauguin's desire to recapture that condition is best illustrated in his *Self-Portrait in Stoneware* (1889) depicting the artist with closed eyes. By contrast, at that time, Cézanne, the source, if any artist was, of Cubism, insisted that the way forward in art was still the consistent study of nature. Of Gauguin's work he commented contemptuously, he 'only made Chinese images'.

Symbolism was the immediate, intellectual and mystical matrix out of which the Formalesque style emerged. Georges-Albert Aurier (1865–1892), the leading Symbolist critic, took Gauguin as its exemplar in painting. He is one of the 'sublime seers ... with the clairvoyance of that inner eye of man of which Swedenborg speaks'.[56] Gauguin quoted Swedenborg and must have taken part in the neo-Platonic discussions of the Symbolist circles. In Tahiti he read Moerenhout and Massey, combining his primitivism, his desire to be 'savage', with a deep interest in the occult search for a universal religion. J. A. Moerenhout, in his *Voyages aux îles du grand océan* (1837), appears to have followed Dupuis and envisaged Polynesian deities in the form of heaven and earth, male and female dualities, comparing them with those of ancient cultures, especially Greek. By contrast, Gerald Massey (1828–1907), the British writer whose *A Book of the Beginnings* (1881) Blavatsky quotes, believed that the cradle of all civilisations derived from Egypt and Africa.

There is no point in recounting here, even in outline, the history of primitivism, beyond stressing that it is a trope that has endured in European art and thought since antiquity, by means of which other cultures perceived to be 'closer to nature' could be admired

[55] Cheetham 1991.
[56] Quoted in Goldwater 1979, p. 183.

and used as a critique of the state of European civilisation itself. In this process Gauguin was of course but one link in a long chain. Nevertheless his overriding importance for the history of Modernity cannot be gainsaid. In an obsessive life filled with pain and suffering he enacted what others artists talked about, reaching out for a universal, syncretic art that might transcend the traditional arts of Europe. That his art is, as it had to be, essentially European, that it 'appropriated' ideas from other cultures, is of minor consequence; to appropriate both within a culture and between cultures has always been a part of the creative process. After Gauguin, neither European nor non-European art could ever be quite the same again. He began to construct a bridge for others to cross.

Something of what he sought may perhaps be glimpsed in his reply to André Fontainas's criticism of one of the last of his great paintings, *Where do we come from? Who are we? Where are we going?* (1897):

Here near my cabin, in complete silence, amid the intoxicating perfumes of nature, I dream of violent harmonies. A delight enhanced by I know not what sacred horror I divine in the infinite. An aroma of long-vanished joy that I breathe in the present. Animal figures rigid as statues, with something indescribably solemn and religious in the rhythm of their pose, in their strange immobility. In eyes that dream, the troubled surface of an unfathomable enigma. Night is here. All is rest. My eyes close in order to see without actually understanding the dream that flees before me in infinite space; and I experience the languorous sensation produced by the mournful procession of my hopes.[57]

So it was that Gauguin sought to invoke that primordial anamnesis of which Plotinus speaks: 'Such vision is for those only who see with the soul's sight – and at the vision they will rejoice, and awe will fall upon them, and a trouble deeper than all the rest could ever stir, for now they are moving in the realm of Truth.'[58]

Although Gauguin lived from 1891 to 1893 in Tahiti, again from 1895 to 1901 in Tahiti, and in the Marquesas from 1901 until his death in 1903, his paintings make little use of the *formal* elements of Polynesian art. They are evidence rather of the syncretic/ universal art he sought. In this he was, like Mondrian and

[57] Rewald 1943, pp. 21–24.
[58] Plotinus, *Enneads*, i.6.4, trans. C. Mackenna; quoted in Tatarkiewicz 1970, p. 331.

Kandinsky, unwittingly, the agent of a new chapter in the history of cultural imperialism (despite, ironically, his intense opposition to the bureaucratic imperialism he confronted in Tahiti) that would spread throughout the world in the wake of his considerable achievement. In one sense Gauguin's 'Pacific' art is a direct product of French colonial expansion. Tahiti had been transformed from a French protectorate into a colony in 1881, ten years before Gauguin arrived there and, as Kirk Varnedoe reminds us, of the other two places he considered visiting, Tonkin was forced to become a French Protectorate in 1883, and Madagascar was recognised, at least by the British, as a French protectorate in 1890, shortly before Gauguin set out for Tahiti.

Although formally, Gauguin, in his paintings, derived little from Polynesian art, he was the first European artist in his woodcuts and sculpture to make creative use of Polynesian art. However, it is not his direct borrowings that are significant in our context but his syncretic orientation. 'Always have before you', he advised his friend Daniel de Monfreid when he thought of taking up sculpture, 'the Persians, the Cambodians, and a little of the Egyptians. The great error is the Greek, however beautiful it may be.'[59] And his own art mingles the influence of Javanese, Japanese, Easter Island, Cambodian, Aztec, Marquesan, Indonesian and ancient Greek art (despite his disclaimers) and Christian iconography. It combines art as decoration with art as a potent, multi-faceted signifier, both symbolist and sensuous. No artist was more eclectic than Gauguin; yet all art, it should not be forgotten (other than the mute copy), is, in a profound sense, eclectic. But in Gauguin's case the eclecticism was stimulated by an inner personal ambiguity about his own origins, the conviction that he was both aristocrat and 'savage'.[60]

Gauguin's theogony was historically potent – implicitly anthroposophical before Steiner coined the meaning to his own purpose. His fusion of a universalising exotic with a universalising occult deeply affected the whole course of modern art. Robert Goldwater noted that 'two conflicting traditions concerning primitive peoples' combine in his art 'the idyllic and the malevolent', the one stemming from Rousseauean romanticism, the other from the tradition 'that violence and brutishness manifest themselves initially in the primitive mentality'.[61] Elsewhere, I have described these traditions as the noble and ignoble savage modes of primitivism.[62] Of interest in our present context is the fact that the impact

[59] Lettres de Gauguin à Daniel de Monfreid, ed. and annot. Joly Segalen, Paris, [n.d.].
[60] On this, see Varnedoe 1984, vol. 1, p. 186.
[61] Goldwater 1986, p. 278.
[62] Smith 1950, pp. 65–100.

of Gauguin later spread into three broad streams: one feeding into the occult Formalesque of the art of Kandinsky, Mondrian and Malevich; another into the picturesque Formalesque of the Fauves and Matisse; and a third into the Cubist Formalesque of Picasso, Braque and their followers.

It is in this context that Gauguin may also be seen as the paradigmatic figure for a global, rather than an overly European, understanding of twentieth-century art. Because twentieth-century art has been written from a European viewpoint, Gauguin's contribution to modernism has been undervalued. To Europeanists residually mourning the classical tradition, there is something at once over-decorative and syncretic about it. Gauguin's art is a European art but one in which the European centre is no longer holding. It is those artists who contributed to the revitalisation of European art at the end of the nineteenth century, while clinging to its classical centre – notably Turner, Manet, Monet, Cézanne, van Gogh and Matisse – who have been canonised as the masterly forerunners of modern art. For Cézanne, Matisse and eventually Picasso successfully assimilate the lessons of the exotic while maintaining the ascendancy of the European tradition. The bridge to this assimilation was Europe's traditional 'other', the Orient. In our context they are the masters of the early Formalesque, that last of nineteenth-century modernisms. By contrast, Gauguin, while unquestionably contributing to the creation of the Formalesque, is also the forerunner of that global modernism of the twentieth century which succeeded it: the modernism that is still called Postmodernism, in mourning for its European predecessor.

For Gauguin's art prefigured a world art that eventually challenged the Formalesque after it had past its zenith during the last third of the present century. This is not in any way to question the *aesthetic* achievement of Gauguin's great contemporaries but rather to insist that it was the very nature and quality of their achievement and its subsequent historic influence that made possible the institutionalisation of the Formalesque after World War I and sustained the artistic hegemony of European art throughout an increasingly postcolonial world during the greater part of the century. Of course Gauguin's art also made its contribution to that hegemony, but it contained immanent contradictions that led eventually to the dismantling of its dominance. Stephen Eisenman has argued that Gauguin was regarded by the Polynesians as an androgyne, a *mahu* or third sex figure, and that this persona embodied in Gauguin himself a hybrid personality, 'a complex figure of Polynesian sexuality and colonial resistance'. His great painting *Where do we come from? Who are we? Where are we going?* (1897) embodies in

Eisenman's view 'gender liminality, kinship, joking and respect relations' that are 'all prominent themes framed by the artist's nostalgia for the past and fear of the future'.[63] Let us now consider briefly, in contrast, the achievements of some of Gauguin's contemporaries: Cézanne, van Gogh, Monet, Matisse.

PAUL CÉZANNE

There is nothing in Paul Cézanne's (1839–1906) art to suggest that he wished to reach out beyond the European tradition. Though intensely aware that empirical naturalism had run its course as a creative technique, he still insisted upon painting *en plein air*. He sought a universalist vision of nature that would justify Impressionism in the light of his native Provence, the Venetian and Spanish masters, Chardin and Poussin. It is a universal, classicising art by which he sought to revitalise European naturalism. His advice to Bernard was Platonic in its austerity and essentialism, yet it still remained within the guidelines of the scientific naturalism made possible by Brunelleschi and Alberti: 'treat nature by the cylinder, the sphere, the cone, everything in proper perspective so that each side of an object is directed towards a central point'.[64] Cézanne is a naturalism in extremis, stubbornly confronting a ruthlessly dynamic tradition, a genius who succeeded in transforming Impressionism into a highly creative classicism, while it yet remained a naturalism that could be pressed no further without rejecting its central assumption, art as a naturalistic mimesis. At the root of Cézanne's art is an archaism, essentially European, but one possessed of universalist ambitions. All his early champions – Bernard, Denis, Meier-Graefe, Fry – will launch him upon the European public in this manner, as the genius who consolidated Impressionism, melding it to European tradition. Paradoxically, the solitary genius who detested art's institutions created a style apt for the universalisation and institutionalisation of the Formalesque. 'Institutions, pensions, honours can only be made for cretins, rogues and rascals', Cézanne told Bernard. Yet within forty years of his death ardent young modernists would be Cézannizing nature all over the globe. Like Duchamp after him, he became his own institution.

[63] Stephen Eisenman, 'Gauguin's Third Sex'; quoted from an abstract of the paper delivered at the conference 'Re-Imagining the Pacific', Humanities Research Centre, Australian National University, Canberra, August 1996.

[64] Cézanne to Bernard, Aix, 15 April 1904; quoted in Chipp 1968, p. 19.

VINCENT VAN GOGH

Van Gogh was not so Eurocentric as Cézanne. 'You will be able to get an idea of the revolution in painting', he informed his sister Wilhelmina, 'when you think . . . of the brightly coloured Japanese pictures one sees everywhere, landscapes and figures. Theo and I have hundreds of them in our possession.'[65] He felt that Europe did not provide him with the kind of light his art needed and dreamt of a community of tropical painters. 'In the future many painters will go and work in tropical countries. Why did the greatest colorist of all, Eugène Delacroix, think it essential to go South and right to Africa? Obviously, because not only in Africa but from Arles onward you are bound to find beautiful contrasts of red and green, of blue and orange, of sulphur and lilac.'[66] Yet van Gogh was never able, or never expressed a desire, to submit his own art and temperament to the exigencies of a radically different culture as Gauguin did. Others of course had done so well before him, but the most they were able to achieve was the absorption of their exotic experience into the naturalistic vortex of the all-powerful European tradition. After the art of Gauguin and the issues it raised the internal self-confidence of that tradition is shaken.

CLAUDE MONET

For Monet the *idea* of the revolution in painting lay not in a global but in an oriental source, the Japanese print. David Bromfield has shown how much that revolution was due to Claude Monet – who found his first Japanese prints in a junk shop in Le Havre in the 1850s. Their influence begins to appear in his work when he began to acquire such prints for himself in the 1860s.[67] With the opening up of Japan, under naval and political pressure from the United States and Britain, Japanese goods became increasingly available from the early 1860s. Japanese art appeared in strength in Paris in the International Exhibition of 1867 and by the 1880s masterpieces of Japanese art of all periods were available, through Parisian dealers such as Bing and Hayashi. Japanese prints and scroll paintings provided Monet with a new version of realism, one not based upon traditional European conventions using drawing and tone to define and enclose pictorial motifs but one based upon a purely

[65] Van Gogh 1959, vol. 3, p. 431.
[66] *ibid.*, pp. 431, 39.
[67] Bromfield 1987.

optical vision that fragmented the old methods of defining motifs by a visible use of brushstrokes and individuated daubs of colour. Brushwork no longer concealed the process of defining motifs but made it visible. The result was an innovatory style depending less upon cognitive and more upon optical vision. Of course this is not to say that Impressionism resulted from the Japanese print. Many other factors, such as the impact of the work of Turner, must be considered in accounting for its appearance, but there need be little doubt that the 'fragmented' character of Monet's motifs after 1865 owes much to his immersion in *Japonisme*.

HENRI MATISSE

Henri Matisse (1869–1954), like van Gogh, was in search of exotic light and exotic methods of formal construction but not the alterity of exotic cultures. And like van Gogh he responded to the desire to move south in search of light more brilliant, and colour richer, more sensuous. Shortly after his marriage in 1898 to Amelie Payrayre at the age of twenty-eight, they spent six months in Corsica and then a second six months in Toulouse, Amelie's home town. Matisse developed a great love of the Midi and spent many summers in Collioure on the French coast a few kilometres from the Spanish border. On his first visit to Collioure he was able to visit Daniel de Monfreid's collection of Gauguin's South Sea paintings. Matisse's first 'pure and characteristic' Fauve canvasses were inspired by the light and colour of Collioure.[68] A visit to Italy in the summer of 1907 confirmed an admiration for Giotto and the Sienese primitives. As with Cézanne, Matisse's avant-gardism is mediated by archaism. In the summer of 1910, having already developed a great interest in Near Eastern art, he travelled to Munich to see the important exhibition of Islamic art assembled by Hugo von Tschudi. It left a profound and enduring impression upon him. In the autumn of 1911, at the invitation of his patron Sergey Shchukin, he visited Moscow where he studied icons. Moscow seemed 'like a huge Asian village'. During the winter and spring of 1910–11 he visited Moorish Spain and worked there. The next winter and spring found Matisse and his wife in Tangier. They wintered in Morocco again the following year. At the time, the French were attempting to 'pacify' the local population. They were largely confined to a grand hotel where 'the atmosphere was pala-

[68] Barr 1951, p. 55.

tial . . . guaranteed fresh flowers, beautiful women, clear skies and blue seas all year round'.[69] Meanwhile the French general, Lyautey, was subduing the Moroccan tribesmen around Fez.[70] In 1930 Matisse travelled to Tahiti. One of the earliest paintings he had ever acquired (in 1898) was a *Head of a Boy* by Gauguin. But in Tahiti he painted nothing, swam in the lagoon and lazed in the night-clubs. 'I realised there that I had no pictorial reaction whatsoever, and there was nothing to do but languish in the thick, cool shadows of the island mountains.'[71] The corals in the lagoons plunged him 'into the inaction of total ecstasy'.[72]

The first painting Matisse ever acquired was a Cézanne from Vollard, and he gained more from Cézanne than from any other artist. From him he learnt how to employ colour to express both space and surface, to respect the 'integrity of the picture plane', and to remain within the figurative tradition of Mediterranean art. Grounded in Cézanne's analyses of light, colour and composition, he succeeded in evolving a personal decorative art apt for western society during the twentieth century. Unlike Cézanne he did not seek to revitalise the naturalistic tradition by returning to classical roots but reached out to the Orient, to Moorish Spain, to Morocco, to Persian textiles and Russian icons, not in order to absorb the nature of the culture from which they had emerged but to further the project central to Impressionism, the exploration and celebration of colour and light, all with a new sense of freedom not to be found in the old European masters. Matisse's exotica is thus an abstracted, universalising exotica that extrudes form, light and colour from its cultural matrix. He became a master in kenosis, emptying out the sacred in his search for the decorative.

One day Matisse saw a small wooden carving of a negro head in a shop window. It reminded him of the 'huge red porphyry heads in the Egyptian galleries of the Louvre. I felt that the methods of writing form were the same in the two civilisations, no matter how foreign they may be to each other in every other way.'[73] Soon afterwards he showed it to Picasso, who was astonished by it. They discussed it at length: 'that was the beginning of the interest we all have taken in Negro art . . . It was a time of artistic cosmogony.'[74] That is to say from the inspiration of oriental and African exoticism

[69] Pierre Schneider, *Matisse*, Paris, 1984, p. 496; quoted in Dahrouch 1993, p. 20.
[70] *ibid.*, p. 17.
[71] 'Matisse Speaks, 1951', transcribed by Teriade; published in Flam 1973, p. 61.
[72] Flam 1973, p. 110.
[73] *ibid.*, p. 134.
[74] *ibid.*

lay the promise of a universal art. Yet it was a universality totally
Eurocentric in its assumptions. 'Matisse travelled the globe as a
tourist; a tourist who in a certain sense never left his mother
country.'[75]

Matisse's central achievement was to take the decorative arts and
place them at the centre of the Formalesque style. He raised Owen
Jones's proselytising of the decorative arts to the status of art in the
special sense. Decoration manifest in the intuitively personal and
expressive use of light, colour and composition was his basic con-
cern. 'Composition is the art of arranging in a decorative manner
the diverse elements at the painter's command to express his feel-
ings.'[76] In this respect Matisse's painting, for all its modernism, lies
at the end of a powerful nineteenth-century tradition of French
pictorial orientalism – Ingres, Delacroix, Decamps, Dinet and
Besnard, to name but a few – an orientalism done over again after
Impressionism. He is the last and greatest master of the exotic,
Eurocentred, picturesque.

It the autumn of 1906 Derain, Vlaminck and Matisse 'discovered'
for themselves in the Trocadero African sculpture from Dahomey
and the Ivory Coast. Their interest was probably stimulated by the
woodcuts and sculptures influenced by Polynesian art which they
saw in the Gauguin Retrospective held in the Salon d'Automne that
year. Derain's *Crouching Man* (1907), perhaps his finest sculpture,
reveals the influence of Marquesan work seen through the eyes of
Gauguin.

Neither the Fauves nor the Cubists were deeply involved in the
occult. They turned to 'primitive' art for its new formal possibilities
for taking advanced European art beyond Cézanne while incorpo-
rating his formal achievements. To do this they had to disembed
African and Oceanian art from its cultural matrix and blend it with
their fascination for the portrayal of light and their passion for the
Japanese print and the oriental decorative arts.

It is of interest to note finally that the Fauves did not become
involved in the cultural *meaning* and significance of oriental art; it
was its decorative forms and colour that concerned them. This is in
sharp contrast to those artists who were inspired by the occult, such
as Kandinsky and Mondrian, for whom the religions of the Indian
sub-continent, as mediated by theosophy, exercised a powerful
influence upon the hidden *content* of their increasingly abstract art.
Perhaps Islam was too much the 'other' of Christianity, as Asia was

[75] Dahrouch 1993, p. 23.
[76] Matisse, 'Notes of a Painter', 1908; quoted in Barr 1951, p. 119.

so powerfully the 'other' of Europe, to be readily appropriated, transformed and aestheticised into the *content* of a European avant-garde art. So oriental form was appropriated but with its religious content suppressed.

5 The creation of the Formalesque

In the previous chapters we have traced the several sources, theoretical, practical, exotic and occult, of the period style I have described as Formalesque. I have argued that it was a late nineteenth-century style, avant-garde from about 1890 to about 1914. It was then the most recent of the many modernisms that emerged as critiques of Modernity from the fifteenth century on and was driven by the ambition to create a world style that was comprehensible in terms of the history and aesthetics of modern European art, a European imperial style universal in its global compass.

By replacing the naturalistic style that had animated European art from the fifteenth to the end of the nineteenth century with a strong preference for formal values, it was possible to encompass not only the ethnic arts of non-European cultures world-wide but also the art of children, the mentally disturbed and the insane. The Formalesque thus put into question the distinction that had developed powerfully in the nineteenth century, under the conditions of industrialism, between the fine and the decorative arts, and between art and craft. I have suggested that this distinction may, theoretically, be traced back to Aristotle. But today the distinction is now irretrievably blurred and in use only as an old-fashioned status symbol or as a marker to distinguish the artefacts to be found in one institution from those to be found in another. So, apart from such bureaucratic needs, it is better abandoned. All human artefacts whether described as craft, decorative or naive are as entitled to be called visual art as architecture, sculpture and painting.

However, it is useful, in order to note the distinctions with which history has endowed them, to describe those European (Renaissance and post-Renaissance) conceptions of art that privilege the fine arts, as art in the special sense, and the more inclusive conception of art (first described by Aristotle) as art in the general sense. The increasing popularity of this latter sense is perhaps the major conceptual achievement of the Formalesque. It has been endorsed recently by the authoritative *Dictionary of Art* (Macmillan, 1996), which gives for the first time in such dictionaries as much attention to art in the general as it does to art in the special sense.

The Formalesque emerged as one of Modernity's modernisms

during the late nineteenth century. But it is no longer a mod-
ernism. It was foreshadowed by the creation of the modern intellec-
tual disciplines of art history and aesthetics. Art history found that
the formal constituents of artefacts, their shape, size, texture,
colour and so forth, provided invariables by means of which they
could be classified systematically and arranged historically. In this it
was fortified by its sibling disciplines, archaeology and anthropol-
ogy. Aesthetics distinguished the way in which artefacts might be
seen as works of art rather than as possessions or utilities. Again it
was the formal constitutents, shape, size, texture, colour, etc., and
the ways they were seen to be assembled within the finitude of the
artefact, that constituted, when seen with disinterest, its aesthetic
value. For both art history and aesthetics it was ultimately irrel-
evant whether the artefact in question was traditionally classified as
fine art or as an artefactual example of art in the general sense. The
formal method could be applied to either with equal value. Both
disciplines thus prepared, from a European perspective, a global
vision, an imperial gaze, that could be directed at any artefact
produced by the incommensurable cultures of the world.

By contrast to these European-based disciplines, the work of the
artists themselves who helped to fashion the Formalesque style was
inspired largely by extra-European, that is to say, exotic practice,
as a result of their enthusiasm for the superior quality of non-
European, crafted artefacts – of art in the general sense – rather
than by works traditionally classified as fine art: 'Etruscan' vase
paintings,[1] Chinese ceramics, lacquer work and patterned silks,
Egyptian jewellery, Indian textiles, Indonesian batiks and African
sculpture. Many, like Delacroix and later Matisse, worked beyond
Europe in the footsteps of generations of artists who had travelled,
in response to imperial expansion, to the Americas, China, India,
the Pacific and Africa, their work lithographed in innumerable
volumes of picturesque topography during the first half of the
nineteenth century. It brought home to Europeans the presence of
unknown worlds of decorative art that the European obsession
with naturalism had largely ignored. So too did the ethnographic
collections, another product of empire, established in the major
cities of Europe. By the end of the century the great gap that had
long existed between the fine and decorative arts was closing; and
the closure was finally institutionalised by the Arts and Crafts
Movement and Art Nouveau.

[1] Flaxman's drawings discussed in Chapter 3 were inspired by Greek vases in Sir
William Hamilton's collection that were then thought to be of Etruscan origin.

Because it privileged form in greater measure than any previous period style and discounted the value of narrative, the didactic, and meaning in art, and was spearheaded by the secular disciplines of art history, archaeology, anthropology, aesthetics, and the informational art of travel, the Formalesque was, in one sense, as secular as it was formal – secular, that is to say, in its forms, but not necessarily so in the meanings it conveyed. For it emerged at a time of great doubt in Europe. Eight years after Darwin published *The Origin of Species* (1859), Matthew Arnold, in *Dover Beach* (1867), heard the 'melancholy, long, withdrawing roar' of 'the sea of faith' as it retreated down the 'naked shingles of the world'. Then in 1892 just as the Formalesque was being brought to birth, Nietzsche announced, much more stridently than Arnold, that God was dead.

But the Formalesque was not embarked on a secular destination. Assuming that Nietzsche's dead god was essentially European, it began searching for a spirituality that was more powerful, more imperial, less bound to local cult rituals and liturgies. Forty years before Nietzsche announced the death of his god, Mrs Hayden, a professional medium from Boston, was able to introduce in Europe a modern form of spiritualism, by table-turning, that spread like wildfire. It was soon followed by other institutionalisations of spirit such as theosophy and anthroposophy.

It was in this disturbed spiritual climate that the Formalesque emerged as an avant-garde style accompanied, like earlier modernisms, by charismatic and paradigmatic masters. In 1890 the symbolist painter Maurice Denis (1870–1943) provided his now famous advice: 'It is well to remember that a picture – before being a battle horse, a nude woman or some anecdote – is essentially a plane surface covered with colours assembled in a certain order.'[2] That as well as any will provide us with a definition of Formalesque painting at the moment of its emergence as an avant-garde style. Denis, himself in search of a new spiritual art, deplored naturalistic art. But why did it linger for so long in Europe?

With a discontinuous history since antiquity, naturalism remained dominant throughout most of the nineteenth century probably because there was still one major genre that had not yet been fully explored in naturalistic terms – that is to say, landscape painting. It is unnecessary to outline here the history of European landscape beyond saying that since the seventeenth century it was the one genre of high art that continued to produce highly innova-

[2] Originally published in *Art et critique* (Paris) (23–30 Aug. 1890); quoted in Chipp 1968.

tive results in terms of an art grounded in perception. There were still naturalistic problems to be solved aesthetically in landscape, and their importance was compounded by the use-value of landscape for Europeans living in colonial situations, in the physical and emotional appropriation of land from indigenous peoples.[3] But by about 1910 landscape in Europe appears to have exhausted its former resources as an art grounded in perception.

If we are prepared to forsake a narrowly European point of view in our historical assessment of late nineteenth-century modernism in favour of a more distanced vision, the long-term trends we have been considering should come more clearly into focus. The particular value of a distanced view, as we reach the end of our millennium, will be to provide late nineteenth-century modernism its rightful place in the history of art, and not diminish it as the 'other' of so-called Postmodernism. This contentious perspective distorts and belittles the aesthetic achievements of the Formalesque. Would it not be better to assess it historically in the terms of its own time and presuppositions and not anachronistically in terms of our own agonistics?

Of course temporal distancing has its problems but is central to the practice of history, part of its stock in trade. It is spatial distancing that offers the greater challenge. It is now a truism that we can only speak from our own situation, our own perspective, our own space and time. But if historians must confront temporal distancing there is no good reason why they cannot confront spatial distancing as well. All this is obvious enough. I repeat it because it is not yet obvious in the normal practice of art historians. We are more provincial in this matter than are most of the human sciences. The problem is a pressing one. To see the world as a unified spatial field is the kind of vision we hopefully (and despairingly) seek to impose upon the United Nations and its staff. Is it not time that art historians sought to cultivate a spatial vision in the form of unified fields that avoid national ideologies? If we attempt this the continuities, rather than the disjunctions marked by successive avant-garde movements, may become clearer. Take for example, the revolution wrought by Picasso and Braque and their followers in the space of a few years between 1907 and 1914, in the creation of Cubism. This is regarded, with virtual unanimity among Eurocentred art historians, as the most radical revolution in art since the fifteenth century, and naturally so, if we view it exclusively from a Renaissance to romanticism perspective. But on a larger view of art it represents, in some powerful respects, a return

[3] See Mitchell 1994, pp. 5–34.

to origins – to quote but a few examples: to Iberian art (Picasso), Romanian folk art (Brancusi), Russian folk art (Kandinsky). It is only to be viewed as a major revolution when viewed against its traditional other, the Renaissance and post-Renaissance tradition of naturalism.

So what happens if we attempt to see the change that took place during the first decade of the twentieth century from a temporally and spatially distanced perspective and not privilege the history of French art in its relation to, and over against, African and Oceanic art? What we see, I would suggest, is a fascinating process of cultural traffic taking place. European art which had, in a sense, detached itself from the arts of the non-European world in its long centuries of devotion to the problems of perception, returned once again to the more normal processes of artistic exchange. As Europe learned, once again, how to borrow radically from non-European art, so the non-European arts began to borrow radically from Europe. A world of, admittedly uneven, free trade in aesthetic appreciation and understanding with all its monumental advantages and disadvantages began to appear upon the global horizon. But Europeanised art history has tended to view only one side of this equation. Obsessed by the vision of non-European art as something timeless, and pure and original in its timelessness, it denied the aesthetic value of the work of indigenous peoples possessed of any traces of what the European critics of the time, steeped as they were in the ideology of primitivism, saw as civilisation's corruptions – that is to say, their own European civilisation. Yet the vision of primitive art as universal and timeless was little more than a mirror image of the art, universal and imperial in its universality, that the Formalesque aesthetic promoted. It was a nineteenth-century vision made possible by Europe's mastery of the world, a mode of inverted racism that disavowed the social Darwinism on which it was grounded.

To what extent is Picasso's *Les Demoiselles d'Avignon*, so often presented as the paradigmatic work of twentieth-century modernism, a late nineteenth-century painting? And in what ways does it herald twentieth-century art? William Rubin in his exhaustive discussion of the painting's sources argues that it 'obliterates the vestiges of nineteenth-century painting still operative in Fauvism'.[4] This is a close-focus view. Such a view will certainly stress, as Rubin does, Picasso's movement from a perceptual to a conceptual way of working: the greater angularity of form, the lack of modelling and

[4] Rubin 1984, vol. 1, p. 253.

the flatness of effect. Yet Gauguin and his friends at Pont Aven had already taken that path. A more distanced view will find continuities not only with the Fauves but with earlier European art. Picasso employs the pinks, blues and rusts that are a feature of much of his own earlier work. El Greco's *Apocalyptic Vision* (1608–14) was available in the Paris studio of Picasso's friend Ignacio Zuloaga; he saw it there constantly and, as John Richardson points out, it played a key role in the conception of *Les Demoiselles*, not only in its size, format and conception, but in its apocalyptic power.[5] A more distanced reading of *Les Demoiselles* would stress both its own, and Cubism's, link with El Greco. This reading is supported by Picasso himself, who said, 'Cubism is Spanish in origin, and it is I who invented Cubism. We should look for the Spanish influence in Cézanne . . . Observe El Greco's influence on him. A Venetian painter but he is Cubist in construction.'[6] And does not El Greco's art itself, in Rubin's own terms, represent a movement 'from a perceptual to a conceptual way of working'? Iconographically *Les Demoiselles* is well known to be deeply embedded in the 'Venus Anadyomene' motif so popular in Salon painting and brilliantly exploited by Ingres and Bouguereau.[7]

Although the Formalesque emerged, as the result of a conjunction of European and non-European modes, as a generic European style, the distinctively national factors that contributed to its development are usually discounted. Though Picasso, like most of the advanced painters of his generation, opposed academic classicism as a young man, he was proud of his Andalusian roots; the first source of his primitivism came from Andalusia with the excavation of archaic Iberian sculpture the influence of which is to be found possibly in the portrait of Gertrude Stein and certainly in the three nudes on the left in *Les Demoiselles*. Despite his radical contribution to the development of Cubism and its consequences for the emergence of a radical international style, Picasso remained very much a part of the European tradition. His *personal* rupture with it was

[5] Richardson 1991, p. 430, and 1996, pp. 15–17. And note Henri Zerner's comment on the exhibition, *Picasso: The Early Years, 1890–1906* at the National Gallery of Art, Washington (1997). 'The current exhibition is a vivid reminder that under the great twentieth-century innovator there always remained something of the nineteenth-century painter' (*Times Literary Supplement*, 1 Aug. 1997).

[6] Romuald Dor de la Souchère, *Picasso in Antibes*, London, 1960, p. 14; quoted in Richardson 1991, p. 430.

[7] For a detailed analysis of the nineteenth-century iconographical sources of *Les Demoiselles* and its imperial implications, see, particularly, Francis Frascina, 'Realism and Ideology: An Introduction to Semiotics and Cubism', in Harrison, Frascina & Perry 1993, pp. 113ff.

never as profound as was Gauguin's. And though it was the influence of Gauguin, particularly his ceramic sculpture, such as *Oviri*, that turned Picasso towards non-European art, he was always 'loathe to admit Gauguin's role in setting him on the road to primitivism'.[8] *Les Demoiselles* exercised, of course, a potent influence upon twentieth-century art, but it is essentially a nineteenth-century influence that led to the establishment of the Formalesque style as the Eurocentred hegemonic style of the twentieth century. What is most characteristic of twentieth-century painting developed in dialectical opposition to *Les Demoiselles* and what it foreshadowed.

Architecture was the art by means of which, more than any other, the Formalesque was conceptually institutionalised, folded over from a modernism as a critique into a celebration of Modernity. As an art form architecture occupies, as Batteux noted, an ambiguous position between the useful and the fine arts. It straddles, on the one hand, the material world in which the power of finance capital is continuously constructed and reconstructed and, on the other, the quasi-autonomous world of fine art. It may be viewed as a function of a Modernity driven by the power of science, technology and instrumental rationality. In the case of the new architecture, the stress on function was compatible with the goals of Modernity, whereas the modernism of sculpture and painting was grounded deeply in an exotism that offered a critique of Modernity. Formalesque architecture became the servant of Modernity since it possessed an imperative, by the nature of its role as a useful art, to translate form into function. It is because of architecture's ambiguity – *of* Modernity while seeking to be self-consciously modernist – that it found itself, as an art, virtually impossible to play a continuing critical role within Modernity, since it was the very art by which Modernity embodied and embedded itself, made itself physically and symbolically visible to the general public, indeed housed itself. This perhaps is why Hegel designates architecture as the first of the arts, because it symbolises for him the beginning of civilisation as expressed in the Tower of Babel and the zigurats of Babylon.[9] And it is Modernity that still assumes, however awkwardly, the mantle of civilisation.

There was but one way in which architecture could express a critique of contemporary society, by creating utopian conceptions of Modernity's immanent future. It is in such cases that we may perceive the role of architecture in the development of the

[8] Richardson 1991, p. 459.
[9] Hegel 1975, vol. 2, pp. 630ff.

Formalesque as a catalyst, because it is the art by which, more than any other, Modernity achieves its empowering visibility, as both a fine and useful art. It provides a bridge, both practical and aesthetic, by which the quasi-autonomous life-world of painting and sculpture can mediate with Modernity. Architecture was the art by means of which Formalesque painting and sculpture learned how to mediate with Modernity, the art by which the modernist critique of Modernity was transformed into its celebration. It provided the aesthetic residence within which members of the avant-garde might become celebrated members of Modernity's establishment.

Perhaps it is for such reasons that architecture possesses no single building as central as *Les Demoiselles* to the creation of the Formalesque style. Nevertheless we may take Adler and Sullivan's Guaranty (now Prudential) Building in Buffalo, New York (1894–96), as an appropriate metonym for the early architectural Formalesque. The building itself, even more clearly than Picasso's painting, indicates its nineteenth-century origins while at the same time foreshadowing the imperial, twentieth-century dominance of the Formalesque as realised in the International Style. The ultimate source of the building lies in the adoption of large-scale iron construction during the Enlightenment, notably in the erection of the first cast-iron bridge over the Severn in 1767 by the third Abraham Darby (1750–1791), followed by the use of iron for skeletal construction in commercial buildings by James Bogardus (1800–1874) in New York and elsewhere in the 1850s, which led ultimately to the construction of skyscrapers in all the major cities of the world. This is the architectural Formalesque's most visible stylistic contribution to Modernity.

Within it lay the traces of the Formalesque's esoteric modernism. Both Louis Sullivan and his most famous pupil, Frank Lloyd Wright, were influenced by theosophy, and the Rosicrucian and Swedenborgian movements. The sources of their interest stemmed ultimately from *Architecture, Mysticism and Myth* (1891) by W. R. Lethaby (1857–1931), which documented the role of sacred geometry, the symbolism of the circle, square cross and triangle, and their use in antiquity as the expression of an hermetic ideal. For Lethaby, modern architecture could only be valid if it assimilated symbolic imagery homologous to humanity's relation to its environment.[10] Lethaby's ideas were communicated to Sullivan and

[10] Less work has been done on the impact of occult and hermetic concepts on the development of modern architecture than for sculpture and painting. But see Proudfoot 1994, pp. 81–91, and Bletter 1981, pp. 23–31.

Wright through the writings of Claude Bragden, the American architect and occult author who published many books on the fourth dimension from 1912 on.

Esoteric influence, as we have noted, by its nature was hidden, visible only to initiates. Architects, like other artists, who dabbled in the occult preferred not to make their interest public, regarding it as a hidden form of inspiration. What was to be made visible was the new interest in form and function, not the hermetic symbolism they might embody. So the Isabel Roberts House, River Forest, Illinois, of Frank Lloyd Wright (1867–1959), completed in the same year as *Les Demoiselles*, may be read as possessing a similar inter-penetration of planes and a similar flexible planning of its inner spaces that are, broadly speaking, characteristic of Picasso's master-piece. Wright's lifelong interest in the fireplace, the hearth, as the heart of the home, also symbolises the profound nineteenth-century origins of his domestic work, a native archaism as the heart of his modernism.

By 1900 Auguste Rodin (1840–1917) was at the height of his international fame. But by 1914 the avant-garde sculptors of Europe had rejected his achievement, viewing it as the last gasp of Renaissance naturalism. They had turned towards the constructed sculpture of Picasso's late Cubism. Although the earliest work of Constantin Brancusi (1876–1957), the pioneering master of early Formalesque sculpture, is naturalistic in the manner of Rodin, it took a strong primitivistic turn after he visited the Gauguin retrospective at the Salon d'Automne of 1906, which included Gauguin's revolutionary carvings. Brancusi turned to direct carving in wood and stone without recourse to a model and produced his *Head of a Girl* and *Kiss* (both 1907). Sidney Geist has shown that by 1913, in such works as *The First Step*, Brancusi was profoundly influenced by African sculpture.[11] In the early 1930s Brancusi denied the influence of *l'art nègre*, as did Picasso, after World War II, on *Les Demoiselles*. Many Formalesque artists were reluctant to acknowledge specific influence, for it violated the concept of the artist as genius who drew only upon the voice of inner (often occult) necessity. But there is little doubt that all the sculptors who contributed to the creation of the Formalesque style were influ-enced, either directly or indirectly, by African and/or Oceanian, and at times Egyptian and Meso-American, sculpture: Jacob Epstein (1880–1959), Alexander Archipenko (1887–1964), Jacques Lipchitz (1891–1973), and Henri Gaudier-Brzeska (1891–1915).

[11] Geist 1984, vol. 2, pp. 346–47.

That is to say, the revolution which took place in sculpture between *c.* 1907 and *c.* 1914 was largely inspired by the indigenous art which Europe had collected, from its colonies.

Because the early Formalesque exercised such a powerful influence upon the creation of an hegemonic, Eurocentric style for the twentieth century, it is difficult to perceive it now from the perspective of its origins and setting. For it is now valued in terms of its twentieth-century presence. Yet what it represents as a whole is an end phase of European culture in a condition of global imperialism prior to the collapse of its innumerable colonies, protectorates and mandates. Viewed from a world perspective, the congeries of modernist *movements* that flourished so vivaciously during the first decade of the twentieth century and collapsed so swiftly after 1960 are witness to the desire to translate European art into a global art suited to the conditions of cultural imperialism.

A close-focus view certainly testifies to a myriad of highly interrelated movements from Art Nouveau to Cubism. Together, viewed generically, they testify to the birth of the Formalesque as a period style. Its leading features may be readily grasped by contrasting art work produced under the aegis of the style with art produced during the nineteenth century up to Impressionism. That of course is what a period style implies, drawing large contrasts from a distanced viewpoint that makes a *longue-durée* visible. Among these features may be noted: a freer emphasis upon form, texture and colour treated as relatively independent entities; an immanent trend towards abstraction; a flattening of the picture plane; a new stress upon the physicality of the work; and its presentation as a concrete material object possessed of its own 'reality' and not as a representation of nature.

The Formalesque reduced meaning to style and style to form. It was the syntagmatic relationships of line, tone and colour that counted in painting. The ur-motif beneath its aesthetic was the creation of a timeless, universal harmony of which the individual creative artist was fount and origin. Although traditional genres of European art, such a portraiture, still life and landscape survived, their independence was continually put into question. Meaning was reduced to a function of the artist's creative powers. Among those who were drawn towards the occult, the interpretation of meaning was hidden or suppressed, for that is what being occult meant. Such artists respected the constituent concept of the occult as hidden wisdom, revealed only to initiates. When, after Sixten Ringbom's seminal article of 1964, the significance of the occult for the hermeneutics of the Formalesque began to be made public, it

came from a disinterested scholar, not from the artists themselves. In any case the Formalesque aesthetic, quite apart from its occult exponents, tended to suppress meaning in the interest of form.

Until the end of World War I the Formalesque style was largely a European phenomenon, one not yet accepted into the mainstream of European culture. The popular view was that it was the product of degenerates, anarchists and Bolshevists, evidence of Europe's spiritual decline. There was little awareness that the Formalesque was emerging as a mode of art admirably suited to cultural dominance on a world scale, an art that, as Meyer Schapiro noted, could trace its origins back, not to European origins only, but to sources from all parts of the world. Its greatest achievements lie in the creation of the International style of architecture and the creation of new genres of art, the abstract arts of sculpture and painting, arts which expressed the personal subjectivity of the artist more intensely and extremely than any of the older genres, such as portraiture and landscape.

The potential globalism of the Formalesque, however, involved a generational disavowal of the visual arts which Europe had made use of, from the fifteenth to the nineteenth century, to dominate the world: the high arts of naturalistic mimesis. At the height of its colonial power, Europe disavowed the visual arts that served such purposes: topographical and picturesque art, monumental portraiture, etc. In future, European art was not to be the grand exception but the rule. By extending the concept of art to the 'crafts' of indigenous peoples, to folk art, the art of the insane, child art, and naive art, the Formalesque avant-garde made its grand gesture towards ubiquity. European art was to become again art in the general sense.

This disavowal not only involved forsaking the mimetic naturalism that Europe had cultivated since the fifteenth century but the rejection of all such art still being practised by conservative artists both within and beyond Europe. European colonies could not have been established without the use of such 'rearguard' art. But the Formalesque decreed it to be either non-art, or art of such low aesthetic quality that it could be viewed as nothing but sad evidence of a *retardataire* or immature culture. For seen from a distance, it becomes clear that the Formalesque, despite its rupture with positivism, still clung to the shadow of a belief in positivistic science. Its practices were grounded in the assumption that the creative artist was compelled to 'make it new', that he or she must appropriate the past and recreate it under the heartless mirror of Modernity. In practice this meant that all art practised in Europe's colonies into

which a post-Renaissance mimetic naturalism had been introduced was, by definition, outdated. Their historic duty and destiny was to catch up with the Formalesque or be consigned to aesthetic oblivion.

Nevertheless the disavowal of the mimetic naturalism inherited from classical antiquity was comparatively short-lived. Gauguin took, despite his expressed intentions, his classicism with him to Polynesia, but none of his own generation and that which succeeded it were keen to live out their lives among 'savages'. As an avant-garde style, the Formalesque will have had its day by 1915. After the 'Call to Order' of the early 1920s, it will be transformed into a dominant style and acclaimed throughout the world. Mimetic art, for its part, will become a revenant ceaselessly changing its shape while clinging desperately to its antique origins.

Part Two

THE FORMALESQUE AND TWENTIETH-CENTURY MODERNISM

6　The origins of twentieth-century modernism

The modernism of the twentieth century does not trace its origins back to Manet and Cézanne. These masters and their epigones constitute the Formalesque that after World War I gradually established itself as the dominant (but no longer avant-garde) period style of the twentieth century. Twentieth-century modernism originated in Europe on the eve, during and after the Great War of 1914–18, and developed in dialectical opposition to the institutionalised Formalesque for the rest of the century. We may witness this opposition emerging under the traumatic conditions of that war, in Dada, the Neue Sachlichkeit and Surrealism.

By 1914 the cultural field within which European artists worked was firmly established as a relatively autonomous world. As we have noted, the establishment of that world had been proceeding (as one aspect of Modernity) since the fifteenth century. Just what began to occur around the time of World War I is probably best understood in terms of the concepts developed by Bourdieu in his brilliant work on the field of cultural production. For Bourdieu, the modern artist works as a privileged member within a cultural field that is itself contained within the dominant field of social, political and economic power, while at the same time 'possessing a relative autonomy with respect to it'.[1] Although the cultural field is itself dominated by the dominant field, it is contained within that field which is 'the dominant pole of the field of class relations'.[2] However, as Bourdieu makes clear, the cultural field maintains its relative autonomy within the dominant field of power by means of a symbolic disavowal of the normally accepted modes of exhibiting and displaying social, political and economic status.

> In the most perfectly autonomous sector of the field of cultural production, where the only audience aimed at is other producers . . . the economy of practices is based, as in a generalised game of 'loser wins', on a systematic inversion of the fundamental principles of all ordinary economies: that of business (it excludes the pursuit of profit and does not guarantee any sort of

[1] Bourdieu 1993, p. 37; and Bourdieu 1996, pp. 183–84, 376–77n17 et al.
[2] Bourdieu 1993, p. 38.

correspondence between investments and monetary gains), that of power (it condemns honours and temporal greatness), and even that of institutionalised cultural authority (the absence of any academic training or consecration may be considered a value).[3]

One of the great values of Bourdieu's concept of a field of cultural production is that it avoids the simplistic use of Marx's distinction between an economic base and cultural superstructure on the one hand, and the tendency on the other, to discredit the primacy of economic needs by conflating them with cultural production.[4] In the former case, culture is reduced to no more than an epiphenom-enon of productive forces (the Stalinist model) when in fact a culture has itself deep roots in the economic and social structure. In the latter case, economic needs and cultural processes are conflated to such a degree as to render their dialectical interaction ineffective. They must be distinguished conceptually if a relatively autonomous cultural realm is to be historically specified. Bourdieu's schema makes it possible to accept the mutual embeddedness of an economy and its culture while also allowing, as Randal Johnson notes, for the recognition of a 'degree of autonomy of a particular field [to be] measured precisely by its ability to refract external demands into its own logic'.[5] Such a logic, as Bourdieu says, entails the consistent disavowal of real power in exchange for the benedic-tions of symbolic power.

It is indicative of the historic strength of the field of cultural production in twentieth-century Europe that it was able to sustain its relative autonomy even at a time when the field of real power on which it ultimately depended was itself deeply threatened by the mass destruction and disintegration of the European social order by the effects of World War I. By that time it had become an eradicable feature of European culture. Yet it was only sustained after a profound transformation of the dominant principles that had gov-erned artistic practice throughout the nineteenth century. Under the extreme pressure of war and the presentiments of war the problematics of form that had come to dominate avant-garde prac-tice in France since the 1860s began to give way to the insistent problematics of meaning.

Bourdieu's link between economy and culture insists upon the linkage being sustained within the terms of a cultural rather than a

[3] *ibid.*, p. 39.
[4] As in my view Raymond Williams does in Williams 1977, pp. 90ff.
[5] Bourdieu 1993, p. 14.

social logic if the relative autonomy of culture is to be sustained. World War I placed the stylistic logic of the Formalesque under severe strain because the precedence of form over meaning was one of the central principles by means of which the Formalesque had established its relative autonomy within the wider field of social power.[6] But the exigencies of war demanded that all aspects of civil society within the warring nations be directed towards winning the war. On the one hand, all cultural activities were pressed into supporting and propagandizing the war effort; on the other (to the extent that the traditional liberties of the European democracies survived the wartime conditions), a cultural space survived within which artists might express their personal feelings about the devastation, human waste and carnage of war. Either way placed the privileging of form as the cardinal principle of the Formalesque under severe threat. Yet such was the resilient autonomy of the realm of cultural production that its basic structure was not destroyed entirely. In consequence, and according to the logic of the relationship between the cultural and the social realm, the Formalesque was radically altered, but survived into the post-war years transformed, institutionalised and no longer avant-garde.

THE GREAT WAR OF 1914–1918

Coming events cast their shadows before. In 1911 Oswald Spengler (1880–1936) began to write his *Decline of the West*, though it was not published until 1918–22. In it he argued that European culture had passed its zenith and entered an irreversible decline. European civilisation rested, in his view, upon an uneasy, brittle surface of profound and bitter national resentment fed by deeper myths and memories of ancient warring tribes. As if to prove his thesis, the Balkans, while he was writing, became the site of increasing tension that culminated in intermittent warfare during 1912–13, the prelude, it was widely believed, to a major conflagration.[7] The fear that began to grip Europe affected its artists whether of the avant-garde or the Academy. It is a classic case of the way in which a relatively autonomous realm was modified by the dramatically changing nature of the dominant social power within which it was embedded. Yet art historians, until recently, paid little attention to

[6] On the suppression of meaning in relation to abstract art, see Mitchell 1989, pp. 348–71.

[7] The civil war in Bosnia-Herzegovina at the end of this century might be cited in further support of his thesis.

the transformation of the Formalesque under wartime conditions.[8] Although the predominance of formal interests was sustained, the style was severely stretched to accommodate the profound emotional stress borne of the experience of war, stress far greater than was present during the first decade of the century. Predictably, it was those modes of the Formalesque, such as Expressionism and Futurism, that sanctioned the discharge of high degrees of emotional tension and the declamation of personal outrage, rather than the more impersonal modes such as Cubism and Neo-plasticism that came into favour increasingly in war-torn Europe.

The new tone was set before the war, in the ambience of the Balkan crisis, by the series of Apocalyptic landscapes painted by the German Jewish artist Ludwig Meidner (1884–1966). During 1912–13 he painted disquietening visions that foreshadowed the carnage to come.[9] Meidner's nightmarish scenes herald the wartime paintings of Franz Marc (1880–1916), Otto Dix (1881–1969), Oskar Kokoschka (1886–1980) and Max Beckmann (1884–1950). These artists are conventionally described as Expressionists, a vague term that is used in a number of ways: normatively, to describe the peculiar characteristics of Germanic art since the Middle Ages; generically, to define the basic qualities of modernism;[10] and more specifically to point to the general character of Germanic and Nordic modernism.[11] What is relevant in our context is that the 'moods of anxiety, frustration, discontent, mockery, rejection, exclusion and resentment towards the modern world'[12] that became common to so much twentieth-century art were charged powerfully by wartime experience. But, significantly, for artists trained in the skills and aesthetics of the Formalesque this did not mean a return to the nineteenth-century realism of a Goya, Géricault or Courbet. Their sense of personal outrage, stemming from a power beyond the formal fields of art, was nevertheless expressed within the distended parameters of the Formalesque style. That this was so may be taken as exemplary of Bourdieu's contention that the relative autonomy of the modern art world,

[8] Richard Cork's book *A Bitter Truth* (Cork 1994) has done much to redeem the situation.

[9] On Meidner, see Cork 1994, pp. 13–17; Whitford 1972, pp. 54–59; and *The Apocalyptic Landscape of Ludwig Meidner* (exh. cat.), ed. C. Eliel, Los Angeles, Los Angeles County Museum of Art, 1989.

[10] For example, by Cheney 1934.

[11] An excellent survey of the connotations of the term for modern art historical discourse is contained in the article by Harold Osborne on 'Expressionism' in *The Oxford Handbook to Twentieth Century Art*, 1981.

[12] *ibid.*, p. 180.

though affected by the field of primal power within which it is embedded, is not affected directly by that power but according to its own aesthetic logic. It is also exemplary of the fact that the Formalesque style possessed great resilience and flexibility in response to external circumstances in colonial and neo-colonial situations, where Expressionism became one of the most popular modes of the Formalesque during its hegemony for the expression of anxiety, discontent and social protest.

The Formalesque could also be stretched in support of the war itself. A very large number of the young men who served on both sides went into the war with a sense of relish and excitement. They had been taught to believe that war was a form of purification. For many the inspiration was Friedrich Nietzsche (1844–1900) whose *Thus Spake Zarathustra* (1883–85) had become essential reading for artists around the turn of the century; its heady rhetoric succeeded in dazzling and befuddling a generation of youth.

> My brothers in war, I love you thoroughly; I am and I was of your kind. And I am also your best enemy. So let me tell you the truth . . . I know of the hatred and envy of your hearts . . . You should have eyes that always seek an enemy – *your* enemy. And some of you hate at first sight. Your enemy you shall seek, your war you shall wage – for your thoughts. And if your thought be vanquished, then your honesty shall still find cause for triumph in that. You shall love peace as a means to new wars – and the short peace more than the long. To you I do not recommend work but struggle. To you I do not recommend peace but victory.[13]

Futurism was the Formalesque mode which accommodated itself most readily to the glorification of war. This is not surprising, for it was also the mode that identified itself most completely with the technological character of Modernity, a mode of social organisation that has notoriously made its greatest technological advances under wartime conditions. Futurism's critique of Modernity took a utopian turn. The problem with Modernity was that it was not modern enough. Marinetti's Futurist manifesto (1909) reads like a footnote to Nietzsche. 'We will glorify war – the world's only hygiene – militarism, patriotism, the destructive gesture of freedom-bringers, beautiful ideas worth dying for, and scorn for women.'[14]

Although the Futurists worked within the style code of the

[13] 'On War and Warriors', in *Thus Spake Zarathustra*; quoted in Kaufmann 1971, pp. 158–59.

[14] Quoted in Harrison & Wood 1992, p. 147.

Formalesque, they interpreted its formalism dynamically, in Bergsonian terms, as visual metaphors of change, movement, speed and power. Although their finest and most characteristic achievements, such as Boccioni's *Funeral of the Anarchist Galli* (1910–11), were completed before the war, they vociferously supported Italy's revocation of the Triple Alliance and its active intervention on the side of Britain and France, seeing the defeat of Austria as essential for the completion of the unification of Italy. This is admirably illustrated in Marinetti's collage *Parole in liberta* (*Irridentismo*) (1914–15). After Italy declared war on Austria on 24 May 1915 the art of all the Futurists began by expressing their patriotic support of the war. Gino Severini (1883–1966), for example, featured the modern weapons of war in a celebratory fashion in his *Plastic Synthesis of the Idea 'War'* (1915). But by 1916 those who were still alive were reassessing their attitudes. Between February and June 1916 the French and German armies lost half a million men between them in the attack upon and defence of Verdun. Boccioni died in service in August; Antonio Sant'Elia (1888–1916), the young, highly talented Futurist architect, in October. Even in the work of Giacomo Balla (1871–1958), perhaps the most loyal of them all to the principles of Futurism, patriotism began to give way to grief as the carnage of war dragged on; his *Battleship + Widow + Wind* (1916) is flooded with a dispirited melancholy.

Although World War I stretched the Formalesque in the direction of a grotesque and revitalised realism in German Expressionism and towards a frenetic patriotism in Italian Futurism, the controlling privilege given to form – to line, tone and colour as the dominant constructive components of art – was never seriously challenged. The formal autonomy universally accepted by the avant-garde was sustained. Whereas the early avant-garde, pre-war Formalesque, from Cézanne to the Cubism of Picasso and Braque, is dominated by a distanced respect for the classic, the wartime Formalesque of Expressionism and Futurism reasserts the romantic component always present in the generic style. However, a more serious challenge had begun to emerge in the years preceding World War I.

The Formalesque had, as we have seen, sought to discredit mimetic naturalism in the search for a universal aesthetic code, and in the work of masters such as Kandinsky, Kupka and Mondrian to escape from the mimesis of naturalism altogether. Yet the works of the Formalesque avant-garde continued to be read in terms of semblance, and the traditional genres (despite all the emphasis placed on deformation) – portraiture, landscape and still life –

continued to retain their categorical and mimetic distinctions. Even in the most non-representational work, meaning was rarely intended to be ambiguous: a line was a line; a tone, a tone; a colour, at most the particular nuance of a colour. The Formalesque did not indulge in ambiguities of visual hermeneutics. Meaning, if not repressed, was discounted, considered to be a non-aesthetic supplement as the Formalesque aspired towards a global aesthetic. The marks placed on canvas, moulded into clay or scraped onto stone were not intended to be read as problematic, linguistic signs, but to be seen with an innocent eye and as related to the other marks in the visual field.

THE INVENTION OF COLLAGE

Picasso's invention of collage in 1912 problematised that kind of formal vision. Already in *Les Demoiselles* (1906) he had used African masks in order to escape, from the constraints of semblance, into the new compositional freedoms of solid and void, straight and curved, transparent and opaque. As Christine Poggi has noted, 'In his work with collage, these oppositions would be expanded to include figure and ground, the machine-made and the hand-drawn, the visual and the tactile, and the literal and the figured.'[15] But in this regard collage did no more than extend the technical domain of the Formalesque. What is more significant is that collage reintroduced, within the quasi-autonomous world of high art, and by, as it were, the back door, the problematics of meaning, which had been suppressed in the aesthetics of the Formalesque.

At the root of that aesthetic lay the assumption of the innocent eye – an eye that sees shapes, tones and colours without the mediation of cognition – the assumption that vision is prior to language. This assumption was called into question, though indirectly, by the work of Ferdinand de Saussure (1857–1913), the most influential linguist of the nineteenth century. His *Course in General Linguistics* (1916) was not written by himself but reconstructed from his lecture notes by two of his students.

During the hegemony of the Formalesque, collage was interpreted as a crucial technique in the development of the style. Clement Greenberg, for example, first in 1948 and later in 1958, wrote detailed critical analyses of the use of *papier collé* in formalist terms: 'collage as employed by the cubists always emphasised the

[15] Poggi 1992, p. xii.

identity of the picture as a flat and more or less abstract pattern rather than as a representation; and it is as a flat pattern that the cubist *papier collé* makes itself primarily felt and enjoyed'.[16]And in 1958, 'the surface was now *explicitly* instead of implicitly indicated as a tangible but transparent plane.'[17]

Saussure's linguistics raises a major problem for interpretations of collage based upon Greenberg's assumptions. For Saussure, language (*langue*) was a structured social code. Speech (*parole*) was created from words available to the speaker in the language available to him or her at the time. Words are verbal signs, either spoken or written, and thus material phenomena, but that which words refer to are not material but conceptual (i.e. signifiers). Furthermore, the relationship between a sign and its signifier is arbitrary. For example, there is no resemblance or logical relationship between the word for *air* and what it refers to. Indeed we can't tell what it refers to unless we understand English and the context in which the word is mentioned. That is to say, sign and signifier together evoke a referent which is absent. It is this referent that must be supplied by the listener or reader, for neither sign nor signifier refers directly to a specific referent. He or she must decide, for example, if *air* is mentioned, whether it refers to, say, 'mountain air', 'a confident air', or an 'air on the G string'. The word 'air' then possesses a linguistic *value* that incorporates all such meanings but does not, in itself, possess any meaning. The meaning of *air*, in any specific context, can only be established by its difference in a context from its other possible meanings.[18]

However, there is an initial problem in applying Saussure's concepts to visual art. Whereas the word 'river' bears no resemblance to a river, the sign for a river in the visual arts usually bears some resemblance, even if a slight one, however conventionalised it may be. That is to say, visual signs, as distinct from verbal signs, are usually to some degree transparent.

Cubism had already challenged several of the long-standing conventions of mimetic art, such as the centrality and unity of the human figure, and painting as a consistent, three-dimensional illusion. With collage it challenged an even more fundamental assumption, the cognitive transparency of visual signs. Shapes,

[16] Greenberg 1986, vol. 2, p. 261.

[17] *ibid.*, vol. 4, p. 62.

[18] Since the 1960s several art historians and critics have applied Saussure's structural linguistics to Picasso's and Braque's use of collage: Pierre Dufour (1968), Jean Laude (1971), Leo Steinberg (1976), Pierre Daix (1980), Rosalind Krauss (1980, 1981), and Christine Poggi (1992).

colours and tones were no longer to be read directly as objective references to things in the real world but as signifiers that could only be translated in terms of their two-dimensional or three-dimensional visual syntax, and against a play of absence and difference among possible resemblances.

In a penetrating analysis of Picasso's use of collage, Rosalind Krauss contends that he deployed the visual sign on Saussurian lines 'as substitute, proxy, stand-in for an absent referent'. She draws attention to the f-shaped violin sound holes that are inscribed on work after work of Picasso's from 1912 to 1914.

> The semantic interpretation of these fs is that they simply signify the presence of the musical instrument; that is, they label a given plane of the collage-assembly with the term 'violin' . . . But there is almost no case from among these collages in which the two fs mirror each other across the plane surface. Time and again their inscription involves a disparity between the two letters, one bigger and often thicker than the other. With this simple, but very emphatic, size difference, Picasso composes the sign, not of violin, but of foreshortening: of the differential size within a single surface due to its rotation into depth. And because the inscription of the fs takes place within the collage assembly and thus on the most rigidly flattened and frontalised of planes, 'depth' is thus written on the very place from which it is – within the presence of the collage – most absent. It is *this* experience of inscription that guarantees these forms the status of signs.[19]

We do not know whether Picasso had any knowledge of Saussure's linguistics. It is just possible that an awareness of his theories may have reached some members of *La bande Picasso* who drifted in and out of the Bateau Lavoir between 1904 and 1912. Saussure taught comparative grammar at the École des Hautes Études, Paris, from 1891 until 1901 – Picasso made his first trip to Paris late the year before. Saussure taught general linguistics at Geneva from 1907 to 1913. It is possible that some of his ideas may have reached Picasso indirectly; but having regard for Picasso's general contempt for theory, it is most unlikely that he would have had much patience with it. And Saussure's *Course in General Linguistics* was not published until 1916. It is better therefore to see the link between Picasso's *papiers collés* and Saussure's linguistics as a cultural homologue. At a time when Saussure directed attention to the free play of the sign in its signifying process, Picasso's visual marks and

[19] Rosalind Krauss, 'In the name of Picasso', in Krauss 1986, p. 33.

assemblages were beginning to convey intrinsic *verbal* information best interpreted in terms of difference. Here then was a direct challenge to any aesthetic that privileged form as a system of transparent relations drained of meaning.

Krauss interprets Picasso's use of collage around 1912 as 'the threshold of a postmodernist art', quoting Wölfflin when he speaks of 'a formal decay in art, a death of the feeling for form'.[20] Was that then already happening to the Formalesque? Though it flourished long after 1912 as a dominant style, there are early forebodings that around 1912 it is ceasing to envisage the new dialectical situation now appearing in European art.

Picasso's collage also testifies to a return to meaning in a more direct way. Francis Frascina has drawn attention to the fact that in his *La Suze* (1912) collage he makes use of newspaper cuttings from *Le Journal* of 12 and 17 November 1912 that provide horrifying accounts of the Balkan war. Picasso positioned these accounts upside-down when pasting them on the composition but placed an account of a huge pacifist demonstration against the war the right way up enabling it to be read easily. May we not then interpret these positionings as a social comment of the anarchist Picasso upon the vicious upsidedownedness of warring Modernity? It seems a reasonable conclusion.[21] Furthermore, it is of interest to note that it is the Balkan Wars of 1912–13 that stimulates here, as in the case of Meidner, the expression of social concern within the stylistic parameters of the Formalesque. Coming events cast their shadows before.

Although there is no evidence that Picasso was aware of Saussure's theories, there is some indication that the 'linguistic turn' in his collages is a function of his interest in African art. Fernande Olivier, Picasso's mistress during his years at the Bateau Lavoir, and a friend, Francis Carco, both report that a French naval officer told Picasso how he once showed a tribe of Africans that produced sculpture a photograph of himself. One of them, who took it, could not understand it at all. When it was explained, the man laughed and then took paper and pencil and drew a portrait of the officer – head, body, legs and arms in the traditional tribal style – and showed it to the officer. He then took it back again to add to the man's uniform the shiny buttons that he had forgotten to draw, and then he surrounded the face with buttons. He put the officer's stripes at the side of his arms and over his head as well. After that,

[20] *ibid.*, p. 38.
[21] Harrison, Frascina & Perry 1993, pp. 92–94.

Olivier reports, 'a lot of curious things turned up in the cubist paintings'. Carco described its affect on Picasso: 'Astonishing discovery! The dissociation of objects was discovered, admitted, acquired, and this must have inspired Picasso in his very first researches because he decreed a short while later "If you paint a portrait, you put the legs on the canvas separately." '[22] So whereas Expressionism and Futurism stretched and distended the Formalesque expressively, collage began to subvert it hermeneutically. It was left to Dada to challenge it head on. It is a significant distinction. There is no firm evidence that Picasso ever intended his collages to be read in a 'Saussurian' fashion. But even if such interpretations are intrinsically anachronistic, they are revealing. An artist may work consciously within the constraints of a dominant style, in this case the Formalesque, and at the same time be subject to pressures of which he or she is not consciously aware, pressures that leaves visible traces in the work itself. Schelling had already asserted that in the nineteenth century. Saussurian linguistic analysis probably first became available to the visual arts in the 1920s with the Russian Formalists. Nevertheless there are grounds for concluding that the 1912–14 collages of Picasso reveal the first, virtually unconscious, appearance of a new oppositional system at work within the Formalist aesthetic.

DADA

What is latent and subliminal in the 1912–14 collages of Picasso emerges as a declarative programme with Dada. To what extent then may Dada be taken as marking the presence of a major disjunction between the Formalesque and twentieth-century modernism? To what extent is it possible to install a radical break between late nineteenth-century modernism and the modernism of the twentieth century, the modernism still called Postmodernism?

History, viewed as the past abyss of time, is, as we have noted, a seamless webb. Historians make use of periodic disjunctions pragmatically to distinguish between their own significant themes and trends. Most are well aware that there are bridges across, secret passages through all the breaks they choose to make in their accounts; they know that cast-iron *epistemes*, those 'epistemological' cracks that would detach one historical period totally from another

[22] The stories are recounted in Poggi 1992, pp. 50–51.

are little more than structural (and 'structuralist') devices. That
being so, it is salutary to recognise that all the significant artists who
participated in Dada whether in Zurich, New York, Berlin or Paris
had strong personal links with the Formalesque. There is little
to distinguish the Dada soirées at Zurich during World War I, as
Haftmann, Martin and others have noted, from the Futurist per-
formances that had taken place all over Europe since 1912.[23] Dada
manifestos and posters, the use of photomontage and the phonetic
poem all find precedents in Futurist practice, and Dada's extensive
use of collage, of course, originates in Cubism.

Nor was it only at the level of form that there was a carry-over
from the Formalesque to twentieth-century avant-garde mod-
ernism. The occult, as we have noted, sought to endow the
Formalesque style with universalist, transcendental meaning, and a
profound interest in the occult was carried over into twentieth-
century art not only as the Formalesque transformed itself into the
dominant style of the first half of the twentieth century but also, as
we shall see, into Dada/Surrealism, which provided the basic oppo-
sition to the dominant Formalesque.

Nevertheless a case may be made that Dada inaugurates a
twentieth-century modernism which differs radically from the
late nineteenth-century Modernism instituted by Cézanne, Manet
and Gauguin. The break is implicit in Tristan Tzara's comment, 'The
beginnings of Dada were not the beginnings of art but of disgust.'[24]
For the Dada groups were the first to denounce Formalesque art as
an institution, to begin the deconstructive performance Peter
Bürger calls the distinctive role of the 'historic avant-garde'. How-
ever, in so doing they made possible the revival of a concept of art
that sought to end the distinction between art and life, that art,
in the special sense, inscribed. Although Dada's origin lay within
the relative autonomy of the European art world of the nineteenth
century, and derived its modes of protest from within the formal
structures already established by the Formalesque, it drew its blas-
phemy, its sense of outrage, and its ironic comedy and passionate
conviction from the wartime situation. The horrific carnage of
1914–18 endowed Dada's nihilism with an all-powerful imperative.
In Dada, changes within the world of art and beyond it in the field
of naked power coalesce. The Dadaists attacked art as an institution
because it had for them in fact already collapsed in the chaos of war.

[23] See Werner Haftmann's Postscript to Richter 1965, p. 217; and Martin 1968, pp.
134ff.
[24] 'Conference sur Dada', Weimar Congress, 1922; trans. in Motherwell 1981, pp.
246–51.

So too, at least in their eyes, had the economic and political structures that supported it. Their markets, their traditional life-styles, had been taken from them. The only hiding places the societies into which they had been born now provided them were the trenches. Dada was not a style like Fauvism or Cubism, it was an attitude, a frame of mind *directly* induced by war; yet its particular codes of expression could only be determined by what the pre-war world of art had to offer. For art develops out of its own logic, despite the fact that that very logic is itself determined by the morphology of the culture to which it is affiliated and owes its being.

Art in the special, European, sense, as it had been evolving since the fifteenth century, was challenged by artists who had been trained in that tradition. Although they were only half aware of it, they were promoting the revival of an older concept of art that made no significant distinction between the practice of art and the practice of life as described long before, as we have noted, by Aristotle. In Dada's deconstruction of the European institution of art lay the potential of a new twentieth-century concept of art.

The story has often been told, but the implications largely ignored. Dada is still viewed in conventional histories of modern art as a hiccup, an involuntary spasm, in a history of a modernism that begins with Manet and Cézanne and proceeds down to the present time. Such a view suppresses the oppositional forces that flowed from Dada as so many lost causes, as late nineteenth-century modernism was re-established and institutionalised following World War I. It was still possible as late as 1944 for Clement Greenberg to describe Dada as 'artificial nonsense'[25] and for William Rubin, in 1968, to describe it as 'moribund' after 1924.[26]

It cannot be dismissed so easily. Though anti-rational and predicated upon chaos, it was pregnant with the culture of the twentieth century. Tristan Tzara (1896–1963), the Romanian poet who edited the periodical *Dada*, wrote, 'I smash drawers, those of the brain and those of social organisation . . . Dada means nothing . . . Art falls asleep . . . Art – a parrot word – replaced by Dada . . . Art needs an operation. Art is a pretension, warmed by the diffidence of the urinary tract, hysteria born in a studio.'[27] He spoke as an expatriate, sheltering in Zurich, that soft eye in the storm of war.

Peter Bürger contends that this was the first occasion upon

[25] Greenberg 1986, vol. 1, p. 225.

[26] Rubin 1968, p. 61. I myself, critical of the manufacture of neo-Dada ready-mades for the art market, proclaimed Dada 'as dead as the dodo' in the Antipodean manifesto (Aug. 1959).

[27] Quoted from Richter 1965, pp. 34–35.

which art as an institution had been attacked: 'art enters the stage of self-criticism . . . Dadaism, the most radical movement within the European avant-garde, no longer criticises schools that preceded it, but criticises art as an institution.'[28] But this is a foreshortened view. It was not the first time that art as an institution had been attacked. Fifty years before Dada, William Morris had attacked art (in the special sense) as an institution even more effectively and continuously than any Dadaist. 'These arts [architecture, sculpture and painting]', Morris wrote, 'have been the handmaids of luxury, of tyranny and of superstition . . . I do not want art for a few, or freedom for a few . . . [R]ather than the wheat should rot in the miser's granary, I would that the earth had it, that it might yet have a chance to quicken in the dark.'[29] The weakness of Bürger's argument is that he does not view the institution of art historically. Art as an institution was developing its own forms of autonomy from the fifteenth century onwards. The early critiques levelled at this cultural institution should not be conceived, as Bürger does, merely as one *school* of art criticising a previous school but rather as successive critiques of art's historic forms of institutionalisation. How else may we explain the emergence of art academies in opposition to the medieval guilds and, later, the rise of technical art schools in the nineteenth century in opposition to the teaching of the academies, and the emergence, distinct from private collections, of public art museums and galleries?[30] The great significance of the Dada critique is, in a sense, not that it was the first but that it was the most recent and most theatrical. And on Bürger's own account of the matter the Dada critique was little more than a brief but brilliant failure. The institutionalisation of art has continued to proceed relentlessly despite Dada and its greatest, most consistent exponent, Marcel Duchamp (1887–1968).

Nevertheless Dada is of crucial importance in our present context. Whereas Post-Impressionism, Fauvism, De Stijl, Cubism, Expressionism, and the like, had been avant-garde *movements* successively critical of each other *within* the Formalesque, Dada developed a radical critique of the Formalesque itself, the generic style to which they all belonged. That is why it should be seen as the primal, though not exclusive, source of twentieth-century modernism.

[28] Bürger 1984, p. 22.
[29] William Morris, 'The Lesser Arts', delivered before the Trades' Guild of Learning (4 Dec. 1877), and published in Morris 1889, pp. 6, 35.
[30] See for example Nikolaus Pevsner's pioneering *Academies of Art*, New York, Da Capo Press, 1973 (originally published in 1940).

DUCHAMP AND DADA

Viewed from this perspective, Duchamp is the paradigmatic figure for twentieth-century modernism as Cézanne and Manet are paradigmatic for the Formalesque. Gauguin's primitivism, as we have seen, held an early promise of a world art for the twentieth century, a potentiality never fully realised within the parameters of the Formalesque. For the universality that it achieved was a Eurocentric universality grounded ultimately in Cézanne's classicism – a universality of form, inspired largely by syncretic spirituality and performed by socially accredited shamans.

Dada attacked the universalist assumptions of the Formalesque. After Dada, innovative art becomes heterogeneous and is locked into an oppositional dialectic with the Formalesque as the latter is steadily transformed into the dominant style of the first half of the twentieth century. By asking the question 'what is the meaning of art and what is its use', Dada reasserted the whole question of meaning not only about the forms art takes but about the meaning *in* art which the Formalesque had suppressed, as it privileged style as form. Duchamp articulated the critique by provocatively questioning with his own work the status of painting and sculpture and by implication the cultural status of painters and sculptors. 'I wanted', he said, 'to get away from the physical act of painting. I was much more interested in recreating ideas in painting.'[31] As is well known, in 1913 Duchamp fastened a bicycle wheel to a kitchen table; a little later he bought a cheap oleograph of a winter landscape, added two small dots, one red, one yellow, and called it *Pharmacy*; in 1917 he bought a snow shovel at a hardware store and called it 'in advance of the broken arm'; and to the first exhibition, that same year, of the Society of Independent Artists (New York), of which he was a founder-member, he submitted a urinal which he had purchased and signed 'R. Mutt'. When it was rejected he resigned from the Society.

Many critics have noted how Duchamp's visual provocations, his metaphysical nihilism (to which he said, 'I am still very sympathetic'),[32] anticipate much of the art of the 1960s such as Pop Art, Anti-art, neo-Dada, Happenings, Conceptual Art, Assemblages, Installations, etc. So he is frequently seen as a precursor of Postmodernism. Ihab Hassan, the critic, who has as good a claim as anyone for inaugurating the postmodern literary discourse during

[31] Quoted from Chipp 1968, p. 393.
[32] Quoted from 'Painting . . . at the Service of the Mind', in Chipp 1968, p. 394.

the 1960s, describes him as 'the ironic apostle of postmodernism'.[33]
Rosalind Krauss has examined Duchamp's deep involvement with
semantic puzzles, citing his painting *Tu m'* (1918) as a 'panorama of
the index' – taking 'index' here in the sense given it by C. S. Peirce
as that kind of sign in which there is a *physical* link between it and
its signified. For example, a shadow is an index of the angle of
the sun. In the case of Duchamp's *Tu m'*, his own ready-mades, the
bicycle wheel, the hat rack, and a corkscrew, are projected onto the
canvas by means of cast shadows, indexical traces of their originals.
Krauss notes that the paintings of Duchamp's early career from
1903 to 1911 are largely autobiographical. It is only at the end of
this series, in *The Sad Young Man*,

> do we find that directness swamped by the adoption of a cubist-
> informed pictorial language, a language Duchamp was to con-
> tinue to use for just six more months, and then to renounce,
> with a rather bitter and continuing series of castigations, forever.
> It was as if cubism forced for Duchamp the issue of whether
> pictorial language could continue to signify directly, could pic-
> ture a world with anything like an accessible set of contents. It
> was not that self-portraiture was displaced within Duchamp's
> subsequent activity. But only that the project of depicting the self
> took on those qualities of enigmatic refusal and mask with which
> we are familiar.[34]

One way of escaping the dilemma was by means of photography.
Krauss describes how in his major work the *Large Glass* the motif of
'sieves' are coloured by dust that had been allowed to fall on the
glass surface of the work over months. Man Ray photographed the
dust and both Duchamp and Ray signed the photograph; it thus
became the material index of the passage of time.[35] In such works
and by such devices Duchamp foreshadowed what became a cen-
tral interest to much of the art of the 1970s, the visual mark not as
semblance but as sign.

That Duchamp is a precursor of so-called Postmodernism is now
widely accepted. The full implications are not. Duchamp's art is
witness to a major break with the Formalesque and constitutes a
paradigmatic model for twentieth-century modernism. Despite this
there was still much that bound him to art as an institution. He
could not escape from it any more than William Morris could
escape it – though both championed art in the general sense in

[33] Hassan 1987, p. 216.
[34] Krauss 1986, p. 202.
[35] *ibid.*, p. 203.

opposition to art in the special sense – Morris explicitly, Duchamp implicitly. Perhaps no one better than Duchamp exemplifies Bourdieu's brilliant formulation of the 'inversion' of symbolic, cultural capital that is involved in the establishment of reputation within the art world, 'a systematic inversion of the fundamental principles of all ordinary economies'.[36] At least Duchamp played it out with integrity. For he was content to remain within the art world and patiently explain to generations of admiring critics and commentators his own views, above all that he wished art to turn to 'an intellectual expression'. Though he stopped painting, having no wish to be *'bête comme un peintre'*, with *Tu m'* painted at the age of thirty-one, he did not spend the rest of his life playing chess, at which he was adept, but continued to work hermetically for twenty years (1946–66) on *Étant donnés*, his last installation.

Duchamp's art constitutes a powerful rejection of the purely formal aspects of the Formalesque but not the esoteric meanings by means of which so many Formalesque artists from Georgiana Houghton to Mondrian justified their practices. John F. Moffitt has demonstrated that from the time he painted the portrait of his friend Ramond Dumouchel in 1910 to his last great work, *Étant donnés*, Duchamp was deeply interested in the occult, particularly the idea of the fourth dimension and alchemical practices.[37] What we witness, as the Formalesque aesthetic is confronted and disparaged increasingly by Dada/Surrealism during the early twentieth century, is not a cessation of occult interest but rather its transformation from theological forms of the transcendent, as in theosophy and anthroposophy, to a more securalised occultism which gained credence and support from fashionable scientific and pseudo-scientific concepts such as the belief in ether, the discovery of Röntgen rays and relativity, and Freud's formulations about the nature of the unconscious. New scientific hypotheses fed and supplemented occult beliefs.[38] Duchamp, like Gauguin, enacted, in and by his life, his aesthetic beliefs, and, like Gauguin, believed that the artist was a medium, a kind of shaman. Perhaps that is why he described himself as a *respirateur*, 'a mechanical apparatus seeking to clarify the fetid air of Modernity'. Yet he was content to stay comfortably within the semi-autonomous institution of art, as it

[36] Bourdieu 1993, p. 39.

[37] See Moffitt 1986, pp. 257–71, and Moffit 1996, pp. 1–13. In the latter, Moffitt establishes beyond reasonable doubt that the iconography of *Étant donnés* is based upon a tale told by a traveller in search of Hermetic Wisdom that is recounted in the *Musaeum Hermeticum reformatum et amplificatum* (1677).

[38] On *Étant donnés*, see also Mitchell 1974, pp. 84ff.

reconstructed itself after World War I, an elitist and superb crafts-
man who spurned craft. The art world lionised him, and continue
to puzzle over the meaning of his assemblages and installations in
the way literary critics puzzle over Joyce's *Finnegan's Wake*. By
rejecting art he became his own art institution. In 1968 an exhibi-
tion to honour him was held in Paris on his eightieth birthday, the
year of his death. Duchamp continued to play the role of the artist
as shaman to Modernity. It was a cherished convention that the
new modernism of the twentieth century clung to as firmly as did
the Formalesque.

Even though Dada may now be seen as representing a major
break between the art of the nineteenth and twentieth centuries, it
would be misleading to present it as an epistemological break. It
is to be seen rather as a rupture within which Dada emerged as a
new oppositional force within the realm of Modernity, as the
Formalesque transformed its avant-garde, nineteenth-century role
into a dominant twentieth-century one. By means of their experi-
ments with chance and accident in the composition of poetry,
collage and painting, Tzara, Arp, Schwitters, Richter, Picabia and
Duchamp, among others, introduced a novel element into modern
art that was in fundamental contradiction to the aesthetics of the
Formalesque.[39] For even though the unconscious was a recognised
factor among romantics, at least since Schelling, Formlesque art *per
se* was a highly self-conscious practice that left little to accident.
Indeed the Formalesque may now be seen as a reconstruction of art
based on the classical model of beauty, as expressed idealistically by
Plato in the *Philebus*, phenomenologically by Kant in his *Critique of
Judgement*, and positivistically by Greenberg in his life-long defence
of the autonomy and self-containedness of art.

However, the use of chance by Dadaists did not mean that the
Formalesque style was no longer a powerful factor in their actual
practice. That is how they had been trained and how they contin-
ued. Generically, the paintings, sculptures and textiles of Hans Art
and Sophie Tauber, created in Zurich, are stylistically Formalesque
work. What is new is the Dadaist nihilism from which it emerges.
Some Dadaists like Tzara, Duchamp and Picabia expressed that
nihilism more strongly than others like Arp, Janco and Richter. A
persistent dialectical interchange between nihilist theory and
Formalesque practice took place within all the Dada groups of
Europe. In the realm of practice, we need to remind ourselves
constantly, even systemic breaks occur gradually. What Dada

[39] See Richter 1965, pp. 50ff.

heralded at the beginning of the century was a renewed engage-
ment between the rival concepts of art in the special European sense
and art in the general sense; but it was articulated in Dada as an
attack upon high art. An older and more fundamental conception of
art was re-emerging to oppose a conception grounded in the profes-
sional status of architects, sculptors and painters that had, over the
centuries, created a quasi-autonomous realm within civil society.
This opposition is continuous and fundamental to any understand-
ing of the nature of twentieth-century modernism on a world scale,
and was fought on many fronts. But in practice, as distinct from its
vociferous, nihilist theory, Dada emerged gradually – at times al-
most imperceptibly. The re-emergence of Gothic(k) architecture in
Europe affords an interesting comparison. In this case historians
have experienced difficulty in deciding just what may be described
as Gothic survival and Gothic revival – for the transformation
emerged almost imperceptibly as an element in changing taste.

Dada then did not destroy art, despite the ecstatic gestures of its
devotees gathered in the cabarets of Zurich, Berlin and Paris. But it
heralded a systemic transformation. Whereas the Formalesque aes-
thetic ultimately privileged the classical dictum, recycled by Roger
Fry,[40] who said that the goal of art was order in variety, twentieth-
century modernism, under the initial aegis of Dada, began to
privilege the fragmentation of content and the juxtaposition of
accidental associations. Whereas the Formalesque had privileged
form, art after Dada, paradoxically, by proclaiming that art pos-
sesses no meaning, began to privilege the meanings in art, the
meanings with which readers and viewers endow art rather than
the meaningful intentions of artists themselves. Whereas late
nineteenth-century modernists extolled Schopenhauer's dictum
that 'all art aspires to the condition of music', visual art after Dada
aspires to language, to meanings once suppressed in the pursuit of
form. It is not that the pursuit of form was abandoned. How could
it possibly have been? But form was no longer placed above mean-
ing. There were reasons both cultural and artistic for this. The
distinction is significant and one that Bourdieu elides by not distin-
guishing clearly enough between the field of art and the field of
culture. Certainly they have much in common and overlap consid-
erably, most notoriously in their inversion of their own values from
those of the fields of business and commerce. But their identifica-
tion leads to confusion. The world of culture embraces not only the

[40] '[T]he first quality that we demand in our sensations [of art] will be order . . . and
the other quality will be variety' ('Essay in Aesthetics', *New Quarterly*, 1909; quoted in
Fry 1937, p. 33).

field of art but the fields of science, morality and intellectual life, fields that possess their own institutions. They too mediate, according to the inverted logics of their own specific forms of production, within the dominant, overarching fields of financial and economic power. Or to put it more simply, they possess their own professional ethics. The distinction is relevant when we come to consider the transformation that occurred between late nineteenth-century and twentieth-century modernism: the turn from form to meaning.

Although, as we have seen, the emergence of a quasi-autonomous world of art may be seen in Europe from the sixteenth century, its most rapid development took place between 1815 and 1914, a time when Europe enjoyed a long period of comparative internal peace and was able to give more time to the domination of external cultures. During this period not only art practice, but the institutions of art, such as art colleges and museums, and the history and criticism of art, perfected their methods and techniques. This led to an emphasis upon form, by means of which the practice, criticism and history of art could be distinguished from other cultural practices and a measure of relative autonomy achieved for each. By 1914 that identifying, formalising and individuating stage was, if not wholly complete, highly advanced. In this regard the growth of art institutions may be compared with those of science during the same period. But the shock of World War I led to much reflection on the validity and function of art's autonomy within the social realm. The relationship of those relative autonomies, whether of art, morality or science, in relation to civil society, became a more pressing matter for the twentieth-century than it had been for the avant-gardes of the nineteenth. Artists became more involved with the relationship of art to language, to politics, to class, to gender, to the nation. The Formalesque avant-gardes had, of course, already learned how to admire the art of the so-called primitive peoples of non-European regions. They had opened a door ever so slightly to art as practised beyond Europe. After Dada, art begins to become increasingly interested in the traditional and cultic arts of places other than Europe. At the end of the twentieth century, Europe is becoming aware that even *contemporary* art is practised beyond Europe and the United States of America.

SURREALISM

Surrealism was the catalyst for all this; the intellectual child of a rebellious parent; an intellectualism that questioned the primacy of

intellect; the first and perhaps only true avant-garde of twentieth-century art. After Surrealism, the so-called avant-gardes, which echoed and recycled the Formalesque aesthetic, became little more than marketable brand names, increasingly irrelevant as *critiques* of Modernity. They were transformed into its celebrants and messengers, especially in provincial and colonial settings. To be known as 'avant-garde' became *de rigueur*, as the Formalesque gradually became the dominant art mode during the 1920s, first in Europe, then in the United States, and eventually throughout the world. To be known as avant-garde was to be a champion – often a utopian champion – of Modernity.

In this process of inversion, Surrealism became a bridge between the old and the new, between nineteenth- and twentieth-century art, developing the dialectic, inaugurated by Dada, between the Formalesque and the diverse, fragmented arts of the twentieth century that developed in opposition to it. The fragmentation took manifold forms impelled by a resurgence of nationalism and politics; a renewal of interest in language and meaning previously suppressed by the dominance of formal interests; and the growth of relatively independent, metropolitan art centres in Europe's former colonies that became increasingly impatient with Eurocentric universalism as they sought to establish their own cultural identities. As Formalism institutionalised itself, Surrealism emerged as the prime oppositional avant-garde of the twentieth century.

The new situation developed in wartime France. Opinion, predicably, became increasingly hostile to all things German; and avant-garde art, Cubism particularly, became identified, both within the art world and on its fringes, as pro-German and hostile to French traditional culture. Camille Mauclair (1872–1945), the conservative critic and champion of French classicism, asserted, 'the war has . . . dug a trench between yesterday's ideas and those of today'.[41] The young dealer David-Henry Kahnweiler (1884–1979), who had supported Picasso and Braque, buying and exhibiting their first experiments in Cubism, found himself an enemy alien and fled to Bern, in neutral Switzerland.[42] His stock of over 700 paintings by Braque, Derain, Gris, Léger, Picasso and Vlaminck were sequestered by the Government and sold in four auctions between 1921 and 1923.[43] In 1915 Tony Tollet, a champion of the Salon painters

[41] Mauclair, *L'Avenir de France*, p. 512; quoted in Silver 1989, p. 27.

[42] On his years of exile, see Assouline 1990, pp. 119ff.

[43] Gee 1979, p. 102. And Gee notes that the important collection of Wilhelm Uhde, an early supporter of Picasso and Braque and a leading advocate of Henri Rousseau and naive painting, was also sequestered and sold.

Baudry and Bouguereau, gave a lecture 'On the Influence of the Judeo-German Cartel of Parisian Dealers on French Art'. Popular cartoons sought to identify Cubism with Germany.[44] Sentiment grounded in patriotism and the national defence flooded into the 'relative autonomy' of the art world. Artists at the front found themselves in their letters and reports representing the war as 'a positive liberating force';[45] those like Matisse who remained in their studios because of age or other reasons revealed a sense of guilt. In a letter to his friend Purrmann, Matisse tells how elated he found Derain on his return from the trenches.'This war will have its rewards – what a gravity it will have given to the lives even of those who did not participate in it if they can share the feelings of the simple soldier who gave his life without knowing too well why but who has an inkling that the gift is necessary.'[46]

It was in this situation, so problematic for the Formalesque as an avant-garde style, that we may discern the first moves towards its institutionalisation. Between 1915 and 1917 the Paris art market was relatively stagnant because of the wartime situation. So Leonce Rosenberg began buying up Cubist work systematically. In 1918 he opened the Galérie de l'Effort Moderne after having made commercial arrangements with about twelve artists working in the Cubist manner, and he promoted a 'house' style, a Cubist classicism, exemplified in the work of Juan Gris, Jean Metzinger, Jacques Lipchitz and Gino Severini.[47] It was built upon an archaising predisposition characteristic of European modernisms since the sixteenth century, the perennial appeal to classicism. During 1919 Rosenberg discussed with Severini the theories of Pythagoras and Plato, and between 1918 and 1920 his gallery deepened its commitment to the revival of reason in art and to the promotion of a new Cubist 'classical' style. Although Leonce Rosenberg's attempt to market a 'collective' Cubism was not immediately successful, it foreshadowed things to come.[48]

The desire to return to classical ideals preceded the war and is, of course, one aspect of the legacy of Cézanne. In 1912 Maurice Denis, who heroised Cézanne, published his *Théories (1890–1910): Du symbolism et de Gauguin vers un nouvel ordre classique*. But it was the carnage and disruption of the war, not the Cézanne heritage, that

[44] Silver 1989, pp. 8, 10–12.
[45] *ibid.*, p. 29.
[46] Barr 1951, p. 182.
[47] See Green 1976, pp. 11 et al.
[48] Gee 1979, pp. 101–03, and Green 1976, p. 195.

consolidated the return to classicism. In this the art market was crucial; it was the bridge between the art world and civil society. Although dealers were a crucial part of the former their clients were not; they were part of the general bourgeois culture. Dealers influenced taste but did not control it. The taste of their clients was mediated between the world of art and the bourgeois life-world. And what that world at large in the immediate post-war years yearned for was a return to order, to tradition. All this made not for a rejection of the Formalesque but for its gradual transfiguration from an avant-garde mode to an increasingly respected tradition of Modernity. The Formalesque was transformed by the immanence of its own logic. It took some time.[49]

Surrealism took over the mantle of Dada and continued the role that European modernisms had played since the sixteenth century in their critique of Modernity. How does it then testify to a major disjunction between late nineteenth- and twentieth-century modernism? André Breton (1896–1966) is the key to the break, the mastermind behind it that provided the nihilism of Dada with a programme. It is better therefore to think of Dada and Surrealism not as two distinct movements but as a Dada/Surrealist front against formalism stimulated by World War I, developed during the 1920s and 1930s and continued, during World War II, by the Surrealist exiles in the United States against the abstract art of the late Formalesque.

Breton was a medico and poet, not an architect, sculptor or painter – the distinction is significant. As a young orderly he had worked behind the lines at Verdun 'where the battle raged for nine months and left hundreds of thousands of casualties'. 'The spectacle of wholesale death [was] imprinted on his mental horizon.'[50] His passion for the poetry of Lautréamont and Rimbaud identified him with the torment of war, the civil strife of the 1870 Commune and a Romantic movement rejected by the 'Call to Order'. Imagery thus became a concern to privilege above form. His readings in Freud, Hegel, Marx and Engels provided him with an aesthetic and a political programme. Freud, with his powerful concepts of the id, unconscious and preconscious, ego and superego, gave him new tools with which to grapple with the nature of the creative imagination. Although, as we have noted, the role of the unconscious had been recognised in romantic art and philosophy at least since

[49] On the return to classicism in Europe generally during the post-war years, see Cowling & Mundy 1990.

[50] Sawin 1995, p. 17.

Schelling, Freud provided it with a new scientific status. The unconscious became a powerful new source of inspiration. Breton let Freud loose among poets and artists.

Here perhaps is the key to the basic difference between the nineteenth century's modernisms and twentieth-century modernism. Technical devices for tapping into the unconscious became the daily preoccupation of the Surrealist cenacle. Already in Zurich, Hans Arp had torn up a drawing, allowed the pieces to float to the floor then pasted them up as they had fallen; Tristan Tzara used similar techniques with words.[51] With Philippe Soupault, Breton experimented with 'automatic writing', which they published in 1919 in *Les Champs magnétique*. Automatism became the central principle of the groups associated with the journal *Littérature* (1919–24). They sought to separate word and image from their syntactical and visual contexts, and their conventional significations; 'the touch of the paint brush on canvas carries the meaning intrinsically . . . a pencil line is the equivalent of a word'.[52] Visual automatism was sought by painting dreams, as in De Chirico's *The Child's Brain*, and in the bizarre juxtapositions found in his paintings of hallucinatory piazzas. Obviously there were problems with the status of dream paintings as autonomous creations. For they are, at best, conscious, volitional representations of dreams recalled. So the technique more favoured was 'automatic drawing', lines drawn or painted with the least possible mental control, perfected by Masson and seen in the *frottage* and *grattage* techniques developed by Max Ernst (1891–1976). The search for automatism proceeded relentlessly. Onslow Ford developed the pouring process he called *coulage*;[53] Wolfgang Paalen, his paint and candle process called *fumage*; Boris Margo, his 'monotype' process known as 'decalcomania' – all techniques developed to tap into the unconscious and preconscious regions of mental activity. Such methods were a challenge to the Formalesque verities. The mark as an implicit *verbal* sign rather than a visual form was returned to art. Titles became important. When Picabia exhibited a meticulous drawing of a spark plug and entitled it *Portrait of a Young American Girl in a State of Nudity* (1915), the title was as relevant to the understanding of the work as was its shape.

Breton's readings in Marx and Engels, and the October Revolution of 1917, committed him to communism, but not to Stalinism,

[51] Richter 1965, pp. 51–55.

[52] The quotation is from the Surrealist Max Morise, in Morise 1924, p. 27.

[53] Sawin 1995, p. 52.

or to the dominance of politics over free artistic activity.[54] Under him Surrealism was organised along political lines for the daily pursuit of experimentation. That was the paradox. Organisation was tight and 'excommunications' frequent. Breton became the 'pope' of Surrealism. But his intransigence kept the Surrealists together for over two decades and laid the foundations of twentieth-century modernism.

Breton realised that Surrealism, like Dada, was the child of war and revolution. He insisted that the work of Lautréamont and Rimbaud be 'restored to their correct historical background: the coming and the immediate results of the war of 1870'.[55] He knew that he himself had been formed intellectually by his wartime experience: 'the last in date caught many of us at the very age when Lautréamont and Rimbaud found themselves thrown into the preceding one, and by way of revenge has had as its consequence – and this is the new and important fact – the triumph of the Bolshevik Revolution'.[56] What bound the Surrealists to Lautréamont and Rimbaud was 'wartime *defeatism*'.[57] It was the outbreak of yet another war, the French colonial war in Morocco of 1925, which induced the Surrealists to reassess their position. It caused them, Breton said, to move from their *intuitive* to their *reasoning* phase. That meant a balancing of political and poetic activity. Breton found himself adopting political methods to ensure the movement's survival by asking its members to deliberate upon its position vis-à-vis politics and art. Predictably, it aroused passionate argument and dissension, complicated by the complexity of the politics involved. For there were members with attachments to the French Communist Party, with its loyalty to Stalin and Stalinist methods, and others, like Pierre Naville, who possessed a deep affection for Trotsky. Among those who opposed the idea of common action were Bataille, Leiris, Masson, Miro and Ernst.[58]

The Surrealists saw themselves as the inheritors of the romantic tradition, and the role Surrealism played in its relation to the Formalesque, as the latter gradually established itself as the hegemonic style of the first half of the twentieth century, may be viewed as the expression of a desire to develop and maintain a new role for the imagination in a Modernity possessed technologically of

[54] For a concise and factual account of the involvement of Dadaists and Surrealists in left politics, see Egbert 1970, pp. 295ff.

[55] Breton 1936, p. 44.

[56] *ibid.*, p. 45.

[57] *ibid.*, p. 47.

[58] Nadeau 1967, pp. 155–56.

ever-increased power to absorb, transform and appropriate all criticism into celebratory effusions of its technologically driven teleology. The subsequent history of the Formalesque in its relation to Surrealism should therefore not be seen as two distinctive trends, the one dominant and the other oppositional acting more or less independently, but rather as a highly intricate and complex dialectic acting and interacting from the 1920s onwards throughout the twentieth century. This is not to say that within the generic style of the Formalesque itself there were not considerable transformations but that they were enacted within art as an autonomous institution, that very institution Dada had arisen to question. During the twentieth century the Formalesque revealed little desire to transgress the boundaries of the relatively autonomous art world that it had done so much to establish during the previous century. By contrast Surrealism, the child of Dada, is characterised by its transgressions. It began, like Romanticism, as a literary movement and, like Dada, did not produce a distinctively visual *style*. Herein lies one of the basic epistemological distinctions between the Formalesque, the modernism of the late nineteenth century and the twentieth-century modernism heralded by Dada/Surrealism. Because Dada had attacked the meaningfulness of art itself, the meaning of art, not its form, became the central critical issue for the art of the century. Whereas the Formalesque had jealously guarded its autonomy – for *l'art pour l'art* was its fount of origin[59] – twentieth-century modernism related art to language, to politics, to gender, to ethnography, continually questioning an epistemology that had throughout most of the nineteenth century sought to draw a distinction between art and life. Surrealism, unlike Dada, developed a subversive programme that was sustained, though with difficulty, in the years between the wars and was then either suppressed, assimilated, transformed or appropriated by the aesthetics and practice of the late Formalesque, as it attained *Eurusan* (see p. 255) dominance after World War II.

Dada/Surrealism is usually presented by art historians as a reaction against Cubism, which by 1919, as we have noted, was beginning to be institutionalised. This is brilliantly demonstrated in Christopher Green's *Cubism and Its Enemies*.[60] Dada/Surrealism certainly rejected institutionalised Cubism – but not only Cubism. It developed a critique of the aesthetic of the Formalesque as a generic

[59] See Bell-Villada 1996 for the most complete account of *l'art pour l'art*.
[60] Green 1987.

style, with its primal source in Cézanne. This is nowhere better illustrated than in Francis Picabia's *Dada Picture* in which Cézanne is represented together with Renoir and Rembrandt as an ape. What is significant here in our context is that the Formalesque is being targeted as a nineteenth-century style fatally complicit with traditional European art.

The major disjunction effected by Dada/Surrealism has not yet found favour among art historians. For William Rubin, 'the programs of Dada and Surrealism were, historically, a major interlude . . . of reaction against the main premise of modern art, which was the direction of the *increasing autonomy* of art as such'.[61] This widely held view is sustainable only if we take the universalism implicit in the concept of an autonomous art championed by the Formalesque as that which is most characteristic of the art of the twentieth century. It ignores the structural heterogeneity and fragmentation that developed in world art during the century as foreshadowed in the Dada/Surrealist programme. It elides the dialectics of the twentieth-century situation in which the relative autonomy of the field of art was questioned constantly for manifold reasons, above all by politics and nationalism. According to Rubin, 'since 1950 there has been no such thing as Dadaist or Surrealist art properly speaking'.[62] But there has been a great deal of it, one might say, *improperly* speaking. For Dada/Surrealism is characterised by its transgression of the sanctities of autonomous art.

Surrealism was also *systematically* transgressive in its approach to language, politics and sexuality. It thus opened a way to transcend European art in the special sense and held out the promise of a world art. Yet much held it fast to European tradition: the image of the artist as a hero, the distinction that it retained between the imaginative life and the world of work which most Surrealists spurned. There is little place for craft in Surrealist thought. They did all they could to suppress or deny the craft that went into the production of their 'automatic' creations or, for that matter, their interest in 'surrealist objects'. In this respect they clung to the classical conception of genius, with the difference that genius is now immanent within the creative process no longer transcendent. Their greatest achievement probably lies in their profound interest

[61] William Rubin, *Dada and Surrealist Art*, London, 1969, pp. 14–15; quoted in Green 1987. In his book Rubin 1968, p. 182, Rubin wrote, 'it appeared by 1955 as if the entire Dada-Surrealist adventure was a kind of anti-modernist reaction situated parenthetically between the great abstract movements prior to World War I and after World War II'.

[62] Rubin 1968, p. 185.

in accidental conjunctures, the unpremeditated juxtapositions, and surprising and unpredictable coming together of things, people and ideas.

James Clifford has demonstrated how important the Surrealist interest in accident and chance is for an innovative twentieth-century aesthetic not grounded in Eurocentred universalisms. As he put it: 'I am using the term *surrealism* in an obviously expanded sense to circumscribe an aesthetic that values fragments, curious collections, unexpected juxtapositions – that works to provoke the manifestation of extraordinary realities drawn from the domains of the erotic, the exotic and the unconscious.'[63]

Clifford noted how ethnographers such as Michel Leiris and Georges Bataille, both deeply involved with the Surrealists during the 1920s, developed an approach to the study of indigenous peoples qualitatively different from the primitivism of Gauguin. Leiris, after breaking with the Surrealists in 1929, studied ethnography under Marcel Mauss at the Institut d'Ethnologie, Paris, founded in 1925, just one year after the publication of Breton's first Surrealist manifesto. Another student of Mauss, Alfred Metraux (1902–1963), became a famous field ethnographer and formed a lifelong friendship with Georges Bataille (1867–1962), the editor of *Documents*, which was sub-titled *Archéologie, beaux-arts, ethnographie, variétés*. It is this publication that Clifford cites as a remarkable instance of Surrealist and ethnographic collaboration. Bataille, in the company of many other members, left the Surrealist group following the schism of 1929 prompted by Breton writing a letter to some sixty-odd members asking them 'for an account of their present ideological position with a view to individual or collective action'.[64]

In order to understand the Surrealist contribution to a potential world art we must distinguish between primitivism and the exotic. The exotic is an aesthetic category, the spatial antinome of the beautiful; primitivism, an ideology fashioned from exotic material by means of which one culture defines itself in relation to cultures regarded as technologically inferior. Modern European culture has produced many modes of primitivism all of which tend to conflate non-European cultures into fictive universalisms that function as European 'others'. One of the earliest is to be found in the use of the term 'Indian'. At one time or another virtually all the inhabitants of the world, apart perhaps from Africans, have been described

[63] Clifford 1988, p. 118.
[64] Nadeau 1967, p. 155.

by Europeans as Indians; not only the inhabitants of the Indian sub-content, but Asians in general, Filipinos, the indigenous peoples of the two Americas, and the countries and islands of the Pacific. Following the discovery of African art by the Fauves and the Cubists, the vogue for *l'art nègre* during the 1920s in Paris incorporated everything exotic from jazz to Pacific cult objects under the trope. It remains a current practice. After Said's *Orientalism* appeared in 1978 and became high intellectual fashion, a tendency developed among intellectuals who should have known better, to describe *all* European perceptions of the exotic as 'Orientalist'. The ideology of primitivism contains an immanent drive that reduces the most heterogeneous ethnicities into a mirror images of Europe's alterity. Indeed that is its primary function.

Nevertheless primitivistic notions have revealed a capacity to transform their structures, and Surrealism has played a creative part in the process. To grasp what has occurred let us consider Picasso's primitivism. His reception of African sculpture has been the subject of extensive discussion. On the evidence available we may agree that the effects of his first visit to the Trocadero probably in 1906 were revelatory and perhaps traumatic.[65] But he had already been psychologically prepared by his interest in archaic Greek *kuroi*, and the Iberian heads from Osuna which he saw at the Louvre in 1906. There need be no reasonable doubt that his initial enthusiasm was formalist, as his earliest comment about it to André Salmon reveals. He said he liked African sculpture because it was *raisonnable*.[66] Indeed it was one of the major influences which helped him to move from the sentiment of his 'rose' period to the formalism of Cubism, a mode he himself described as 'an art dealing primarily with forms'.[67] Like most people, Picasso described past experiences in a variety of ways at different times of his life. Later he came to deny, against the evidence, that he had seen African sculpture prior to painting *Les Demoiselles*.[68] By then he had also

[65] The question is discussed in detail by Rubin, in Rubin 1984, vol. 1, pp. 254–55.

[66] André Salmon, *La Jeune Peinture française*, Paris, 1912, p. 43; quoted in Golding 1954, p. 59.

[67] Marius De Zayas, 'Picasso Speaks', *The Arts* (New York) 5, no. 3 (May 1923), pp. 315–26; quoted in Ashton 1972, p. 59.

[68] Rubin 1984, vol. 1, p. 254. Richardson argues that Picasso 'lied' about the influence of African sculpture on *Les Demoiselles*, first in 1920, 'when he was in thrall to classical sculpture' and because he reacted against the vogue for *la nègre* of that time stimulated by the dealer Paul Guillaume; and after 1935, when his 'caginess' about his intentions increased, and also when the Spanish Civil War brought out his sense of loyalty to Spain, and his desire to express the Iberian sources of the painting, not his debts to African ones. Franco had come from Africa with Morrocan troops (Richardson 1996, pp. 25–26).

acquired a great deal of African and other cult objects, and much later described to Malraux, Rubin and others the psychological effects of his first encounter at the Trocadero with African art in terms of 'shock', 'revelation', 'charge' and 'force'.[69] We need not doubt such reactions. What they reveal is a transformation of Picasso's initial reaction to African art in 1906 from one of an essentially formalist kind in which he had no interest in the 'meaning' of the sculpture, to a more sophisticated primitivism in which the compelling strangeness of the initial contact was rationalised into a new awareness, though still a primitivistic one, that the objects also possessed a spiritual content relevant to his aesthetic response. It is likely that his close friendship with Michel Leiris, one of the leading figures in the Dakar-Djibouti expedition of 1931, which brought back a great deal of African material culture and later lodged it in the Trocadero, had much to do with this transformation. Picasso, like many of his generation of avant-garde artists, moved from a naive primitivism in the pre-war years that appropriated the formal qualities of African sculpture while ignoring its content to a more sophisticated primitivism that appropriated form *and* content and transformed the latter to suit his own cultural needs. For Picasso, African art reinforced his view that the artist was a shaman for his own culture. Anthony Blunt's reminiscences are of interest in this regard. Speaking of his early reaction to African art he wrote:

> We were equally blind about Negro art. We admired it because it had been used by Picasso and Braque, but we viewed it only from the point of view of its formal qualities, and all the elements of magic or other ritual significance we simply ignored. I think it is true that the people through whom we drew this inspiration did the same; Picasso and Braque were also only interested in the formal qualities . . . and it is typical that they were never interested in the more savage kinds of primitive art, say Oceanic art, which were later to inspire the surrealists.[70]

The move from a naive, formalist primitivism to a sophisticated, contentual primitivism is traced by Clifford in his survey of Bataille's *Documents*. In one article, for example, Carl Einstein interprets Masson's metamorphic paintings as expressive of a psychic archaism. Masson, that is, does not merely imitate the forms but

[69] Rubin 1984, vol. 1, p. 255.
[70] Blunt 1973, p. 165.

dons the mask of the shaman. Those who wrote for *Documents* transferred the delight of the Surrealist in the 'marvels' to be found in Paris flea markets to their admiration of exotic cult objects. They did not seek to understand them rationally or attempt to place them organically in a constructed anthropology of their own perceiving but delighted in placing them, with European or other artefacts, in juxtapositions that were bizarre, disturbing or scandalous. In this way they called into question ruling categories such as 'beauty', 'the sublime', 'art', 'taste', etc. Universalisms generated by European culture were thus implicitly interrogated by the irreducible particularities of other cultures. But European thought has never taken kindly to heterogeneous oppositions: it prefers to perceive difference as binary – agonistic mirrors of its own Modernity. Hence Europe's archaic need to reduce heterogeneity to singularity in the form of a countervailing, dialectical thrust which ensures that the diversity of the other, whatever its form, is conflated into a singular and antipodal universal whose function it is to mirror the European culture inversely as an assurance and comforter of Europe's own dubious unity.

It is not surprising therefore that the liberating praxis of *Documents*, its technique of 'juxtaposition – fortuitous or ironic collage', as Clifford calls it – did not survive. *Minotaure*, the sumptuous, glossy magazine that replaced it certainly promoted Surrealism as an avant-garde mode but no longer provided space to ask the complex questions that the ethnography of Bataille and Leiris invoked.

The move from *Documents* to *Minotaure* is paralleled by the transition in the Parisian museum world from the Trocadero to the Musée de l'Homme, which opened its doors in 1937. The one celebrated a bizarre clutter of artefacts from disparate cultures, the other a systematic presentation within 'an evolutionary, diffusionist frame'.[71] Something was gained in this ordering of global culture to accord with a scientific viewpoint, but something was also lost in terms of cultural understanding.

The Surrealist painters did not create a new style. Like the Dadaists, but in a more sophisticated fashion, they embarked upon a complex dialectical relationship with the Formalesque. To paint and be modern in the years between the wars was to paint in some variant of the Formalesque style even though one was opposed to the Formalesque aesthetic and its recognised masters. Breton in

[71] Clifford 1988, p. 139.

1927 described 'Cézannism' as a 'continued scandal'. Matisse and Derain were 'discouraged and discouraging old lions', but Picasso, in his view, was one of the founding fathers of Surrealism. For fifteen years he had explored a path 'bearing rays of light with him as he went'.[72] So it was that Breton, appreciating the dialectics of survival, appropriated the greatest master of the Formalesque to the Surrealist collective. Since his marriage in 1918 to Olga Koklova, a ballerina from Diaghilev's troupe, Picasso had led a bourgeois life-style. But he kept in touch with avant-garde activity and attended Dada soirées in Paris. The second number of *La Revolution surréaliste*, of January 1925, included an illustration of one of his 1914 Cubist constructions. In the fourth, Breton published an illustrated article on Picasso expressing his great admiration for the artist. Though he never joined their cenacle, Picasso gained inspiration from the Surrealists, particularly the poets. The transparently formal meanings of his pre-war Cubism were now replaced by works that, while retaining the formal innovations of Cubism, were invested with content that Breton would read and describe as 'prodigious'.

> How could that ridiculous word 'cubism' unveil for me the prodigious meaning of the discovery that, to my mind, took place in his work between 'The Horta and Ebro Factory' [1909] and the portrait of M. Kahnweiler [1910]? . . . In order to be able to break suddenly away from sensible things, or with more reason from the *easiness* of their customary appearance, one has to be aware of their treason to such a high degree that one cannot escape recognising the fact of Picasso's immense responsibility.[73]

Here Breton is thinking of the move into Cubism not as one towards a higher degree of abstraction but as a move away from visual forms as transparent signs. He is thinking of meanings that may arise from forms *as* signs that convey the marvellous, the extraordinary, the monstrous; meanings that are not transparently singular. Indeed he seems to be thinking in a Saussurian fashion when he writes a little later of 'The responsibility of painters . . . to prevent . . . the survival of the sign for the thing signified . . . [T]he mind slips up on this apparently fortuitous circumstance as on a piece of banana-skin'.[74] This reads like an attack upon reading visual forms as transparent signs when they may, in fact, refer to

[72] André Breton, 'Surrealism and Painting', in Breton 1936, pp. 20, 21, 15.
[73] *ibid.*, p. 15.
[74] *ibid.*, p. 19.

cryptic signifiers. Breton is suggesting that the turn from transparent form to enigmatic meaning is implicit in Picasso's first moves towards Cubism even prior to his use of collage.[75]

The paradox that thus emerges here is that Cubism, which is conventionally understood to be the high point of the Formalesque as an avant-garde style, is also a primal *source* of the style that replaced it – a twentieth-century modernism, launched by Dada/Surrealism, that only became dominant in the 1960s. In this way Surrealism was inextricably entangled dialectically with Cubism, the style that it confronted.

Stylistically, Surrealist painting, despite its variety, was created under the sign of the Formalesque. Although the works of De Chirico, Ernst, Masson, Klee, Miro, Arp, Tanguy, Dali, Giacometti, Matta and Delvaux, to name but a few of its most prominent masters, raise new and momentous issues for the interpretation of meaning in modern art, from a purely formal point of view all this diversity may be seen in retrospect to have been produced within the ambience of the Formalesque as a dominant period style. But the new interest in chance, in dream imagery, in the marvellous and prodigious, in the fragmented and adventitious, privileged figural imagery within the dominant style. It set up a major challenge to the immanence of abstraction within the Formalesque. And predictably, it was by the new art of film, which owed its very ontology to the figural, that Surrealism offered its most profound challenge to Formalesque abstraction. From his *Un Chien andalou* (1928), which he made with Salvador Dali as an exposition of automatism, to *L'Âge d'or* (1930), which deploys the Surrealist concept of *l'amour fou* as a destructive but revitalising force, and to his *Le Charme discret de la bourgeoisie* (1972), Louis Bunuel (1900–1982) revealed how much Surrealism could offer a creative genius working within film, the unique art form of the twentieth century.

THE NEUE SACHLICHKEIT

It was not only Dada/Surrealism that opposed the authority of the Formalesque during the twentieth century. A twentieth-century mode of realism began to emerge within Berlin Dada around 1918.

[75] cf. Dawn Ades comment: 'The great unstable scaffoldings of the hermetic cubist paintings by Picasso and Braque of 1911–12 revealed for Breton the possibilities of a representation freed from naturalism, governed only by the imagination, and opening onto a dreamlike world in which bodies could be reconstructed at will' (Ades 1993, p. 8).

It became known as Die Neue Sachlichkeit (the New Objectivity) during the 1920s,[76] and persisted as a powerful, but often suppressed, mode throughout the century. What Surrealism was for post–World War I Paris, the Neue Sachlichkeit was for post–World War I Berlin and to a lesser extent Dresden, Cologne, Düsseldorf, Hanover and Munich; it was the German as distinct from the French child of Dada. Several of the most prominent members of the Neue Sachlichkeit, such as George Grosz (1893–1959), Otto Dix (1891–1969), Rudolf Schlichter (1890–1955), and John Heartfield (1891–1968), were originally members of Berlin Dada. It was in the Neue Sachlichkeit that realism first achieved a distinctively twentieth-century look.

However, like Romanticism and Surrealism, Realism is not an exclusively visual style. It is a cultural concept that embraces certain kinds of literature and thought as well as visual art. And, as Timothy Williamson has reminded us, the word is used 'in a bewildering variety of senses',[77] from Plato's contention that ideas constitute the ultimate reality to the phenomenologist's claim that all reality is reducible to sensory experience. 'Realism', as used in criticism and art history, tends towards the latter position. Mondrian, whose art might be taken as justifying a Platonic realism, is rarely called a realist.

Historically speaking, modern realism emerged in the nineteenth century in literature and art as a programme that insisted upon the depiction and criticism of contemporary life: '*Il faut être de son temps.*' Only that which could be seen should be painted. Nineteenth-century realism developed under the sign of naturalism; twentieth-century realism, under the sign of the Formalesque. There is a basic stylistic difference between the realism of Courbet and Daumier, and the realism of George Grosz, Otto Dix, and Max Beckmann (1884–1950) and their numerous colleagues. Whereas the nineteenth-century realists worked within a naturalistic style, accepting perspective as a traditional scientific achievement, the Neue Sachlichkeit used it freely as an artistic device. Whereas the nineteenth-century realists used depth and chiaroscuro to endorse their realism, the Neue Sachlichkeit eschewed atmospheric effects, preferring the 'flatness' of the Formalesque. But they also rejected the drive towards abstraction immanent in the Formalesque and stridently attacked the bourgeois life-style of Weimar Germany,

[76] The name was coined by G. F. Hartlaub, director of the Mannheim Kunsthalle, for an exhibition he organised there in 1925.

[77] 'Realism and Anti-realism', in *The Oxford Companion to Philosophy*, 1995. See also Nochlin 1971, pp. 12–56.

thus moving their art beyond the self-contained autonomy of Formalesque art and the subjectivity and irrationality of its Expressionism. 'Let's hope,' wrote Beckmann, 'that from a mindless imitation of the visible . . . we are now arriving at a transcendent objectivity arising from a deep love of nature and human beings.'[78] The title for their first exhibition in Mannheim (1925) was to have been 'Post-Expressionism'. It is misleading therefore to think of them as Expressionists and conflate them with Die Brücke and Der Blaue Reiter against whose art and ideas they were in violent opposition. In that their art centred upon a critique of the twentieth century, and of the city, they were children of Baudelaire. Yet though they rejected the occultic universalism of Blaue Reiter Expressionism, they inherited its techniques: its personalised brushstroking, highly emotive colour, mask-like faces, and prevailing angst. The source of their energy and inspiration lay, of course, in the Great War of 1914–18. Like the Dadaists and the Surrealists they experienced the trauma of that war and it changed their lives and art. Though from a formal point of view, and in a generic sense, they worked under the sign of the Formalesque, they were temperamentally opposed to it – the revolting sons of a dominant father. Their involvement in the moral, social and political realms of society was prophetic of the profound sense of dissidence that was to dominate the best art of the twentieth century. The Neue Sachlichkeit also absorbed the lessons that the arts of indigenous peoples had to teach while rejecting the primitivistic ideology that had been imposed upon it. 'Let's be honest!' wrote Beckmann; 'Let's admit that we are not negroes or Christians of the early Middle Ages.'[79]

From the Neue Sachlichkeit there emerged a vigorous eclectic style that conflated Expressionism and the inventions of Cubism, such as collage, with a new twentieth-century realism. The global significance of the Neue Sachlichkeit has been marginalised by Eurocentred critics and historians, perhaps even more than Dada and Surrealism,[80] probably because its influence was felt after the 1920s not so much in Europe itself as in colonial and post-colonial situations where artists became involved in liberationist struggles for independence against their colonial masters. And at its best the Neue Sachlichkeit developed a new kind of objectivity that did not

[78] Quoted from Ursula Zeller article on the Neue Sachlichkeit in Dictionary 1996, vol. 22, p. 923.

[79] From *Kunst and Kunstler* 12 (1914), pp. 299ff.; quoted in Lloyd 1991, p. 85.

[80] See Martica Sawin's exemplary *Surrealism in Exile and the Beginning of the New York School* (Sawin 1995).

merely replicate its Germanic original but made creative use of techniques acquired from Dada and Surrealism on the one hand and the heritage of the Formalesque on the other in order to create forms of realism relevant to the problems of the life-world of the twentieth century. Thus transformed and reinvigorated, the ghostly presence of the Neue Sachlichkeit may be seen in the work of the Indonesian artist Affandi (1910–1988), the Indian artist Francis Newton Souza (b. 1924), the Puerto Rican artist Elizam Escobar (b. 1948), the American artist Nancy Spero (b. 1926), the Guyanese artist Aubrey Williams (1926–1990), and the South African artist Penelope Siopis (b. 1953). The Neue Sachlichkeit would also appear to be the original twentieth-century source of that social realism which inspired so many artists drawn into political struggles for social justice, land rights, and national identity in colonial and post-colonial situations. It is a constitutive strand of twentieth-century art that needs to be further researched in order to distinguish it from the imperialising Socialist Realism of the Soviet Union and its agent, the Comintern, with which it is still often confused.[81]

The work of the Australian artist George Gittoes (b. 1949) may be taken as evidence of the continuing vitality of the Neue Sachlichkeit tradition at the end of the present century. During the past decade (1987–97) he has developed a practice of visiting vital trouble spots throughout the world, places where civil strife is transformed all too often into inhuman savagery, and usually on both sides of the political spectrum. He has experienced at first hand conflict between police and the aboriginal community of northern Australia (1983); between Sandinistas and U.S.-backed contras in Nicaragua (1986); between the National People's Army (NPA) and the Government army and paramilitary known as the Vigilantes in the Philippines (1989); between U.S. and Australian forces, and the Somali warlords in Operation Solace (1993); between the United Nations forces involved in the Cambodian election of 1993 and the Khmer Rouge (spending six weeks in a Khmer Rouge village). The year 1994 was, even for Gittoes, a busy one. He was able to cover both sides of the struggle between the Polisario and the Morrocan army of King Hassan II; in Israel he witnessed the Hebron mosque massacre and its aftermath, spent time with both United Nations peace observers and the Israeli

[81] A significant beginning has been made by the art journal *Third Text: Third World Perspectives on Contemporary Art and Culture*, established by Rasheed Araeen in 1987.

army; and in Southern Lebanon he witnessed Hezbollah actions against Southern Lebanese and Israeli armies before moving on to South Africa to join ANC representatives in the townships of Katlahong-Alexandra and Epangeni. The year ended for him being beaten up while documenting the activities of AWB Terre Blanche party of the South African extreme right. In 1995, while in Rwanda, he witnessed not only the Kibeho massacre by RPA Tutsi forces while with a United Nations medical unit but also killings by the Hutu militia. After the establishment of peace in Mozambique in 1995 he was able to interact with both the Frelimo and the Renamo in the former civil war, and then became involved with the United Nations in the land mine clean up. Travelling to Bosnia via Zagreb, and basing himself in Sarajevo, he succeeded in working among all sides in the prolonged conflict – Muslim, Serb and Croat – visiting such troubled centres as Mostar, Grozda and Bihac. In 1997 he spent some time with an IRA cell and also mingled with the broader Catholic community before gaining access through the Orange Lodge to the militant Protestant areas of Belfast, attending the 12 July 1997 marches that aggravated, once again, the political situation there.

Gittoes travels light and alone, armed only with drawing paper and pencils. The people he meets, who are often traumatised by the situation they are living or dying through, respond, he finds, more positively to a draughtsman with a pencil than to a cameraman. For in drawing they see both the process in action, which takes more time than a camera shot, and the result, whereas they often react negatively to the idea of becoming invisible images in a black box. To an extent he thus becomes a part of *their* situation. He gets to know the names of people he meets and their predicaments, incorporating their stories into the margins of his drawings, along with his own observations. It thus becomes a kind of illustrated diary. He works later from recent memories as a release to feelings aroused after witnessing 'the most horrific and cruel events'.[82]

Prior to his visits Gittoes does his best to make a detailed study of the history and culture of the people of the region he plans to visit. Without that it is impossible to gain any sense of respect from the participants in the conflict or, for that matter, for him to emphathise with others. To be at the centre of such events it is essential to convince participants who hold authority to accept and acknowledge the value of his role as a recorder of events. In the

[82] Communication from the artist (13 Aug. 1997).

event most of his work is centred upon the victims and the stories they have to tell.

Predictably the paintings that have emerged from Gittoes involvement possess an aggressive, but compelling, visual challenge utterly distinct from the work of artists who practice their art in the more secure, urban environments of twentieth-century Paris, London, Sydney or New York.

7 Institutionalising the Formalesque

As it ceased to be an avant-garde style during the 1920s, the Formalesque was institutionalised in France, Russia, Germany, the United States and England. Let us consider each situation in turn.

FRANCE

In 1918 Léonce Rosenberg's Galérie de l'Effort Moderne, as we noted, began to present Cubism as a renascence of classicism in a modern 'French' manner congenial to patriotic sentiment. But the process of institutionalising the Formalesque had begun even before that. World War I aroused popular hostility to all things German, and Cubism like other forms of avant-garde art was viewed as pro-German, as evidence of a pre-war malaise, a decadence that only war itself could redeem. Reactionary critics like Léon Daudet (1868–1942) and Camille Mauclair (1872–1945) regarded it as further evidence of a cultural decline that had affected France since the Franco-Prussian War of 1870.

To resist such chauvinism, the young Jean Cocteau (1889–1963) co-published with the designer Paul Iribe (1883–1935) the first issue of *Le Mot*, a few months after the war began. It sought to rescue 'modernism and imaginative creative endeavour from accusations of German affiliation'.[1] While adopting a cautious line and accepting many of the accusations about French 'decadence', it set out to support *French* modernists such as André Gide (1869–1951) and Albert Gleizes (1881–1953), the Cubist Roger de La Fresnaye (1885–1925) and the Fauvist Raoul Dufy (1877–1953). Picasso, a non-combatant Spaniard who remained in France throughout the war, was rarely mentioned. *Le Mot* ceased publication in April 1915 and was succeeded by *L'Élan*, established by Amédée Ozenfant (1886–1966), a magazine, more forthright in its support of modern art, that was prepared to attack reactionary critics like Daudet. Works by Picasso were illustrated. Art was defended because it strengthened national morale in a time of crisis. Artists like Matisse

[1] Silver 1989, p. 45.

were exhorted to paint to defend the 'French tradition'.[2] In his book *Technique et sentiment: Études sur l'art moderne* (1919), the young art historian Henri Focillon (1881–1943) wrote that art must 'enter the battle' because it represented 'the program of a race and the embodiment of our instincts'.[3] On the occasion of the last great German offensive of 1918, he wrote: 'Let us come back to ourselves, to our past, to all the monuments of our effort . . . History . . . is the memory of a people. It does not turn one away, but exhorts and encourages to action.'[4]

However, when the chips were down and France was fighting for its existence, it was not the classical antiquity that its journalists invoked but the original tribes that had fashioned the nation. The wartime magazine *La Race* features a Gallic warrior beneath dolmens and menhirs. And in his *Patriotisme, impérialisme, militarisme* (1915) Lucien Roure wrote: 'Each country . . . has its own character. It represents a distinct combination of intellectual and moral qualities issuing from the soil, from the climate, from the race, above all from culture and history . . . The fatherland is, with all that, a certain form of feeling, of thinking, of wanting; it is a certain manner of understanding and expressing the truth.'[5]

What is significant here is that wartime pressure was able to dictate, even within a nation in which the relative autonomy of art had developed more fully than anywhere else, the kind of art that was perceived to suit its national need. And to invoke its needs was to turn to its 'racial' origins. Although the classicism of antiquity was central to European culture and operated across national borders, in times of stress modern Europe has never been more than a congeries of belligerent nations that turned not to classicism but to its cherished Bronze Age creation myths.

Yet after Italy entered the war in April 1915, it was no longer a blood relationship with Frankish tribes but the 'Mediterranean heritage' that was invoked. France was now in a better position to universalise her claims and argue that as the living representative of the classical tradition she spoke for all humanity whereas Germany spoke and fought only for *its* own particular tribal hordes.

The art of Picasso was profoundly affected by the war. His Cubist experiments ended as war began. He turned to realism with *The Painter and His Model* (1914) and the portraits of Max Jacob and Ambrose Vollard (both 1915), recalling Courbet and Ingres.

[2] *ibid.*, pp. 59–60.
[3] Quoted from *ibid.*, p. 61.
[4] *ibid.*
[5] Quoted from *ibid.*, p. 63.

Severini, domiciled in France with a French wife, turned from Futurism towards a domestic realism in his *Portrait of Jeanne and Motherhood* (both 1916). By contrast many young artists in uniform at the front continued to draw or paint when they could in a Cubist manner. Unlike artists on the home front, those in the trenches did not have to contend with censorious patriotic fervour. But the unenlisted, like Picasso and Severini, were in danger of collecting white feathers as they walked in the streets of Paris. The dialectics of survival and transformation in art as it negotiates acute historical contingencies are immeasurably complex, and were never more so than at that moment when popular opinion pressed heavily upon cultural production.

It expressed itself as a neo-classical 'Call to Order', a creation of the French Right as it responded to wartime conditions. The young, well-connected Jean Cocteau emerged into public notice as a part of that world, but as the war continued he became increasingly discontented with it. Late in 1915 he met Picasso at a time when most of Picasso's former friends were at the front and his mistress, Eva Gouel (Marcelle Humbert), was dying of cancer. Lonely and alienated, he welcomed Cocteau as a new and influential friend. Cocteau himself described the occasion:

> There were two fronts: there was the war front and . . . the Montparnasse front . . . where I met all the men who helped me emerge from the famous Right in which I had been living . . . I was on the way to what seemed to me the intense life – toward Picasso, toward Modigliani, toward Satie . . . All those men had given proof of their Leftism, and I had to do the same. I was suspect . . . on the Right, which I was leaving, and suspect on the Left, where I was arriving . . . The man who made it possible to stick at the controls was Picasso.[6]

Likewise, Cocteau, as Silver neatly puts it, 'facilitated Picasso's wartime entry into the *beau monde* of the Right Bank'.[7] He introduced Picasso to Serge Diaghilev (1872–1929) as a result of which the ballet *Parade* was premiered at the Théâtre de Châtelet on 18 May 1917, with libretto by Cocteau, choreography by Massine, sets by Picasso and music by Satie. *Parade* was not intended to be a deliberate attempt to shock the bourgeois in the manner of the Dada soirées then being held at the Café Voltaire, Zurich. It was intended, as Apollinaire wrote in its programme, to appeal to the

[6] Steegmuller 1986, p. 149.
[7] Silver 1989, p. 112.

elite.[8] For him Satie's music had reflected 'the marvellously lucid spirit of France, Picasso and Massine had achieved a consummate alliance between painting and dance, and Cocteau a realistic ballet.[9]

The public reaction was different. Cocteau's touching little story-line presents a small group of wandering players who perform a side-show in the street to entice an audience inside – but without success. It was intended as a fable, the plight of artists who lacked an audience. Picasso's sets were eclectic, the curtain traditional enough in a *commedia dell'arte* vein, but the costumes were stridently avant-garde, fancy-dress Cubism. It was all too much for the audience. They missed the point entirely. Outraged by Picasso's sets and Satie's music, they rose and screamed '*Sales Boches*'. Cocteau's efforts to unite the cultural Left and Right in the persons of Picasso and Diaghilev underestimated the chauvinism of his audience. After all it was an exceptional time. The autonomy of the art world was shaken by the war. As *Parade* was playing, some 120,000 Frenchmen were in the process of being slaughtered in a disastrous attack on the Hindenburg Line. There were serious mutinies in fifty-four French divisions that year. A few months before *Parade* opened, the February Revolution erupted in Russia. Perhaps it is not surprising that a near riot developed on the first night. Yet Diaghilev persisted with the ballet and in the end it was well received. Mediated in part through ballet decor, the pre-war Cubist achievement began to be accepted and institutionalised. As was Picasso. He designed three more ballets for Diaghilev, rather more conventional and romantic: one set in Naples, the other two in Spain. Before the war Picasso had depended financially largely upon rich Russian, German and American expatriates, Shchukin and Morozov, Wilhelm Uhde, Gertrude and Leo Stein, and his loyal German dealer, Kahnweiler, for his bohemian survival. The war obliterated such support. From 1914 to 1925, in the wake of Cocteau's friendship, Picasso's production developed along two distinct lines: one returned to a more traditional mode influenced, by the *commedia dell'arte*, Ingres, Chardin, archaic Greek sculpture, Renoir and Maillol; the other continued his deep involvement with Cubism. By such means he negotiated a difficult time. The bohemian Spaniard was accepted into French society and adopted an increasingly bourgeois life-style.[10] Picasso was steadily

[8] Apollinaire 1960, pp. 426–27.

[9] *ibid.*

[10] His opinion may have been interested, but it is worth noting that Kahnweiler upon his return to dealing in Paris in 1920 was enraged at Diaghilev's influence on Picasso and Gris. He was convinced that 'when they returned to their easel [afer working for the Ballets Russes] their work had deteriorated perceptibly' (Assouline 1990, p. 192).

translated into a myth that became a European, then international, institution.

And with him the institutionalism of the Formalesque itself began in the years between 1919 and 1925. It is a complex story, a dialectical interplay of reciprocal influences activated by critics, dealers and collectors seeking to define the historical and aesthetic structures of *French* modern art in relation to the traditions of the art institutions supported by the state. In 1920 André Salmon, one of the original members of the *bande à Picasso*, published *L'Art vivant*, a short history of recent French art. It began with the legacy of Impressionism in Bonnard, and proceeded through the Fauves to Cubism, presented as a rejection of colour in favour of form. Artists such as Fernand Léger (1881–1955) and André Lhote (1885–1962) also sought in letters to the press to structure the recent *history* of French art along similar lines.[11] One of Picasso's close friends, Maurice Raynal (1884–1954), who wrote the first monograph on him in 1921, published an *Anthologie de la peinture en France de 1906 à nos jours*, which divided French art into three broad categories: idealism (covering Ingres *and* Cubism); realism (covering Courbet *and* de Segonzac, Gromaire, Vlaminck and Soutine); and eclecticism (which linked the first two categories and sought for a French classical style). Raynal's eclectics included Derain, Kisling, Friez and Favory.[12] What is of interest here is that all these critics were seeking to *structure* recent French painting generically according to *style* and provide Cubism with an historic place in their accounts of an essentially French tradition.

As a result the Formalesque was gradually accepted into the state's art institutions between 1920 and 1925. The champions of a *formalist* modernism from Cézannists to Cubists were all opposed to the academic naturalism officially supported by the Salon des Artistes Français, the most conservative institution of all, and by its rival, the Salon de la Société Nationale. It was through the influ-ence and values asserted largely by these two salons that state patronage operated – such as the awarding of the *Prix de Rome*, École de Beaux-Arts medals, and commissions for public buildings, and purchases for the Musée du Luxembourg and provincial muse-ums. Vehemently opposed, at least in theory, to these official bureaucracies were the artists marshalled by Salmon under *L'Art vivant*. *L'Art vivant* corresponded closely to what I have called the Formalesque. Its champions had exhibited since 1884 in the Salon des Indépendants which had been formed in response to the refusal

[11] Green 1987, pp. 124–25.
[12] *ibid.*, p. 125.

of the Salon des Artistes Français to show work by Impressionists. It allowed any artist for a small entry fee to show at least two paintings. There was no jury and no medals were awarded. Since 1884 the Indépendants usually exhibited under canvas, a kind of fairground free-for-all on the Champs de Mars. It was at the first Indépendants exhibition of 1884 that Seurat and Signac showed their first canvasses to the general public; and it was with Neo-Impressionist work that the Formalesque style made one of its initial breaks with the naturalism of Impressionism. Then in 1903 the writer and architect Frantz Jourdain (1847–1945) established the Salon d'Automne in which the avant-garde work of the Fauves and Cubists were welcomed.

After the war things changed. In 1920 for the first time both the Salon d'Automne and the Indépendants were permitted the use of the State's Grand Palais for their shows. The following year the Société Nationale des Beaux-Arts invited some of the Indépendants associated 'with . . . Fauve and Cézannist tendencies'[13] to exhibit. A few had been invited even before the war.[14] In 1922 André Lhote, an Indépendant with Cubist leanings, was invited by Jacques-Émile Blanche (1861–1942), doyen of the Société Nationale, to advise on the organisation of the prestigious exhibition *One Hundred Years of French Painting*. The recent victory over the Germans had encouraged a sense of cultural and national unity. There was even talk of amalgamating the Artistes Français, the Société Nationale and the Salon d'Automne. Nothing came of it, but to complicate matters further two prominent artists of the Société Nationale, Edmund Aman-Jean (1858–1935/36) and Albert Besnard (1849–1936) initiated yet another Salon, in 1923, the Salon des Tuilieries, which ranged over the full spectrum of contemporary French art from Besnard to Gleizes. Nevertheless state patronage was still controlled largely by the director of the École des Beaux-Arts and the curator of the Musée du Luxembourg, the state museum of modern art, where even the Impressionists were still hidden away in two side rooms. Both Paul Léon (1874–1962), director of the former, and Léonce Bénédite (1859–1925), curator of the latter, were staunchly conservative.

But their long reign was coming to an end. The huge Exposition Internationale des Arts Décoratifs et Industriels Modernes held in the heart of Paris from April to October 1925, with pavilions constructed by twenty-one participating countries, effected a major

[13] *ibid.*, p. 127.
[14] *ibid.*

change in the legitimisation of Formalesque architecture, sculpture, decorative arts and painting. From its effect upon taste, the term 'Art Deco' was eventually coined in the later 1960s[15] for the style characteristic of the architecture and decorative arts of the 1920s and 1930s.[16] The Exposition was sponsored by the French Minister of Commerce and organised on a scale commensurate with the industrial exhibitions of the nineteenth century inspired by London's Great Exhibition of 1851. Intended as a 'colossal advertisement for French decorative and industrial arts',[17] it was a highly chauvinistic expression of France's economic recovery from the war. Germany was not permitted to participate. France's colonial possessions were represented proudly in separate pavilions: a Pavillon de l'Asie Française, part-French, part-Vietnamese; a Pavillon de l'Afrique Française, featuring 'mock-African mud brick architecture; and a Pavillon de L'Afrique du Nord, featuring 'a white-washed Moroccan style house'.[18] A highly representative exhibition, *Fifty Years of French Painting*, in the Pavillon Marsan, included a broad spectrum of Formalesque painters: Vuillard, Bonnard, Rouault, Signac, de Segonzac, Friez, Utrillo, Matisse, Derain, Vlaminck, Dufy, Favory, Braque and Picasso, among others. It was the first major step in the *bureaucratic* institutionalisation of the French Formalesque, a position consolidated with the death of Bénédite while the Exposition was still running. A new curator, Charles Masson, and his assistant, Robert Ray, responding to the swift change in official and popular taste, rehung the Musée du Luxembourg in a manner that now gave centre stage to the Caillebotte Bequest of Impressionist paintings, consigned many great nineteenth-century history paintings, by Fernand Cormon (1845–1924), Alexandre Cabanel (1823–1889) and William Bouguereau (1825–1905), among others, to the basement, and began to purchase modern works by Vlaminck, Utrillo, Marchand and the like. Academics and moderns were hung together: Matisse and Bonnard juxtaposed to Besnard and Jacques-Émile Blanche. A pyrrhic victory perhaps? But what other victory was possible?

Institutionalisation went hand in hand with nationalism. Whereas the creation of the Formalesque style by the avant-garde of Paris between 1890 and 1914 had been cosmopolitan, relatively

[15] Bevis Hillier records that Hilary Gelson published a full-page article entitled 'Art Deco' in the London *Times* on 2 November 1967, in which she noted that the term was then in use among connoisseurs (Hillier 1968, p. 12).

[16] By Bevis Hillier in Hillier 1968.

[17] Silver 1989, pp. 362–63.

[18] *ibid.*, p. 365.

autonomous, and city-of-Paris based, its institutionalisation was
French, that is to say, nation-based and chauvinistically political.
And what occurred in France between 1919 and 1925 provides us
with a model of the transformation of the artistic scene of Europe
at large during the 1920s and 1930s. As the institutionalisation
of the Formalesque advanced, nationalism becomes the most
powerful item on Modernity's cultural agenda.

RUSSIA

In Russia the origins of the Formalesque may be traced back to the
1870s with the establishment of an artists' colony at Ambramtsevo
by Savva and Yelizaveta Mamontov. A man of enormous talent and
energy, a singer, sculptor, stage director and dramatist, Mamontov
(1841–1918) was also a great patron of the arts who established a
private opera company and provided inspiration and support for
three generations of artists. They called themselves 'The Wan-
derers' and, like the French nineteenth-century avant-garde,
opposed academic classicism, which in Russia centred upon the
teaching of the St Petersburg Art Academy. But in Russia, nation-
alism rather than formalism was the primary inspiration of
aesthetic reform. Situated on the eastern rim of Europe, it was
geographically as much Asian as European. There was a powerful
formalism, icon painting, in its national tradition. Art in the west-
European sense, as first fully defined historically by Vasari, devel-
oped as a break from what he called the 'Greek' style, that is to say
the iconic mode identified with Orthodox Christianity. Not surpris-
ingly the Abramtsevo community, led by Yelizaveta Mamontova,
promoted the rehabilitation of icon painting and Russian medieval
architecture. Icon painting was, of course, much more formalist in
character than the naturalistic tradition developed during the Ital-
ian Renaissance. Indeed it was the very style that the Renaissance
consigned to oblivion in western Europe. But icon painting was not
the only art form promoted by the Mamontovs. Inspired by ideals
of social amelioration, they set out to revive the crafts and cottage
industries. Following a cholera epidemic, they built a hospital on
their estate. A year later a school was added, in which Mamontova
taught the children of neighbouring peasants, then a church,
around which a great deal of the interest in Russian medieval art
was developed.

 Much of the art of the Wanderers, such as that of Vassily Surikov
(1848–1916) and Ilya Repin (1844–1930), was inspired by Russian

legend and history, large narrative paintings in a realistic manner similar to much nineteenth-century academic painting in western Europe. But the beginnings of the Russian Formalesque also stem from Abramtsevo in the work of Michael Vrubel (1856–1910). His restoration of the Church of St Cyril, Kiev, equipped him with a deep appreciation of Byzantine art. 'Byzantine painting', he said, 'differs fundamentally from three-dimensional art. Its whole essence lies in the ornamental arrangement of form which emphasises the flatness of the wall.'[19] Deeply interested in Slavonic mythology, Art Nouveau and Symbolism, Vrubel was unquestionably the precursor of the Russian Formalesque. He was deeply critical of Repin's painting, in which he said, 'Form, the most pre-eminent plastic quality, has been abandoned'.[20]

Geographically, Russia was admirably positioned to conflate and institutionalise the Formalesque style. The process began and was taken to a high level of success by the World of Art (Mir Iskusstva) movement that developed in St Petersburg during the 1890s. It included Serge Diaghilev, Alexandre Benois (1870–1960) and Leon Bakst (1866–1924). The movement was cosmopolitan in outlook and sought not only to bring to Russia a knowledge of the avant-garde art of western Europe from Impressionism to Gauguin (by means of exhibitions and an art journal, also called *Mir Iskusstva*), but also a knowledge of Russian art to western Europe. In this latter project it succeeded in uniting the rich and colourful decorative arts tradition of oriental Russia with the plastic and pictorial concerns of the European avant-garde, especially in sets and décor developed for theatre and ballet. In the Ballets Russes de Diaghilev the pictorial concerns of the western avant-garde were conflated and transformed; everything from Monet's Impressionism to Picasso's Cubism became grist to Diaghilev's impresarial skills. In consequence the Russian ballet became itself a European institution, eventually an international one, and with Art Deco, one of the most powerful cultural forces in Europe promoting the institutionalisation of the Formalesque. But whereas Art Deco eclecticised the Formalesque by means of classical and traditional French elements, the Ballets Russes succeeded in orientalising it. One of the major catalysts in this was Sergey Shchukin (1854–1936), the greatest Russian collector of Formalesque art in the years before the war. By 1914 he had acquired 221 works from the French Impressionists to Picasso. His favoured artist was Matisse of whom he owned over 50

[19] In a letter to his sister, May 1890; quoted in Gray 1962, p. 32.
[20] *ibid.*, pp. 33–34.

works. For him Matisse's art was a triumphal synthesis of tradi-
tional Russian and modern Western art, a marriage of Orient and
Occident. His friend Ivan Morozov (1871–1921) also made a great
collection of modern work. The link between Moscow and Paris
was strengthened by little magazines such as the *Golden Fleece*
(1906–09), printed in Russian and French and edited and financed
by Nikolai Ryabushinsky (1876–1951), 'to propagate Russian art
beyond the country of its birth to represent it in Europe in a whole
and integrated fashion'.[21] The Golden Fleece organised exhibitions
of modern French art in Moscow. The first, held in 1908, was in the
opinion of Alfred Barr 'the most discriminating general exhibition
of French post-impressionist painting held anywhere – including
France – up to that time'.[22] It combined contemporary Russian with
Western artists in order to display their differences and similari-
ties,[23] and sought to blend cosmopolitan with national interests,
aesthetic quality being perceived in terms of national psychology, a
prominent feature of the first phase of the institutionalisation of the
Formalesque in the years before World War I. It is characteristic of
the sensibility of avant-garde critics at the turn of the century such
as Julius Meier-Graefe (1867–1935). Although the birth of the
Formalesque as a generic style in Paris was city-based and cosmo-
politan, so soon as it was presented at a national level, whether in
France, Russia or Britain, it began to be assessed by dealers and
critics increasingly in the terms of a perceived national psychology.

In the years before World War I the Russian Formalesque
acquired characteristics that distinguish it from its Parisian origins.
It is more ornamental, possessed of iconic splendour and brilliant,
decorative colour. Vrubel became their Cézanne; Matisse their most
favoured French painter. The Russian Formalesque is also more
intrinsically spiritual, more deeply embedded in the heritage of its
own *fin de siècle* Symbolism than was the French in theirs; it was 'an
outgrowth of Symbolism not its denial'.[24] Kandinsky is its paradig-
matic painter. It was the Nabi, the most spiritually oriented avant-
garde group among the French Formalesque, that found most
favour among the World of Art and Golden Fleece circles, and it
was the deeply religious Maurice Denis, artist and theorist of the
Nabis, who contributed most frequently to the highly influential
Golden Fleece magazine. However, with the notable exception of

[21] *ibid.*, p. 80.

[22] Barr 1951, p. 110.

[23] Introduction to *Zolotoye Runo Katalog, Vuistavki Kartin*, 1909; quoted in Gray 1962,
p. 82.

[24] Bowlt 1986, p. 167.

Kandinsky, none of the Russian Formalesque were deeply read in occult texts. They responded rather to the general intellectual climate; especially the Symbolist magazines current in St Petersburg and Moscow. As John Bowlt has shrewdly observed, 'artistic consciousness is perhaps fashioned more by veiled allusion and free association than by the specific readings and scheduled meetings often documented as primary sources'.[25]

The Russian Formalesque also responded more deeply to folk art than did the pre-war Parisian avant-garde. Picasso admired the work of Henri Rousseau (whose work is 'naive' rather than folk) and *images d'Épinal* but was not deeply influenced by them. On the other hand, members of the Russian avant-garde such as Natalia Goncharova (1881–1962) and Mikhail Larionov (1882–1964) were profoundly interested in folk art, and developed their own style of Russian primitivism, based on their love of medieval icons, peasant embroidery and popular wood engravings (*lubki*).

The Russian Formalesque, then, was the product of a dialectical interchange between originating urban centres (Paris, Munich, Milan) and a provincial but proudly national culture. What stands out is the *conflation* of styles that are, in a sense, species-specific – Post-Impressionism, Fauvism, Cubism, Futurism, etc. – on their originating home ground, Paris, into a Russian Formalesque style that conflates Cubism and Futurism into a Cubo-Futurist style, and permits national factors, such as a deep investment in Symbolism and a national affection for folk art, to colour and give a distinct character to the Russian Formalesque as a generic style. Another characteristic is a greater willingness to transgress conventional limits – art/craft, art/ballet, painting/music, art/religion – in a search for synaesthetic modes. The deep respect and fascination that the World of Art group held for the Lithuanian musician and painter M. K. Ciurlionas (1875–1911) is a case in point. The profound nature mysticism of his talent produced some of the earliest non-objective, if not abstract, paintings to be produced in eastern Europe – not excluding Kandinsky.[26] A section of the World of Art exhibition of 1912 was devoted to a retrospective of his work. The Russian Formalesque painters had no desire to work exclusively within the 'essential' guidelines of a given category of art (painting, music, etc.) that was to become a central determinant of the late Formalesque. The Russians conflated and synthesised as they institutionalised their avant-garde experiments into a modern national

[25] *ibid.*, pp. 166–67.
[26] See Sepetys 1977.

art. Not that this was a conviction or expressed intention. Few would have seen themselves as overt nationalists. Nationalism consisted, for the most part, in a *disavowel* of meaning in the Formalesque, not an external force acting from without upon the relative autonomy of the field of cultural production, but an imma-nent property of the field itself, in the work of both artists and critics. It reveals itself in its interpretations, a hermeneutics intrinsic to place, even while both artists and critics avidly profess universalist sentiments.

Between 1909 and 1911 Moscow art circles were subject to the impact of Cubism from Paris, Die Brücke from Dresden, and Futurism from Milan and Rome. Marinetti's Futurist manifesto was translated and published in the Russian press immediately after its appearance in *Figaro* in 1909.[27] The effects of these diverse influences were revealed in the exhibitions organised by Natalia Goncharova and Mikhail Larionov between 1910 and 1914 at the Knave of Diamonds (1910, 1912), Donkey's Tail (1912) and Target (1913) exhibitions all held in Moscow. Kasimir Malevich gave the name Cubo-Futurist to the works he submitted to the Donkey's Tail and Target shows, and it was at the latter that Larianov issued his Rayonnist manifesto.

Its significance lies not so much in the work exhibited, for the movement was short-lived, but for its conflation of styles and concepts that helped to institutionalise the Formalesque in Russia. For here we find evidence of the emphasis upon art as the expres-sion not only of modern technology, as in the Futurist manifestos, but of much else. In agreement with Marinetti, Larionov wrote, 'We declare: the genius of our days to be: trousers, jackets, shoes, tramways, buses, aeroplanes, railways, magnificent ships.' But Rayonnism also was 'a synthesis of Cubism, Futurism and Orphism . . . [a] style . . . concerned with spatial forms which are obtained through the crossing of reflected rays from various objects, and forms which are singled out by the artist'.

> The essence of painting is . . . combination of colour, its satura-tion, the relationships of coloured masses, the intensity of surface working . . . a skimmed impression . . . perceived out of time and space – it gives rise to a sensation of what one may call, 'the fourth dimension', that is the length, width and thickness of the colour layers. These are the sole symbols of perception which emerge from this painting which is of another order. In this way painting parallels music while remaining itself . . . From here

[27] Gray 1962, p. 94.

begins the creation of new forms, whose meaning and expression depend entirely on the degree of saturation of a colour-tone and the position in which it is placed in relation to other tones. This naturally encompasses all existing styles and forms of the art of the past, as they, like life, are simply points of departure for a Rayonnist perception and construction of a picture.

And to this detailed, *technical* aspect of the manifesto, Larionov added a strong nationalist rider: 'We are against the West, vulgarising our Oriental forms and rendering everything valueless.'[28]

Here then Rayonnism becomes an assertion of the Formalesque, not as yet another avant-garde movement that follows upon their predecessors diachronically, as in Paris, from Impressionism to Cubism, but of successive substyles embraced synchronically as a generic style: art as a relationship between line, tone and colour, as a 'skimmed impression', as an art aspiring to the condition of music, as a representation of the technologies of modern life, as an art that reveals the fourth dimension and, while paradoxically asserting an anti-Western stance and solidarity with the Orient, at the same time asserting a universalism that 'encompasses all existing styles and forms of the art of the past'. In short, a syncretic modernism at once nationalistic and universalist. Furthermore, it must be stressed, despite the manifest presence of an interest in the occult and nationalistic ideology, all aspects of the Rayonnist manifesto arise from factors immanent within the Russian field of cultural production during the years prior to the 1917 Revolution. Yet in 1914 Larionov and Goncharova left Russia to join Diaghilev as ballet designers, bringing their syncretic formalism to the West they had so vehemently opposed a few years before.

The persistence of mysticism, inherited from Symbolism, in Russian avant-garde practice, is best exemplified in the St Petersburg circle that comprised the musician and artist Mikhail Matyushin (1861–1934), the Futurist poet Aleksey Kruchonykh (1886–1968) and the painter Kazimir Malevich (1878–1935). In 1913 Matyushin composed the music, Kruchonykh wrote the libretto, and Malevich designed the sets and costumes for the Cubo-Futurist opera *Victory over the Sun*. It was for this opera first produced in the Luna Park Theatre, St Petersburg, in December 1913 that Malevich produced two abstract backcloths, one of which consisted of a white and a black square divided diagonally, whence he developed his Suprematism, which he called 'the new realism' and defined as 'the

[28] *ibid.*, pp. 136–41.

supremacy of emotion'. He did not, however, exhibit Suprematist works (geometric forms in pure colour on white grounds) until December 1915 in the so-called *0.10 The Last Futurist Painting Exhibition*, Petrograd. It included his famous *Black Square*.[29] It is this work that reveals the pictorial logic to which the Formalesque could be driven, that is to say towards a paradoxical negation, a minimality of formal relationships, an immanent drive towards abstraction. Many artists after Malevich, such as Ad Reinhardt and Donald Judd, would drive their art towards a similar visual minimalism. But Malevich was not working within a secular formalism in the manner of the Constructivists and later the Minimalists.

For the Cubo-Futurists, formalism took on a spiritual meaning: together, they insisted, painting, writing and music would transform human consciousness. Central to such transformation was the creation of a transcendental language which Kruchonykh called *zaum*, meaning 'beyond reason'. 'We were the first to say', he wrote, 'that for portraying the new and the future *completely new words and new combinations* are necessary',[30] and he turned to the ecstatic speech of Russian religious sects for evidence of the presence of the new language which he found in D. G. Konalov's *Religious Ecstasy in Russian Mystical Sectarianism* (1908).

Both Kruchonykh and Matyushin were devout admirers of the hyperspace philosophy of the Russian theosophist P. D. Ouspensky (1878–1947), whose many publications brought together in a popular form a great deal of Eastern and Western mystical thought from yoga to spiritualism.[31] In this *Tertium Organum* Ouspensky described four stages in the psychic development of humankind. The fourth and highest stage (which was the one the Cubo-Futurists sought after) he described as 'a feeling of four-dimensional space. A new sense of time. The live universe. Cosmic consciousness. Reality of the infinite. A feeling of communality with everyone. The unity of everything. The sensation of world harmony. A new morality. The birth of a superman.'[32]

Malevich sought to give this higher consciousness, this 'Zaum realism' (transrational language) he called it, expression in his paintings. In this way he interpreted his Cubist depiction of peasants in landscapes, such as *Morning in the Village after the Snowstorm* (1912). As he put it to Matyushin in the summer of 1913:

[29] On the creation and context of the *Black Square*, see Golding 1975, pp. 96–106, and Compton 1974.

[30] Kruchonykh, *The New Paths of the Word*; quoted in Steiner 1984, p. 140.

[31] Douglas 1986, p. 186.

[32] Quoted from *ibid.*, p. 187.

We have come as far as the rejection of reason, but we rejected reason because another kind of reason has grown in on us, which in comparison with what we have rejected can be called beyond reason [*zaumny*] which also has law, construction and sense, and only by learning this shall we have work based on the law, of the truly new 'beyond reason'. This reason has found Cubism for the means of expressing a thing . . . I am beginning to understand that in this beyond reason there is also a strict law that gives pictures their right to exist. And not one line should be drawn without the consciousness of its law, then only are we alive.[33]

Cubism, for Matyushin and Malevich, was a way into the fourth dimension. The former translated Gleizes and Metzinger's *Du cubism* (1912) into Russian with that in mind.

By 1915 Malevich had abandoned Cubist forms altogether and sought 'to give direct visual form to *zaum* perceptions'. Butler has argued convincingly that Malevich's Suprematism was most probably influenced by the discipline and practice of the Advaita version of Vedanta thought popularised by the Swami Vivekananda, whose highly influential book *Raja-Yoga* (1896?) was translated and published in Russia in 1906. The Swami promoted a vividly transcendental version of the *masculine* Self: 'No books, no scripture, no science, can ever imagine the glory of the Self, which appears as man – the most glorious God that ever was, the only God that ever existed, exists, or ever will exist. I am to worship, therefore, none but my self. "I worship my Self," says the Advaitist. To whom shall I bow down? I salute myself."'[34]

In working on his Suprematist paintings Malevich expressed a similar view. 'This is how I reason about myself and elevate myself into a Deity saying that I am all and that besides me there is nothing and all that I see, I see myself, so multi-faceted and polyhedral is my being . . . I am the beginning of everything, for in my consciousness worlds are created. I search for God. I search within myself for myself.'[35]

The Russian Futurist poets like Malevich's friend Kruchonykh

[33] Malevich to Matyushin, undated [summer 1913], archives of the Tret'yakov Gallery, f. 25, no. 9, sheets 11–12; quoted in Douglas 1986, p. 188.

[34] Swami Vivekananda, Jnana Yoga, in *Vivekananda: The Yogas and Other Works*, ed. Swami Nikhilananda, New York, Ramakrishna-Vivekananda Center, 1953, p. 616; quoted in Douglas 1986, p. 188.

[35] Malevich, *The Artist, Infinity, Suprematism: Unpublished Writings, 1913–33*, ed. Troels Andersen, Copenhagen, Borgens Forlag, 1978, pp. 29, 12; quoted in Douglas 1986, pp. 189–90.

were closely allied to and gained theoretical support from the school of literary criticism now known as Russian Formalism.[36] It grew out of two small discussion groups, the Moscow Linguistic Circle, established in 1915, and Opoyaz (Society for the Study of Poetic Language), set up in Petrograd the following year. Its early theoretical interests were closely associated with the innovative practices of the Futurist poets. Like the Futurists they were vehemently opposed to Symbolism, 'the poetry of apocalyptic forebodings, anguished soul searching, and the tortured calm before the storm',[37] and it was also yet another case of an avant-garde generational rejection of the father. The Futurist manifesto entitled *A Slap in the Face of Public Taste* (1912) was signed by David Burlyuk (1882–1967), Velimir Khlebnikov (1885–1922), Aleksey Kruchonykh and Vladimir Mayakovsky (1893–1930). Their intention, they said, was to throw 'Pushkin, Dostoevsky, and Tolstoy overboard from the steamer of modern times', sentiments echoing Marinetti's fanfares to Modernity. However, the Russian Futurists were more interested in innovatory form than technological content. 'If there is a new form, there must also exist a new content', wrote Kruchonykh. 'It is form that determines content.'[38]

The Russian Formalists sought to bring precise, theoretical weight to that position, but their aim was wider: to develop literary scholarship and criticism as an independent and self-consistent intellectual activity. In this they were aware that they were taking a path that the German art critics and historians Fiedler, Hildebrand, Meier-Graefe, Riegl, Wölfflin and Worringer had followed and were still following.[39] In order to do so it was necessary to attack the metaphysical and occult presuppositions of Symbolism, and to distinguish their own formal approach from the biographical, psychological, sociological and aesthetic concerns of their predecessors; in short, they were positivists.

Their position was ably described by Boris Eichenbaum (1886–1959), one of the most brilliant members of Opoyaz:

> [W]e did not, and do not, possess any . . . ready-made system or doctrine. In our scholarship we value theory only as a working hypothesis with the help of which facts are disclosed and take on meaning, that is, they are apprehended as immanent properties

[36] On Russian Formalism, see Erlich 1955, Steiner 1984, Striedter 1989, Matejka & Pomorska 1978, and Medvedev & Bakhtin 1978.

[37] Erlich 1955, p. 25.

[38] Roman Jakobson, *Novejshaja russkaja poèzia*, Prague, 1921, p. 8; quoted in Erlich 1955, p. 27.

[39] Erlich 1955, pp. 40–41.

and become material for investigation. [W]e are not concerned with definitions . . . We establish concrete principles and adhere to them to the extent that they are proved tenable by the material.'[40]

One of the most telling of the 'concrete principles' espoused by the Formalists was specified by Viktor Shklovsky (1893–1994): that of displacement or de-familiarisation. 'Every art has its own organisation – that which transforms its material into something artistically experienced. This organisation is expressed in various compositional devices, in rhythm, phonetics, syntax, the plot of the work. It is the device that transforms extra-aesthetic material into the work of art by providing it with form.'[41] For Shklovsky, poetry (and art) were systems of devices. By the use of such devices the artist 'deformed' our normal recognition of things, sharpened our perception, thus providing density (*faktura*) to this world of manufactured objects, 'the totality of which we call art'.[42]

The Russian Formalists came into existence a few years before the emergence of the Constructivists in Russia and became their implicit partners in a dialogue about word and image that would continue to flourish for the rest of the century. In 1913 Vladimir Tatlin (1885–1953) began to construct small objects from materials such as metal, wood and glass. Some years before, he had become associated with Larionov and Goncharova (who introduced him to icon painting), but in 1912 he broke from their group and took to stage design,[43] which involved him with three-dimensional modelling, and began to experiment with Cubist drawing. In 1913 he travelled to Berlin and Paris, where he met Picasso and Lipchitz. The year before, Picasso had produced his first collage, *Still Life with Chair Caning* (1912). It was probably the visual stimulation received from his visit to Paris that resulted in the production of Tatlin's first 'painterly relief', *The Bottle* (*c.* 1913). A year later he began calling the works he exhibited 'counter-relief'. He was moving away from painting towards innovative non-utilitarian constructions. In this, as Christina Lodder suggests, Tatlin may have been influenced not only by Boccioni's *Technical Manifesto of Futurist Sculpture*[44] but by Larionov's Rayonnist manifesto with its talk of 'spatial forms,

[40] Matejka & Pomorska 1978, pp. 3–4.

[41] Shklovsky, *Iskusstvo cirka*, p. 138; quoted in Steiner 1984, p. 50.

[42] Erlich 1955, p. 150.

[43] On Tatlin's contribution to stage design, see Baer 1991, pp. 61–62, 85–86, 98–100 et al.

[44] A Russian translation of the manifesto had appeared in *Apollon*, no. 9 (1910), pp. 17–18 (P. Buzzi, 'Pis'ma iz Italii'). See Lodder 1983, pp. 17, 270n50.

arising from the intersection of reflected rays from different objects'. However, like so many avant-garde artists of his time, Tatlin denied influences of any kind from contemporary sources. 'He does not', he insisted, 'belong to Tatlinism, nor to Rayism, nor to Futurism nor to the Wanderers, nor to any other similar group.'[45]

Tatlin's innovations were followed up by Aleksandr Rodchenko (1891–1956), Ivan Puni [Jean Pougny] (1892–1956), Pyotr Miturich (1887–1956), Lyubov Popova (1889–1924), Varvara Stepanova (1894–1958), and the two brothers Naum Gabo [Pevsner] (1890–1977) and Antoine Pevsner (1886–1962). Together they developed an interest in non-utilitarian constructions in the years immediately before the outbreak of World War I. However, a split developed between Tatlin's interests and those of the Pevsner brothers. Tatlin was interested in materials and fabrication, problems arising out of construction, not in turning his experiments into 'aesthetic' objects. Gabo and Pevsner, though deeply involved with three-dimensional construction, sought to produce artistic creations. Gabo expressed his position in his Realist manifesto, signed by his brother and issued as a poster to advertise their exhibition in Moscow in 1920. It began with a paean of praise for revolutionary change expressed in Nietzschean terms, equating realism with the 'real laws of life' which know 'neither good nor bad nor justice as a measure of morals . . . [N]eed is the highest and most just of all morals . . . deed is the highest and surest of truths.' It condemned all forms of art from naturalism to symbolism and mysticism but did not reject art *in toto*, asserting that it must 'face the fact of new forms of life, already born and active'. It affirmed the light-absorbing tones of substance: line 'as a direction of static forces', depth 'as the only pictorial and plastic form of space', and 'kinetic rhythms as the basic forms of our perception of real time'.[46]

Today this might be read as a *constructivist* manifesto rather than a realist one. But Gabo was never happy about his work being called 'constructivist', which for him signified a utilitarian, not an aesthetic, objective. He preferred to call his own work 'constructive' not 'constructivist'. The fine distinction is usually ignored. In 1920 Gabo left Russia and did not return. His brother left in 1923 and settled in Paris. It is of interest that Gabo and Pevsner, like Malevich, were happy to call their work and manifestos 'realist' while working well within the parameters of what I have described here as the Formalesque. It underlines the fact that realism is not a

[45] Lodder 1983, p. 17. The brochure was written with Tatlin's approval, but he may not have been the author of the text.
[46] A translation of the manifesto is contained in Harrison & Wood 1992, pp. 297–99.

specific style term appropriate to a visual stylistic any more than is Romanticism or Surrealism. It is in such instances a personal description, of that which one choses to regard as reality. Apart from that, the use of realism to describe Formalesque work by Gabo, Malevich and others may have been prompted by the desire to be 'politically correct' in the knowledge that Lenin and Trotsky, to name but two of the Russian Communist Party leaders who had recently come to power, strongly favoured realism at a time when Lunacharsky's protective umbrella as head of Narkompros made a diversity of creative cultural activity still possible in the new Soviet state. For between 1915 and 1925 the Russian Constructivists perceived their innovatory fabrications as a new material reality relevant to the time.

The Formalesque was first institutionalised bureaucratically in Soviet Russia but did not succeed in becoming dominant. After the February Revolution of 1917 a Union of Art Workers in Petrograd was established that included artists from the avant-garde to members of the traditional Mir Iskusstva. Its immediate objective was the destruction of the power the Petrograd Academy of Arts held over cultural and artistic life, an activity comparable to that of the Parisian avant-garde between 1922 and 1925 in reducing the hegemony of the Salon des Artistes Français and the Société Nationale des Beaux-Arts. But in Russia the task was accomplished much more swiftly because of the 1917 Revolutions. In Paris the state, as we have seen, supported the two conservative Salons which in their turn were protected by the existence of a strong, traditional civil society that had been developing since the French Revolution. In Russia, after October 1917, the Communist Party was determined to destroy the power of all bourgeois institutions and in the process eventually annihilated any civil society capable of functioning independently between state and public opinion. The process took some time.

After October 1917 the state's relationship to the arts ceased to be mediated through the Union of Art Workers and came under the direct control of the People's Commissariat of Enlightenment (Narkompros) administered by Anatoly Lunarcharsky (1875–1933), a friend of Lenin and a cultivated man who was tolerant of the avant-garde, providing it did not claim the right to speak on behalf of the Party. The great majority of the avant-garde were initially enthusiastic supporters of the Revolution, including many such as Kandinsky and Gabo who later left Russia. Within Narkompros contemporary art affairs came under the control of the Fine Arts Department (IZO), which was run by boards set up in

1918 with departments in Petrograd and Moscow. Board members contained some famous people such as the poet Mayakovsky, the critic Osip Brik (1888–1945), and the artists Malevich, Ol'ga Ozanova (1886–1918), Tatlin and Kandinsky. The old Petrograd Academy of Art was closed during the summer of 1918, its teachers sacked, its paintings requisitioned. For a short time it survived as an autonomous body but was then reformed under IZO as Svomas (Petrograd Free Studios). Everyone over sixteen seeking specialist art training was accepted, including those belonging to previous art schools, and considered to be members of the new body. Students were permitted to divide up into their own working groups and elect their own professors. Tatlin, Malevich and Ivan Puni were among the many who received free studios. In Moscow too that year the old College of Painting, Sculpture and Architecture, and the Strogonov School of Applied Art were closed and transformed into Vkhutemas (Higher Artistic and Technical Workshops). Naum Gabo, who worked in his brother Antoine Pevsner's studio there, described the new body as both school and academy, with departments for painting, sculpture, architecture, ceramics, metalwork, woodwork, textiles and typography. Discussions were held in which the public could participate. There were several thousand students, but the enrolment was a shifting one because of the civil war. Ideological questions were continuously threshed out. From these discussions the ideas that evolved into Russian Constructivism eventually emerged.

Lenin, it soon became clear, was not an enthusiast for modern art. Reading Campanella's utopian *City of the Sun* (1602) inspired him with the desire to erect monumental statuary as a form of educational propaganda. During 1918 many Tsarist monuments were demolished and new ones erected in Petrograd: to Radishchev (1749–1802), the founder of the revolutionary tradition in Russian literature and thought; to Lassalle, the hero of the German labour movement; and to Marx, Chernyshevski, Heine and others. But they were criticised by the avant-garde as perpetuating outmoded bourgeois styles. Such criticisms inspired Tatlin's *Monument to the Third International*. As head of the Moscow IZO he had been involved in the monument project from the beginning but was highly critical of the state promoting bad taste and advocated a need for 'fresh and youthful artistic talent', arguing that monuments should be 'free creations' to celebrate the Revolution itself. Early in 1919 IZO commissioned him to execute such a project. He set out to create 'a truly revolutionary monument, responding to and expressing the dynamism of a socialist and revolutionary society'. It

is from the art historian Nikolay Punin, who was then head of the Petrograd IZO that we first hear of Tatlin's plans. He sought a synthesis of architecture, sculpture and painting. The monument's form would consist of cubes, cylinders, spheres, cones, segments, and spherical surfaces, the aesthetic ideality of Plato and Cézanne once again. Separate units would interconnect by lifts.[47] It was a grandiose, utopian conception that recalls Boullée's designs created on the eve of the French Revolution. It was to stand in the centre of Petrograd, 400 metres high, straddle the Neva, and contain three rooms surmounting one another: the lowest, a cube, intended for the legislature, would rotate once a year; the second, for executives, would rotate once a month; the third and topmost, for information and publicity services, once a day. The design expressed a cosmic symbolism associated with Tatlin's 'messianic conception' of the artist's role in the new society.

Tatlin's ideas were an inspiration to the Society of Young Artists (Obmokhu) established in 1919 by students of the State Free Art Studios. If Tatlin's monument recalls Boullée and the Eiffel Tower, Obmokhu recalls Jacques-Louis David's studio during the French Revolution. Its students decorated the streets for revolutionary festivals, prepared posters for the abolition of illiteracy, and made sets for the theatre in Moscow and the provinces. Members of Obmokhu exhibited (1919–21) anonymously and developed Tatlin's ideas, working in iron, glass and wood to create fine, linear, skeletal inventions of a non-utilitarian character yet with strong technological implications and 'a pronounced emphasis on the precision, clarity and economy of the geometric form'.[48]

In developing their constructions Tatlin's generation thought along lines similar to the Russian Formalists. Both rejected the notion that a work of art was essentially inspired by metaphysical, personal, emotional or spiritual elements. Art was a matter of working with the devices and techniques available. They were producers rather than artists in the bourgeois sense. The literary critic Osip Brik insisted that art was 'like any other means of production'.[49] What was needed was knowledge, craft and skill. The complex relations between the creation of art and the production process were debated intensely between 1917 and 1929 within the overarching presence of Marx's historical materialism. Neither Marx nor Engels had developed a systematic theory of

[47] Lodder 1983, pp. 56–57.

[48] ibid., p. 72.

[49] Brik, 'Drenazh iskusstvu', Iskusstvu kommuny, no. 1 (1918), p. 1; Lodder 1983, p. 76.

aesthetics. From what they had written, art was generally assumed to be a part of an ideological superstructure wholly determined by an economic and social base. What was largely ignored was that both Marx and Engels were well aware that art was also driven by its own immanent development. It was assumed that the role of art in the new Soviet, as part of the superstructure, was to assist in the building of socialism. In practical terms that meant the rapid development of industry. So the relation of industrial construction to art became a burning one hotly debated for over a decade, and one that, in our context, was contested, so far as the avant-garde was concerned, within the generic co-ordinates of the Formalesque style.

The theoretical aspects of Russian Constructivism began to develop from intense discussions published in *Art of the Commune* (*Iskusstvo Kommuny*), the official journal of IZO (1918–19). The journal was open to diverse views. Art, many of the contributors agreed, was essentially the creation of objects, a form of work. This led to a need for a distinction between handicraft and industrial production. Some, such as Puni, who was a friend of Malevich and one of the earliest followers of his Suprematism, argued that art could not be useful. One did not need artists but technicians and mathematicians to ensure the functional utility and beauty of industrial productions.[50] Osip Brik, in contrast, argued that the working class could not regress into aesthetic contemplation of the old, or indulge in passive enjoyment of ancient artistic monuments – the heritage syndrome. As a result of these discussions the *Art of the Commune* in 1919 enumerated six items considered to be essential criteria of value for professional art: material, colour, space, time, form and technique.

The analysis of these criteria became one of the main objects of the Institute of Artistic Culture (Inkhuk) set up, apparently on the initiative of Kandinsky, in March 1920 under the aegis of IZO. Papers were read on child art, African sculpture and Russian folk art. Interest ranged over the constitutive elements of painting, music, sculpture and poetry and their interactive affinities. Kandinsky, fascinated by such matters, conducted investigations among its members into the psychological effects of lines, colours, tones and sounds, and asked them to nominate colours appropriate, say, to the twittering of a canary, a cow lowing, or the wind whistling; to chose colours that most befitted specified shapes, such

[50] Puni left Russia for Finland and Germany in 1921 and moved to France in 1924, where he was known as Jean Pougny.

as a triangle, a square, or a rectangle. But such investigations into reception psychology soon fell into disfavour. Kandinksy left the Institute in January 1921 and the following year joined the Bauhaus in Germany.

The debate now turned increasingly towards the artwork as an object, as formulated by El Lissitsky in the journal *Object* (*Veshch*). Art, it claimed, was the creation of new objects, but artistic production was not limited to the production of utilitarian objects. It approved Tatlin's counter-reliefs and Lissitsky's concept of the *Proun*. The word was an abbreviation of the Russian words *Proekt utverzhdeniia novogo* (project for the affirmation of the new); the works themselves consisted of two-dimensional experiments undertaken by Lissitsky, between 1919 and 1924, into the creation of innovatory forms 'by means of the economic construction of materials to which a new value is assigned'. They were a part of a 'systematic investigation into the formal elements within a given work of art',[51] a programme closely analogous to the literary interests of the early Formalists. *Object* opened the debate between formalists and utilitarians, that is between the Constructivists and the Productionists. For the first three months of 1921 a new group, the General Working Group of Objective Analysis, discussed these questions. They tended to centre upon the difference between the meaning of construction and composition. Construction, it eventually concluded, was concerned with the best use of materials and the absence of unnecessary components. Composition was arrangement according to conventional significations. What was at stake in fact was the role of painters working in two dimensions and architects and engineers working in three, and the place of both in the new socialist society. For Rodchenko, who played a leading role in these debates, composition was an anachronistic concept, an outmoded aesthetic notion related to 'taste'. Construction represented 'centuries of artistic development' and was the product of technology and engineering.[52]

In March 1921 the First Working Group of Constructivists was set up. The membership included Aleksei Gan (1889–1940), who had previously worked with Malevich and the Russian Futurist groups; Vavara Stepanova, active both as a theorist of constructivism and for her work in theatre, costume, graphics, textile and typographic design; the brothers Vladimir Stenberg (1899–1982) and Georgii Stenberg (1900–1933), activists in

[51] See Lodder 1983, p. 80.
[52] *ibid.*, p. 88.

publicising constructivist theory and together in charge, from 1928 to 1948, of the November decorations in Red Square, Moscow; and Konstantin Medunetsky (1899–1934), who exhibited constructions with Obmokhu in 1920, and designed the models for the kiosks in the Soviet section of the Paris Exposition des Arts Décoratifs of 1925, and décor for the Kamernyi Theatre; and Karl Ioganson (c. 1890–1929), a Latvian sculptor who exhibited in the exhibition of Soviet art held in Berlin in 1922.[53]

All were highly committed to the new society. Their programme asserted their commitment to 'scientific communism, based on the theory of historical materialism'.[54] In 1922 Gan's *Constructivism* appeared. It traced its origins from the involvement of the Constructivists in the revolutionary struggle, designing posters, agitational propaganda and mass festivals. Art, he claimed, was destined to disappear with the bourgeois society that had created it. Modern technology had created Constructivism.[55] The book was designed not so much to set out the formal principles of Constructivism – though it did that – as to justify it in the Marxist terms that appealed to the Soviet Government.

But what precisely was to be understood as 'production art'? Nikolay Tarabukin (1889–1956), trained in history and philosophy and secretary of Inkhuk, presented a paper entitled 'The Last Picture has been Painted' in August 1921, which he later developed into his book *From the Easel to the Machine* (1923).[56] It was highly critical of the Constructivist position, seeing it as a dilettantish imitation of engineering structures. What was needed, in his view, was an organic interaction that linked work processes with creativity.

This was precisely what the Constructivists were attempting to do in the Higher Artistic and Technical Workshops (Vkhutemas) established in November 1920. Vkhutemas was designed for advanced artistic and technical training to prepare artists for industry, and instructors for technical education. The school provided a Basic Course after which students could receive specialist training in one of seven faculties (painting, sculpture, textiles, ceramics, architecture, woodwork and metalwork). The long struggle between the claims of those who supported the fine arts and those who supported 'production' art continued to divide the school. Its major achievements were the one year Basic Course and the Wood

[53] On these artists, see Baer 1991.
[54] Lodder 1983, p. 94.
[55] *ibid.*, p. 99.
[56] *ibid.*, p. 263.

and Metalwork Faculty (Dermetfak). Their teachers held to Constructivist principles. Rodchenko's class in Construction was typical of the Basic Course. It consisted in the construction of forms, colour and painterly space, with exercises in structures using diagonals, pyramids, verticals, horizontals and their combinations. Similar and more advanced classes developing the central tenets of Constructivism were developed over the years between 1920 and 1929. Dermetfak taught more than its name suggests. Its staff came to include many of the major Constructivist artists. Rodchenko became deputy head of metalwork in 1922, Gustav Klucis (1895–1944) taught colour theory in woodwork from 1924 to 1930,[57] Lamtsov taught spatial theory, and Lissitsky, on his return from western Europe in 1925, taught furniture and architectural design until 1930. In 1927 Tatlin ran a course on the culture of materials and the design of household items. During its life Dermetfak teaching moved from craft-oriented, applied and decorative art traditions to a modernist design-based engineer-oriented training.

Despite the advanced nature of Dermetfak design teaching, little of it ever reached production stage, owing largely to the devastation wrought by revolution and civil war. Nor did industry recover sufficiently during the New Economic Policy (NEP) from 1921 to 1928 to be able to take advantage of the new ideas. The one area in which constructivist ideas reached mass production was in the work of Stepanova and Popova[58] in textiles and clothing. In their view clothing was not for taste or fashion but for work, that is for 'comfort and the appropriateness of dress for a given productive function'.[59] It is exemplified in the work suit that Stepanova designed for her husband Rodchenko and the actors' overalls that Popova designed for Meyerhold's production of Crommelynck's play *The Magnanimous Cuckold* (1922).[60] In their textile designs they rejected traditional Russian floral patterns for geometric forms. None of Dermetfak's furniture designs were ever mass produced but Rodchenko did succeed in designing and executing a Workers' Club interior for the Exposition des Arts Décoratifs, Paris (1925). Lissitsky designed 'constructivist' chairs for International Fairs held in Leipzig and Dresden in 1930, but none were mass produced in

[57] Klucis helped to organise the Soviet section at the Exposition Internationale des Arts Décoratifs, Paris, in 1925. He was arrested and died during the purges of World War II.

[58] On Popova, see Baer 1991, pp. 43–44 et al.

[59] Lodder 1983, p. 149.

[60] Meyerhold's innovations in theatre were denounced after Stalin came to power. He was arrested in 1939 and shot in 1940.

Russia. The one area in which the full thrust of constructivist design made a powerful appearance was in theatre design, especially in Meyerhold's theatre.[61]

Meyerhold avoided realism and the portrayal of individualistic emotions. 'The theatre was to present the ideal proletarian, well-skilled and well-organised. The concept of biomechanics was influenced by circus acrobats, the conventions of *commedia dell'arte* and the Chinese and Japanese theatres. Like these, it cultivated the economy and intensity of the stylised gesture.' [62] Popova's set and costumes for Meyerhold's *The Magnanimous Cuckold* and *The Earth in Turmoil* (1923) were among Constructivism's greatest triumphs in the field of design.

Constructivism also made highly creative use of innovative typography, photography, photomontage and cinematography. It was in the fields of advertising, propaganda and entertainment that it flourished most vigorously. The larger ambition to bring the concept of 'production' art into the wider world of industrial progress failed, in part because of the relatively primitive and chaotic condition of Soviet industry during the 1920s and also because the Bolsheviks were highly critical of Constructivism and all forms of avant-garde art from the beginning.

For it must be stressed that although the avant-garde supported and welcomed 1917 with a sense of utopian enthusiasm, Constructivism itself was not an achievement of the Revolution. It was the child of Cubism and Futurism, both of which became possible in Russia as the result of the emergence of a bourgeois civil society during the nineteenth century that had cultivated the autonomy of art.

Bolshevik art policy also owed more to the nineteenth century than to the twentieth. It began to emerge in Lenin's paper on 'Party Organisation and Party Literature' written following the 1905 Revolution. He was concerned, on this occasion, primarily with the role of journalism as a revolutionary activity, in a situation in which the Tsar and the Dumas still held supreme power. Lenin argued a paradoxical case that in the long term proved disastrous for art in the Soviet Union. On the one hand he accepted the bourgeois concept of artistic freedom. 'There is no question', he wrote, 'that in this field [literature] greater scope must undoubtedly be allowed for personal initiative, individual inclination, thought and fantasy, form and content. All this is undeniable.'[63] But in contrast to that

[61] Baer 1991, pp. 45–49 et al.

[62] Lodder 1983, p. 170.

[63] Quoted from Solomon 1979, p. 180.

freedom, he developed the principle of party literature (*partiinost*) which must subordinate its freedom to the party's political platform. Lenin's position regarding artistic freedom was that it could only be realised in a classless society. Bourgeois freedom was a hypocritical freedom based on the power of money; true artistic freedom 'will be openly linked to the proletariat'. His paradoxical position made it possible for him to allow Lunarchasky a relatively free reign in arts policy within Narkompros. That Lenin did not intend his concept of *partiinost* to be applied to literature as a fine art was made clear in a letter written by his wife, Krupskaya, but not published until 1960.[64] His literary taste, however, strongly favoured the nineteenth-century social realism of Nikolay Nekrasov (1821–1877) and Nikolay Chernyshevsky (1828–1889), and he detested the futurist poetry of Mayakovsky. The residual liberalism in Lenin's thought vis-à-vis art and society was quickly obliterated after Stalin rose to autocratic power in 1928. Under him Socialist Realism, strongly influenced by his doctrine of 'socialism in one country' and modelled on popular enthusiasms for the nineteenth-century narrative art of the Wanderers, was adopted as the official and only legal art, and the one form of art championed by the Comintern, the administrative organ of international communism.

To what extent then is it possible to say that the Formalesque was institutionalised in Russia between 1917 and 1928? There is a sense in which, in its Constructivist mode, it was created, institutionalised and transformed within a series of micro-institutions such as IZO, Inkhuk and Vkhutemas, under the protective umbrella of Narkompros, and transformed under the social conditions of the new Soviet Society into a mode of the Formalesque that vehemently rejected its bourgeois origins. In the process it attempted to reject art itself as an autonomous social institution in favour of a utopian ideal of creative industrial production that, in the circumstances of the 1920s, it failed to achieve. But it was never institutionalised to the extent that it became a dominant style within the educational system or the state propaganda apparatus. That, of course, became subsequently the role of Socialist Realism. Yet during its existence Soviet Constructivism did develop powerful international ramifications. Both the first *Russian Art Exhibition*, Berlin (1922), and Alexander Melnikov's Soviet pavilion of the Exposition des Arts Décoratifs, Paris (1925), drew western Europe's attention to the highly advanced nature of design in the new Soviet

[64] *Druzhba Narodov* (1960), no. 4; quoted in Fischer 1969. See also Berger 1969, p. 54.

state. Lissitsky, who had studied architecture in Darmstadt (1909–14) and visited Paris and Italy before the Revolution, became, during the 1920s, in Reyner Banham's phrase, 'the apostle of Constructivism to Western Europe'.[65]

GERMANY

With the rise of Stalin to supreme power in the Soviet Union, Constructivism was aborted. In Germany the possibility of a socialist revolution on the Soviet model was itself aborted as a result of the murder, in January 1919, of Karl Liebknecht and Rosa Luxemburg, the Spartacus leaders of the German Communist Party. However, the fragile civil society that emerged a month later from the revolutionary situation and was sustained precariously in Germany during the Weimar Republic (1919–33) made it possible for the ambitions of the Russian Constructivists to be achieved in the Bauhaus, first at Weimar (1919–25) and then at Dessau (1925–28), as a result of the work of Walter Gropius (1883–1969) and the talented team he was able to gather about him. As Sigfried Giedion put it in 1959, 'under Gropius the effort was made to unite art and industry, art and daily life, using architecture as the intermediary'.[66]

The Bauhaus provides us with a classic example of the way in which a modernism critical of Modernity's shortcomings may be transformed into an effective ideological instrument of Modernity itself. Here, as so often, architecture was the catalyst by which the transformation was effected. Prior to the establishment of the Bauhaus and during its early years, the Formalesque reveals itself primarily as a critique of Modernity, that is to say of the then existing mainstream styles in painting, sculpture and architecture, a critique basically concerned with the demolition of the authority of academic classicism.

The role of architecture as critique, however, is oxymoronic in its practice. For it is manifestly a useful and practical art, its products are a visual manifestation, not a criticism, of Modernity. True enough, as with all other arts, the architect may criticise the practice of the past by means of his own work, but he is constrained from criticising contemporary architecture and planning, in any fundamental sense, by his actual practice in these fields, because it becomes a part of Modernity by virtue of its very existence. For it is

[65] Banham 1960, p. 185.
[66] Giedion 1959, p. 485.

the architect and engineer, and their acolytes in design, who construct the material fabric of contemporary society. This is indeed true in a weaker sense of the other visual arts also for they too become a part of the present, of Modernity, by their practice. But because of the relative autonomy of the field of art, the existence of a civil society provides a freer creative and critical space for the writer, the painter, and even the sculptor than it does for the architect. For architecture is an art that is more capital intensive, and much more an integral part of the economic, social and political fabric of Modernity. It is for this reason that avant-garde architecture reveals its critique (if at all) in a utopianism that becomes a mode of practice, and so remoulds and reconstructs modernist critiques of Modernity into characteristic expressions of modern society.

Ever since Vitruvius, architecture has been assumed to be the mother of the arts, the art that provides a sheltered space that homes the other arts. Precisely for this reason architecture cannot by its nature develop a major critique of the society that creates it, for it is itself a material *expression* of that society. Of course architectural constructions may be interpreted a posteriori as social critique, as in the critique of slum housing. But architectural critique as practice normally takes the form of utopian visions – such as those of Boullée and Sant'Elia. It is because architectural critique takes on a utopian semblance that its critique of Modernity, if we may so call it, takes the form of a celebration of Modernity's future potentials. In this respect both Italian Futurism and Russian Constructivism foreshadow the institutionalisation of the Formalesque. Their rhetoric rejected the past and exalted the future, and had little truck with primitivism. The future is to be occupied not rejected and the present criticised because it is not prepared to grasp the future's potential that lies within its grasp. It is for these reasons that architecture tends to act as a catalyst by means of which modernism, as a critique of the present whether in literature or art, is transformed eventually into a celebration of the status quo.

This is one of the reasons why the ideals and principles of Formalesque architecture are first enunciated in the writings of social critics of contemporary society, with regard to its shortcomings in social planning and design – as in Ruskin, Morris, C. R. Ashbee (1863–1942), and the work of architects such as Hermann Muthesius (1861–1927) and Henry Van der Velde (1883–1929), better known for their reforming zeal in the *Werkbund* than for their architectural achievements – or that it was Jane Jacobs, an influential writer not an architect, who spearheaded the attack

upon Formalesque architecture in the 1960s after it had achieved imperial dominance as the International Style.[67] There are, of course, significant exceptions to such generalisations. Frank Lloyd Wright and Le Corbusier criticised the contemporary architecture of their time as much in their practice as in their writings. But they took up the torch of reform after others had lit it and acted as powerful catalysts by means of which the avant-garde modernist critique of Modernity was transformed into a new cultural ideology, no longer primitivistic or archaising in inspiration but advocating a new, atemporal, universalist version of classicism.

It was also under the aegis of architecture that the Formalesque established itself categorically as a *generic* period style. Both Art Nouveau and Art Deco are best understood as phases in the development of the architectural Formalesque. Both are, in our present context, essentially substylar modes of the Formalesque, pointers on the road towards its institutionalisation, and formative in the process of sifting the traditional, vestigial and primitivistic elements from its modernising components, in the evolution of the period Formalesque. Art Nouveau, of course, gained its thrust from reform in the decorative arts and had its roots deeply within the Rococo Revival and the Arts and Crafts Movement. As architecture, it did much to free architecture from the conventional use of the classical orders and neo-Gothic quotations, while developing a freer, more flexible and organic treatment of internal space.[68] As design, its influence is present in the symbolist painting of Odilon Redon (1840–1916), the Neo-Impressionism of Seurat, the synthesism of Gauguin, Bernard and Denis, the sculpture of Maillol, the posters of Toulouse-Lautrec, and the turn-of-the-century drawings and paintings of Picasso. In thus drawing together a variety of more or less contemporary, but relatively independent, trends in the visual arts and melding them with influences from the recent past, such as the art of the Pre-Raphaelites and the architecture of Viollet-le-Duc, Art Nouveau, as a mode of the early Formalesque, reveals a capacity to synthesise and conflate specific styles, in painting, sculpture and architecture, into a generic period style. It is significant, in our context, that this process of integration proceeded under the aegis of architecture and design.

Like Art Nouveau, Art Deco is essentially a substylar mode of Formalesque, and like it was syncretic in its formation, drawing its inspiration from 'the more austere side of Art Nouveau, cubism, the Russian ballet, American Indian art and the Bauhaus' while

[67] Jacobs 1961.
[68] On this point, see Hitchcock 1959, pp. 144–45.

responding 'to the demands of the machine and of new materials such as plastics, ferro-concrete and vita-glass'.[69] Both Art Nouveau and Art Deco brought the formalist innovations achieved in the high arts of painting, sculpture and architecture to the wider realm of popular consumer demand and advanced taste, and in the process helped to meld the distinct achievements of independent avant-garde movements into a dominant period style.

However, it is the Bauhaus that was central to the institutionalisation of the Formalesque as the dominant period style of the twentieth century. It developed a coherent educational programme by means of which its beliefs and values were disseminated globally. Its values were universal and its span ultimately imperial. It owed something to the political urgency of the times and to the ardent discussions in IZO from early 1918 about the nature and limitations of art that began in Russia after the October Revolution. But for the most part, the theory and practice developed in the Bauhaus was of German origin.

In this the Arbeitsrat für Kunst (Work Council for Art, AFK), founded by the architect Bruno Taut (1880–1938) in November 1918, was seminal. Taut rejected Marxism–Leninism and the politics of central-state socialism that flowed therefrom. He was deeply influenced by anarcho-syndicalist theories flowing from the writings of the French socialist Pierre Proudhon (1809–1865), the Russian anarchist Prince Peter Kropotkin (1842–1921) and the garden-city ideals popularised in Britain by Ebenezer Howard (1850–1928). National and regional policies should be established by workers' councils not by a state authority. Taut was a socialist who exhalted spiritual and deplored material values. 'Socialism', he wrote, 'in the non-political, supra-political sense is the simple, straightforward relationhip between men, far removed from any form of domination. It straddles the divide between warring classes and nations and binds mankind together.'[70]

The Arbeitsrat für Kunst included, among others, the architects Walter Gropius and Erich Mendelsohn (1887–1953); the painters Erich Heckel (1883–1970), Käthe Kollwitz (1867–1945), Ludwig Meidner, Max Pechstein (1881–1955), Karl Schmidt-Rottluff (1884–1967) and Lyonel Feininger (1871–1956); the sculptor Gerhard Marcks (1889–1981); the art historians Adolf Behne (1885–1948) and William Worringer (1881–1965); and the critic Julius Meier-Graefe. It was a highly political organisation from the beginning and provides us with an interesting test-case of the way

[69] Hillier 1968, p. 13.
[70] Whyte 1982, p. 53.

in which avant-garde architecture begins as a critique and ends as a celebration of Modernity. In its programme, announced in December 1918,[71] the AFK stated that its aim was 'the fusion of the arts under the wing of a great architecture'. Acting as an intellectual elite, it would mould 'the sensibilities of the *volk*' and 'be responsible for the visible fabric of the new state'. A comprehensive educational programme included the dissolution of the Royal Academy of Arts, the Royal Academy of Building and the Royal Prussian Commission of Arts. It embraced an elitist form of socialism, was fervently pacifist, anti-materialist and anti-capitalist. Taut's chiliastic visions figured forth communal great houses of glass and iron that would gleam like crystal in the sun of the new German society. The archaistic vision that inspired him and his colleagues was that of the Gothic cathedral, in which architects, sculptors, painters and stained-glass craftsmen all worked together communally.

But Adolf Hoffman, the Minister for Culture in the Social Democratic (SPD) government, formed immediately after the Revolution of January 1918, quickly deflated his dreams when Taut attempted to present them to him in a deputation shortly after the SPD had assumed power. Dispirited, the AFK aligned its policies with that of the Independent Social Democratic Party (USPD), which supported government by councils rather than the parliamentary form of government adopted by the SPD in December 1918. Taut came increasingly under the influence of the USPD leader, Georg Ledebour (1850–1947), and of Clara Zetkin (1857–1933), a leading communist and pioneering feminist. With Liebknecht, Ledebour planned the abortive communist uprising of January 1919 that resulted in the eventual assassination of Liebknecht and Luxemburg. Dejected by the turn of events, Taut resigned as head of the AFK. It was taken over, a month later, by Gropius, who adopted a more pragmatic, less utopian and less political line, and appealed for funds from 'the traditional patrons of the arts, the *haute bourgeoisie*, and the industrialists'.[72] While retaining much of Taut's visionary utopianism, Gropius rejected his direct political involvements: such as pacifism, decentralisation, and the idea of a central artistic elite controlling art policy on behalf of the state.

Gropius had already designed one of the masterpieces of twentieth-century architecture, the Fagus factory at Alfeld (1914),

[71] In the *Mittellungen des deutschen Werkbundes*, no. 4 (1918), pp. 14–15; quoted in Whyte 1982, App. 2, p. 232.
[72] Whyte 1982, p. 125.

before being invited by the Grand Duke of Sachsen-Weimar to create a new art school at Weimar in April 1919 by fusing the Weimar Academy of Fine Arts and the Kunstgewerbeschule, which had been established by van der Velde in 1904 as an instrument of the *Werkbund* movement.

At the Bauhaus, Gropius continued the visionary ideals of Taut but gave them the non-political, pragmatic turn that he had developed as head of AFK. Thus the Bauhaus became the catalyst by means of which a reformist avant-garde, critical of Modernity, folded the critique over into an identification with and celebration of Modernity. It was a process of legitimation by which critics become gurus; radicals, old masters; and heresies, new classicisms. In the case of the Bauhaus, it was made possible by Gropius's unusual mixture of talent: a brilliant architect, an imaginative educator, and an effective administrator who knew how to bridge the fields of art, administration and politics. And the history of the Bauhaus itself confirms, in little, the movement from critique to celebration that we have been following. For it begins as a highly reformist arts and crafts school and thus develops a powerful new programme for architecture, in its role as the material celebration of Modernity.

Imbued with a spirit of reform, itself inspired by the revolutionary days of his youth, Gropius set out to overturn the traditional training of the architect. Although he fervently believed that architecture was the mother of arts, he also maintained that it was essential to create a school in which design could be taught by means of the imaginative use of contemporary materials: iron, glass, plastics, etc. The first manifesto of the Bauhaus read:

> The complete building is the final aim of the visual arts . . . Architects, painters and sculptors must recognise anew the composite character of a building as an entity. Only then will their work be endowed with the architectonic spirit which it has lost as 'salon' art. Architects, sculptors and painters, we must all turn to the crafts. Art is not a 'profession'. There is no essential difference between the artist and craftsman. The artist is an exalted craftsman. In rare moments of inspiration, moments beyond the control of his will, the grace of heaven may cause his work to blossom into art. But proficiency in his craft is essential to every artist. Therein lies the source of creative imagination. Let us create a new guild of craftsmen, without the class distinctions which raise an arrogant barrier between craftsman and artist. Together let us conceive and create the new building of the

future which will embrace architecture, sculpture and painting in one unity and which will rise one day towards heaven from the hands of a million workers like the crystal symbol of a new faith.[73]

As a front cover for the manifesto, Lyonel Feininger (1871–1956), born in New York and one of the first artists to be appointed to the Bauhaus staff, designed a famous woodcut, *Kathedrale des Sozialismus*, that depicted a crystalline, Cubo-Futurist cathedral brilliantly lit by three stars.

The initial Bauhaus programme was a curious but potent mix of utopian socialism, mysticism and pragmatic vision. Its fundamental reform was to introduce a 'hands-on' material approach to training (which had already been established in the Weimar Kunstgewerbeschule workshops) into architectural and fine art instruction.[74] For staff Gropius turned to artists, most of whom were Expressionists, associated at one time or another with Herwath Walden's Sturm Gallery. Berlin Expressionism was then seen as the modernism highly critical of Modernity, and closely associated with cosmic, occult, socialist and universalist notions.[75] Gropius succeeded in recruiting a staff that possessed a galaxy of talent unparalleled in the whole history of twentieth-century art education: Josef Albers (1888–1976), Herbert Bayer (1900–1985), Marcel Breuer (1902–1981), Johannes Itten (1888–1967), Wassily Kandinsky, Paul Klee (1879–1940), Ludwig Hirschfeld-Mack (1893–1965), Gerhard Marcks, Adolf Meyer (1881–1929), László Moholy-Nagy (1895–1946), Georg Muche (1895–1987), Oskar Schlemmer (1888–1943) and Gunta Stolzl (1897–1923), among others.

The key to Bauhaus reform was its Basic Course established by Itten who, as we noted earlier, was deeply interested in the occult and at the Bauhaus championed the mystical principles of the Mazdaznan sect. When Oskar Schlemmer joined the Bauhaus staff a year after Itten he reported that 'The Indian and oriental concept is having its heyday in Germany. Mazdaznan belongs to the phenomenon . . . The western world is turning to the East, the eastern to the West. The Japanese are reaching out for Christianity, we for the wise teachings of the East. And then the parallels in art. The goal and purpose of all this? Perfection? Or the eternal cycle?'[76]

Georg Muche, who joined the Bauhaus staff in 1920, was also

[73] Bauhaus 1959, p. 16.

[74] See Logan 1950, pp. 36–43.

[75] Long 1986, p. 201.

[76] Oskar Schlemmer Diary, 28 July 1921, in *Letters and Diaries*, pp. 111–12; quoted in Long 1986, p. 212.

interested in the occult and became Itten's close friend. Together they attended a Mazdaznan congress in Leipzig after which Itten sought to convert the Bauhaus to the cult's practices in diet and meditation. Donning a monk's robe and shaving his head, he encouraged them to read medieval mystics such as Meister Eckhardt, and eastern philosophies such as Tao and Zen. Outside his Bauhaus studio he erected a coloured glass spiral sculpture which he called the *Tower of Fire* (1919–20). It possessed a curious affinity to Tatlin's contemporaneous *Monument to the Third International*. According to Schlemmer it was Itten's favouritism to those who followed Mazdaznan practices that split the school into 'two camps'.[77]

Ludwig Hirschfeld-Mack, who was a student during those years, has left a vivid description of the time:

It was a very mixed crowd at the Bauhaus in the early days, but all united in one aim, the seeking of a new way of life, a new architecture and new surroundings and a definite negation of all those forces which had caused the First World War. Thus every kind of tradition became questionable, not only the traditional way of building houses and decorating them, but also education, clothing, food, everyday habits, even the manner of greeting each other and so on.

Experiments were made in gardening methods, in developing new food habits, styles of clothing, forms of dancing and music played on unusual, home-made instruments. We arranged and developed new kinds of festivals such as a kite festival when we marched in procession with hundreds of schoolchildren through Weimar to the top of a hill. The Bauhaus band led the procession and all the children made home-made kites. When we reached the hill a competition in kite flying was held. Masters, students and children made the kites in various Bauhaus workshops at the beginning of autumn each year. Every conceivable kind of kite was made and each was decorated with fantastic designs. There were lantern festivals when hundreds of lanterns made in the workshops were carried through the streets at night time to the market place. There were dances nearly every Saturday night when fantastic masks and costumes prepared by the theatre group were worn. These dances were held in gaily decorated halls and became so popular that many people from Weimar and nearby towns began to attend.[78]

[77] *ibid.*
[78] Hirschfeld-Mack 1963, p. 5.

The heady mix of avant-garde radicalism and educational reform was too much for the citizens of Weimar; Gropius, like the Pied Piper of Hamelin, was leading their children astray. The Bauhaus became the subject of concerted local attacks, partly as the result of bitterness aroused by Gropius's replacement of old Weimar art teachers who did not fit into the reform programme. Its students, it was said, were communists, foreigners supported by state money, mystical Expressionists, or wild Bohemians.[79] In February 1922 Gropius sent a circular to the staff warning them against 'wild romanticism', advising them not to cut themselves off from society or dress in outlandish costumes. Architects should behave like other people. Gropius was keen to gain independent support for the school by means of commissions for the design of industrial products. The emphasis began to swing away from handicraft to industrial design. In December 1921 Kandinsky had received an official invitation to visit the Bauhaus. After a difficult seven years in the Soviet Union, he left, as we noted, the Institute of Artistic Culture (Inkhut) and joined the Bauhaus in 1922, remaining on the staff until it was closed by Hitler in 1933. In 1923 Itten left. Teaching the Basic Course was given to László Moholy-Nagy, a Hungarian painter and sculptor. His appointment was symptomatic of the Bauhaus's transformation from its pioneering, mystical modernism into a highly effective educational instrument for the international dispersion of the Formalesque style. He mediated the move from the critique to the celebration of Modernity.

Moholy-Nagy taught and experimented with collage and photomontage, experimental film, theatre, industrial design and typography, together with painting and sculpture. With Gropius he co-edited the series of Bauhaus books by means of which the Bauhaus method was eventually spread across the world; 'things became more businesslike in every sense of the word: closer ties with manufacturing industry were established, and Bauhaus designs were increasingly used while . . . there was a concomitant decline in mysticism, metaphysics and the fancy dress that went with it'.[80] The first of the Bauhaus books fittingly enough was Gropius's *Internationale Architektur* (1925) followed by books by Klee, Schlemmer, Meyer, Moholy-Nagy, van Doesburg, Mondrian, Malevich and Gleizes, among others. As Banham neatly put it, 'They mark the emergence of the Bauhaus from Expressionist provincialism into the mainstream of Modern architecture, and the

[79] Long 1986, pp. 212–13.
[80] Banham 1960, p. 285.

new buildings at Dessau [1925–26] show that the school had moved into a position of undisputed leadership.'[81]

As the result of the increased opposition of the Government of Thuringia, which was responsible for financing the school, Gropius, the great majority of his staff and most of the students decided to close down the Weimar Bauhaus in April 1925 and accept the offer of Fritz Hesse, the farsighted mayor of Dessau, a small industrial city on the junction of the Elbe and the Mulde. Here Gropius designed a new building for the school which has been widely regarded as the first unquestionable masterpiece of the International Style, a building that achieved a new conception of architectural space, fluently, logically and rationally. At Dessau the school continued to flourish until 1928. A Bauhaus Corporation was established to handle sales to industry of models created in the workshops. Experimental designs originating in the workshops were developed as industrial products and reproduced all over the world, including carpets, fabrics, lighting fixtures, and the famous steel furniture perfected by Marcel Breuer. After nine years of inspired administration Gropius retired from the Bauhaus to resume private practice in Berlin. It was then directed by the Swiss architect Hannes Meyer (1889–1954) until 1930 and then by Ludwig Mies van der Rohe (1886–1969) until it was closed down by the Nazi regime in April 1933.

The Bauhaus method of training architects and designers overturned the two hundred year supremacy of École des Beaux-Arts training. In 1928 Gropius was instrumental in founding CIMA (Congrès Internationale d'Architecture Moderne). In 1937 he accepted the chair of architecture at the Graduate School of Design, Harvard, and in 1945 became involved with founding The Architects' Collective (TAC). Other members of the old Bauhaus staff followed him to the United States: Marcel Breuer in 1937; Herbert Bayer in 1938; and Moholy-Nagy in 1937, when he became the director of the New Bauhaus, in Chicago. Albers had already arrived in 1933. By the outbreak of World War II in 1939 Bauhaus methods and ideas had spread widely throughout the United States and were becoming known in Europe's colonial world.

THE UNITED STATES OF AMERICA

The institutionalisation of the Formalesque in the United States of America may be traced back to two semi-independent sources: a salon in Paris and a photographic gallery in New York. In 1903

[81] *ibid.*, p. 286.

Gertrude (1874–1946) and Leo Stein (1872–1947) set up house-keeping together at 27 rue de Fleuris, in the heart of Montparnasse. A year later they attended the 1904 Salon d'Automne and reacted warmly to paintings by Bonnard, Degas, Gauguin, Renoir, Toulouse-Lautrec, van Gogh and Vuillard. Leo was so enthralled that he penned an essay, 'L'Art moderne', in which he identified Manet, Renoir, Degas and Cézanne as the four leading lights of modern art. Whatever their individual differences, what is significant in our context is that Leo Stein located values which they held in common and which were generically distinct from the painting that had preceded them.[82] A few years before, after studying philosophy at Harvard and biology at Johns Hopkins, he had settled in Florence, met Berenson, and begun to write a biography of Mantegna. But it came to nothing. Instead the moderns focussed his brilliance. As is well known, the Steins created a salon in which Matisse, Picasso, Braque, Apollinaire, and many artists, poets and critics forgathered, usually on Saturday evening. Among them were several young expatriate American artists, including Patrick Henry Bruce (1881–1936), Charles Demuth (1883–1935), Marsden Hartley (1877–1943), Alfred Maurer (1868–1932), Walter Pach (1883–1958), Morgan Russell (1886–1953), Edward Steichen (1879–1973), Maurice Sterne (1878–1957) and Max Weber (1881–1961).

The photographic gallery was set up in New York by Alfred Stieglitz (1864–1946) at 291 Fifth Avenue. Stieglitz began life as an engineer but developed an enthusiasm for amateur photography at a time when the place of photography as an art was hotly debated. As early as 1859, as a result of pressure from its devotees, the French Government permitted a Salon of Photography to be displayed as a part of the Salon des Artistes Français. Its establishment aroused intense controversy. Baudelaire, despite his ardent advocacy of an art that reflected modern life, detested the innovation. 'I am convinced', he wrote, 'that the ill-applied progress of photography has contributed much . . . to the impoverishment of French artistic genius . . . If photography is allowed to stand in for art in some of its functions it will soon supplant or corrupt it completely thanks to the natural support it will find in the stupidity of the multitude.'[83] But neither Baudelaire nor the many critics who agreed with him could restrain the advocates of this new pictorial technology. By the end of the century photographic prints were being produced that sought to rival painting, a mode that came to be known as pictorialism. Stieglitz was a talented pictorialist, an

[82] See Stein 1950.
[83] Quoted in Scharf 1968, p. 110.

ardent champion of aesthetic photography. For him photography was a significant component of modern art.

But the relationship of photography to late nineteenth-century modernism, to the Formalesque painting that Stieglitz was about to welcome into 291, was paradoxical. The discovery of photography had changed the course of the visual arts. No longer was painting responsible for the accurate depiction of reality. Scientists could use photographs where they once used drawings and paintings. That is why Baudelaire felt that photography was getting beyond itself. 'It must return to its real task,' he wrote, 'which is to be the servant of the sciences and the arts, but the very humble servant, like printing and shorthand which have neither created nor supplanted literature.' But it was not to be. For, as we shall see later, though photography promoted the creation of the Formalesque by relieving it of its responsibility to mimetic naturalism, it also contributed to its fall from supremacy.

In 1900 Stieglitz met Edward Steichen, the young painter and photographer who made many trips to Paris between 1900 and 1914 and frequently visited the Steins. Stieglitz and Steichen formed a powerful team, both saw a parallel between the avantgarde opposition to academic art and the split opening up within photography itself. They became leaders in organising an exhibition of pictorial photography in New York (1902), entitled *Photo-Secession*, and in 1903 established the pictorialist journal *Camera Work*. When asked at the exhibition what 'secession' meant, Stieglitz replied, 'In Europe, in Germany and in Austria, there have been splits in art circles and the moderns call themselves Secessionists, so Photo-Secession hitches up with the art world.'[84] In 1905 they set up the Little Galleries of the Photo-Secession in Steichen's studio at 291. *Camera Work* soon became much more than a photographic magazine, publishing articles on Bergson, and work by Wilde, Maeterlinck, Kandinsky and Gertrude Stein. Stieglitz began to show the work of the first of the American Formalesque painters: Marsden Hartley (in 1909), Arthur Dove (in 1910), Georgia O'Keefe (in 1916, 1917 and 1926). If one person may become an institution, Stieglitz became America's first modernist institution. He created the inspirational oral gospel of early modernism . . . His commitment was unsullied by commerce: he didn't advertise exhibitions, never locked the gallery's doors, kept no records, accepted no commission from his artists, and sold work only to those he judged capable of appreciating it.'[85]

[84] Quoted in Newhall 1964, pp. 105–06.
[85] Watson 1991, p. 81.

The roles played by the Steins and Stieglitz in acclimatising the Formalesque upon American soil raises the general question of the relationship between an avant-garde and the institutionalisation of the aesthetic upon which its practice is grounded. In discussing this question in his essay *Manet and the Institutionalisation of Anomie*,[86] Pierre Bourdieu treats the institutionalising process as a negative affect upon creativity, irrespective of whether it is operating under the power of the state to control artistic freedom or on the other hand working towards a condition of anomie by annihilating all standards of value (such as the creation of the Salon des Refusés in 1863). But a wholly negative view of institutionalisation sets up a tension within Bourdieu's own concept of *habitus*, as a 'set of dispositions which generates practices and perceptions'.[87] For individuals may act creatively in the production of institutions, indeed as a catalyst or accoucheur, as, for example: Leonce Rosenberg in the case of Cubism; Lunarcharksy in the case of Russian Constructivism; Herwath Walden and Gropius, in the linked cases of German Expressionism and the creation of the Bauhaus; and here, in the case of the United States, the Steins and Stieglitz, in the avant-garde transplantation of the Formalesque to American soil. Such people with one leg, often creatively (e.g. Gertrude Stein), in the field of cultural production and the other in the world of power, politics, finance and patronage may help to transform dissenting modernisms into celebrations of Modernity. Their position in society does not involve them in that inversion of values, in Bourdieu's terms, by means of which creative artists and writers accumulate the symbolic capital upon which cultural fame and reputation rest. Patrons tend to be modernisers not modernists. Consider the case of John Quinn, the brilliant financial lawyer who helped to organise the Armory Show for the Association of American Painters and Sculptors in 1913. Quinn devoted a small fortune to art and literature, and by 1912 already possessed works by Cézanne, Gauguin and van Gogh. From the Armory itself he bought 'a whole heap of pictures' ranging from the Symbolism of Redon to the Cubism of Jacques Villon, and from the rostrum at its opening announced that 'Tonight will be the red-letter night not only of American but of all modern art'. During the next few years Quinn became the most powerful and influential patron of early

[86] Originally published as 'L'Institutionnalisation de l'anomie', *Les Cahiers du Musée national d'art moderne* 19–20 (June 1987), pp. 201–10; trans. in Bourdieu 1993, pp. 238–53.

[87] I have here used Randal Johnson's precise formulation of Bourdieu's concept, for the sake of brevity. Bourdieu 1993, p. 5.

American modernism. The work of a new generation of local artists began to appear in New York commercial galleries, such as Bruce, Demuth, Stanton McDonald-Wright (1890–1973), Georgia O'Keefe (1887–1986), Charles Sheeler (1883–1965) and Joseph Stella (1877–1946). Quinn succeeded in obtaining the removal of the fifteen per cent tariff on imported works of art. After the Armory Show, Henry McBride, an old friend and champion of Gertrude Stein, began his long career on the *New York Sun* as critical advocate of modern art and won a generation to the aesthetics of the Formalesque. However, the sudden success of modern art in New York disturbed Stieglitz profoundly. He had become accustomed to working in an embattled and oppositional position. He considered closing 291, thinking its mission complete. Even his closest friend, Edward Steichen, thought it had become 'history'. The few, short, bohemian years of New York modernism ended with the Armory Show. It entered a period after which it was transformed into a symbolic expression of the Modernity of the United States. Steven Watson's account of these stirring times in his attractive book *Strange Bedfellows* provides ample empirical evidence to support the theory of aesthetic valuing that Bourdieu enunciates in his essay 'The Market of Symbolic Goods' (1971).[88] How well, for example, do the roles played in the new-world, evangelising theatre of the modern by Gertrude and Leo Stein, Alfred Stieglitz, Marsden Hartley, John Quinn and Henry McBride, to name but a few of the principal players, exemplify Bourdieu's concepts of 'positions' and 'position-takings'.

> The position-takings which constitute the cultural field do not all suggest themselves with the same probability to those occupying at a given moment a determinate position in this field. Conversely, a particular class of cultural position-takings is attached as a potentiality to each of the positions in the field of production and circulation (that is, a particular set of problems and structures of resolution, themes and procedures, aesthetic and political positions, etc.). These can only be defined differentially, that is, in relation to the other constitutive cultural positions in the cultural field under consideration.[89]

The Formalesque, as we have seen, had produced its paradigmatic artists, such as Cézanne, Manet and Picasso, its gurus, like Frank Lloyd Wright and Gropius, its patrons, like Shchukin and the

[88] Bourdieu, 'Le Marche des biens symboliques', *L'Année sociologique* 22 (1971), pp. 49–126; trans. in Bourdieu 1993, pp. 112–41.
[89] Bourdieu 1993, p. 132.

Steins, but had not yet produced its art historians, by means of which it would be allocated its place and role in European art. If the Formalesque was to establish historical legitimacy, this was one of the essential 'positions' that, in Bourdieu's phrase, had to be 'taken'. The first art historian to embark seriously upon this task was Alfred H. Barr, Jr. (1902–1981), the son of a Presbyterian pastor of Baltimore. Alice Marquis, in her admirable biography of Barr, reveals him as a man in whom the missionary zeal and fund-raising genius of his father was transferred from the imperative needs of the Christian faith to the secular needs of modern art.[90] At Princeton, Barr read Charles Rufus Morey's course (1921) in medieval art, completed a thesis on Piero di Cosimo, then taught art history for a year at Vassar before embarking with a friend in the summer of 1924 upon a tour of Europe. Voracious for knowledge, they visited thirty Italian cities in as many days, listing each day the masterpieces glimpsed. At Harvard, Barr took Paul Sachs's pioneering course in museum management. While at Princeton his interest in modern art developed through reading magazines like *The Dial* and *Vanity Fair*, and visiting in 1921 an exhibition of Impressionist and Post-Impressionist paintings held at the Metropolitan Museum of Art, New York, containing many works from John Quinn's private collection. In 1925, while teaching traditional art history at Princeton, Barr organised his first art exhibition from works borrowed from friends and students. It included work by Redon, Degas, Vlaminck and Maillol. The following year he organised a loan show of modern work at the Fogg Art Museum, while teaching at Wellesley, and in the process developed a newspaper controversy with an article asserting that it was impossible for Boston students to study 'the great forerunners of the contemporary tradition: Cézanne, van Gogh, Seurat, Gauguin . . . masters honoured the world over', because Boston's galleries possessed no examples of their work. In 1927 he initiated a course in contemporary art at Wellesley, probably the first of its kind anywhere. Apart from fine arts, he discussed Marcel Breuer's chairs, African and Melanesian artefacts, and photographs by Steichen, Feininger and Man Ray. Students were asked to study, and assess aesthetically, buildings, automobiles, modern advertisements. In his Fogg show he mixed pioneering American moderns, Maurice Prendergast (1858–1924), Max Weber, Edward Hopper (1882–1967), Charles Sheeler, O'Keefe and Demuth with the Europeans, Pissarro, Monet, Seurat, Rousseau, Léger, Gris, Beckmann and Chagall. Before he left

[90] Marquis 1989.

Wellesley he gave five lectures on modern art, in which he described the ideal of a 'pure' art, total abstraction, relating it to architecture, photography, theatre, film, photography, typography, and decorative and commercial art. Child art, 'primitive' art, 'dream' art and the art of the mentally ill were discussed. Barr was already establishing himself as an arbiter of modern taste, reviewing books by possible rivals severely. In 1927 he made another trip to Europe with a friend, Jere Abbott. On this occasion it was to prepare a doctoral thesis on modern art. He submitted it twenty years later. Meanwhile he got around and met people who mattered: in London, Wyndham Lewis (1882–1957); in Holland, the architect J. J. Oud; in Germany, Gropius and most of the Bauhaus staff, including Moholy-Nagy, Schlemmer, Albers, Kandinsky, Bayer, Klee and Feininger. He and Abbott then spent three months in the Soviet Union, where he appears to have met Lunacharsky, Litvinov, Tatlin, Rodchenko, Lissitsky and Sergei Eisenstein (1898–1948). Although distressed by the chronic disorder, inefficiency and bureaucracy that prevailed everywhere in the Soviet Union, Barr considered his trip there 'the most wonderful experience of my life'.[91] He then toured Germany and Switzerland, to visit collectors and museums in Stuttgart, Frankfurt, Darmstadt, Mannheim and Basel. When his travel funds dried up he returned (steerage) to New York.

A year later Barr was appointed founding director of the Museum of Modern Art, New York. It grew from the interest that Mrs Abby Aldrich Rockefeller (heiress to one of the most lavish U.S. fortunes) and two of her friends, Lillie P. Bliss and Mary Sullivan, had developed during the 1920s for collecting modern art. As a result of their enthusiasm and the friendly advice of A. Conger Goodyear, a former president of the Albright Museum, Buffalo, it was agreed that a 'modern art' museum should be established. Paul Sachs's recommendation that Barr be appointed director was accepted. The founding committee consisted of some of the most wealthy collectors of modern art on the Atlantic seaboard and the opening exhibition held in November 1929 consisted mostly of works from their collections.

Barr brought an incisive intellect and copious but discerning taste to his directorship, but indifferent managerial skills. His preferences were cosmopolitan rather than nationalist. As in his teaching at Vassar and Wellesley, he took a broad view of the nature of art. Not only architecture, but modern design, photography and film,

[91] *ibid.*, p. 57.

became a feature of MOMA exhibitions, and its scholarly catalogues set out to endow modern art with an historical legitimacy it had not previously possessed. This had the result eventually of establishing historically what I have called the Formalesque style as the dominant style of the century. It was Barr who first described the architectural Formalesque as the International Style.[92] The broad outlines of twentieth-century art that he laid down in his MOMA books and catalogues such as *Cubism and Abstract Art* (1936), *Fantastic Art, Dada, Surrealism* (1937), *Picasso: Fifty Years of his Art* (1946) and *Matisse* (1951), with their accompanying exhibitions, became canonical. What he did not do himself his curators at MOMA were happy to do for him. By 1950 a MOMA history of modernism was well established and Barr became the leading world authority on twentieth-century art. H. H. Arnason's *History of Modern Art* (1968), which became the basic text for several generations of college students not only in the United States but throughout the world, closely follows the path laid down by Barr and MOMA.[93] It is ironic, but perfectly understandable, that it was published at a time when the hegemony of the Formalesque was beginning to be first seriously questioned. Minerva's owl takes wing at twilight.

The basic reason why the avant-garde art of the 1870s through to 1914 is still hypostasized as modern at the end of the twentieth century may well be the acquisition policy adopted by MOMA. During its early years the museum's shows were assembled almost entirely from the private collections of its members and friends. During its first six years, Barr spent only $1,000 in purchase funds.[94] But when Lillie Bliss died in 1931 she left an important collection that included work by Cézanne, Matisse, Modigliani, Picasso, Seurat, Redon, Renoir and others. That raised sharply the issue of a permanent collection. The sum of $600,000 was raised to support the endowment required to secure her bequest. Barr outlined to his trustees an acquisition programme that would be 'concentrated in the early years of the twentieth century, tapering off into the nineteenth'.[95] It was first assumed by both Goodyear and Barr that as works over time ceased to be modern they would 'find their way into . . . other museums'.[96] This was the way in Paris the Musée du Luxembourg functioned, syphoning off masterpieces no

[92] The third exhibition of the 1931–32 MOMA season, *International Modern Architecture*, established the term. It is conceivable that the title of Gropius's book *International Architecture* may have suggested the name.

[93] 'Arnason . . . jovially blamed Barr for getting him involved in the study of modern art at all' (Marquis 1989, p. 316).

[94] *ibid.*, p. 119.

[95] *ibid.*, p. 116.

[96] *ibid.*, p. 115.

longer 'modern' to the Louvre; so too the Tate Gallery in relation to the National Gallery, London. But Barr was cultivating a host of rich collectors with a view to enriching the permanent collection: 'it seemed unlikely that they would ever be disgorged from the museum collection, no matter how old they became. Furthermore the museum's benefactors were learning that a timely gift to the museum did wonders for the value of works by the same master still in their private collections.'[97] So for MOMA the 'modern' became everything, aesthetically satisfying, from the Impressionists to the present day. There were powerful financial reasons why it should remain so. If art is what is in art museums then what is in the MOMA permanent collection is ipso facto *modern* art. And what MOMA decided, the art world eventually accepted.

The introduction and reception of the Formalesque into the United States during the first half of the twentieth century raises general questions as to the nature of cultural imperialism. It is clear from the brief survey undertaken above that it cannot be viewed entirely as a repressive force, though it can act to suppress other cultures and aspects of an existing culture. Cultural imperialism operates quite differently in settler societies than it does upon the cultures of indigenous peoples. In the latter case an imperial culture normally operates to assimilate, neutralise or exterminate the culture of the indigenes. But in the case of settler societies, cultural imperialism acts as a *reinforcing* cultural agency acting most powerfully upon settler elites. The United States of America has become the most successful of all Europe's settler societies. Its mix of European migrants has created a local civil society that is far more multicultural than the European civilisation from which it largely derives, the latter never having succeeded in freeing itself from its tribal/national origins, despite the brittle solidarity provided by the Judeo-Christian religion and Graeco-Roman culture. The abiding cultural problem of settler societies has been to develop and nurture a national culture that is at once distinctive from its European origins while retaining its affiliation with European civilisation. But the moving frontiers of settler societies (both spatial and temporal), and their perpetual confrontation with the indigenous cultures they seek to displace or assimilate, together with the non-European environments in which they flourish, challenge, constantly and continuously, all settler-culture predispositions to Eurocentricity, which manifests itself as a nostalgic yearning for origins that affects all members of the society and even affects assimilated or partly assimilated indigenes.

[97] *ibid.*, pp. 118–19.

With this in mind it is possible to see cultural imperialism in settler societies not as something enforced and then tolerated, but as a fulfilment of cultural desire. The Steins, Stieglitz, Quinn, McBride, Barr, were all aware of a lack which they sought to fulfil. Only Europe could provide it. They saw themselves as civilisers seeking to enrich the settler culture into which they had been born. Without their work the culture would remain provincial, lacking the sophistication of its parent. Cultural imperialism acts in this way upon those of European ethnic origin. It is a hunger for an inverted exotic that reveals itself as the Janus face of the older, originating culture; one that seeks to console settler elites confronting their own displacement. But to embrace, to know and understand, the parent culture is not the kind of knowledge that comes from normal lived experience, like the culture of peasants or nomads. It requires education about, and travel to, historic 'homelands'. In consequence it becomes a hallmark of cultural status. In the United States it emerges and is most visible first in older and/or richer cities, such as New York, Philadelphia, Boston and Chicago, and among well-established families who can afford to collect the material artefacts of the older, originating European cultures, such as the Steins, Rockefellers, Cones and Arensburgs.

This is not the only way, however, in which, the modernism of the later nineteenth century, that is to say, the Formalesque, came to dominate the culture of the United States during the first half of the twentieth century. Nativist factors were also present from the beginning. Visual culture in the modern world is dependent upon the production of wealth. The transposition of the European Formalesque to American soil, from the Steins to the Rockefellers, depended in large measure upon inherited wealth. It is inherited wealth that seeks most ardently to appropriate the wealth of its own originary cultures. Locally produced wealth on the other hand tends to support locally based culture. The situation is of course at all times immensely complex. Inherited wealth will certainly support local culture but normally, because it tends to view culture as a universalism transcending the claims of locality or nation, it seeks its standards in the inverted exotic of Europe. To paint in a manner like Matisse is seen to express universal values. Culture grounded in local wealth will often support such transcendent values also as it seeks to identify itself with the cultural elites it envies. But its natural predisposition is to support native talent – the mirror of its own.

Relevant to this context is the case of Henry Ford (1863–1947), the industrialist who revolutionised factory production by

assembly-line methods. The technology of the assembly line, the direct product of U.S. inventiveness, capital accumulation and political clout, bore powerfully upon the relative autonomy of cultural production in the United States as it expressed itself in such institutions as the Museum of Modern Art. Yet it operated at a distance from those dominant aesthetic values.

Here once again architecture served as a catalyst. The modern architecture that the MOMA circle of taste-makers, Alfred Barr, Philip Johnson and Henry-Russell Hitchcock, most admired was that of Gropius and his European contemporaries, Erich Mendelsohn, J. J. Oud, Le Corbusier and Mies van der Rohe. They respected the work of Sullivan and Wright, of course, as early American masters of modern architecture, but in the influential MOMA *International Exhibition of Modern Art* (1932) it was the work of the European masters that became canonical to the creation of Barr's International Style. The work of Albert Kahn (1869–1942) was ignored. Yet it can be argued that the radical pragmatic functionalism of Kahn was a more profound expression of Modernity than the symbolic functionalism of Gropius and the Europeans. For Kahn, in his long years of service to Henry Ford's requirements, gave architectural expression, in his factory buildings, to assembly-line production and to the related time-and-motion studies of Frederick Winslow Taylor (1856–1915), the 'father' of scientific management.[98] The functionalism of Kahn's buildings was a much more direct expression of the economic needs and pressures of the dynamic world of U.S. industrial capital and political power than the relative autonomy of cultural production enjoyed by the artists canonised by MOMA. Kahn and Associates were the architects for the American automotive industry, designing Packard's buildings for thirty-five years, Ford's for thirty, and Chrysler's for twelve. Such 'nativist' modernism was also present in the photography and painting of the Precisionist Charles Sheeler. Although Sheeler frequented the Arensburg cenacle, where he met Picabia and Duchamp, his art is directed more towards the 'nativist' modernism associated with Ford than the cosmopolitan modernism associated with Arensburg, Barr and MOMA. Throughout his life Sheeler's photography and painting were inspired by commerce and industry. The skyscraper became the central icon of 1920s American nativist modernity. This is the time when a subtle dialectic begins to be played out in the United States between the modernist critique of Modernity as exemplified in the work of Duchamp's ready-

[98] On Kahn and Ford, see Smith 1993, pp. 57ff.

mades and Picabia's mecanomorphs, and the celebrations of American Modernity revealed in the work of Sheeler and his friend Morton Schamberg (1881–1918). Yet Picabia, on arriving in New York in 1913, had said, 'France is almost outplayed. It is in America I believe that the theories of the New Art will hold most tenaciously.' America he believed was 'the cubist, the futurist city'.[99] Here, once again, we may see how architecture and the imagery of architecture transforms the critiques of modernism into celebrations of Modernity. The dialectical tensions that emerge in the United States in the early 1920s are, however, not only between the critique and celebration of Modernity; they are also stimulated on the one hand by a universalising aesthetic originating in Europe and on the other by an emerging nativist aesthetic energised by the power of U.S. industrial capital and patriotic pride. Precisionist art takes over some of the Formalesque vocabulary of Cubism but links it with the 'new' art of photography – a mimetic art with a vengeance. So yet another dialectic arises, one that will continue throughout the century, between the abstract trajectory of fine art, derived from late nineteenth-century Europe, and the realisms immanent within the new technologies of photography and cinematography.

ENGLAND

When did the Formalesque style first secure a foothold on English soil? A convenient date might be November 1878 on the occasion of Whistler's successful libel action against Ruskin for his criticism of the artist's *Nocturne in Black and Gold: The Falling Rocket* (1874). Whistler defended his painting on formal grounds against Ruskin's insistence upon the priority of naturalism. 'I have . . . meant', he said, 'to indicate an artistic interest alone in my work . . . it is an arrangement of line, form and colours first.'[100] And in his famous 'Ten O'Clock Lecture' delivered at the Prince's Hall, London, in February 1885 he defended the view that art was a form of coding nature, not of imitating it. 'Nature contains the elements, in colour and form, of all pictures, as the keyboard contains the notes of all music. But the artist is born to pick and choose . . . as the musician gathers his notes and forms his chords.'[101] Here once again, the

[99] Quoted from Lucic 1991, pp. 28–29.
[100] Quoted from Farr 1978, p. 15.
[101] Quoted from Sutton 1963, p. 114.

Formalesque style, as we noted earlier, aspires to the condition of music.

But Whistler's farthing damages awarded against Ruskin was little more than a foothold. The Royal Academy exerted an exceptionally strong rearguard action in the defence of academic classicism well into the 1930s. The institutionalisation of the Formalesque in Britain was a gradual process in which official institutions played a relatively minor role. A significant change began with Roger Fry (1866–1934), a connoisseur with a special knowledge in Italian Old Masters, after he saw works by Cézanne in 1906. It converted him to 'modern art'. In 1909 he published 'An Essay in Aesthetics' in the *New Quarterly*. In it he distinguished the actual life from the imaginative life. The latter was characterised by an 'absence of responsive action'. Art was the chief organ of the imaginative life and was 'distinguished by the greater clearness of its perception and the greater purity and freedom of its emotion'. It was a neo-Kantian aesthetic, with a strong neo-classical stress on order and variety. Fry's position was simplified by his friend Clive Bell (1881–1964) in his little book *Art* (1914) in which he defined art as 'significant form'. It became a rubric by which the Formalesque was popularised in the English-speaking world during the next three decades.

English cultural life was characterised by its continuity. It did not encourage 'epistemological breaks'; the modern flowed from the not-so-modern; old institutions were adapted to new conditions. In 1917 the Report of the Curzon Committee of the National Gallery in London made it possible for the Tate Gallery (established in 1897 to collect and exhibit British Art) to acquire modern foreign art as well. This made possible the Tate's acquisition of important Impressionist paintings from the collection of Hugh Lane, such as Manet's *Musique aux Tuileries* and Post-Impressionist paintings, such as van Gogh's *Champ de blé et cyprès* from Samuel Courtauld.

Since then the Tate has become the principal British art museum for collecting and exhibiting contemporary art, and this work is housed under the same roof with works by Hogarth, Constable and Turner. Britain did not establish its Institute of Contemporary Art (as the result of the initiative of Sir Herbert Read) until 1947, and its Hayward Gallery, solely for temporary exhibitions of contemporary art, until 1968. Art history was not read at university level in England until the establishment of the Courtauld Institute of Art in 1932. Although modern art found a significant place in its curriculum, it was treated as part of a continuum of art history studies in

general, in sharp contrast to Alfred Barr's evangelistic role at MOMA for the Formalesque.

In painting, Whistler's victory over Ruskin was indeed a pyrrhic one. English painting produced only one great abstract painter in Ben Nicholson (1894–1982). Britain's major achievement in the Formalesque lies in its sculpture, in the works of Gaudier-Brzeska, Jacob Epstein (1880–1950), Barbara Hepworth (1903–1974) and Henry Moore (1898–1986). In Moore, Britain produced the greatest sculptor of the century; his profound response to the nature of the human condition transcended the formal austerities of his time.

The truth of the matter is that the Formalesque was never radically institutionalised in Britain. It existed as one contemporary trend among others. It did not dominate British criticism until colonised in admiration of the late Formalesque from the United States during the 1960s, as in the painting of John Hoyland (b. 1934) and the sculpture of Sir Anthony Caro (b. 1924). Its major painters opted for a peculiarly British kind of twentieth-century realism, quite distinct from the *neue Sachlichkeit*, in the work of Mark Gertler (1891–1939), Stanley Spencer (1891–1959), Francis Bacon (1909–1992) and Lucien Freud (b. 1922). Although their work was created under the sign of the Formalesque, it developed, as did Surrealism (to whom it sometimes owed much), in opposition to it. The transfigured ghost of John Ruskin's naturalism still seems to inhabit English soil.

8 The 1930s: Politics and the Formalesque

Until recently twentieth-century art historians largely ignored the 1930s.[1] Taking the aesthetics of the Formalesque as their valuing system, they virtually removed the decade from their histories. H. H. Arnason's most widely read of all such accounts[2] has nothing to say about the history of art in Germany or the Soviet Union during the 1930s, and, in his opinion, the quality of the art produced in the United States made it seem 'a bleak and reactionary time',[3] and he dismisses the Mexican muralists in a few brief paragraphs. The position of architecture is not dissimilar. Henry-Russell Hitchcock, who wrote the most widely read survey in English of nineteenth- and twentieth-century architecture,[4] has nothing of interest to say about the state of architecture under Hitler and Stalin. His treatment of twentieth-century architecture is written under the sign of the Formalesque – or as he called it, the International Style. For Arnason and Hitchcock, and many of the art historians who wrote during the Cold War, the 1930s are an aberration better forgotten.

However, it is now possible to see more clearly that the institutionalisation of the Formalesque during the 1920s did not result in its gaining popular approval. No longer creatively avant-garde, the Formalesque, during the 1930s, was still little more than an aesthetic embraced by an influential minority of artists, patrons, dealers, art historians and educationists of Europe and the Europeanised world. Those who lived their lives outside that relatively autonomous world of art responded sympathetically neither to its aesthetic nor to its universalist assumptions. They preferred arts that expressed their own sense of identity, whether personal, ethnic, tribal or national. When, during the 1930s, the political realm became all-powerful in Italy, Russia and Germany, and quite considerable in the United States, nationalism challenged the

[1] Recent studies to which this chapter is particularly indebted include Bown 1991, Hinz 1980, Hayward 1995, and Kaplan 1995.

[2] Arnason 1968.

[3] *ibid.*, p. 428.

[4] Hitchcock 1958.

supremacy of the Formalesque severely – but in the end unsuccessfully.

The decade places Bourdieu's description of the field of cultural production under strain. His idea of a 'cultural field' was mapped out largely from an explication of nineteenth-century French literature, notably of Flaubert, and the relative autonomy of the visual arts from the 1860s, a period that witnesses the emergence of the Formalesque. Although Bourdieu insists that the field of cultural production, understood as an ahistorical universal, must be modified in the light of changing historical contexts, it is a concept that can operate freely only within a social space protected by the presence of a civil society that accepts and has the strength to maintain a diversity of opinion between state power and civil polity. What Bourdieu does not make sufficiently clear is that the autonomy of the field of cultural production also depends upon the existence of a delicate balance between political and economic power. The 1930s challenge to the dominance of the Formalesque issued fundamentally from an imbalance between political and economic power. During much of the 1930s, political power, in many countries, sought to dominate, or at least to curb, economic power in the constitution of Modernity. The Formalesque was dependent upon a field of cultural production that was dominated ultimately by economic power, mediated through dealers' markets, their patrons and contiguous educational institutions. The erosion of economic power by political power during the 1930s radically altered the nature of the game. Economic power is universalist in its ambitions; it seeks to transcend national boundaries; in this it found a natural ally in the universalist aesthetic of the Formalesque. Political power, on the other hand, sought to promote national and, in its manic mode, imperial sentiment in the arts. It thus found itself out of sympathy with the relative autonomy of the cultural field's promotion of the Formalesque and sought to delimit its operations. One of the limitations of Bourdieu's analysis of the culture of Modernity is that it does not distinguish sufficiently between the dissimilar objectives of economic and political power as dominant fields within which the cultural fields are sustained within the polity of Modernity.[5]

[5] This was written before I read the Postcript to his most recent book, *The Rules of Art* (Bourdieu 1996, p. 343), entitled 'For a Corporatism of the Universal' in which Bourdieu notes that 'the very existence of the field of cultural production must reckon with obstacles and powers which are ceaselessly renewed, whether we are dealing with external powers such as the Church, the state and great economic enterprises, or internal powers, and in particular those which accompany control of the specific instruments of production and distribution (press, publishing, radio, television)'.

THE SOVIET UNION AND THE THIRD REICH

Stalin achieved supreme power in the Soviet Union in 1929; Hitler, in Germany, in 1933. Both the Russian and the German experience indicates that when political power acquires complete dominance over the economy the relative autonomy of the cultural field is markedly reduced, though never obliterated absolutely. This effect is particularly noticeable in that section of the cultural field which Bourdieu describes as the field of 'restricted' production, that is of 'high' art, wherein producers produce for the esteem of their co-producers, competing for prestige, consecration and celebrity rather than monetary profit and conventional fame. During the 1930s, 'high' art was particularly vulnerable in Europe to a politics of reaction that could marshall popular cultural sentiment against the avant-garde on the grounds that it was threatening the 'health' and unity of the nation. German culture continued to draw sustenance from its nineteenth-century roots, but its capacity for experimental development in avant-garde art was curtailed.

This was not owing to the inherent nature of fascism as such. In fascist Italy, Spain and Portugal avant-garde activity was less constrained than in Germany under Hitler. Yet the Nazi regime did not itself produce an art tailored politically to its ideology as the Soviet Union did with Socialist Realism. It promoted a conservatism in art that most of the public and indeed the majority of German artists favoured when Hitler achieved power. Hitler 'aestheticised' the political on a scale that had not been seen in Europe since the time of Robespierre's festivals to the Supreme Being. To do this it was not necessary to create new forms of art but to destroy resistant forms, and reinvigorate a popular culture grounded in nineteenth-century German traditions. Grandiose architecture and superbly organised mass rallies and pageants were drawn upon to provide a totally politicised expression of twentieth-century Modernity.

Consider a typical example. Back in 1854 August von Veit had erected his Glaspalast in Munich, in response to the new iron-wood-and-glass functionalism of the Crystal Palace, London (1851). It was destroyed by fire in 1931, two years before Hitler came to power. The Weimar Republic had launched a design contest for a new building which the National Socialists abandoned. A new building, called the House of German Art, was designed, with Hitler's active collaboration, by Paul Ludwig Troost (1879–1934), his first, trusted art adviser. The day Hitler laid the foundation stone was turned into a 'Day of German Art'. The style adopted was the

monumental nineteenth-century neo-classicism of Karl Friedrich
Schinkel (1781–1841).[6]

According to Albert Speer (1905–1981), his favourite architect,
Hitler took refuge in utopian fantasies. 'Speer,' he said, 'you know
I always wanted to be an architect. I wanted to make history not
with won battles but with buildings you and I designed together. It
will be like that . . . after we have won . . . we will build palaces and
glorious buildings. They will be monuments of our victory over the
Bolshevists.'[7]

Stalin was not so involved with architecture, but the results were
similar. Although at the onset of his tyranny a monument such as
Aleksey Shchushev's Lenin Mausoleum (1929–30) could still be
built in a fine 'stripped modernist' mode, the final design for the
Palace of the Soviets (1933–34), by Boris Iofan, Vladimir Shchuko
and Vladimir Gel'freykh, was created in a grandiose style that
combined neo-classical and Art Deco elements, topped by a huge
statue of Lenin. Although never built, it may be taken as an
example of Stalin's architectural taste. But not even power as
complete as that of Hitler or Stalin could eradicate fully, even for a
decade, the influence of the Formalesque. Though no longer domi-
nant, it did not cease to be influential. Matthew Bown has shrewdly
observed that the Palace of the Soviets' towering circular form
was an 'unmistakable echo' of Tatlin's *Monument to the Third
International*.[8] Moreover, both Hitler and Stalin accepted glass and
ferro-concrete for industrial construction, wherein a functional
engineering aesthetic prevailed and cultural values were not in
question. For traditional and monumental building they preferred
the symbolic language of classical architecture. 'Our Doric style',
Hitler said, 'is the expression of the New Order.'[9]

Like Le Corbusier drawing lessons from the architecture of
Greece and Rome, the Russian and Soviet architects of the 1930s, at
the behest of their political masters, deferred to classical precedent
in response to symbolic need. Hitler, like the Emperors of Rome and
Byzantium, was only too well aware of the political value of sym-
bolic architecture. For him the glass and steel constructions of Mies
van der Rohe belonged to the world of technology, not the world of
government. Cathedrals and opera houses were an aspect of gov-
ernment.[10] On one occasion he told Speer:

[6] Hinz 1980, pp. 5–6.
[7] Speer 1976, pp. 214–15.
[8] Bown 1991, p. 40.
[9] Speer 1976, p. 175.
[10] *ibid.*, p. 274.

The Church will come round. I know that crew of black crows well enough to see that. What did they do in England? And how about Spain? All we have to do is to apply pressure to them. And our great Movement buildings in Berlin and Nuremberg will make cathedrals look ridiculously small. Just imagine some little peasant coming into our great domed hall in Berlin. That will do more than take his breath away. From then on the man will know where he belongs.[11]

Architectural practice does not fit easily into Bourdieu's notion of a 'relatively autonomous field'. The architectural field, as we have noted, is bonded more closely to economic and political power than are the fields of literature, painting and sculpture. Not surprisingly, the architectural Formalesque became involved in Germany and Russia at this time in a dialectical interaction with the symbolism of classical architecture that was already foreshadowed in the Art Deco architecture of the 1920s.

Formalesque painting and sculpture were even more vulnerable. to reaction. Yet there was a moment in the early 1930s when Expressionism might have been integrated into the ideology of the Third Reich. As Jill Lloyd has noted, 'Before it became clear that conservative, neo-classical realism was to be the representative style of the Third Reich and the full-scale attack on modernism began, there was considerable support for Expressionism within the Nazi hierarchy.'[12] In the summer of 1933 when the National Socialist Party came to power, its League of German Students proclaimed their support for the Expressionism of Barlach, Heckel, Nolde and Schmidt-Rottluff. A year later, Gropius, Mies van der Rohe and Hans Peolzig entered the competition for a new Reichsbank in Berlin. When Mies van der Rohe won the prize Hitler intervened and awarded the commission to Heinrich Wolff's neo-classical design.[13] Emil Nolde (1867–1956), a member of Die Brücke during 1906–07, joined the Danish section of the National Socialist Party in 1933 or 1934[14] and remained a loyal Nazi for most of his life, continuing to seek support from party leaders during the war years even though over one thousand of his works were confiscated from German public museums by the Commission established under Adolf Ziegler, president of the Reich Chamber of Visual Arts. Indeed there was a deep strand of racial thinking in

[11] *ibid.*, p. 16.
[12] Lloyd 1991, p. 162.
[13] See Whyte 1996, p. 261.
[14] Lloyd 1991, p. 162.

Expressionist theory and practice itself; for example, in Wilhelm Worringer's identification in his *Formprobleme der Gotik* (1911) of the Gothic with a Nordic and Germanic abstract sensibility that was antipathetic to the classic Mediterranean south. But to this strand of proto-Nazi culture Hitler, oddly enough, was totally unresponsive. The Austrian Baroque of his youth appealed more to his personal taste than either German Gothic or Schinckel's Prussian classic. In consequence even the work of Impressionists like Corinth and all work by Expressionists were removed from German public museums. During 1933–34 Ziegler, with ruthless efficiency, purged every museum of its 'degenerate' art. Troost used Carl Einstein's book *Die Kunst des 20. Jahrhunderts* in the Propylaen art history series – then the most comprehensive contemporary survey of modern art – for identifying 'degenerate' artists.[15]

While there is no doubt that this attack upon the Formalesque was undoubtedly due largely to Hitler's own fanatic animosity, the cultural climate within which it flourished was the result of popular philistinism, mass ignorance, and the sinister intellectual legacy provided by the influential writings of de Gobineau, Nietzsche and Spengler. Alfred Rosenberg (1893–1946), the Nazi ideologist, listed Nietzsche as one of the 'personalities' to whom National Socialism was 'vitally and directly bound'.[16] And Oswald Spengler (1880–1936), though rejected by the National Socialists because of his pessimism, helped to prepare the ground for Hitler's fanaticism and welcomed Hitler's rise to total power. 'No one can have looked forward to the national revolution of this year with greater longing than myself.'[17]

To dramatise his own taste Hitler opened the *Great German Art Exhibition* in Troost's new House of German Art, Munich, on 18 July 1937, accompanied by a folkish pageantry that illustrated two thousand years of German culture. Some six hundred thousand attended the exhibition. In his opening speech he claimed that it laid the foundations 'for a new and genuine German art'.

Nine hundred works were chosen from fifteen thousand submitted in response to a national competition designed to constitute 'a high-quality display of contemporary art'. Hitler himself apparently played some part in the final selection, adding a number that had not been selected by the judging panel and rejecting

[15] Hinz 1980, pp. 24–25.

[16] Alfred Rosenberg, *Gestaltung der Idee*, 1937, p. 18; quoted in Rader 1939, p. 149.

[17] Oswald Spengler, *The Hour of Decision*, trans. C. A. Atkinson, New York, Knopf, 1934, p. ix; quoted in Rader 1939, pp. 279–80.

about eighty others with the comment, 'I won't tolerate unfinished paintings.'[18]

A contemporary review provides us with some idea of its contents:

> Most of the painting shows the closest possible ties to the Munich school at the turn of the century. Leibl and his circle and, in some cases, Defregger are the major influences on many paintings portraying farmers, farmers' wives, woodcutters, shepherds, etc., and on interiors that lovingly depict many small and charming facets of country life. Then there is an extremely large number of landscapes that also carry on the old traditions. In these paintings, and indeed in all the paintings in this exhibit, sketchiness has been rigidly eliminated. Only those paintings have been accepted that are fully executed examples of their kind and that give us no cause to ask what the artist might have meant to convey. We also find a rich display of portraits, particularly likenesses of government and party leaders. Although subjects taken from the National Socialist Movement are relatively few in number, there is nonetheless a significant group of paintings with symbolic and allegorical themes. The Führer is portrayed as a mounted knight clad in silver armour and carrying a fluttering flag. National awakening is allegorised in a reclining male nude, above which hover inspirational spirits in the form of female nudes. The female nude is strongly represented in this exhibit, which emanates delight in the healthy human body.[19]

In order to dramatise and contrast the new 'degenerate' culture, 112 works were chosen from among the thousands sequestrated from the public museums. They ranged from 'sketchy' Impressionist paintings by Corinth through German 'modernism' from Paula Modersohn Becker to such well-known artists as Feininger, Dix, Grosz, Klee, Kokoschka, Marcks, Macke, Nolde, Pechstein and Schmidt-Rottluff. The *Great German Art Exhibition* had been housed in the fine rooms of the new House of German Art. This 'degenerate' art was 'crowded together' in an adjacent old building in 'long narrow rooms', the paintings 'plastered from floor to ceiling', hung 'helter skelter' without any sense of order and 'provided with inflammatory labels, commentaries and obscene jokes'.[20]

[18] Hinz 1980, p. 9.
[19] J. Wulf, ed., *Die Bildenden Kunste im Dritten Reich*, 1963; quoted in Hinz 1980, p. 16.
[20] Hinz 1980, p. 40.

Hitler spent much of his opening speech at the *Great German Art Exhibition* deriding the show in the adjacent building:

Art can in no way be a fashion . . . Cubism, Dadaism, Futurism, Impressionism, etc., have nothing to do with our German people. For these concepts are neither old nor modern, but only the artifactitious stammerings of men to whom God has denied the grace of a truly artistic talent, and in its place has awarded them the gift of jabbering or deception. I will therefore confess now, in this very hour, that I have come to the final unalterable decision to clean house, just as I have done in the domain of political confusion, and from now on rid the German art life of its phrase-mongering.[21]

Although monumental architecture, painting and sculpture were delivered, under Hitler, back to their German neo-classical sources, industrial design and the decorative arts retained and developed much that Constructivism and Bauhaus-informed art education under the Weimar Republic had provided. A notable example is the streamlined designing of the Zeppelin airships of the 1930s. In the deck of the LZ 129 Zeppelin (1936), designed by Fritz August Breuhaus (1868–1960), the influence of the Bauhaus persists. He had already supervised the designs of the ocean liners *Bremen* (1929) and *Europa* (1930) before Hitler came to power.[22] In 1935 Wilhelm Wagenfeld (b. 1900), a student under Moholy-Nagy and later a teacher at the Bauhaus, was appointed director of Lausitzer Glaswerke (VLG) in Weisswasser until 1944. He became famous for his well-designed, pressed glassware made for everyday use. Though no Nazi, Wagenfeld was appointed a member of the organising committee for the German Pavilion at the 1937 Paris International Exposition.

In the Soviet Union, Socialist Realism was not the child of Stalin in the way that the campaign against 'degenerate' art was the evil brainchild of Hitler. It had its source in the 1920s in conservative aesthetic opposition to the work of the Russian Constructivists. The Association of Artists of Revolutionary Russia (Akhrr) was formed as early as 1922. Its first chairman, Pavel Radimov (1887–1967), had been a former member of the Wanderers. It espoused a revolutionary realism, and 'catered to the taste of Lenin and most of the party elite'.[23] Its manifesto stated that it would 'provide a true

[21] From Hitler's speech published in *Die Kunst im Dritten Reich* (Munich) 1, nos. 7–8 (July–Aug. 1937), pp. 47–61; trans. Ilse Falk and quoted in Chipp 1968, p. 479.

[22] Heskett 1995, pp. 262, 269.

[23] Bown 1991, p. 33.

picture of events and not abstract conceptions discrediting our Revolution in front of the international proletariat'.[24]

Setting itself against the 'constructivist' avant-garde, by the mid-1920s it had become the most influential body of artists in the Soviet Union.[25] Lunacharsky, the pluralist, ever responsive to the aesthetic preferences of his political masters, supported Akhrr's programme when he opened its seventh exhibition in 1925. The proletariat, he said, needs 'the great social *kartina*, which will be the start of a new era in art'.[26] Isaac Brodsky (1883–1939) pioneered this revolutionary antitype of history painting, in such works as *The Shooting of the Baku Commissars* (1925) and *Lenin in Smolny* (1930), paintings designed to stimulate revolutionary sentiment and appeal to a mass audience. Brodsky's work raises interesting taxonomic questions. How should we place him in relation to modernism and Modernity? He had exhibited in the Salon d'Automne of 1909 and his work derived inspiration both from French models such as David, and from Repin, the 'Wanderer'. Repin was a realist who, like Courbet, first painted in opposition to the political hegemony of his day. To the extent then that modernism is a critique of Modernity, both Courbet and Repin may be viewed as among the modernists of their day. But if we incline to a purely formal taxonomy, that is to say to the aesthetic of the Formalesque, Brodsky will be classed as reactionary, as one incapable of keeping up with the formal changes in the art of his times. On the other hand, if we take a dialectical view and consider his art in relation to the power structure within which he practised, he may be seen as neither modernist nor reactionary but as an approved painter of Modernity whose work sought to conform to the economic needs, political demands and expectations of his society. To adopt such a dialectical view one must abandon the notion that art progresses experimentally in a unilinear fashion wholly determined by immanent potential techniques implicit in its practice and substitute a valuing system that relates aesthetic value to an interactive relationship conducted at the interface between economic and political power on the one hand and immanent artistic practice on the other. On this view Socialist Realism as practised in the Soviet Union during Stalin's ascendancy is modern but not modernist. It offered no critique of his tyranny. It was all for his Modernity.

[24] *ibid.*

[25] See John E. Bowlt, 'Association of Artists of Revolutionary Russia', in Dictionary 1996, vol. 2, pp. 633–34.

[26] Bown 1991, pp. 46–47.

In the ideological construction of Soviet Modernity, photography and film, the new visual technologies, played a crucial role. In 1922 Lenin had advised Lunacharsky: 'You must always remember that of all the arts the most important for us is the cinema.' Films should be 'imbued with Communist ideas and [reflect] Soviet reality'.[27]

But, as Brandon Taylor has noted, there was a paradox there: 'the actual-as-actual of the documentary excludes the future', whereas 'imag(in)ing the possible or theoretical future [i.e. 'Communist ideas'] seems to exclude the here-and-now'.[28] How did Socialist Realist painters solve the paradox. Quite simply. They used photos and touched them up. When Brodsky painted *Lenin Giving a Speech to Troops . . . on May 1920*, in 1933, that is after Stalin came to supreme power, he used an old photograph that included Trotsky and Kamenev standing by Lenin's rostrum. But their images were excluded from the painting. Socialist Realism involved the retouching of history.

Not all Soviet artists agreed with Akhrr's programme. The October Group formed in 1928 considered realism to be bourgeois. It called for 'the method of dialectical materialism in the creative practice of proletarian artists'. Its members included architects, sculptors, painters, graphic artists, industrial designers, photographers and film makers, such as Alexandr Deineka (1899–1969), Gustav Klutsis (1885–1938), the Vesnin brothers and Eisenstein. It represented the last gasp of the Soviet avant-garde. With Stalin's rise to absolute power, all the artists' groups were formed into a single union, with regional sections in the main cities Moscow, Leningrad, etc. It was the Moscow section of the union (Mosskh) that came to assume national responsibility and wield supreme power. All of this supports the view that art, even in a tyranny, is the creation of cities rather than nations. Under Mosskh, Socialist Realism came to prevail as official doctrine. The term, apparently, first appeared in print in 1932, and Maxim Gorky published an important article in the following year entitled 'On Socialist Realism', describing it as an art that could only be created from the 'data of socialist experience'. It was said that Stalin himself suggested the term at a party in Gorky's apartment in 1932. Gorky's description implied that it could only be practised in the Soviet Union. But the term was soon given a universalist, imperial role. 'Comrade Stalin's words of genius about Soviet art as an art of socialist realism represents the peak of all progressive strivings of

[27] Taylor 1996, p. 250.
[28] *ibid.*

the aesthetic thought of mankind.'[29] Given official sanction by the Comintern, Socialist Realism became the only form of art given unqualified approval by communist parties throughout the world. It came to play a significant role in colonial liberation movements world-wide while retaining, in the Soviet Union itself, an official role that effectively censored all other forms of artistic practice. Both synchronically and diachronically Socialist Realism could serve the cause of liberty *and* respond to the requirements of tyranny. Its values cannot be assessed in a purely formal or moral way. It needs to be viewed dialectically with respect to the fields of political and economic power and artistic practice within which it operates.

In the Soviet Union itself the life of the artist lived under the domination of Socialist Realism became, from a creative point of view, subhuman and fraught with peril. Matthew Cullerne Bown has described in detail the persecution harassment, banishment or execution that many had to endure, particularly in the aftermath of the show trials of 1937.[30] Here one must stand for many: the case of Nikolay Punin (1888–1953), art historian and critic, theorist and museum curator. Prior to the Revolution of 1917, he was one of the first scholars to develop a critical appreciation of old Russian painters. After that he helped to organise Narkompros and directed its Department of Fine Arts (IZO) and was one of the founders of Inkhuk. He wrote a history of European art from the third to the twentieth century and monographs on Tatlin, Larionov and other contemporary, as well as nineteenth-century, Russian painters. From 1944 to 1949 he was professor of art at Leningrad University. 'On 26 August 1949 he was arrested without charge and sent to a concentration camp near the Arctic circle where he died [in 1953].'[31]

During the post-war years the Stalin cult (until his death in 1953) turned Socialist Realism into an efficient suppressive instrument of state power. Andrey Zhdanov (1896–1948), the close friend of Stalin who had led the defence of Leningrad during the German siege of the city (1941–44), became Leningrad's political boss in the post-war years and issued a series of suppressive decrees on culture between 1946 and 1948. They produced the time known as *zhdanovshchina*, sustained until Khrushchev's speech to the 20th Congress of the Communist Party of the Soviet Union of 1956, in

[29] From 'Khudozhnik Grazhdanin', *Tvorchestvo* 11 (1939), pp. 2–3; quoted in Bown 1991, p. 89.

[30] Bown 1991, pp. 126ff.

[31] Alla Rusakova, 'Punin', in Dictionary 1996, vol. 25, pp. 735–36.

which the extremes of Stalin's tyranny were made known to the world. *Zhdanovshchina* was a period of great repression, exacerbated by the Cold War. Cosmopolitanism was ruthlessly condemned. All influences, such as 'sketchy' Impressionism from the 'west', were suspect. Russian chauvinism prevailed. Any art revealing 'national' tendencies in the non-Russian republics of the Union was condemned. The cultural imperialism imposed within the Soviet Empire was more ruthless than anywhere else in the twentieth-century world.

FASCIST ITALY

In fascist Italy, though political dissent was ruthlessly suppressed, more social space for the autonomy of its art world was provided than in Nazi Germany or the Soviet Union. When Mussolini assumed power in October 1922 most of the surviving Futurists publicly supported him. That helped to sustain some plurality in fascist art policy. Giuseppe Bottai (1895–1959), Minister of Corporations from 1929 to 1932, Governor of Rome in 1935–36, and Minister of National Education from 1936 to 1943, played a comparable role to that of Lunacharsky in the Soviet Union during the 1920s, but more successfully, maintaining a policy of liberal pluralism for art during most of the regime.

In consequence, the Formalesque came to be accepted generically as a modern period style during the fascist regime. Cézanne and the artists he influenced became acceptable. In 1920 the policy of the Venice Biennale changed significantly: Cézanne was shown in the French pavilion, Archipenko in the Russian. In 1922, the year Mussolini came to power, works by Modigliani, Bonnard, Denis and Bernard were displayed. In 1924 Degas appeared and Gauguin; in 1932, Matisse, Toulouse-Lautrec, van Dongen, Zadkine and Monet. So it was that Venice under fascism proudly displayed the French masters of the Formalesque until the beginning of World War II. Although the periodical *Valori plastici* (1918–21), founded in Rome by Mario Broglio, ran a strong 'Call to Order' line, it continued to bring news of the French avant-garde. The war brought change. The 1942 Biennale was given over to the support of the war effort and Goebbels was in official attendance as Nazi Minister for Propaganda.

The Formalesque had emerged, as we have seen, as an avant-garde utterly opposed to academic classicism. Yet classicism in a more general sense, and in one or other of its protean modes, was

never far from its centre. Predicably, under fascism, it took the form of an adoration of the grandeur of Imperial Rome, invoked as the avatar of civilisation, with Italy its true and only protector. It was a case once again of a national culture taking on the mask of civilisation for its own purpose. The Futurists argued for a 'spiritual' imperialism in such tracts as *Futurist Democracy*.[32] The myth of *Romanita* 'evolved from an expression of national pride to a justification for colonial empire and "universal" fascism . . . especially after the invasion of Ethiopia in 1935'.[33] But unlike the Prussian classicism of Germany, Italian classicism under fascism was deeply inflected by avant-garde attitudes. Futurism and its successor, the Metaphysical painting of Giorgio De Chirico (1888–1978) and Carlo Carrà (1891–1966), endowed classicism with an ironic mask. Both painters, like Picasso, felt the powerful political thrust of the 'Call to Order' during the immediate post-war years, and their response, like his, was subtle. They had met in a military hospital in Ferrara in 1917. Out of it came for them a 'new way of seeing' which they called the Pittura Metafisica. From his deep immersion in the work of Arnold Böcklin (1827–1901) and Max Klinger (1857–1920), his readings in Nietzsche and Schopenhauer during his Munich years (1906–10), and the traumas of his childhood, De Chirico created a revolutionary, dream-like art that used the language of classicism, not to reinforce the values of the Academy, but to mock them. In his work, perspective ceases to be a scientific device and becomes a visual metaphor; architecture takes on the semblance of dream. The classical heritage is retained by a tour de force that empties it of its traditional tropes and reinvents it as enigma. Although De Chirico is obviously, stylisticly, a Formalesque painter, his work is among the first to challenge its privileging of form. Before a De Chirico, formal relationships dissolve into labyrinths of signs; the hegemony of form gives way before vertigos of meaning. In this he is a harbinger of twentieth-century modernism. Yet it was achieved as Italian fascism consolidated its political power, and the 'Call to Order' challenged the supremacy of Cubism.

In the decorative arts the Formalesque continued to prevail. Art Nouveau (or *Stile Liberty*, as it was generally known in Italy) became fashionable after its official recognition in the International Exhibition of Modern Decorative Art held at Turin in 1902. The brilliant wrought-iron work of Alessandro Mazzucotelli (1865–1938) maintained its supremacy well into the 1920s. The Paris Exposition of

[32] Marinetti, *Democrazia Futuristica*, Milan, 1919; quoted in Braun 1990, p. 346.
[33] Braun 1990, p. 345.

1925 popularised Art Deco in Italy among the groups known as the Novecento Italiano and the Rationalists. They developed a 'stripped' classicism that found favour with Mussolini. In relief sculpture, wrought iron gave way to aluminium. It was used brilliantly by Ernesto Michahelles (1863–1959; known as Thayaht), a Futurist who produced the *Friendship Triptych* (1932), a highly effective expression of fascist ideology which reveals, if anything does, the survival of the Formalesque style under Mussolini. So too do the 1930 designs in aluminium (strongly influenced by the work of Marcel Breuer, Mies van der Rohe and Le Corbusier) of Giovanni Ponti (1891–1979).[34] Although the Formalesque under fascism was strongly inflected by the art of ancient Rome, it is a flattened and linear Roman style that reveals the dominance of the Formalesque as the period style of the epoch. It is revealed admirably in the poster advertising the exhibition *L'Art Italien XIXe–XXe Siècles*, held in the Jeu de Paume, Paris, in 1935 designed by Umberto Brunelleschi.

MEXICO

During the 1930s the Formalesque aesthetic was severely challenged in Mexico and the United States. From 1910 to 1920 Mexico experienced a series of revolutionary crises sparked initially by popular dissatisfaction with the policies of Portifiro Diaz (1830–1915), whose administration favoured landowners and rich industrialists. The time of troubles continued until Lazaro Cardenas took office in 1934 and at last legitimised the constitution that had been written under President Venustiano Carranza in 1917. It confiscated land from wealthy landowners, guaranteed workers' rights and limited those of the Catholic Church.

The Mexican Revolution developed its momentum prior to the Russian revolutions of 1917, and the artists caught up in its rationale were obliged to confront not only a class but also an ethnic divide between privilege and poverty. The presence of both the mestizo (part Indian) and the indigenous Mexicans offered a significantly new challenge to the universalist assumptions implicit in the Formalesque aesthetic. The distressed social conditions and the turbulent politics of the times encouraged the growth of social realism in the graphic arts. Despite severe government censorship, a vigorous tradition of political satire flourished in the newspapers

[34] De Guttry & Maino 1995, pp. 169–93.

and illustrated periodicals during the later nineteenth and early twentieth centuries. At the centre of this tradition is the work of José Guadalupe Posada (1851–1913), who produced about 20,000 prints in lithography and etching satirising wealth, hypocrisy and power. He died in penury but his work stimulated and bonded the revolutionary activities of the Mexican muralists. The seeds of what is now sometimes called postcolonialism lie in the graphics of Posada. The Mexican Revolution provided a social space for a popular art quite distinct from the enforced 'popularism' of Stalin and Hitler. While still a student at the San Carlos Academy, Mexico City, Diego Rivera (1886–1957) became acquainted with the cartoons and engravings of Posada, and his career developed in a kind of negative dialectic to the Formalesque. To begin with, it was typical of that followed by hundreds of talented colonial artists of European or part-European descent since the invasion of the Americas. Trained in post-Renaissance techniques of drawing and painting in colonial schools and ateliers, they hungered for study in the great art centres of Europe – Rome, Madrid, Paris, London – and for an opportunity to study the European masters, particularly the Renaissance masters, upon which their studies had been grounded. In Rivera's case it was a sympathetic governor of Vera Cruz who provided a stipend that enabled him to study in Spain during 1908–09. While in Europe he visited Italy and was profoundly affected by the mural art of the Renaissance. Arriving in Paris in 1914 he soon (a Spanish speaker) made contact with Gris and Picasso, and from 1915 was one of the leading Cubist painters of Paris, 'constructing figure paintings and still-lives with flat elementary shapes and resisting the consistency of perspectival spaces'.[35] He became one of the Cubists supported by Leonce Rosenberg's Galérie de l'Éffort Moderne. Like many artists of the time he became fascinated by the possibility of capturing the 'fourth-dimension' in his paintings, and experimented with a device he called 'la chose', a viewer that provided multiple refractions of light, conceivably envisioned as glimpses of a 'fourth-dimensional' reality. Working with this contraption may have brought him back to a closer study of the objective world. He also continued to draw realistic portraits, as did Picasso and other Cubists, under the impact of the 'Call to Order'.[36] In 1918 he became associated with Ozenfant, Jeanneret and Lhote in Louis Vauxcelle's campaign in Le Carnet de la semaine against Cubism, which asserted that it was no more than a passing phase

[35] Green 1987, p. 7.
[36] See Favola 1984.

even with artists like Picasso.[37] But it was Rivera (impelled by
ethnic, national and revolutionary sentiment) who abandoned
Cubism more thoroughly than any of his former colleagues. In
1919 he met David Siqueiros (1896–1975) in Paris and they dis-
cussed the need to transform Mexican art. Siqueiros had also
trained in the San Carlos Academy and had served in General
Carranza's armed forces against Diaz. After he become the first
president of the new Republic, Carranza had sent him to Europe on
artistic and diplomatic duties. Rivera and Siqueiros discussed the
need for a new art that would relate positively to Mexico's new
political programme.

In 1922 Rivera returned to Mexico to a post-revolutionary situa-
tion and began his well-known mural paintings. He became one of
the first modern artists to develop a postcolonial mode of the
Formalesque that drew upon both the Formalesque and the
Renaissance mural in the cause of revolution.

Rivera's postcolonial turn was made possible by a remarkable
man, José Vasconcelos (1882–1959), philosopher and educationist,
who called for a synthesis of Mexican society based upon the
indigenous culture. His five-volume autobiography (1935–59) is a
major sociocultural study of twentieth-century Mexico.[38] After
serving as rector of the University of Mexico he was appointed
Minister for Education (1920–24) by President Obregón. Following
Comte, Vasconcelos believed that society passed through three
stages, the theological, the metaphysical and the positive, and that
Mexico was entering upon the third, within which the aesthetic
would be an essential component. He also believed that for
Mexicans the *visual* aesthetic was the most popular and influential.
So he set up a mural programme for the schools and colleges in his
mandate and gave the artists commissioned freedom to work in any
style and with any themes. In consequence Mexico was able to
provide a social laboratory for a political modernism where Russia
and Germany failed. Rivera and Siqueiros became the two most
politically committed artists of the century. Both professed commu-
nism; but that did not mean agreement. Rivera became a friend of
Trotsky; Siqueiros, a supporter of Stalin, and he was seriously
implicated in an attempted assassination of Trotsky in 1940.

Rivera returned to Mexico in 1921; Siqueiros a year later. The
mural movement began when Vasconcelos gave them and others

[37] Green 1987, pp. 8–9.
[38] Published as *Ulises Criollo* (1935), *La Tormenta* (1936), *El Desastre* (1938), *El
Proconsulado* (1930), and *La Flama* (1959); and abridged as *A Mexican Ulysses* (1962).

the walls of the National Preparatory School (ENP), Mexico City, to paint on. Pre-conquest Mexican cities had been covered with murals. Rivera saw some when he visited Chichén Itzá with Vasconcelos shortly after arriving back in Mexico. This presence of a pre-Renaissance artistic tradition in Mexico pointed up the difference that all modern artists had to confront in colonial and postcolonial situations, the presence of an indigenous society, ethnically, linguistically, socially and traditionally different. The Mexican mural movement was the first significant major visual arts programme of the twentieth century fully to confront such a situation. Vasconcelos was seeking a fusion of the pre- and post-Hispanic cultures as a way towards the social and political emancipation and the redemption of his society. The muralists were in broad agreement and tended to stress the historic class and ethnic divisions that permanently divided the nation. Towards this end they championed a public art (murals) against the bourgeois art of easel painting, a position made with passion by Siqueiros, in 1922 in his 'Declaration of Social, Political and Aesthetic Principles' for the Syndicate of Technical Workers, Painters and Sculptors:

> The Syndicate of Technical Workers, Painters and Sculptors directs itself to the native races humiliated for centuries; to the soldiers made into hangmen by their officers; to the workers and peasants scourged by the rich; and to the intellectuals who do not flatter the bourgeois . . .
>
> The noble work of our race, down to its most insignificant spiritual expressions, is native (and essentially Indian) in origin. With their admirable and extraordinary *talent to create beauty, peculiar to themselves, the art of the Mexican people is the most wholesome spiritual expression in the world* and this tradition is our greatest treasure. Great because it belongs collectively to the people and this is why our fundamental aesthetic goal must be to socialise artistic expression and wipe out bourgeois individualism.
>
> We *repudiate* so-called easel painting and every kind of art favoured by ultra-intellectual circles, because it is aristocratic, and we praise monumental art in all its forms, because it is public property.[39]

However, Rivera's first major mural in the auditorium of the ENP, entitled *Creation* (1922), conformed to Vasconcelos's preference for an allegorical, neo-classical style, almost Pre-Raphaelite in mood,

[39] Harrison & Wood 1992, p. 388.

and influenced by Rivera's admiration for the paintings of Giotto, Michelangelo and other muralists which he had studied on a seventeen-months' tour of Italy before he returned to Mexico.

One of the signatories to the Declaration of the Syndicate was José Clemente Orozco (1883–1949), probably the most powerful and talented of all the muralists. Unlike Rivera and Siqueiros, Orozco had never been to Europe but had learned from its Renaissance lessons. After being taught architectural drawing in the Academia S. Carlos, and art from 1906 in the Academia de Artes, Orozco began his career as a cartoonist. His mature style emerged dramatically in the magnificent five-year mural programme on which he was engaged at the ENP from 1922 to 1927. It has nothing of the academic neo-classicism of Rivera's *Creation*; it is an earlier, harsher, more realistic classicism, influenced in part by Masaccio and Giotto. Yet it is a contemporary art. Orozco rejected not only Cubism as an exotic French importation but also the decorative folksiness of the hybrid style resulting from a mix of Mayan, Aztec, Parisian and Spanish Colonial themes that Rivera preferred. He sought for a revolutionary art that carried conviction by means of its expressive thrust, moral force, and dark, powerful rhythms. Orozco was, in a sense, a home-grown product. He did not visit Europe until 1934, well after much of his best early work had been completed. His creative need was utterly distinct from the European modernism of a Picasso. He had no desire to reject classicism in order to define his own style. His need was for the scale and power of early Renaissance art in order to capture the revolutionary mood of contemporary Mexican society. His work is a exemplary postcolonial mode of the Formalesque style put to a revolutionary purpose.

Like their Soviet, Constructivist, contemporaries, the Mexican muralists of the early 1920s were ahead of popular taste. Orozco's murals were continually defaced by conservative students of the ENP. Obregón's relatively peaceful four-year presidency came to an end in 1924, when Vasconcelos also retired. Commissions were withdrawn and the first phase of the mural movement came to an end. The centre of mural activity moved to Guadalajara, where the governor continued to commission murals from Siqueiros, Orozco and others. However, Rivera was permitted to continue the cycle of murals he had begun in the Ministry of Education, Mexico City (1923–29).

Rivera worked in a flattish, decorative and highly colourful manner to depict the history and culture of Mexico in terms of

Marxist ideology. The work testifies to both his Cubist affiliations and his admiration for Renaissance art. It is unquestionably a personal mode of the Formalesque dialectically engaged with an iconography that expresses a utopian vision of a socialist future for the whole of Mexican society. It may therefore be fittingly described also as a mode of Socialist Realism; a Socialist Realism *avant la lettre* of Gorky, Stalin and Zhdanov. Octavio Paz put it in a nutshell: 'these works that call themselves revolutionary, and that in the cases of Rivera and Siqueiros expound a simple and Manichean Marxism, were commissioned, sponsored and paid for by a government that was never Marxist and ceased being revolutionary . . . [T]his painting helped to give it a progressive and revolutionary face.'[40]

But of Orozco this cannot be said. When he was able to return to the EPN and complete his cycle of frescoes on the ground floor, his new paintings questioned the grander, utopian simplicities of his colleagues. *The Revolutionary Trinity* may be interpreted as exemplifying Revolution's inordinate capacity to devour its children. Postcolonial though he was, Orozco still sought a universalising art that transcended the folk art of regions and the art of nations. 'Painting in its higher form', he said, has invariable universal traditions from which no one can separate himself.[41] As Dawn Ades has lucidly put it, 'his painting sets up an internal dialectic between the power and the dangers of the traditional icons and political myths of the Revolution, in which he too once had "exhuberant faith".'[42] Unlike Orozco, Rivera did not question his youthful revolutionary faith and deeply studied the Toltec, Mixtec and Aztec codexes in search of pre-Columbian modes and themes. Despite the risk of primitivism, he sought the universal in the regional.

Siqueiros was the most unremittingly political of all three and, technically, the most innovative. It is an unusual combination. He became increasingly critical of the 'folksiness' that he felt was creeping into Rivera's art. By 1934 he could write: 'We must rid ourselves of the European Utopia of *art for art's sake*, and also the Mexican *demagogic opportunism*. We must put an end to superficial folk art, of the type called "*Mexican curious*" which predominates in Mexico today.'

[40] Paz, 'Social Realism in Mexico: The Murals of Rivera, Orozco and Siqueiros', *Artscanada* (Dec.–Jan. 1979–80); quoted by Dawn Ades in 'The Mexican Mural Movement', in Ades 1989, p. 165.

[41] Quoted from Ades 1989, p. 168.

[42] *ibid.*, p. 170.

Instead he advocated the Marxian concept of 'praxis',[43] that thought about production and production itself are indivisible:

We must coordinate our abilities and experience and work together as a technical team. We must put an end to the *egocentrism* of modern European art and the false *collectivism* of official 'Mexican' art with its 'socialism'. We shall both learn and teach our new art in the *course of producing it: theory and practice will go together* . . . we shall establish the fundamental premise that *art movements should always develop in accordance with the technical possibilities of their age* . . . we must develop a *polygraphic art* which will combine both plastic and graphic art and provide a greater potential for artistic expression. Art must no longer be separated into units, either pure painting or pure sculpture, it must find a new, more powerful, more modern language which will give it much greater repercussion and validity as an art expression.[44]

Around 1930 the work of the Mexican muralists attracted a great deal of attention in the United States. While living in New York between 1927 and 1934, Orozco had carried out mural projects at the New School of Social Research, Claremont College, and at Dartmouth College, New Hampshire. Rivera painted a mural at the new Stock Exchange, San Francisco, in 1930 and for the Detroit Institute of Arts in 1932. In 1933 he began a mural at Rockfeller Center, New York, which was destroyed before completion because it included a head of Lenin. Siqueiros first worked on public and private murals in Los Angeles in 1932 but was deported the following year. He returned to the United States in 1936 and established an experimental workshop in New York, which made much use of industrial materials, collage and photography. His work attracted a great deal of attention (just as the country entered the Great Depression) because of its scale, innovatory practices and public nature, and because of the contribution it had already made to a renaissance of Mexican culture.

THE UNITED STATES OF AMERICA

When Franklin D. Roosevelt became president of the United States in March 1933 there were thirteen million unemployed and the farming community was in desperate plight. Two years before, the

[43] On praxis, see the helpful discussion in Kitching 1988.
[44] Harrison & Wood 1992, p. 413.

Soviet Union had advertised in the U.S. press for 6,000 skilled workers. It received 100,000 applicants.[45] Roosevelt appointed Harry Hopkins (1890–1946) to administer the Works Progress Administration (WPA). By 1938 Hopkins had allocated $8.5 billion to the relief of some fifteen million unemployed. In 1933 there were 9,000 artists in New York City alone registered on Hopkins's Civil Works Administration (CWA) programme. In the hope of alleviating the situation, George Biddle (1885–1975), a well-known artist and school friend of Roosevelt, wrote to him in May 1933. Citing the example of the Mexicans, he suggested that the artists of the United States could also produce a vital public art under the New Deal.[46]

Roosevelt discussed the proposal with Hopkins, and Edward Bruce (1879–1943) was appointed to administer the project. Bruce, an eighth-generation settler American, trained as a lawyer, had turned to business, first in the Philippines and then in China, where he developed the Pacific Development Corporation. But the competitive practices of J. P. Morgan destroyed his own business and his faith in the ethics of business. He turned to art, studying landscape painting with a friend, the artist Maurice Steine (1878–1957), and later held shows in New York and Paris. Leo Stein held a high opinion of Bruce's work, claiming that it was more significant than that of Utrillo, Segonzac or Derain.[47] Bruce was versed in William James's existential pragmatism and the idea of a philanthropic capitalism, as outlined in Andrew Carnegie's *Gospel of Wealth* (1889). He distrusted the universalism immanent in abstract art and advocated the support of 'American scene' painting in government projects. New Deal art under Bruce's agency and the cultural climate of the 1930s thus began to develop a significant opposition to the philosophy and programme of the Museum of Modern Art under Alfred Barr.

Bruce administered three distinct sections of New Deal Art: first, the Public Works of Art Project (PWAP) financed from relief funds from the Civil Works Administration, which functioned for seven months from December 1933 to June 1934; second, the so-called Section on Painting and Sculpture funded by the Federal Treasury, which functioned from October 1934 to June 1943; and

[45] D. Smith and J. Siracusa, *The Testing of America*, p. 129; quoted by Jonathan Harris in Wood et al. 1993, p. 9.

[46] George Biddle, 'An Art Renascence under Federal Patronage', *Scribner's Magazine* (June 1934), p. 428; quoted in Contreras 1983, p. 31.

[47] Leo Stein, 'Edward Bruce', *Creative Art* 3 (Nov. 1928), p. 1; quoted in Contreras 1983, p. 33.

third, the Treasury Relief Art Project (TRAP), which operated from July 1935 to June 1938. A fourth, and by far the best known New Deal art project, was the Works Progress Administration/Federal Art Project (WPA/FAP), administered by Holgar Cahill (1887–1960), which ran from September 1935 to May 1943.

The son of an Icelandic migrant, Cahill after some *Wanderjahre* as a seaman and watchman on barges on the Great Lakes, began a career in journalism in New York and wrote articles and mono-graphs on American art for *Creative Art* and *Parnassus*. This led to his employment by John Cotton Dana, director of the Newark Museum, New Jersey, to develop its collection of American art (1922–31). Visits to Sweden, Norway and Germany in 1922 stimu-lated an interest in the folk art of the United States prior to the Civil War and to his eventual establishment of the Index of American Design under the FAP. Both Bruce and Cahill, though different in background and temperament, were nativists seeking through their work to promote the identity of U.S. art as distinct from European 'modernism'. During 1932 Cahill was Director of Exhibitions at the Museum of Modern Art during Barr's year of absence on leave.

Bruce's first project, the Public Works of Art Project (PWAP), called for the employment of 2,500 artists and 500 labourers for the embellishment of public buildings and parks.[48] Regional committees were appointed to review applications and select artists. Subjects reflecting the 'American scene' were to be preferred. There were problems from the beginning. Isamu Noguchi (1904–1988), the New York sculptor, wanted to produce innovative weather vanes for public buildings and a play mountain for children in Central Park, but the New York committee did not take kindly to his projects. He complained about their resistance to new ideas. Then, in San Francisco, a group of artists employed on the Coit Memorial Tower wanted to incorporate – the times being what they were – the hammer and sickle, 'workers of the world unite', and books by Marx into their designs and were supported by both the Artists and Writers Union of San Francisco and the Artists Union of New York. The destruction of Rivera's mural at Rockfeller Center the year before would have been much in their minds.

In April 1934 an exhibition of 500 works sponsored by the PWAP chosen from the 15,000-odd produced during the preceding five months was held in the Corcoran Gallery, Washington. At the official opening Roosevelt noted that the 'pictures were honest, depicting American life in an American way'. A couple of months

later the project came to an end; the first U.S. attempt by govern-
ment to support the visual arts on a democratic and nation-wide
basis. Before it terminated, Bruce managed to gain the support of
the Federal Treasury to extend PWAP-type work by means of one
per cent of their cost towards the embellishment of new Treasury
buildings. It became known as the Treasury Relief Art Project
(TRAP). Political issues soon asserted themselves again. Charles
Biddle had prepared a plan for a team of artists to paint murals in
the Justice Building in Washington. But the long-standing Com-
mission of Fine Arts rejected the proposal and informed Roosevelt
of their decision. So the President wrote to his old school friend: 'I
can't have a lot of young enthusiasts painting Lenin's head on the
Justice Building. They all think you're communists. Remember my
position please.'[49]

The Section's first national commission involved murals for the
new Post Office and Justice buildings in Washington. Among the
team commissioned were the well-known artists Thomas Hart
Benton (1889–1975), Rockwell Kent (1882–1971) and Grant Wood
(1891–1942) for the Post Office; and for the Justice Department,
George Biddle, John Steuart Curry (1897–1946), Boardman
Robinson (1876–1952), Maurice Sterne (1878–1957) and Emil
Bisttram (1895–1976). The artists were required to submit designs
anonymously and were paid in three stages contingent upon the
approval of each stage. The designs were then submitted to the
supervising architect and later to committee bureaucrats. It was all
too much for Benton, who dropped out. Rockwell Kent's mural
displayed a thinly disguised attack upon United States imperialism
in Puerto Rico and Alaska. It portrayed a group of Puerto Rican
women with a letter from some Eskimo friends written in Aleut.
Translated it read: 'To the people of Puerto Rico, our friends. Go
ahead. Let us change chiefs. That alone can make us equal and
free.' It produced a press controversy. In his defence Kent said that
'Art is always propaganda for the beauty of life. And there can be
little beauty in life when existence is ridden with tyranny, when
the fundamental principles of democratic freedom are revoked,
when poverty, suffering and exploitation prevail. That is why the
artist must be a visioned social idealist: to preserve the kind of life
in which beauty is possible.'[50]

The statement has something in common with Matisse's famous

[49] Biddle, *An American Artist's Story*; quoted in Contreras 1983, p. 51.
[50] Les Finnigan, 'Rockwell Kent Defends His Use of U.S. Walls for Propaganda',
Washington Daily News (1 Nov. 1937); quoted in Contreras 1983, p. 53.

statement: 'What I dream of is an art of balance, of purity and serenity devoid of troubling or depressing subject matter, an art which might be for every mental worker, be he business man or writer, like an appeasing influence, like a mental soother, something like a good armchair in which to rest from physical fatigue.'[51] Written in 1908 it was wholly in the spirit of the late nineteenth century when neo-Kantian aesthetic assumptions remained substantially unchallenged. But Kent lived in the 1930s and was thinking of an art that might help bring beauty into the life, not of writers and business men, but of people suffering under imperial domination, whom Fanon a few years later would call 'the wretched of the earth'.

Bruce was alarmed that the brouhaha over the mural would prejudice the whole project, but Kent refused to remove the offending inscription and eventually received full payment for his work without having to change it. Then there were more problems. Ben Shahn (1898–1969) included a verse from Whitman in his Bronx Post Office mural. A Brooklyn Jesuit asserted that it was an insult to Christianity. Whitman's works were listed as heretical on the Catholic Index. Maurice Sterne, Bruce's mentor, was castigated by Monsignor Ready, director of the Catholic Welfare Agency, for his mural entitled *Cruelty* on the Justice Building; it was an attack upon Catholic tradition by a Jewish painter. John Dewey, the philosopher, entering the debate, asserted that Ready was being anti-Semitic. Eventually a committee was set up to examine the issue, an agreement was reached with Ready, and Sterne was allowed to proceed with his murals. But Bruce continued to find keeping government content on one side, and maintaining the expressive freedom of artists employed in the public service on the other, a tricky business. In the end Treasury officials questioned the existence of the project as a relief programme. Treasury, they said, was not really in the relief business. TRAP was terminated in June 1939. Nevertheless Bruce persisted with his community arts programmes. Orozco's work at Dartmouth College had sparked his interest. He discussed it with the Guggenheim Foundation and the Carnegie Corporation and funds were provided from which he was able to set up Artists-in-Residence programmes that provided studio-space and teaching facilities to artists in colleges throughout the country. Similar schemes eventually spread into most democratic countries throughout the world.

In January 1935 Roosevelt launched his second New Deal, with

[51] From his 'Notes of a Painter' (1908); quoted in Barr 1951, p. 122.

$4.8 billion to provide jobs for those on relief. As part of the programme Hopkins designed a project known as Federal Project Number One that included art, theatre, music and literature. Hopkins asked Bruce to direct the new project but early in June he suffered a severe stroke that paralysed his left side. Holgar Cahill took up the post. It was essentially a relief programme and the selection of artists was confined to those on relief rolls. Contreras notes that Cahill owned Edward Hicks's *The Peaceable Kingdom* and that his own ideal community envisioned artist and society living in unity. It was towards that end he established the Index of American Design. It sought to demonstrate that the ante-bellum United States had produced well-designed products prior to the industrial revolution, when the distinction between art and craft was irrelevant.

Between 1933 and 1939 Cahill set up community art centres in order to decentralise the practice and appreciation of art throughout the United States. The first was the Raleigh Art Center, North Carolina. Popular classes were provided in sketching, painting, sculpture and craft skills. Under the guidance of the Center, a gallery for blacks was established as an extension activity of Shaw University. Eventually 103 centres were in operation federally. Cahill also established a National Exhibition Section in Washington that sent travelling exhibitions of WPA/FAP artists to community centres and federal galleries across the country. But he noted that experimental and advanced art was not at first well received. Cahill's advice was: 'To understand is simply to participate. Go and see it, Expose yourself to it, Look at it.' [52]

In order to win over the aesthetic high ground, Cahill organised a national exhibition of WPA/FAP work in the Phillips Memorial Gallery, Washington, in June 1936 and then a second in the Museum of Modern Art, New York, in September. Critical reviews were predictable. Those who sought high quality were disappointed. Those who realised that the programme was devoted to the aesthetic education of the nation were enthusiastic. It was still three years before Clement Greenberg would write his watershed essay 'Avant-Garde and Kitsch', dividing aesthetic sheep from aesthetic goats. But it would be timely, for the ambitious New Deal programme for democratising the arts in the United States was nearing its end. The 1938 elections resulted in a retrenchment of the New Deal and a decline in the art projects. Hitler's invasion of Poland in September 1939 'marked the end of

[52] Cahill's *Reminiscences*, p. 453; quoted in Contreras 1983, p. 162.

the New Deal era'.[53] Then, when Hitler invaded western Europe in
the summer of 1940, thousands of European refugees, including
artists, writers and intellectuals, poured into the United States. Its
'postcolonial' period quickly drew to a close. It become what
Arnold Toynbee called an 'apparented' civilisation, taking over, as
best it could, the mantle of Europe.[54] By early 1941 the WPA
programme was engaged in developing models for aircraft opera-
tion, charts for military instruction, decorations for army recreation
halls – adapting, whenever and wherever it could, its practical skills
to wartime needs. In March 1942 the WPA art programme was
converted into the Graphics Section of the War Services Program.
By April the year following, all the activities directed by Cahill were
terminated.[55]

How did the Museum of Modern Art, New York, cope with the
cultural and political problems of the decade? MOMA's policy, as
we noted earlier, was strongly cosmopolitan, not nativist. Barr's
'entire education had been oriented to the great European tradi-
tion, of which he considered American art a derivative colonial
offshoot'.[56] And he had found that European moderns drew greater
public interest than the works of local artists.[57] The Board and
Trustee members of MOMA preferred to collect European rather
than local art. Exhibitions of modern European art focussed public
interest and enhanced the monetary value of their own collections.
Barr himself loved travelling to Europe with his Italian wife
Margaret to obtain works on loan for such early MOMA shows as
Painting in Paris and *Weber, Klee, Lehmbruck and Maillol* (both 1929),
Toulouse-Lautrec and Odilon Redon (1930) and *Henri Matisse* (1931–
32), even when they had to ship third class across the Atlantic on
their modest MOMA travel allowance.[58] During the 1930s elite taste
in the United States retained a colonial respect for the superiority of
European culture.

MOMA had opened its doors in November 1929, the same
month as the Wall Street Crash. Eighteen months later the United

[53] Malcolm Cowley, 'A Farewell to the 1930s', *The New Republic* (8 Nov. 1939), p. 42;
quoted in Contreras 1983, p. 219.
[54] On Toynbee's notion of 'apparentation and affiliation', see Toynbee 1934–61, vol.
4, pp. 78–79; vol. 6, pp. 324–25.
[55] Cahill, 'Record of Program Operation and Accomplishment', p. 1; quoted in
Contreras 1983, p. 231.
[56] Marquis 1989, p. 142.
[57] During MOMA's first three years the attendance figures for exhibitions of
European work greatly exceeded those for exhibitions of local artists. See Goodyear
1943, App. H.
[58] Marquis 1989, p. 75; Goodyear 1943, App. H.

States possessed eight million unemployed. In April 1932 five hundred artists of Greenwich Village set up an open-air market for their work in Washington Square.[59] Such events heralded a significant change in taste even before Roosevelt established the first WPA scheme in November 1933. Perhaps it is not surprising that MOMA's first exhibition of 1932, devoted to Diego Rivera, 'broke all daily attendance records', exceeding the number who attended the Matisse exhibition that preceded it by almost twenty thousand.[60]

The Rivera show heralded a change from a European to an American focus. 'From the opening of the 1932–33 season to the fifth anniversary show two years later the exhibitions, almost without exception, were devoted to American art.'[61] This was owing in part to the fact that Barr through overwork was by the spring of 1932 in a state of nervous collapse. He was given a year's leave on half-pay, and Holgar Cahill became acting director. Cahill's first exhibition, *American Painting and Sculpture and Folk Art*, drew over one hundred thousand, almost twice that of any previous MOMA exhibition. There followed a show of Chicago architecture from 1870 to 1910, showcasing its contribution to the (recently MOMA-defined) 'International Style'. Then an exhibition of the art of Maurice Sterne was followed by the work of young architects of the Midwest and, to end the season, an exhibition entitled *American Sources of Modern Art*, which brought together sculpture, pottery, gold and silver artefacts from the Maya, Toltec and Aztec cultures of Latin America.[62] This last show was an ambitious and, by today's standards, a naive exercise in archaism, seeking to appropriate Amerindian art to the aesthetics of the Formalesque style. It also testified to the powerful Pan-American and nativist tendencies current in the United States during the Depression years.

Plagued by insomnia, Barr spent part of his year off work with Margaret at Stuttgart, during the winter and spring of 1933, and underwent psychiatric treatment. Hitler became German Chancellor earlier that year. With increasing horror, Barr attended meetings in which he saw the National Socialists brutally impose their sinister chauvinism upon the German art world. By June 1933, unable to stand it any longer, they moved to an artist's colony in Ascona, Switzerland. There he wrote articles to one leading U.S. magazine after another about the desparate condition

[59] Contreras 1983, pp. 21, 29.
[60] Goodyear 1943, p. 36 and App. H.
[61] *ibid.*, p. 41.
[62] *ibid.*, p. 44.

of contemporary art in Germany under Hitler. They were all rejected. But he managed at least to get a brief account of the closure of the Bauhaus into the MOMA bulletin of June that year. The Bauhaus had reopened as a private school under Mies van der Rohe after being forced to leave Dessau in 1932. 'In April 1933', Barr wrote, 'the National Socialist storm troopers forcibly removed the students and faculty from the old factory where they had been holding lessons . . . Classes are at present being held in the houses of the various professors.'[63] Many of Barr's affluent U.S. colleagues were blind or indifferent to the Nazi threat. When he returned to New York he found that his close friend Philip Johnson (b. 1906), the architect and chairman of the MOMA Department of Architecture, had returned from a trip to Germany with a 'glowing admiration for Hitler'.[64]

In the United States, as in Germany, patriotic sentiment dominated taste. Barr resolved the tensions between local and cosmopolitan in a brilliant move when, returned to health, he resumed the directorship of MOMA. During his leave he had succeeded in getting the Louvre to lend Whistler's *Arrangement in Grey and Black, No. 1: The Artist's Mother*. Advertising it as one of the six most popular pictures in the world and the greatest by an American artist, he shipped it around the U.S. art museums on an eighteen-month tour 'preceded by police escorts and surrounded by armed guards'.[65] On its return to MOMA, the mother of President Roosevelt was persuaded to be photographed in front of it for its final display on the Mother's Day weekend.[66] That Whistler had left the United States at the age of twenty-one to make his reputation in France and Britain and had never returned resolved the tensions between patriot and expatriate art wonderfully. Culture, Barr was suggesting delicately, was an 'othering' process. For Americans, art was something that, at its best, occurred elsewhere.

Hitler had made that brutally plain. When he returned, Barr spent a great deal of time helping to get art historians and artists out of Europe. Among the first were Erwin Panofsky (1892–1968) and his pupil H. W. Janson. Then came Josef Albers, after the Bauhaus was closed, to teach at Black Mountain College, North Carolina, and, from 1936 to 1941, at the Graduate School of Design, Harvard University. They were the first of a flood that began to pour into the

[63] Marquis 1989, p. 109.
[64] *ibid.*, p. 84.
[65] *ibid.*, p. 111.
[66] *ibid.*

United States after 1939. Kurt Seligman (1900–1962) was the first of the Surrealists to arrive. With Barr's assistance he set in motion the process that brought Breton and Masson. Barr's wife Margaret liased with the Quaker Varian Fry, stationed in Marseilles by the Emergency Rescue Committee, to get Jewish and other artists and intellectuals out of occupied France. Just as the war broke out Peggy Guggenheim visited Paris once again to augment her collection. 'Parisians were expecting a German invasion and were delighted to sell everything and flee . . . [E]veryone pursued me mercilessly.' She decided to buy a work of art a day.[67] But by July 1941 the situation had become scary. So she flew from Lisbon in a Pan Am Boeing with Max Ernst – whom she married to get him out of France. By then New York was already giving asylum to most of the leading Surrealists of Paris. Their presence was to exercise a profound effect upon art in the United States.

There was a less pleasant side to MOMA's wartime story. By 1939 the Nazi's had stolen thousands of art works from German public museums and private, mostly Jewish, collectors. On 20 March 1939 they incinerated at least four thousand works in a huge fire in Berlin's principal fire station, but gave a few dealers 'about seven hundred items to sell for foreign currency'.[68] On 30 June some of the best were auctioned in Lucerne. Two months after the sale MOMA announced that it had bought from the Bucholz Gallery five items sold in Lucerne. They were added to MOMA's Tenth Anniversary Exhibition, *Art in Our Time* (1939). All five had been looted by the Nazis from German public museums, specifically: Derain's *Valley of the Lot at Vers* (from Cologne), Kirchner's *Street Scene*, Lehmbruck's *Kneeling Woman* (both from Berlin), Klee's *Around the Fish* (from Dresden) and Matisse's *Blue Window* (from Essen). Barr's complicity in, and uneasiness about, these deals is discussed in detail by Alice Marquis.[69]

FRANCE

The Formalesque continued to flourish throughout the 1930s wherever civil society and art's autonomy were not suppressed by state political power. In France abstract art was stimulated retroactively by the challenges presented by the Socialist Realism of the

[67] *ibid.*, p. 188.
[68] *ibid.*, p. 177.
[69] *ibid.*, pp. 177–79.

The Spanish pavilion designed by Josep Lluis Sert (1902–1983) and Luis Lacasa was by far the most distinguished. Sert had helped to found the Catalan group of 'rationalist' architects known as GATEPAC.[70] The pavilion, in its sure grasp of style, its lightness and grace, anticipated, by more than a decade, the early work of Philip Johnson. Spain was then in the worst throes of its civil war and the Republican government devoted its pavilion, not to Spanish industrial and commercial achievement (art in the general sense), but to the critical, avant-garde work of Spanish artists who supported the Republican cause, such as Picasso, Joan Miró (1893–1983), Alberto Perez, and Emiliano Barral and Francisco Mateo who had died defending Madrid the year before. The time had brought even the most avant-garde of them to the harsh realities of politics.

Picasso, an ardent Republican, sent five pieces of sculpture, a series of etchings – *The Dreams and Lies of Franco* – and his monumental painting *Guernica*, completed to fill the wall at the end of the ground floor of Sert's pavilion. He had not known just what to paint when first invited to participate, but the bombing of the Basque town of Guernica on 26 April 1937 by the Luftwaffe provided him with the inspiration he needed. *Guernica* became a focal painting of twentieth-century art, situated as it is between the Cubist tradition of the late nineteenth century, that Picasso himself had done so much to create, and the fragmented angst that has profoundly characterised the art of the twentieth century. *Guernica* has been interpreted in many ways, but in our context it may be viewed as the most telling visual symbol of the convergence, under exceptional conditions, of the knowledge and understanding that Picasso acquired from Cubism, Surrealism, and the nightmare visions of the Neue Sachlichkeit. It memorialised one barbarity and prophesied another. A couple of months after *Guernica* was first displayed in Paris, Hitler's exhibition of 'Degenerate Art' opened in the Hofgarten, Munich.

BRITAIN

With neither revolutions nor war on its soil to instigate major disjunctions, the Formalesque style in Britain evolved gradually from the Arts and Crafts Movement, Art Nouveau and the

[70] The *Grupo de Artistas y Técnicos Españoles para el Progreso de la Arquitectura Contemporánea*. In 1958 Sert succeeded Gropius as Dean of the Harvard Graduate School of Design.

functional lessons taught by the Gothic revival. But the great influence of the Royal Academy slowed the pace of change. Although Charles Rennie Mackintosh (1868–1928) had designed his Glasgow Art School as early as 1896, Jacob Epstein (1880–1959) had exhibited his *Rock Drill* in 1915, and Clive Bell published his influential little book *Art* the year before, in Britain the Formalesque was not firmly established until the 1930s.[71]

Nevertheless the shattering events on the Continent enlivened the local scene. During the decade significant numbers of refugee artists settled in England, some only temporarily, such as Gropius, Breuer, Moholy-Nagy, Gabo and Mondrian. The influx encouraged Freddy Mayor, of the Mayor Gallery, Cork Street, London, to assemble his *Exhibition of Recent Paintings by English, French and German Artists* in April 1933. It included work by Arp, Bacon, Braque, Dali, Giacometti, Kandinsky, Klee, Léger, Miro, Picasso and Soutine. He consolidated this early union of English and Continental modernists six months later in an ambitious exhibition entitled *Art Now*. In 1933 too, Paul Nash (1889–1946) brought together a disparate group of English modernists as Unit One. It included Nash, John Armstrong, Edward Wadsworth (1889–1949), Ben Nicholson, Barbara Hepworth (1903–1975) and Henry Moore, among others. After their London showing at Mayors it toured to Liverpool, Manchester, Swansea and Belfast. Press coverage was extensive though not always favourable.[72] Herbert Read (1893–1968), art critic and poet, acted as their influential spokesman and published his book *Art Now* in October. The British institutionalisation of the Formalesque, a decade behind the Continent, had begun.

In character it bears a similarity to the Russian situation. There, earlier in the century, it was, as we noted, the conflation of Futurism and Cubism, together with the national affection for folk art and the Byzantine tradition that consolidated the Formalesque as a period style, prior to the 1917 Revolution. In Britain the Formalesque developed as a result of the convergence of Surrealism and abstract art and the powerful, vestigial, influence of the British landscape tradition. This is true of the work of both Paul Nash and Herbert Read and of many of their disciples.

Abstract art and Surrealism ran in tandem. Myfanwy Evans's *Axis* (1935–37), 'a quarterly review of contemporary abstract painting and sculpture', sponsored the *Abstract and Concrete* exhibition

[71] See pt 5, 'The Modern Movement in England, 1930–1940', in Farr 1978, pp. 271–324.

[72] Farr 1978, p. 276.

shown at Oxford, Liverpool and Cambridge in early 1936. In June that year the comprehensive *International Surrealist Exhibition* opened in London. Seen by over twenty thousand people, it was, Breton said, 'the highest point in the graph of the *influence* of our movement'.[73] However, it was dialectically opposed to the implicit classicism and autonomy of abstract art in both its reassertion of the romantic imagination and its deep involvement in politics. Surrealism, according to Read, resolved the long conflict between classicism and romanticism by 'liquidating' classicism. For him classicism was the 'intellectual counterpart of political tyranny . . . the official creed of capitalism. [W]herever the blood of martyrs stains the ground, there you will find a doric column.'[74] In *Surrealism*, the book he edited in the wake of the exhibition, Read, Breton and Hugh Sykes Davies did their best to expose the Surrealist substructure of English literature and art.

Nevertheless Surrealism remained oppositional to the dominant Formalesque. Although works like Meret Oppenheim's *Cup, Saucer and Spoon of Fur* touched the ultimate in the realm of oneiric fantasy, the Surrealist painters particularly, such as De Chirico, Dali, Duchamp, Ernst, Klee, Magritte, Masson, Miro, Nash, Picabia and Picasso, to name the most prominent, all painted under the stylistic hegemony of the Formalesque style.

From the events surveyed in the past two chapters we may conclude that the Formalesque, as a period style, emerged from a sequence of late nineteenth-century avant-garde networks and was practised within dispositions, perceptions and attitudes stimulated, encouraged and promoted by the contemporary economic and social situations of those times.[75] The Formalesque was, as we have seen, institutionalised during the 1920s and seriously challenged in the 1930s by a revival of earlier modes of nineteenth-century art and supported by political fiat. Despite the political challenge the Formalesque survived the 1930s as the dominant period style of the first half of the twentieth century.

[73] Read 1936b, p. 95.

[74] *ibid.*, pp. 22–23.

[75] Here once again I am invoking Bourdieu's concept of *habitus*, in order to stress that avant-gardes are the products of their own time, not heralds of time future. Of course all avant-gardes oppose what they perceive as the conventional mores of their times in whatever fields they happen to be active in, but that opposition itself is but an abiding aspect of their own time, an oppositional aspect that does much to define its nature. Their avant-garde status, on the other hand, is a retrospective endowment which they acquire from others, such as critics, historians and sociologists, who need forerunners in order to construct their own models of the course of history. Avant-gardes are aware of their oppositional status but not of their future place in history.

Oddly enough the first attempts to institutionalise the Formalesque appear to have occurred in pre-revolutionary Russia among the group of artists, intellectuals and impresarios associated with Mir Iskusstva (World of Art). This circle was probably the first to grasp the Formalesque as a period style, not as a series of diachronic movements. Perhaps that was because Russians living on the eastern rim of the European world were in a better position to take a distanced and relatively more objective view of Europe's recent artistic past – that and the fact that their very provincialism encouraged their sense of nationality. So the result was a creative eclecticism. Within the spectrum of their aesthetic approval everything was acceptable, from Russian icons and folk art to Impressionism and Picasso; and Diaghilev eventually took it all, in the form of ballet, to the ends of the earth. Several of the children of Mir Iskusstva, such as Altman, Lissitsky, Tatlin, Larionov and Goncharova, continued to project the thrust of its taste into revolutionary Russia, but, as we have seen, the institutionalisation of the Formalesque in its Constructivist mode was aborted with the rise to supreme power of Joseph Stalin and the installation of Socialist Realism as the official style of the Union.

The Formalesque was, or at least aspired to be, an international style. But at heart it was Eurodirected and Eurocentred. And Europe was not so much a civilisation as a group of egregious nationalisms. From the beginning nationalism emerged as the most formidable factor in opposition to the acceptance and spread of the Formalesque. This, ultimately, was the Russian problem: its marginality promoted nationalism. In the end it was Stalin's ambition to create 'Socialism in one country' that led to the triumph of nationalism over internationalism and of Socialist Realism over the Formalesque.

Strong government does not necessarily produce good art; it tends to reduce art to the political will. It was in the weak government of the Weimar Republic that the Formalesque was first successfully institutionalised in Western Europe as an international style as the result of the creative determination of Gropius and his Bauhaus team working under a relatively compliant government and the aura of architecture. For, as we have noted, architecture, the 'mother of the arts', is also the art by means of which dissident modernisms, enthralled and inspired by archaeo-primitivisms, are converted into celebrations of Modernity, thus making it more politically acceptable. By contrast with Germany, the French attempt to institutionalise the Formalesque after World War I, in the Art Deco phase of the 1920s, was diluted by its resurgent

nationalism. The city of Paris provided the cosmopolitan frame-
work within which the Formalesque was able to emerge and be
nurtured as a sequence of avant-garde movements, but the nation
found difficulty in institutionalising the art of its bohemian prodigy.
It was not until after World War II with the foundation of the
Musée National d'Art Moderne in Paris in 1947 that the
Formalesque was fully recognised institutionally.

Britain is a special case. Situated on the Atlantic rim of Europe,
it was also until after World War II the centre of an empire on
which the sun was unable to set. Its prodigious achievements in
colonisation during the nineteenth century privileged art in the
special sense, especially the arts of naturalism. Here British
nineteenth-century art affords a parallel with the art of the Hellen-
istic empire. Colonisation privileged naturalism and from its centre
emerged the genius of Turner and Constable and the naturalistic
passion of Ruskin. Such a culture did not take readily (as critics like
Herbert Read constantly complained) to the aesthetics of the
Formalesque. Although William Morris in his lifelong promotion of
the decorative arts is a major source, as we have noted, for the
emergence of the style, his work had only marginal influence on
architecture, sculpture and painting. And, as the Whistler v. Ruskin
case attested, Britain did not take readily to artistic lessons from
France during the last years of the nineteenth century. So the
institutionalisation of the Formalesque in Britain was promoted not
so much through 'institutions' in the literal sense, but by (as so
much in Britain) a gradual, educational process conducted by
enlightened critics such as Fry and Read, dealers like Freddy Mayor
and Rex Nan Kivell, collectors like Samuel Courtauld, Kenneth
Clark and Colin Anderson, architects like Charles Rennie Mackin-
tosh, and sculptors like Jacob Epstein. By the time that the Arts
Council of Great Britain, established in 1940 (as CEMA), and the
Institute of Contemporary Arts, established in 1947 (on the initia-
tive of Read), came into being, most of the pioneering work had
been accomplished. But though it was a slow process in Britain it
was effective, owing particularly to the tireless efforts of Read. His
Education Through Art published in 1943 championed, at a basic
level, the aesthetics of the Formalesque to English-speaking com-
munities throughout the world, and was taken up internationally
by UNESCO.

Stalin effectively subverted the Russian institutionalisation of the
Formalesque in its Constructivist mode, and Hitler subverted the
German institutionalisation of the Formalesque in its Bauhaus
mode. But in the latter case the dispersion of Bauhaus teachers led

more than any other factor to the world-wide spread of its aesthetic doctrines as a pedagogical imperial culture. The Formalesque triumphed as Bauhaus teaching came to dominate art schools and colleges throughout the world. But the global spread of Bauhaus principles was conducted more from the United States than from post-war Europe. Here the establishment of the Museum of Modern Art, New York, consolidated the ultimate global hegemony of the Formalesque as the United States became, post-war, an imperial dispenser of global taste.

Prior to that, however, the Formalesque suffered severe challenges on all sides during the 1930s. Nationalism both in its pathological modes, as in the Soviet Union and the Third Reich, and in its creative forms in Mexico and the United States, challenged the recently established Formalesque. Why is it that nationalism was so pathological within Europe and creative beyond it? It is difficult to provide any convincing response to this complex question. But multiculturalism may provide some kind of answer. For over four centuries both in Mexico and the United States a blending of ethnic types had been in process. Nationalism was the process by means of which their peoples, whether of indigenous or European descent, sought to attain some sense of national identity. Europe's nations on the other hand had been developed by a process not of a fusion of ethnicities but of exclusion, marked off by official languages, constantly defined and redefined territorial boundaries, and histories that were grounded in immemorial memories of 'racial' origins. European civilisation was a crust of ideologies, sacred, juridical, aesthetic and to a much lesser extent economic, lying over and masking a congeries of ancient, disparate and intractable cultures. By the end of the nineteenth century, as a result of their economic and technological prowess they were much more successful in dividing up the world between them than in agreeing among themselves. So in the first instance, that is to say the 1930s, the institutionalised Formalesque proved to be a period style more amenable for export than for home consumption, more acceptable on its rim, both in the east in Russia and in the west in the Americas, than in its heartland. In both Mexico and the United States it survived the 1930s, but with considerable modification produced by the increasing independence of their emergent national cultures. And in both Mexico and the United States during the 1930s we may witness a process of interaction. On the one hand nationalism tended to democratise and spread realistic modes of the Formalesque whereas cosmopolitanism tended to promote its elitist and Eurocentric affinities.

9 The late Formalesque

We may now turn to a consideration of the last phase of the period style that I call Formalesque. There is today a consensus that during the 1960s the long dominance of formalism gradually came to an end in architecture, sculpture and painting, the three high arts privileged by Renaissance aesthetics. The more recent and popular arts born of and driven by the technological innovations of Modernity – photography, film, television and video – are, of course, another matter. They too were influenced in some degree by the dominance of form over content prevalent in the high arts, whenever they sought to emulate them, but they had such a high epistemological investment in the reproduction of semblance that their historical trajectory lay in quite other directions. Exiled from the high arts, mimesis took refuge in the intricate internets of electronic technology. But that is another story. Here we concern ourselves with the condition of the high arts between 1945 and 1960 under the hegemony of the late Formalesque.

The centre now shifts from Europe to the United States. During the 1930s, as we have seen, both Mexico and the States engaged in what may be described as national experiments, fired by their economic and political situations, to democratise the arts and identify them with the public interest. A broader audience for the visual arts was thus established than had existed in either country during the first two decades of the century. But the high arts in both countries continued to be regarded, by historians and critics alike, as little more than provincial outliers of the Eurocentred Formalesque style.

Hitler's invasion of western Europe in the summer of 1940 changed the situation radically. The stage was set in New York for a struggle between the protagonists of Formalesque art and those anti-formalist drives originally set into play, on the one hand, by Dada/Surrealism, and, on the other, by those nativist sentiments supporting a figurative 'American Scene' painting. This contestation made the late Formalesque in the United States a site of struggle and vitality. An aesthetic that in substance had been laid down before the Great War of 1914–18 battled it out with an opposing aesthetic born of the travail of that war. The contest,

though central to an understanding of the emergence of what is still called Postmodernism, has been obscured by most accounts of the art scene in Europe and the United States between 1945 and 1960 because the overarching hegemony of the late Formalesque has been virtually invisible to those who were engaged in the struggle itself as it produced successive modalities of its late phase.

Before looking at the late Formalesque in detail it will be useful at this stage of our inquiry to ask why it was that the Formalesque, essentially a late nineteenth-century style in its origin and formation, was able to sustain itself throughout the first half of the twentieth century as an increasingly universalising, imperialising and hegemonic style. We have already noted that it was severely challenged by the havoc wrought by World War I and the economic problems, political pressures and nationalising politics of the 1930s in both Europe and the Americas. This would lead one to suspect that there is an immanent component working within the traditional high arts by means of which they sustain a measure of independence, interdependence and historical momentum in the face of external contingency. This is not to assume an immanence unfolding through the centuries, such as Hegel's symbolic, classical and romantic modes of art do, nor of a 'will to form' in the Riegl manner, but an immanence nonetheless that offers resistance to external contingencies while remaining vulnerable to them. Art is not immune from external pressures but neither is it a product of nor slave to them. Perhaps it is the very material limitations of the arts themselves that favour their relative autonomy, limitations that provide finite parameters within which they may change and diversify. The formal vitality of painting, for example, whether it be mural or easel painting, is limited by the physical nature of the support and the geometry of the framing. Both are necessary but not sufficient determinants of its form. Furthermore, in the dynamic conventions that have prevailed in the high arts since the Renaissance in which a premium has been placed upon innovation, the high arts, unlike the crafts, closed themselves out from the mere reproduction of past exemplars. The art of the past may be a mine to be exploited, but innovative art insists that it cannot be repeated. So high art is driven forward into the future continuously yet within the parameters of its material limitations. In this regard the insights of both Bryson[1] and Greenberg[2] are relevant. Paintings change only within the limits of change made possible by the

[1] Bryson 1984, pp. 32ff.

[2] 'Towards a Newer Laocoon', in Greenberg 1986, vol. 1, pp. 23–38.

supports which hold and enframe them and the pigments by which they are produced. It is similar with sculpture – what can or cannot be done within the material limitations of clay, bronze, wood, iron, steel and so forth. Or with architecture – what the constructional materials available allow to be potentially possible. These material limitations fortify the arts from indiscriminate external pressures; they change, but in their own ways, in response to the functional potentials of their materials. Their immanence ultimately derives from their material constitution; it exists latently within the formal and structural potential of those materials. Furthermore, immanence is a function of process. Most artists experience artistic practice as a dialogue with their medium, which itself suggests ways that are possibly valid or possibly invalid in the very process of creation. As William Baziotes put it, 'each painting has its own way of evolving'; or Jackson Pollock, 'the painting has a life of its own'.[3] Most aestheticians agree. There are exceptions of course: Croce, for example, who believed that the work of art is in the mind of the artist; and the conceptualists, for whom the materials and media of art are reduced to trace relics of process. But for most artists the medium with which they work is not a *tabula rasa* upon which to inscribe pure intuition but a mysterious 'other' possessed of an inscrutable language and life that must be cajoled and coaxed into a momentary settlement. It is in the *temporary* nature of the settlement, in the ongoing processes of practice, that the immanence of art asserts itself. And there is yet another factor promoting the immanence of process: the solution of technical and aesthetic problems, and continuous confrontation with other unsolved problems that drives the creative process forward into the future in search of unprecedented results in new work. One work begets another, not only with the individual artist, but also with generations of artists. So it is that immanence, the product of generations of artistic practice upon materials as media, develops the relative autonomy of art over against the fields of economic and political power from which art itself derives its ultimate social sustenance. Of course if the technologies change, if we move from the high arts, into photography or film, say, the whole name of the game changes. They begin to develop modes of immanence quite distinct from those of the traditional Renaissance high arts.

These observations are particularly relevant for any under-

³ Baziotes, 'I Cannot Evolve Any Concrete Theory', *Possibilities* 1, no. 1 (Winter 1947–48), p. 2; quoted in Sandler 1970, p. 93; and Pollock, 'My Painting', *Possibilities* 1, no. 1 (Winter 1947–48), p. 79; quoted in Sandler 1970, p. 102.

standing of a late dominant style beset by factors that continually test its authority, factors that arise not only from new insights into the nature of artistic practice, such as those deriving from Dada/Surrealism, but also from novel geographical, economic and political situations, and change due to new technologies available. Such is the situation that we must examine in the case of the United States where the late Formalesque flourished most vigorously between about 1944 and 1960 in the form of Abstract Expressionism and evolved eventually into a fully fledged, imperial culture with global pretensions.

Abstract Expressionism developed in the United States in opposition to other local versions of the Formalesque as revealed, for example, in the work of Edward Hopper (1882–1967); the Precisionists, such as Charles Sheeler and Morton Schamberg; the Regionalists, such as Thomas Hart Benton (1889–1975) and Grant Wood (1892–1942); the Cubo-Realists, such as Stuart Davis (1894–1964) and Georgia O'Keefe (1887–1986); and the Social Realists, such as Jack Levine (b. 1915) and Ben Shahn (1898–1969). Because so much art historical effort in recent years has gone into distinguishing between these movements, what they have in common has been overlooked, that is to say their common participation in the Formalesque as a dominant period style. One has only to compare a Charles Sheeler with one of Turner's picturesque ports of England, a Hart Benton with a Millet, a Jack Levine with a Daumier, to grasp that we are not only looking at twentieth-century paintings but at work painted under the sign of the Formalesque. For even though the Precisionists, the Regionalists, the Cubo-Realists and the Social Realists all resisted in their own ways the immanent drive within the Formalesque towards abstraction, they could never avoid its dominance entirely. They all worked within the knowledge of the achievements of Cézanne, Manet, Gauguin, Picasso and Matisse and their epigones. It could not have been otherwise. However, it is in the work of the Abstract Expressionists that we may witness the most creative resolution of the dialectical conflict between the Formalesque and Dada/Surrealism that prefigures twentieth-century modernism. Now that neither the Formalesque nor its legatee, Abstract Expressionism, dominates the world art scene it is possible to attempt a brief overview of the latter's place in the history of twentieth-century art.[4]

[4] An attempt possible, it must be said, only in the light of the seminal work of Clement Greenberg, Harold Rosenberg, Irving Sandler, Serge Guilbaut and Michael Leja.

First it must be noted that the term 'abstract expressionism' may be used normatively to describe a style of painting and indeed appears to have been first used in that fashion by Alfred Barr to describe the work of Kandinsky, who has been hailed as the 'founder of abstract expressionism'. It may also be used descriptively to note aspects of the work of say André Masson (1897–1987), Wols (1913–1951) or Pierre Soulages (b. 1919). However, it is now used more frequently as an historical label for the network of avant-garde artists who came to prominence during the 1940s in New York, and are also known as the New York School. They are of special significance in our context because their contribution to twentieth-century art may be read in two compelling yet conflicting ways: the first views their work as a novel development of the work of the French avant-garde proceeding from Manet, Monet and Cézanne to Picasso and Cubism; the second sees their work as a paradigmatic break with that same tradition. On the first reading Abstract Expressionism may be seen as a late phase of the Formalesque; on the second, as a major development of twentieth-century modernism, emerging from the insights of Dada/Surrealism, as they came to terms with the ethos and sensibility of the twentieth century. On this second reading Abstract Expressionism develops in dialectical opposition to the Cubist tradition. However, a generous understanding of the New York School requires that we take neither reading exclusively but view it historically as a synthesis, a sublation of both readings.

Before discussing the implications of the two readings it will be useful to outline briefly the cardinal features of Abstract Expressionism. Like most avant-gardes it was a cultural game played by a loosely defined 'family' of artists possessed of highly personal styles, the principal players being William Baziotes (1912–1963), Willem de Kooning (1904–1997), Arshile Gorky (1904–1948), Adolph Gottlieb (1903–1974), Hans Hofmann (1880–1966), Robert Motherwell (1915–1991), Barnet Newman (1905–1970), Jackson Pollock (1912–1956), Ad Reinhardt (1913–1967), Mark Rothko (1903–1970) and Clyfford Still (1904–1980). The School has been presented in retrospect as two fairly distinct groups: as gesture and colour-field painters. The leading gesture painters were Pollock, de Kooning and Hofmann; the leading colour-field painters, Newman, Rothko and Still. The gesture painters were deeply affected by the theories of automatism proceeding from Surrealism and the Expressionist emphasis upon free brushwork. They were experienced in working on a large scale from their work during the 1930s on WPA murals and used large canvasses as open fields upon

which to paint. They broke with the synthetic Cubist preference for clearly defined, intricately composed, planar units in favour of massive, free-floating images fraught with considerable gestural power. They stressed the importance of meaning; but it was highly subjective, personal meaning. In this, as Sandler shrewdly observed of de Kooning, they 'reversed Maurice Denis's famous dictum, "Remember that a picture – before being a battle horse or nude woman, or some anecdote – is essentially a flat surface covered with colours in a certain order".'[5] Of course they admitted the general thrust of the dictum but insisted on the fact that the 'meaning' of their canvasses was not restricted to the aesthetic appeal of the composition. That was necessary but not sufficient for a true understanding of their work. Nor did they insist, as European abstractionists such as Kandinsky and Mondrian were inclined to, that their works evoked syncretic spiritual meanings. The meaning was particular to the work, personal to the artist.

The colour-field painters, Still, Rothko and Newman, sought to develop the aesthetic potential of large fields of nuanced colour rather than the expressive gestures of brushwork. They were deeply influenced by indigenous art forms. For Newman the crafted designs of Northwest Coast Indians were essentially abstract forms that figured forth the metaphysics of their culture. They were not specific representations of the mythical moments and performances of that culture. This is similar to Picasso's earliest reactions to African sculpture and characteristic of the universalising tendency of European primitivism in general. But for the colour-field painters, unlike Picasso and the Cubists, 'primitive' ideographs embodying universal meanings were not merely of formal significance. In this respect their aesthetic lay closer to an occult epistemology than did that of the gesture painters. Whereas the former stressed the individuality, the latter expressed the universality of their symbolism. They also adapted Edmund Burke's doctrine of the sublime as the antitype of the beautiful. The sublime invoked a sense of fear, powerlessness, the infinite. So they painted on a large scale with veils of colour that ignored the frame as a delimiting compositional imperative. The beholder was to stand close in and be enfolded by shrouds of powerful, intense colour – to experience not beauty but sublimity.

Hitler's war, as we noted, brought the Surrealists pouring into New York: André Breton, Leonora Carrington (b. 1917), Salvador Dali (1904–1989), Max Ernst, Gordon Onslow Ford, Stanley

[5] Sandler 1970, p. 92.

William Hayter (1901–1988), André Masson, Roberta Matta (b. 1911), Wolfgang Paalen (1905 or 1907–1951), Kurt Seligman (1900–1962) and Yves Tanguy (1900–1955), among others.[6] 'We met them and learned that they were men not gods,' said Barnet Newman. Others, more securely linked to the Formalesque tradition, such as Mondrian and Léger, came too. New York became the leading art centre of the world.

But in the United States a deep interest in Surrealism and automatism preceded the arrival of the emigrés. After he graduated from the Harvard Fine Arts Department, headed by Paul Sachs, Barr's old teacher, Julien Levy, became Salvador Dali's dealer in New York. He published his own book on *Surrealism* in 1936, and through the 1930s exhibited work by Ernst, Dali, Giacometti, Magritte, De Chirico and Tanguy in his gallery on Madison Avenue. By 1939 Dali had already exhibited four times in New York and had lectured at MOMA. Arshile Gorky regularly visited the Levy Gallery, read Levy's book and began experimenting with automatism with his friend Gerome Kamrovski. Meanwhile, Siqueiros, in his studio on Union Square, was encouraging his students to use air brushes and experiment with dripping paint; and in the Museum of Non-Objective Art, directed by the Baroness Hilla Rebay (1890–1967), other young artists experimented with dripping melted lacquer from old phonograph records, or with flottage, made by dropping paper or canvas onto oil paint floating on water.[7] It was a time for free experiment with a diversity of processes.

The physical presence, after 1940, of the Parisian Surrealists quickened such experimentation. Motherwell, who had first studied philosophy, then art history, with Meyer Schapiro at Columbia, was encouraged by him to take lessons with Kurt Seligman, the first of the Parisian Surrealists to settle (late in 1939) in New York. Through him Motherwell met other members of the emigré group. In the autumn of 1940 the English painter and engraver S. W. Hayter, who had established Atelier 17 in Paris in 1927 and became a close friend there of the Surrealists, left for the United States and reopened his famous graphic workshop in New York. It was given a space in the New School for Social Research (established in 1919), which had set up a graduate faculty in the social sciences that welcomed to its staff German and French scholars fleeing from Hitler's Europe. There Hayter developed crea-

[6] The story of their exile and influence on U.S. art is recounted in detail in Sawin 1995.

[7] These early New York experiments in automatism are discussed in detail in *ibid.*, pp. 86 et al.

tive contact with Max Wertheimer, one of the pioneers of Gestalt psychology, and Ernst Kris (1900–1957), Ernst Gombrich's friend and mentor in the psychology of art. Atelier 17, New York, became the popular meeting place for Surrealist emigrés and artists like Motherwell, Baziotes and Rothko. Years later Hayter expressed the view that 'the New York School really came together at Atelier 17'.[8]

The Abstract Expressionists have been locked into a highly formalist reading of their achievement by two highly influential critics: Alfred Barr and Clement Greenberg. In 1950 the United States displayed five works by Gorky, three by Pollock and four by de Kooning at the Venice Biennale. It was the first occasion upon which work by members of the New York School had been displayed abroad to a large European public. In his introduction to their work in the Biennale catalogue, Barr endowed the three painters with an historical descent from the European avant-garde: from Gauguin, van Gogh, Redon, the Fauves, Kandinsky, Klee, Arp, Miro and Masson. Such a descent was by no means obvious, particularly in the case of Pollock, the stark audacity of whose large-scale, drip paintings are unprecedented in the work of any of his alleged foster-fathers, but it certainly did much, from the beginning, to endow the New York School with a European genealogy. Barr, in this particular case, was broadly following a line that had already been charted by Greenberg, who suppressed the Surrealist sources of the School. Stressing their nineteenth-century Cubist descent, he ignored their twentieth-century link with Dada/Surrealism. His neo-Kantian aesthetic smothered the historic dialectic then at work between Cubism and Surrealism.

For despite his own late disclaimers to the contrary, Greenberg was a formalist critic *par excellence*; a neo-Kantian for whom the judgement of taste was personal, universal and irrefutable. But he exercised his taste within a firm framework of art history. For him, as for Barr, the New York School was an American fulfilment of the promise of the School of Paris – the creators of the Formalesque. It had propelled the immanent potential of synthetic Cubism towards a post-cubic painterly abstraction. Ultimately Abstract Expressionism, in Greenberg's view, transcended the chiaroscuro of values upon which post-Renaissance painting was grounded and had developed through the centuries.

But if we are to bring the Abstract Expressionists fully into context, we must pay as much attention, if not more, as Fred Orton has insisted,[9] to the views of Harold Rosenberg, who did not trace

[8] Quoted from *ibid.*, p. 155.
[9] Orton 1993a, pp. 147–78.

the descent of the New York School back to the School of Paris. It was in his view 'different from that of the earlier "abstractionists" both the Europeans themselves and the Americans who joined them in the years of the Great Vanguard'.[10] Rosenberg put it in his now famous formulation: 'At a certain moment the canvas began to appear to one American painter after another as an arena in which to act – rather than as a space in which to reproduce, re-design, analyse or "express" an object, actual or imagined. What was to go on the canvas was not a picture but an event.'[11]

If such 'action painting' had any precedent at all it was to be found in Dada, for in Rosenberg's view, 'Dada itself helped to revolutionise the sensibilities by which art today is recognised'.[12] Unlike Greenberg, Rosenberg held positive views about the influence of Dada. In assisting Motherwell to proof Richard Heulsenbeck's 'En Avant Dada', Rosenberg noted with approval Heulsenbeck's views that 'The Dadaist should be a man who has fully understood that one is entitled to have views only if one can transform them into life – the completely active type, who lives through action, because it holds the possibility of achieving knowledge'.[13]

However, Rosenberg's intuition that Abstract Expressionism was linked with Dada and represented an epistemological break with the Formalesque did not pass into conventional wisdom. There were powerful reasons why. Rosenberg's reading linked the School more securely to the idea of revolutionary action, to praxis. It was a plausible reading, for most Abstract Expressionists possessed a history of involvement with radical politics. But such a reading rested uneasily with the notion that they had evolved a distinctly 'American type' painting, one that eschewed politics. Greenberg's reading, by viewing them in descent from the School of Paris, Cubism particularly, assisted the process by which their reputations were depoliticised and legitimated in the eyes of the art-loving and collecting public of the United States.

With the exception of the immigrants Gorky, Hofmann, and perhaps de Kooning, Rosenberg's reading is more in keeping with the Abstract Expressionists' own views about their work. Consider Barnet Newman's memorable statement: 'We are freeing ourselves of the impediments of memory, association, nostalgia legend, myth . . . that have been the devices of Western European painting. Instead of making *cathedrals* out of Christ, man or "life", we are

[10] Rosenberg 1961, p. 24.
[11] *ibid.*, p. 25.
[12] *ibid.*, p. 83.
[13] Orton 1993a, p. 161.

making it out of ourselves, out of our own feelings. The image we produce is the self-evident one of revelation, real and concrete, that can be understood by anyone who will look at it without the nostalgic glasses of history.'[14] Or consider Motherwell's rejection of the French tradition: 'The large format, at one blow, destroyed the century-long tradition of the French to domesticate modern painting, to make it intimate. We replaced the nude girl and the French door with a modern Stonehenge, with the sense of the sublime and the tragic.'[15] Or Still: 'the Armory Show of 1913 – had dumped on us the combined and sterile conclusions of Western European decadence . . . I, for one, refused to accept its ultimatums.'[16] And even de Kooning, who did not deny the weight of tradition, said of French artists, 'they have a touch which I am glad not to have'.[17] Ronald Paulson, in a cogent essay, 'The New York School', has argued that 'the action painting of the 1940s was the real style that evolved to express the American social unrest that had been expressed in the more conventional social-realist forms of Ben Shahn, William Gropper [1897–1977] and others in the 1930s. Rosenberg may still have been very close to the truth when he saw the "gesture on the canvas" in these paintings as a "gesture of liberation, from value – political, aesthetic, moral".'[18] If we accept this 'revolutionary' reading of Abstract Expressionism, the line of descent proceeds not so much from Cubism as from Dada, the Neue Sachlichkeit, Surrealism and the Mexican muralists and may be read as the product of a dialectical exchange with, as Motherwell put it, the French domestication of modern painting. Or, in other words, Abstract Expressionism sought to free itself from the cul-de-sac of the Formalesque and its immanent drive towards a non-representational geometric abstraction by escaping from the Cubist frame. But that, of course, was not Greenberg's view.

His evaluation of the Abstract Expressionists rests in his neo-Kantian faith in the judgement of taste before which there can be no appeal. But judgements as to the quality of their work provide a useful test-case for Bourdieu's alternative account of the produc-

[14] Newman, 'The Sublime is Now', *Tiger's Eye* 1, no. 6 (Dec. 1948), pp. 51–53; quoted in Harrison & Wood 1992, p. 574.

[15] Robert Motherwell interview with Max Kozloff, *Art Forum* 4, no. 1 (Sept. 1965), p. 37; quoted in Sandler 1970, p. 156.

[16] Clyfford Still letter to Gordon M. Smith (1 Jan. 1959); quoted in Sandler 1970, p. 158.

[17] De Kooning, 'Artists' Session at Studio 35', *Modern Artists in America* (1950), p. 13; quoted in Sandler 1970, p. 217.

[18] Paulson 1990, p. 50. The Rosenberg comment quoted is from Rosenberg 1964, pp. 39–47.

tion of taste and aesthetic valuing, before which Kant's judgement of taste seems little more than a priori reception theory. Indeed Bourdieu provides better explanations for the conditions of art production in the United States in the 1940s and 1950s than he does, as we have seen, for the condition of art in Europe and the States during the 1930s, when the political and economic fields of power were themselves in conflict and pressed heavily upon the relatively autonomous field of art. Serge Guilbaut[19] has assembled a network of actors that played key roles in the development of the taste for Abstract Expressionist art during the 1940s. They correspond in real life with Bourdieu's concepts of 'positions' and 'position-takings' in the production of the values of symbolic goods in the high art segment of cultural production. Initiating roles were played by a sequence of dealers, acting in competition and at times in collaboration as to the *type* of art (i.e. avant-garde U.S. art) they supported. Among them were Peggy Guggenheim, who opened her Art of This Century gallery in 1942. Between 1943 and 1947 she held exhibitions of the work of Baziotes, Hofmann, Motherwell, Pollock, Rothko and Still. Their works were tacitly supported by the prestigious modern European works in her own collection. To reinforce her own judgements she consulted with experts such as Alfred Barr, James Johnson Sweeney, James Thrall Soby, Herbert Read and Marcel Duchamp. During 1945–46 Samuel Kootz performed a similar strategy exhibiting Motherwell, Gottlieb, Baziotes and others, intermittently with shows representing Léger, Picasso, Arp, Braque and Mondrian. To encourage American collectors towards purchasing work from his stable, Kootz staged an exhibition of the prestigious Neuberger Collection of modern American art.[20] The Betty Parsons Gallery developed a similar policy. The work of these galleries was reinforced by the writings of art historians Barr[21] and Schapiro,[22] and by Greenberg in company with a plethora of criticism appearing in journals and magazines such as the *Partisan Review*, *Nation*, *Art News*, *College Art Journal*, *Life*, and *Time*. There was of course no overall sense of agreement between the dealers, historians and critics beyond a growing support for abstract art of various kinds. Each had an individual position to

[19] Guilbert 1983.

[20] Roy Neuberger (b. 1903) was a collector who donated items from his collection to over sixty U.S. institutions including the Whitney Museum of American Art and the State Universities of New York.

[21] Particularly his *Cubism and Abstract Art* (Barr 1936).

[22] Such as his article 'The Nature of Abstract Art' (1937); republished in Schapiro 1978.

maintain and reinforce. Greenberg's seminal article 'Avant-Garde and Kitsch' (1939) exemplifies Bourdieu's distinction between high and popular cultural production, the former produced by producers for producers and the latter for a broader audience of consumers. Furthermore Bourdieu's notion of an inverse order of symbolic value operating among the elite producers of high culture is exemplified by the ambivalent attitudes of Pollock, Still and others to the critics and galleries that supported them, and the life-styles they led that distinguished their fame from the conventional fame of figures in the world of high finance and industry. Aesthetic (Bourdieu's *symbolic*) values were established by a complex dialectical interplay of this matrix of forces acting within the relatively autonomous field of cultural production, itself a privileged yet dominated field within the fields of financial, economic and political power. As a result of almost a decade of interaction within this field, Alfred Barr was able to present Pollock, de Kooning and Gorky at the 1950 Venice Biennale as the legitimate heirs of the School of Paris.

The emergence of the New York School was certainly the product of a dialectical interaction between the Cubism of the nineteenth century and the Dada/Surrealism of the twentieth. But it was more than that. Cubism and Dada/Surrealism were both of European origin. The New York School was also inspired by powerful nativist and popularist sentiment. In a persuasive study, Michael Leja has shown how closely the ethos (or what Bourdieu would call the *habitus*) of the Abstract Expressionists was grounded in what he calls 'modern man discourse'. Leja does not claim that the discourse was specific to the United States. It was present in all technologically advanced societies, but in the States (in many ways the most advanced) it found favoured lodgement. Leja examines a great number of texts from the highly philosophical to the popular and observes:

In Modern Man discourse, modernity is defined by catastrophe. The texts themselves articulate their motivation for mining new knowledge in anthropology, psychology and philosophy to formulate and advance a new understanding of human nature and mind as stemming from the conviction that older views had become inadequate in the light of the tragedies of recent history. World War, socialist revolution, political corruption, social conflict, economic depression, the rise of fascism, genocide, the development of nuclear weapons – each and all of these twentieth-century phenomena prompted meditation upon

the makeup and situation of the human (white male) individual and what precisely within or outside him accounted for these tragedies.[23]

Leja records how the members of the New York School were profoundly influenced by this discourse which viewed Modernity in such a tragic light. But, in the event, their art was called upon by a paradox, as tragic as it was farcical, to celebrate Modernity.

It would not have occurred without the support, tacit and explicit, of the growing economic and political power of post-war United States. Whereas in the Soviet Union and Germany during the 1930s, political power had attempted to destroy the Formalesque, in the States it aided the immanent drive within the style towards abstraction. By 1949 the battle *within* the field of cultural production itself had been won, and by early 1947 U.S. Government agencies such as the United States Information Service (USIS) were financing exhibitions abroad that favoured the abstract Formalesque and ignored if not censored its affiliated figural modes. There had been a backlash. Popular taste even by 1950 did not favour abstraction. Indeed some, such as Senator George Dondero, Republican representative for Michigan's 17th District, did not favour any kind of modern art and he spoke for much popular U.S. opinion. His opinions flowed not so much from a dislike of modern art as such as from nativist convictions. The art he detested was foreign art; figural 'American Scene' painting lay closer to his taste.

It reflected, broadly speaking, the taste of one section of the United States' dominant class, that of the right-wing Republicans who favoured isolationism and expansionism *within* the Americas. They had dominated American foreign policy during the interwar years since their effective refusal to join President Wilson's League of Nations. But when the United States emerged from World War II the most powerful nation in the world, their isolationist policies became problematic, if not impractical. The crisis came when Britain withdrew its financial and military aid from Greece in 1947 at a time when the country was threatened by communist insurrection, and Soviet expansion was threatening Turkey. To shore up the situation the United States took over Britain's imperial role in the Near East. The Truman Doctrine was implemented, the U.S. Congress voting $400 billion for the purpose. The Doctrine tipped the balance of power within the dominant U.S. classes away from

[23] Leja 1993, p. 16.

the old-guard, 'nativist', right-wing Republicans towards the liberal internationalists who had already achieved power over *foreign* policy between 1939 and 1941. The Truman Doctrine provided the basis for the rapid growth of a neo-imperial policy, financially, politically and culturally.[24]

In 1947 the U.S. State Department purchased seventy-nine paintings to tour Europe and Latin America. It included work by both Abstract Expressionists, such as Baziotes and Gottlieb, and Social Realists such as Shahn and Levine. But it was criticised as a 'Red Art Show' because several artists, among them, Stuart Davis, William Gropper and Ben Zion, were said to be communists or members of communist-front organisations. The conservative American Artists Professional League asserted that 'the exhibition devalued all that was noble in art, was one sided, and was influenced by radical European trends not indigenous to our soil'.[25] Under pressure the State Department cancelled the exhibition and recalled it. The irony was that it was the American Scene painters working in styles and themes more compatible with isolationist, nativist tastes who were, if anything, the most politically suspect. But so too were many of the Abstract Expressionist artists, for most, if not all, had an historical association with left-wing politics, initially with the Popular Front during the later 1930s and later with the Trotskyism favoured by the *Partisan Review* cenacle. Indeed the great majority of the most creative artists of the United States of the time had a history of left-leaning sympathies. So that at a moment in the United States when it was turning increasingly towards the extreme anti-communism of the early 1950s McCarthy witch-hunts, it became strategically essential for the apparent autonomy of the art field to be asserted publicly. In 1950 the directors of the Museum of Modern Art, the Boston Museum of Fine Arts and the Whitney Museum of Art responded jointly to Senator Dondero's attacks. Modern American art, they said in effect, possessed a clean, non-political skin: 'We . . . reject the assumption that art which is essentially an innovation must somehow be socially or politically subversive, and therefore un-American.'[26]

From that day forward everything was done by the fields of commerce, politics *and* art to ensure that no art representing the United States abroad could be interpreted as being socially or politically subversive, or had been produced by artists who had been

[24] See Orton 1993b.

[25] Open letter to Secretary of State James F. Byrnes published in *Art Digest* 21 (1946), pp. 32–33; quoted in Orton 1993b, p. 184.

[26] Egbert 1967, p. 125n238; quoted in Orton 1993b, p. 185.

communists or members of communist-front organisations. For the
most part they were successful. However, a small hiccup occurred
in 1956 when the magazine *Sports Illustrated* organised an exhibi-
tion entitled *Sport in Art*, sponsored by the United States Informa-
tion Agency, for the 1956 Olympic Games in Melbourne. Prior to
that it was shown in Dallas and ran into trouble. The Dallas Public
Affairs Luncheon Club resolved that it overemphasised 'futuristic,
modernistic, and non-objective [art] and promoted the work of
artists with known communist affiliation to the neglect of . . . many
orthodox artists, some of them Texans, whose patriotism . . . has
never been questioned'. Among the artists in question were Ben
Shahn, who had drawn a baseball game; Yasuo Kuniyoshi and
Leon Kroll, who had painted skating scenes; and William Zorach,
who had painted a fisherman. Although the worst days of
McCarthyism ended in 1954, its aura lingered in Texas. The *Sport
in Art* show was never sent to help celebrate Melbourne's 1956
Olympic Games. That same year the American Federation of Arts
assembled an exhibition of one hundred twentieth-century Ameri-
can paintings to tour abroad but then refused to allow the artists
whose work had been selected to be vetted for their political asso-
ciations at the request of the United States Information Agency
(USIA), the sponsors of the show. When Theodore Streibert,
director of USIA, appeared before a Senate Foreign Relations Com-
mittee, chaired by Senator Fulbright, to explain the matter, he
stated that USIA had a policy 'against the use of paintings by
politically suspect artists in its foreign art shows'.[27] Fulbright, who
happened also to be a member of the International Council of the
Museum of Modern Art, commented at the hearing that he be-
lieved looking into the political beliefs of artists to be an impossible
task. But USIA did not change its policy and sent no exhibitions
abroad for some time. Their job was effectively taken over by the
International Council of MOMA, which could not be said to be a
prima facie U.S. council but a private institution, not accountable to
Congress in the way that USIA was. The International Council of
MOMA became in effect the acknowledged vehicle for the presen-
tation of U.S. art abroad. It was thus able to include the Abstract
Expressionist art that it championed without having to concern
itself overmuch with whether some of its exponents had in the
1930s been members of communist-front organisations. Certainly
the work they were producing in the late 1940s and 1950s revealed
(short of a searching hermeneutic) little evidence of their former,

youthful beliefs.[28] So MOMA became a decisive vehicle for the globalisation of U.S. cultural imperialism in the visual arts during the 1950s and 1960s.

The acceptance and recognition of U.S. Abstract Expressionism in Europe is homologous with the rise of the United States to the status of supreme world power after World War II. In 1948 the U.S. Congress approved the Marshall Plan. During the next four years some $12 billion of economic aid was provided for the economic rehabilitation of the European nations devastated by the war and for the containment of communism. In January that year Greenberg wrote, in an article entitled 'The Situation at the Moment': 'One has the impression – but only the impression – that the immediate future of Western art, if it is to have any immediate future, depends upon what is done in this country.'[29] In his view abstract painting in the United States 'does not seem to be matched either in France or Great Britain'. The new superiority of U.S. painting was due to two principal factors: the alienation of the New York artist, who in Greenberg's view suffered a harsher reality than that of his European counterpart, and his preference for mural-size canvasses which, according to Greenberg, was where creative abstract art was then at.[30] Two months later Greenberg wrote in 'The Decline of Cubism': 'As more and more recent work of the masters of the School of Paris reaches this country after six years' interruption . . . any remaining doubt vanishes as to the continuing fact of the decline of art that set in in Paris in the early thirties.' He spelt out a list of those whose work had fallen off: Picasso, Braque, Arp, Miro, Giacometti, Schwitters, Léger, Chagall, Lipschitz, Mondrian. Only Matisse and the late Bonnard and Vuillard appear to have survived the debilitation.[31] With European art in such a parlous condition, a cultural 'Marshall Plan' seemed to be needed.

> If artists as great as Picasso, Braque, and Léger have declined so grievously, it can only be because the general social premises that used to guarantee their functioning have disappeared in Europe. And when one sees, on the other hand, how much the level of American Art has risen in the last five years, with the emergence of new talents so full of energy and content as Arshile Gorky, Jackson Pollock, David Smith . . . then the conclusion forces itself, much to our own surprise, that the main premises of

[28] I am indebted to Fred Orton's article (1993b) for most of the information in the preceding paragraph.

[29] Greenberg, 'The Situation at the Moment', in Greenberg 1986, vol. 2, p. 193.

[30] ibid., pp. 192ff.

[31] Greenberg, 'The Decline of Cubism', in Greenberg 1986, vol. 2, pp. 211–12.

Western art have at last migrated to the United States, along with the center of gravity of industrial production and political power.[32]

To follow Greenberg's articles and reviews in the *Partisan Review* and *The Nation* during 1948 and 1949 is to watch a master strategist at work. Greenberg possessed a brilliant eye which was, as he repeatedly insisted, his first and only guide to quality in art. He also possessed the deepest respect for the artistic traditions of western Europe and wrote lucid prose – but he was a proud citizen of the United States of America, a closet nativist – not a public one of the Dondero type. And when he saw his chance in 1948, in the high game of artistic diplomacy that he was playing, he took it.

A week after he wrote his 'Situation at the Moment' article in January 1948, he reviewed Robsjohn-Gibbings's *Mona Lisa's Moustache*, a notorious attack on modern art. Predicably, he panned it. It was simple-minded vulgarity. But he did agree with it on one point. T. H. Robsjohn-Gibbings (1905–1976) had discovered that there was something 'very wrong with surrealism, futurism, and Pre-Raphaelitism'. The last aside, this reinforced Greenburg's repeated insistence that the true line of modernism's descent lay through Cubism. Surrealism, particularly, must be removed from the account. This was essential to a nativist account of Abstract Expressionism because it was well known, at least among New York art circles at that time, that the Surrealists exiled in New York, such as Masson and Breton, had exercised a selective but powerful influence in the development of automatism in the practice of the young Abstract Expressionists. Towards the end of January 1948 an exhibition of Pollock's at the Betty Parsons Gallery provided Greenberg with an opportunity to compare his young hero's work with that of Mondrian: 'Since Mondrian no one has driven the easel picture quite so far away from itself.'[33] That not only elevated Pollock but reinforced Greenberg's contention that the future of abstract art lay in mural-scale canvasses. There was to be no mention of the Mexican achievement in modern mural painting on this occasion, or of Pollock's time in Siqueiros's New York studio in 1936.[34] Paris

[32] *ibid.*, p. 215.

[33] Greenberg 1986, vol. 2, p. 201.

[34] Greenberg was not much interested in mural art as such. Perhaps it raised many art-political questions too close to the bone. He *was* interested in the use of a 'mural-scale' by easel painters. In his obituary to Mondrian, written in March 1944, he had already made the point that Mondrian was returning easel painting to the mural. On that occasion, at least, Greenberg did refer to the relevant history ('Puvis de Chavannes, Rivera, and the WPA Projects', in Greenberg 1986, vol. 1, p. 188).

in 1948 was not, of course, producing mural-scale canvasses. It was recovering from the trauma of war.

In 'The Decline of Cubism', mentioned above, Greenberg portrayed its formation as an essentially late nineteenth-century style. It had originated not only from the 'art that preceded it, but also from a complex of attitudes that embodied the optimism, boldness, and self-confidence of the highest stage of industrial capitalism, of a period in which the scientific outlook had at last won a confirmation . . . in which society seemed to have demonstrated its complete capacity to solve its most serious internal as well as environmental problems'.[35] For Greenberg, Cubism expressed the 'positivist or empiricist state of mind' and the conviction that 'the world would inevitably go on improving'.[36] Its primitivistic sources were ignored. After World War I Cubism's history was in decline. But could its heritage be built upon? Not in Europe where 'the general social premises that used to guarantee their functioning have disappeared'. So Greenberg looked to U.S. art to go on where creative Cubism left off. That is to say he hoped for the recrudescence of Europe's late nineteenth-century, positivistic confidence in postwar United States' economic and political supremacy, and anticipated that an art of the same self-confidence would emerge from it. Although he was willing to concede that 'the present situation contains many paradoxes and contradictions that only time will resolve', he would not countenance the notion that Dada and Surrealism may have touched off emotions and intimations that would prevail in the twentieth-century psyche in fundamental opposition to the self-confidence of his 'empirical' Cubism. But when perceived from a more distanced, more decentred, view than Greenberg's intensely internal and interested one, it becomes increasingly clear that his particular reading of Abstract Expressionism (which denied its Dada/Surrealist heritage) was a device, though one he was not, it seems, fully aware of, to shore up what I have described as the Formalesque style or, more precisely, its late, immanent, abstract, dynamic centre, as the dominant period style of the mid-twentieth century.

One powerful aspect of Greenberg's strategy was to praise the work of a small, select group of Abstract Expressionists, such as Basiotes, Gorky and de Kooning, within which Pollock was singled out as the most favoured son. Their work was always compared

[35] Greenberg 1986, vol. 2, pp. 213–14. It is worth noting here that Douglas Cooper, the first major collector of Cubist paintings, insisted that 'true' Cubism, that is, in his view, the art of Picasso, Braque, Gris and Léger, ended with the Great War of 1914–18.
[36] *ibid.*, p. 214.

with European contemporary masters, rarely with local ones, and then only with the work of other members of 'The Club'. Thus an exhibition of Gorky's work at Julien Levy's in March 1948 provided the opportunity to compare him with Mondrian and Miro, to assert that he was 'among the very few contemporary American painters whose work is of more than national importance' and that he was 'the equal of any painter of his own generation anywhere'.[37] An exhibition of de Kooning's work, at the Egan gallery a month later, enabled Greenberg to comment on the 'form' of his little stable. De Kooning 'lacks a final incisiveness of composition' and lacks 'the force of Pollock or the sensuousness of Gorky'. Yet he 'has it in him to attain a more clarified art and to provide more viable solutions to the current problems of painting'.[38] The implication, of course, was that the 'current problems of painting' were in the hands of Greenberg's ever-straining master lads.

This ranking and positioning process proceeded all through 1948. An exhibition of Le Corbusier's Cubism at Rosenberg's gallery, in June, gave Greenberg an opportunity to patronise: 'the grandeur of cubism is absent . . . but something of its quality remains . . . Le Corbusier was more than a little competent as a painter, even if his colour is brittle.'[39] At Kootz's he adopted his customary avuncular manner to Motherwell's work. At last he had made the grade. It was 'another big step forward on his part and, coming after his last year's show, makes his inclusion among our most important contemporary painters obligatory'.[40] In August, a special issue of *Verve* provided an opportunity to patronise Picasso gently: 'essentially a pastoral, lyric artist' and 'incontestably one of the greatest designers in space and line of all time and all culture' was now perhaps entering 'a gentle and elegiac phase . . . such as other great artists before him have known in their old age'.[41] Only Matisse, among all the French, was facing up to the artistic challenges of the post-war years.[42]

Greenberg began 1949 by noting Pollock's 'astounding progress' at his Betty Parsons, February exhibition.[43] Pollock's painting *Number One* 'is as well contained in its canvas as anything by a

[37] *ibid.*, pp. 218–21.
[38] *ibid.*, p. 228–30.
[39] *ibid.*, p. 240.
[40] *ibid.*, pp. 240–41.
[41] *ibid.*, pp. 258–59.
[42] See his review of a Matisse exhibition in *The Nation* (5 March 1949), in *ibid.*, pp. 292–94.
[43] *The Nation* (Feb. 1949), in Greenberg 1986, vol. 2, p. 285.

Quattrocento master'. The following month, in the symposium 'The State of American Art', Greenberg felt confident enough to announce 'a definitely American trend in contemporary art, one that promises to become an original contribution to the main-stream, and not merely a local inflection of something developed abroad'.[44] Gorky, Pollock, de Kooning, David Smith, Roszak, Gottlieb, Motherwell, de Nino and Seymour Lipton – 'all of whom are under forty-five' – were listed as the trendsetters. Paris was much less well endowed with young hopefuls. In March he noted that Jean Dubuffet (1901–1985) was 'perhaps the one new painter of real importance to have appeared on the scene in Paris during the last decade'.[45] But 'despite the appearance of his pictures Dubuffet has not thrown off the past as he seems to think . . . [H]is art is not the raw immediate expression that he himself advertises it as.' In March, a Matisse (now eighty) exhibition gave Greenberg an opportunity to proclaim him once again as the greatest modern painter. In April, a Picasso show revealed his inability to paint like the French. His ambition to be a 'complete' artist 'has for a long time now not permitted him to acknowledge his characteristic limitations'. In the 1930s 'he embarked upon a competition with Matisse in the matter of colour and sheer paint handling . . . Since then his successful canvasses have been few and far between.'[46] By June it was time for U.S. sculpture to get Greenberg's full affirma-tion. The country possessed more promising young sculptors pro-portionally than there were young painters. 'We have four or five [painters] who may figure eventually in the history of the art of our times. But we have as many as nine or ten young sculptor–constructors who have a chance, as things look, to contribute something ambitious, serious and original.'[47]

By the end of 1949 Greenberg's cogent advocacy of 'American type' art was inspiring U.S. dealers and collectors with a new confidence in their nation's art. Peggy Guggenheim displayed Abstract Expressionist work in her Venice residence and Alfred Barr, as we have noted, was able at the 1950 Biennale to trace their descent back to the Parisian pioneers of the Formalesque. Like the broad homology that may be established between the Counter Reformation and the Baroque, Greenberg's promotion of abstract at the expense of figural art co-incided with the onset of the Cold War. Winston Churchill delivered his 'Iron Curtain' speech at Fulton,

[44] Greenberg 1986, vol. 2, p. 287.
[45] ibid., p. 289.
[46] ibid., pp. 297–98.
[47] ibid., p. 319.

Missouri, in March 1946, and the year following, the U.S. Congressman Bernard Baruch coined the term 'Cold War' that marked the estrangement that was to characterise the political relationship between the United States and the Soviet Union for over forty years. Greenberg was positioned in 1947 to spell out with great eloquence the comparable estrangement between abstract and figural art that symbolised, or was seen to symbolise, the art of the capitalist democracies and the totalitarian regimes dominated by the Soviet Union: on the one side 'abstraction', on the other 'realism'. It was of course a gross oversimplification equating a cultural divide with a political one but its effect was too potent to be ignored. Greenberg had begun the promotion of Pollock as early as the autumn of 1943,[48] and a month after Churchill's Fulton speech was able to write of the apparent 'ugliness' in Pollock's painting that 'in the course of time' would 'become a new standard of beauty'. How right he was.[49] It would of course be naive to suggest any causal link between Churchill's speech and Greenberg's comments. It would be even more naive to ignore the prophetic significance of the homology. Churchill foreshadowed a future in international politics that Greenberg foreshadowed in the politics of U.S. culture. There is nothing in his *Collected Essays and Criticism* to indicate that he had anything to say in defence of the many radical writers and artists who were persecuted or deprived of their normal means of subsistence during the worst days of the McCarthyist era.

The economic and political dominance of the United States as a result of the Marshall Plan (1948) and the implication of the North Atlantic Treaty Organisation (NATO, 1949) left a permanent U.S. military presence in Europe and had the effect of increasing the influence of 'American' popular and elite culture throughout Europe. American film, as the result of an advantageous trade agreement, was at last able to penetrate the French film market. During the 1950s the United States began to wage an intense cultural campaign in Europe for the 'containment of communism'. During his election campaign for the presidency of the United States, Dwight Eisenhower, in October 1952, put it this way: 'Our aim in the "Cold War" is not conquest of territory or subjugation by force. Our aim is more subtle, more pervasive, more complete. We are trying to get the world, by peaceful means, to believe the

[48] On the occasion of Pollock's exhibition at Guggenheim's Art of This Century gallery (Nov. 1943); in Greenberg 1986, vol. 1, pp. 165–66.
[49] Greenberg 1986, vol. 2, p. 74.

truth ... The means we shall employ ... are often called "psychological" ... "Psychological warfare" is the struggle for the minds and wills of men.'[50] On the intellectual front cultural magazines supported by the Central Intelligence Agency (CIA) increased markedly.[51] During the McCarthy years exhibitions, financed by *independent* U.S. agencies, of avant-garde U.S. art were held in Berlin, Munich and Paris (1951), in Paris again in 1952, in London (1953), in Paris, Zurich, Düsseldorf, Stockholm, Helsinki, and Oslo (1953–54) and in Zurich, Barcelona, Frankfurt, Düsseldorf, London, Vienna and Belgrade (1955–56).[52]

In consequence U.S. art became as well known in Europe as at home. Because these exhibitions displayed abstract art virtually to the exclusion of all other genres, they provided a powerful fillip to abstraction in Europe, the original source of the genre. Although the impact of U.S. art met with considerable critical resistance, the overall effect was to establish parity between the advanced art of Europe and the United States. No longer could U.S. art be considered provincial. But the campaign for the recognition of its art had been promoted on the grounds not of nationalism but of its superior quality. There was a profound contradiction here. The universal superiority of 'American type' painting had been won as a result of a powerful national campaign backed by U.S. government policy.

[50] Blanche Weisen Cook, *The Declassified Eisenhower*, New York, 1981; quoted in Guilbaut 1983, p. 248n33.

[51] See Lasch 1967, pp. 198–212.

[52] Guilbaut 1983, p. 249n35.

10 The Eurusan visual culture

The late 1950s and early 1960s saw the consolidation, between the United States and western Europe, of a highly integrated visual culture. Although on a close view, regional differences are obvious enough, there was now an enormous amount of cultural interchange, institutionally promoted, between the two regions. It will be useful therefore to see it from a distanced viewpoint as a cultural unity in contrast to the art of the rest of the world. For this reason I shall call it the 'Eurusan' (Euru'san) visual culture. This coinage seems more appropriate than, say, trans-Atlantic or Euro-American, the terms commonly used, since they are more cumbersome and less precise. It also evokes Eurus (Greek for the east wind), the wind that brought many millions of white migrants from Europe and black slaves from Africa to the New World. If Eurasian denotes a matrix of relationships between Europe and Asia then surely Eurusan may be used to denote the close relationship that began to develop in the visual arts between Europe and the United States of America during the 1950s.

The transition from a Eurocentred to a *Eurusan* modernism began about 1950, that is about four years after most of the European countries seriously affected by World War II had begun to recover economically. France, humiliated by Vichy and the German occupation, never recovered its supremacy as the most advanced art nation of the world. Indeed its supremacy, as Romy Golan has argued, had been ailing since the Great War of 1914–18.[1] New York's supremacy during the 1950s provided the groundwork for the late Formalesque to spread throughout the capitalist democracies of the world as an imperial culture. Of course there had been many manifestations of European cultural imperialism ever since the sixteenth century; the Eurusan was the last, in the sense of the most recent, not the first, of the cultural imperialisms originating from Europe. At close range Eurusan art reveals immense complexity. But on a distanced view and from the 1950s, from Seattle to Berlin, from Glasgow to Naples, it is revealed as a closely interlocked visual culture.

[1] Golan 1995.

Consider a few cases – a few stylisms. To the Abstract Expression-
ist, Action, and Colour-field paintings of the United States, Europe
by the 1950s could reply with its Art Informel, and Tachisme.
Pollock was first shown publicly in Europe at the Biennale of 1950;
Wols, the pioneer of Art Informel, had an important show in the
Hugo Gallery, New York, in the same year. In Germany the late
Formalesque abstractions of Willi Baumeister (1889–1955) are
spiritually akin not only to those of Wols and Hans Hartung (1904–
1989) but to American painters like Mark Tobey (1890–1976), an
artist who exerted considerable influence upon Art Informel. The
work of Otto Piene (b. 1928) is typical of the new spatial unity of
the Eurusan Formalesque. Profoundly interested in colour, light
and movement, Piene was a founder of the Zero group (1957) in
Düsseldorf. He held an exhibition in Buffalo in 1965 and taught in
several American universities while continuing to work intermit-
tently in Düsseldorf. Artists of the Zero group held exhibitions in
1964 in New York and Philadelphia. The Scottish painter Alan
Davie (b. 1920), after studying at the Edinburgh School of Art, first
saw Abstract Expressionist paintings in Peggy Guggenheim's house
in Venice in the late 1940s. He held his first American show in New
York in 1956. Since then his work has been acquired by many
public collections in the United States, such as MOMA, the
Albright-Knox Gallery, Buffalo, the Museum of Fine Arts, Boston,
and the Carnegie Institute, Pittsburg. His experience typifies that of
many of the successful artists of his generation.

While informal abstraction and gesture painters were the
favoured children of the 1950s, by the 1960s a significant
generational change had occurred. Colour-field painting, large
monochromatic fields of glowing colour, came to be preferred.
Exhibited by Yves Klein (1928–1962) in London in 1950, and
developed in France in 1952 by Ellsworth Kelly (b. 1923), it became
a favoured Eurusan style of the 1960s in the work of Barnett
Newman, Morris Louis, Kenneth Noland, Sam Francis, and the
German group Zero. They have much in common with the 'colour
painting' of the British artists Patrick Heron (b. 1920), Robyn
Denny (b. 1930), Bernard Cohen (b. 1933) and John Hoyland (b.
1934). Colour-field itself was practised in tandem with what is
known as 'hard edge',[2] a style as visible in the work of the German
Günter Fruhtrunk (b. 1923) as in the American artist Leon Polk
Smith (b. 1906). Op Art, which came into vogue in the mid-1960s,[3]

[2] The term was coined by the art critic Jules Langsner in 1958.
[3] The term is said to have been first used in an unsigned article in *Time Magazine*, 23
Oct. 1964 (Frank Popper, Dictionary 1996, vol. 23, p. 448).

is as prominent in the work of the Hungarian Victor Vasarely (b. 1908) as it is in the work of the British artist Bridget Riley (b. 1931) and the American artist Richard Anuskiewicz (b. 1930). Such communality of style and interests was reinforced by a great deal of travel between Europe and the United States. Many European artists spent years in the States, while American artists lived and worked in Europe. Perhaps it was the British who welcomed the American achievement most unreservedly. The contributions of Patrick Heron, artist and critic, to *Art* (New York) from 1955 to 1958 were, in his own words:

> intensely pro-American . . . [A]*ll* my references to the Americans were wildly complimentary . . . This fact was also extremely well known to all American artists and critics around at the time, who expressed their gratitude in one way or another – since they had not at that time established themselves even in New York, let alone Europe. The Americans to whom I was offering this rather valuable service were indeed the Abstract Expressionists, so-called . . . [I]t was probably the first consistent and effective support they received from abroad – this at any rate is what they told me at the time.

Later Heron came to the view that U.S. painting 'vacated the centre of the stage' after 1952 and that it was in British painting of the last fifteen years (i.e. 1956–71) 'that the most important historical problems in painting have been faced and resolved'.[4] Such patriotic sentiments were predictable in the circumstances, but it did not alter the fact that in the process a transatlantic Eurusan visual culture was being consolidated. In the early 1960s Michael Fried and Greenberg repaid, in a sense, Heron's advocacy of Abstract Expressionism by writing with great warmth about the sculptural achievement of Anthony Caro,[5] who had spent two months in Mexico and the United States in 1959, where he met Greenberg and the sculptor David Smith. Then in spring of 1965 Caro taught sculpture at Bennington College, Vermont.

The Eurusan conflation of the visual arts of Europe and the United States was given a kind of official sanction by the exhibition held at the Tate Gallery, London, in the spring of 1964, entitled *Painting and Sculpture of a Decade 54–64*.[6] Of the 170 artists included,

[4] Heron 1971, p. 124.

[5] Michael Fried catalogue to the Anthony Caro exhibition, Whitechapel Gallery, London, Sept.–Oct. 1963; Clement Greenberg, 'Contemporary Sculpture: Anthony Caro', *Arts Yearbook* 8 (1965); reprinted in Greenberg 1986, vol. 4, pp. 205–08.

[6] It was brought together by the British Arts Advisory Committee of the Gulbenkian Foundation.

40 resided in France, 46 in the United States and 49 in Britain. Representation from other parts of Europe was minimal. Not one artist living beyond Europe or the United States was included. Eurusan art defined the art of the world.

The 1960s situation may be seen as a cultural homologue to the military North Atlantic Treaty Organisation (NATO). Although a degree of mutual rivalry and suspicion was present, natural enough in the circumstances, Eurusan art became a cultural reality in the 1960s. Greenberg, who had done more than anyone else to create the situation, was also one of the first to express concern. As early as May 1960, he noted that 'the arrival [internationally] of American painting has been demonstrated more tellingly by a younger generation of good second-rate artists than by an older generation of major ones'. It was, he said, the older generation that had made 'American painting exportable', and it was the younger generation of 'good second-rate artists' who were proving that it continued to be exportable.[7]

However, it was just when the late Formalesque had become dominant within the Eurusan culture and its cultural colonies that it proved to be vulnerable; the reasons are complex. One highly significant factor is that artists had begun to search for ways of escaping from the constraints imposed by the formal limitations and conventions of the high arts. Greenberg had argued that modernism consisted in the exploration of each individual art's potential autonomy. Good painting emerged from an appreciation of painting's natural and formal limits; good sculpture from a recognition of the spatial implication of sculpture's three dimensions. Confronted by such challenges as Ad Reinhardt's black paintings, artists began to seek for ways to avoid the alleged purities of the high arts. One way out was to produce a *hybrid* art that was neither quite painting nor sculpture. Of course there is a sense in which all art is hybrid, as there is a sense in which all art is eclectic. But the absorbing interest of the 1960s and 1970s was the possibility of hybridising categories. Hybrid arts began to appear *between* architecture, sculpture, painting, theatre, film, dance, and literature and even, in the case of conceptual art, between art and philosophy. It was, in a sense, a return to, but also an extension of, the Wagnerian concept of synaesthesia. Some of these new hybrid arts were more viable than others.

In the early 1950s, Robert Rauschenberg introduced real objects, ladders, clocks, etc., to the painted surfaces of his pictures, des-

[7] *Art International* (May 1960); reprinted in Greenberg 1986, vol. 4, p. 94.

cribing them as 'combines'. They could be read in a number of ways, as they combined the flatness of painting with the three-dimensionality of sculpture, thus transgressing the 'purity' of both arts. They may also be seen as a radical development of Picasso's collage and Schwitters' *merz*, and a return to Dada, for long oppressed by the authority of the late Formalesque. In 1952 Dubuffet called a series of paper collages he made *assemblages*, and the term was adopted by the Museum of Modern Art for an exhibition entitled *The Art of Assemblage* in 1961. The word came to be used for groups of objects normally assembled in a box or cage.

Many of the innovations which flourished in the Eurusan culture during these decades may be read as a recrudescence of early twentieth-century experimental modes quelled by the predominance of late Formalesque theory and practice. For example, what became known as Kinetic Art[8] was pioneered theoretically by Moholy-Nagy in his *Manifesto of Dynamic-Constructive Force-System*, published with Alfred Kemeny in 1922[9] and later practised in Moholy-Nagy's work at the Bauhaus and in Kemeny's sculpture. But the Kinetic Art that flourished during the 1950s and 1960s may also be seen as a mode situated aesthetically between the traditional practice of sculpture and the contemporary arts of electronic and cybernetic engineering. Though it assumed many forms, Kinetic Art had its primary source in the Constructivist tradition of the early Formalesque. Closely related to Kinetic Art are modes that invite the active (often physical) participation of the spectator, as in 'Happenings' (a term coined by Allan Kaprow in 1959), a form of performance art combining the aesthetics of theatre and sculpture. Variants include Installation Art, normally created within a museum or gallery space, with its prototype in Duchamp's *Bride Stripped Bare by her Bachelors, Even* (1915–26), and the Earthworks and Environmental art of the 1960s and 1970s that take the notion of individual (and at times collective) aesthetic creativity into open spaces.

Whilst all of these new modes may be read as the pursuit of potentials within the constructivist aesthetic, there were others such as Conceptual Art,[10] Body Art and Performance Art that pressed the concept of creative individualism to new limits: in the first case, the ideas of the artist are privileged, the objects created

[8] It came into vogue in the writings of Wolfgang Ramsbott (Weisbaden 1960), George Rickey (New York 1967), and Frank Popper (France 1967).

[9] See Popper 1975, p. 13.

[10] The term gained currency in the 1960s and came into vogue after the publication of Sol LeWitt's article 'Paragraphs on Conceptual Art' (LeWitt 1967, pp. 79–83).

being reduced to trace elements of the constitutive ideas; in the second, the body itself becomes the medium of the art, the mind being reduced to a secondary status; the third has been described as 'any form of live art in a public setting'. All these novel hybrid arts also sought by their very nature to escape the high commercialism of the art dealing system.

One of the first, and most devastating, innovations to criticise the late Formalesque aesthetic was Pop Art. It elided Greenberg's distinction between art and kitsch and thus challenged the elitist status that the Formalesque had sought to maintain. Pop Art was introduced by the Independent Group in London between 1952 and 1955. It included the architectural historian Reyner Banham (1922–1988), the art critic Lawrence Alloway (1926–1990), and the artists Richard Hamilton (b. 1922), Eduardo Paolozzi (b. 1924) and William Turnbull (b. 1922). In the mid-1950s a U.S. mode of Pop developed in opposition to the dominance of Abstract Expressionism, in the work of Larry Rivers (b. 1923), Jasper Johns (b. 1930), Robert Rauschenberg (b. 1925) and Andy Warhol (1928–1987). Warhol's multiple images of soup cans and Coca-Cola bottles replay in their own way the aesthetic issues raised in the 1920s by Duchamp's ready-mades. They were also commenting upon the notorious tension between the 'unique' art of painting and the multiples produced by graphic art. Indeed much of the most interesting art of these decades was addressed not to the production of excellence within the constraints of the high arts but to posing aesthetic problems implicit within such constraints. Art, conceived as an object, was transformed increasingly into process, performance, or event as artists worked in the fields between painting and theatre, painting and film, etc.[11]

A growing impatience with the assumptions of the Formalesque aesthetic also appeared at the level of theory. In the spring of 1953 Leo Steinberg (b. 1920) published a seminal article, 'The Eye is a Part of the Mind', in the *Partisan Review*, which challenged the locus of that aesthetic. Previously it had been justified on neo-Kantian grounds, the optical assessment of internal formal relationships constituting the quality of a work of art. But to Steinberg representation rather than formal relationships was central to all art. An art historian, he approached the problem historically: 'the formalist esthetic, designed to champion the new abstract trend, was largely based on a misunderstanding and an underestimation of the art it set out to defend'.[12] He proceeded to argue that, during the early

[11] See Brook 1975, pp. 16–34.
[12] Steinberg 1972, p. 291.

Renaissance, painting was passionately involved in solving the problem of depicting a three-dimensional reality. This 'synthesising will' was responsible for the creation of the high aesthetic quality of the works produced. Medieval art had quite other objectives. Grounded in the spirituality best described aesthetically by Plotinus, it produced a 'system of representation by abstraction' seeking to portray the unchanging spiritual reality behind the veil of natural appearance. Modern art sought something similar but secular. In this case it is a vision of nature as conceived by modern science which also seeks to penetrate the veil of appearance. 'The scientist's sense of pervasive physical activity in space, his intuition of immaterial functions, his awareness of the constant mutability of forms, of their indefinable location, their mutual interpenetration, their renewal and decay – all these have found a visual echo in contemporary art, not because painters illustrate scientific concepts, but because an awareness of nature in its latest undisguise seems to be held in common by science and art.'[13] So Steinberg distinguished for art criticism the difference between representation and resemblance. Both medieval and contemporary art sought to represent that which was invisible. Representation, previously under a cloud, began to regain significance. And representation raised the whole question of meaning, which the Formalesque aesthetic had largely ignored.

Steinberg began to address his attention to the work of Johns and Rauschenberg whose neo-Dada, Pop Art was challenging the hegemony of the Formalesque. Johns' work acted as a revelation.[14] His *Flags*, *Targets* and *Numbers* foregrounded an innovative but banal reality. What did they mean? The Formalesque aesthetic had stuffed meaning under its coloured carpet. But these paintings made Abstract Expressionist work rejoin the arts of illusion. 'De Kooning and Kline . . . were suddenly tossed into one pot with Rembrandt and Giotto.'[15] As Greenberg had puzzled over formal relationships, Steinberg began to puzzle over meaning, to dip into the bottomless pit of visual hermeneutics. He concluded that Johns' works were 'meditations on the nature of painting'. It was an interest that he shared with many of his generation. The formalist hegemony was beginning to crack. As to Rauschenberg, Steinberg noted that he produced his paintings and 'combines' when laid flat, as in the production of a print and, unlike Pollock's drip paintings (also produced on the flat), Rauschenberg's possessed motifs laid at

[13] *ibid.*, pp. 299, 304.
[14] *ibid.*, pp. 17–54.
[15] *ibid.*, p. 12.

all angles intended to be read as flat, even though hung on a
wall. It was another way of interrogating Greenberg's maxim on
the 'integrity of the picture plane'. Steinberg argued that
Rauschenberg's creations were 'post-Modernist' and made 'the
course of art once again non-linear and unpredictable'.[16] Steinberg
chose his Rauschenberg essay to develop a definitive and highly
influential attack upon Greenberg's formalism:

> Reducing the range of reference has always been the appointed
> task of formalist thought, but there has been much hard, serious
> thinking in it. Given the complexity and infinite resonance of
> works of art, the stripping down of artistic value to the single
> determination of formal organisation was once – in the nine-
> teenth century – a remarkable cultural achievement. The
> attempt was to discipline art criticism in the manner of scientific
> experiment, through the isolation of a single variable. Art's
> 'essential purpose' – call it abstract unity of design or what-
> ever prevents buckling and wobbling – was presumed to be
> abstractable from all works of art. And the whole range of mean-
> ing was ruled to be disposable 'subject matter', which at best did
> no harm but which more commonly burdened the form. In the
> formalist ethic, the ideal critic remains unmoved by the artist's
> expressive intention, uninfluenced by his culture, deaf to his
> irony or iconography, and so proceeds undistracted, pro-
> grammed like Orpheus making his way out of hell.[17]

Note that Steinberg here asserts, as has been argued throughout
this study, that formalism was essentially a nineteenth-century
achievement. He went on to state that it was grounded in an
eighteenth-century Kantian aesthetic: 'It is surely cause for suspi-
cion when the drift of third-quarter twentieth-century American
painting is made to depend on eighteenth-century German episte-
mology.'[18] Steinberg gave his lecture 'Other Criteria', in which he
criticised the Greenberg aesthetic, in March 1968. It marks theoreti-
cally an end to the formalist hegemony in American avant-garde
art.

By 1960 Abstract Expressionism was firmly established on the
New York art scene as *establishment* art. This is revealed in a inter-
esting incident.[19] Late in 1959 the *New York Times*, sensing the need
for an alternative viewpoint, employed John Canaday as its art

[16] *ibid.*, pp. 48, 91.
[17] *ibid.*, pp. 65–66.
[18] *ibid.*, p. 68.
[19] See Canaday 1962.

critic. Canaday wrote in a gently ironic vein, full of good humour, not taking abstract art and the modern movement at all too seriously. Indeed it could be said that his approach was neo-Dada. It was all too much for New York's art worthies. After submitting to sixteen months of Canaday ribbing their heroes, forty-nine of them signed a letter objecting to his critiques, accusing him of 'waging . . . a polemical campaign under the guise of topical reporting'.[20] The signatories included painters, poets, sculptors, collectors, art critics, and academics including professors of art history and of philosophy, a veritable phalanx of dignitaries. The letter stimulated 600 replies of which about 550 were supportive of Canaday. One read, 'Anyone who can make so many distinguished people so angry must be doing a good job.'[21] Like Steinberg's 'post-Modern' critique of Rauschenberg, Canaday's intervention signalled the end of an epoch. And of the 1970s Kim Levin could write that it was 'a decade . . . waiting for something to happen . . . The mainstream trickled on, minimalising and conceptualising itself into oblivion, but we were finally bored with all that arctic purity . . . We are witnessing the fact that in the past ten years modern art has become a period style, a historical entity. The Modernist period has drawn to a close and receded into the past before our astonished eyes.'[22]

Greenberg, not flustered by the apparent complexity of 1960s art, was also thinking in terms of period style. In the last of his public lectures to be published in his *Collected Works*, he drew attention to the *apparent* varieties of style present in the art of the sixties:

Approached strictly as a matter of style, new art in the 60s surprises . . . not by its variety, but by the unity and even uniformity it betrays *underneath* all the appearances of variety. There are Assemblage, Pop and Op; there are Hard Edge, Color Field and Shaped Canvas; there are Neo-Figurative, Funky and Environmental; there are Minimal, Kinetic and Luminous; there are Computer, Cybenetic, Systems, Participatory – and so on.

This 'rash of labels' he added, was mostly devised by the artists, whereas it used to be journalists that provided such brand names. But all that had nothing to do with style. He continued:

Well, there are all these manifestations in all their variegation, yet from a steady and detached look at them through their whole

[20] *ibid.*, p. 221.
[21] *ibid.*, p. 238.
[22] Levin 1988, p. 3.

range some markedly common stylistic features emerge. Design
of layout is almost always clear and explicit, drawing sharp and
clean, shape or area geometrically simplified or at least faired and
trued, color flat and bright or at least undifferentiated in value
and texture within a given hue. Amid the pullulation of novel-
ties, advanced art in the 60s subscribes almost unanimously to
these canons of style that Wölfflin would call linear . . . All the
varied and ingenious excitements and 'experiments' of the last
years, large and small, significant and trivial, flow within the
banks of one, just one period style.[23]

In my view Greenberg's lucid distinction between the art of the
1950s and 1960s may be viewed as generational substyles of the
period style I have described as late Formalesque. It is significant
that architecture does not enter into his concept of a modern period
style. If it did he would have to consider the temporal range of the
International Style that prevailed from the 1890s to the 1970s.
Generational change cannot fully explain a true period style. Such
a style would seem to be controlled rather in its duration by the
time it takes, as we have noted, for the immanent potentials within
the new style to work themselves through to exhaustion. Perhaps
the clue to the puzzle of duration lies in architecture itself. It is the
art that, broadly speaking, houses the other arts, provides their
framing. For paintings are framed not only by their own frames but
by the walls that enclose them and the buildings that house them.
Sculpture too is normally enclosed by architecture, if not in rooms
then in public places or gardens defined by architectonic frame-
works. Ruins, not sculpture, are found in the wilderness. To escape
from the domination of the Formalesque architecture of the Inter-
national Style, art had to be thought of not as high art but as art in
the general sense, art that escaped the framings of architecture,
sculpture and painting.

The fierce dialectical interactions of the 1960s and 1970s
between art in the special and art in the general sense, and the
florescence of the hybrid arts that attended them, are also witness
to a steady decline in the dominance of the Formalesque style.
These interactions were played out against the lurid background of
the Vietnam War. Nothing had divided opinion so radically in the
United States since its own Civil War. Outrage against participation
in the war privileged the arts of protest and satire that could not be
accommodated readily into the aesthetics of the Formalesque. So
just as the Great War of 1914–18 heralds the beginnings of

[23] Greenberg 1986, pp. 294–95.

twentieth-century modernism with the emergence of Dada, Surre-
alism and the Neue Sachlichkeit, all of which first challenged the
dominance of the avant-garde Formalesque, so the Vietnam War
heralds the end of its hegemony. By 1970 twentieth-century mod-
ernism had at last become the high style of its own century, under
the rubric of Postmodernism, and began to manifest its own forms
of dominance.

The period style change that eventually displaced the hegemony
of the Formalesque in the high visual arts during the 1960s was
accompanied by revolutionary changes in the realm of popular
culture.[24] Seeds of change were sewn by the Beats of California
during the 1950s. They sought heightened self-awareness induced
by drugs, sex, jazz and Zen philosophy. Rock music, emerging in
the mid-1950s, spread rapidly throughout the world; the music,
life-style and pelvic gyrations of Elvis Presley (1935–1977)
exploded universally. His body became an *imperium*.

The vitality of this new popular culture, initially apolitical,
was incompatible with the austerity that characterised the high
minimalism of the late Formalesque. 'The public behaviour of the
Beatles had its forebears in the *épatisme* of Dada and the
Surrealists.'[25] The difference was that their art was deeply grounded
in the technologies of a globalising capitalist economy. They estab-
lished the highly emotive base upon which, during the 1960s, Bob
Dylan, the Beatles and the Rolling Stones, echoing the more trou-
bled and estranged conscience of the Vietnam generation, came to
fame. At a deeper level than high art, popular culture, during the
1950s and 1960s, became a Eurusan-inspired cultural imperialism
even in its most oppositional modes.

Nevertheless the late Formalesque aesthetic continued to domi-
nate the high arts throughout the 1960s presented under a great
variety of names, a battle of labels for a general style that
Greenberg, as we have noted, following Wölfflin, had described as
linear. It testified to a generation that simultaneously honoured
and disavowed its Abstract Expressionist patrimony. In 1959 Jules
Langsner had called it 'hard edge'. In April 1965 Irving Sandler
called it 'cool art'.[26] In October that year Barbara Rose called it
'A.B.C. Art'.[27] In 1966 Lawrence Alloway called it 'Systemic Art'.[28]
That does not mean that they were all describing precisely similar

[24] See Dickstein 1977.

[25] *ibid.*, p. 12.

[26] *Concrete Expressionism*, Loeb Student Center, New York University, April 1965.

[27] 'A.B.C. Art', *Art in America* (Oct.–Nov. 1965).

[28] *Systemic Painting*, Solomon R. Guggenheim Foundation, New York, 1966.

aesthetic phenomena but that there was a great deal of family
overlap in the works they were addressing, such as that of Carl
André (b. 1935), Richard Artschwager (b. 1924), Anthony Caro (b.
1924), Jim Dine (b. 1935), Al Held (b. 1928), Donald Judd (1928–
1994), Ellsworth Kelly (b. 1923), Roy Lichtenstein (1923–1997),
Robert Morris (b. 1931), Kenneth Noland (b. 1924), Larry Poons (b.
1937), James Rosenquist (b. 1933) and Frank Stella (b. 1936). The
work of these, to use Greenberg's term, 'second-wave' American
artists became familiar throughout Europe and its former colonies
during the later 1960s and 1970s by virtue of the extensive pro-
gramme of exhibitions emanating from the United States during
the Cold War years. The name, however, that best describes their
work as a substyle of the late Formalesque was that coined by the
British philosopher Richard Wollheim, who called it 'Minimal Art'
in January 1965.[29] Unlike most of the others the name caught on.
Wollheim argued that during the previous fifty years or so work
had appeared in the art world that possessed a 'minimal art-
content'. What he had particularly in mind, as indeed everyone in
that decade appears to have had in mind, were the unassisted
ready-mades of Duchamp, for during the 1960s his name was
suddenly upon everyone's lips. Wollheim noted that all artworks
involved work and decision and that decision itself was a kind of
work, and since no work can be completed without decision it may
be argued that works of art may be produced in which 'it is this
second phase in the total process of production that is picked out
and celebrated in isolation'.[30] Moreover all work of the primary
kind does not consist only in 'constructive' work, for the artist may
deface, destroy, erase, in the process of production. This too is
work, as may be seen notably in the work of Ad Reinhardt. In
coining the term 'minimal art' Wollheim was not giving his
unqualified support to the minimal tendency he discerned in cur-
rent art. For with the reduction of 'constructive' work in favour of
deciding and dismantling, 'the claim of the work of art to individual
attention comes to rest increasingly upon its mere numerical diver-
sity'. 'Inevitably', Wollheim added, 'a point will be reached where
this claim, which is so abstractly couched, can no longer be found
acceptable, or even taken seriously. But until then, as we merely
move closer into the area of bare uniqueness, we have progres-
sively brought home to us the gravity, the stringency of art's
demands that we should look at single objects for and in
themselves.'[31]

[29] Wollheim, 'Minimal Art', *Arts Magazine* (Jan. 1965).
[30] *ibid.*; quoted in Battcock 1969, p. 396.
[31] *ibid.*, p. 399.

We had not long to wait. Later the same year (1965) Joseph Kosuth (b. 1945) displayed his *One and Three Chairs*, which comprised a full-scale photograph of a chair, the chair itself, and a dictionary definition of a chair. It was one of the first of his pieces that he described, in three essays entitled 'Art After Philosophy' published late in 1969, as 'Conceptual Art'.[32]

Now there is a strong sense in which all art is conceptual. I recall vividly how Ernst Gombrich, during a lecture at the Courtauld Institute in 1950 that dealt with the young Michelangelo at work in the garden of the Medici casino at San Marco, suddenly asserted, from a context I have long forgotten, 'but of course all art is conceptual'. It hit me with a flash of illumination. I suppose I had believed until then like so many of my generation, together with Herbert Read and John Ruskin, in the 'innocence' of the eye. What Gombrich was referring to was the cognitive theory of perception, delightfully expressed by that anonymous child who is reported to have said, 'First I think, then I draw a line around my think'. In his Mellon lectures six years later Gombrich explained more fully what he meant, which was then published as *Art and Illusion* (1960).

Kosuth's use of the term 'conceptual art', however, differed radically from that of Gombrich. In his first essay he made it clear that it was grounded in the philosopher A. J. Ayer's distinction between statements that are empirically verifiable (synthetic) and those which are true simply in virtue of linguistic rules (analytic). Kosuth came to the conclusion that a work of art was analogous to an analytic proposition. Art, he felt, provided no information about matters of fact. It was a presentation of the artist's intention. Freud was tossed out of the window and the 'intentional fallacy' ignored.[33] Kosuth agreed with Donald Judd that 'if someone calls it art it's art'. However, Kosuth was not referring to objective entities that might emerge from artistic activity, in Judd's sense. Such entities for Kosuth are mere traces of artistic activity (which is conceptual and linguistic) and possess in themselves no artistic value. Kosuth was pressing Wollheim's position; art could result from decision without accompanying work (e.g. Duchamp's ready-mades). But he disagreed with him in that the 'decision' was not addressed to the work but was a decision about the nature of art itself arrived at in the process of creating (non-artistic) artefacts such as could be used by dealers in any way they thought fit. Kosuth did not explain how it was possible to comprehend the artist's definition of art without recourse to his material

[32] *Studio International* (Oct. 1969), pp. 134–37.
[33] See Wimsatt & Beardesley 1976.

productions. In practice, what became known as Conceptual Art was as artefactual as traditional art but the works were particularly characterised by their 'documentary' function. Like other works of art they were usually encountered in dealers' galleries and a little later in art museums. But because they were often small in scale and of rudimentary value they could be readily transported by mail or electronically. It was a Eurusan artistic innovation that rapidly spread world-wide; a kind of conceptual cultural imperialism.

The close-knit, national interactions characteristic of the Eurusan visual culture persisted into the 1980s. Late in 1981 Kim Levin noted how U.S. and German art were still in process of amalgamating in a North Atlantic visual culture:

> In Germany Photo-Realism looks just like another kind of Pop art, and the earliest Pop looks very much like the latest post-Punk . . . Museums are full of Euro-Minimalists we've scarcely heard of, along with Euro-Op and Euro-Pop . . . I'd always heard that the best American art of the '60s went to German collections. It's true. Not just the best but the earliest Pop Art . . . In the museums in Krefeld, Mönchengladbach, and Cologne, there are paintings from Lichtenstein's first show at Castelli, with all the awkwardness and gaucheries that soon got smoothed out, early paint-by-numbers and dance-step Warhols, paint-splattered Oldenbergs, early Rauschenbergs, early Segals, early Dines, early red wooden Judds and what may be the one good piece of sculpture Robert Indiana ever made.[34]

Levin argued that the neo-Expressionism that swept both Europe and the States during the early 1980s was 'closer to being an unrecognisable mutation of American styles than it is a descendant of the old German Expressionists'.[35]

Nevertheless a growing consensus emerged that during the 1980s the U.S. segment of the Eurusan visual culture declined in influence and quality. New York became one city among others that had experienced and passed its cultural apogee. The emergence of Joseph Beuys (1921–1986) as the most powerful cultural shaman and performance artist on the Eurusan scene marked the city's decline and the revival of a vigorous post-war German visual culture. Opinions as to the quality of Beuys's work varies widely. Genius or charlatan? Some American critics such as Benjamin

[34] Levin 1988, p. 213.
[35] ibid., p. 214.

Buchloch[36] and Kim Levin[37] interpreted his symbolism as a sinister revival of National Socialist ideology. The British critic Terry Atkinson saw him as one of capitalism's showmen, and accused him of a Sartrean form of 'bad faith'.[38] On the other hand, Donald Kuspit is one of the many who defend Beuys's creative use of a personal mythology as a form of healing both himself and his nation for the evils inflicted during World War II. What is clear is that if Beuys had not lived he would have had to be invented. And in a sense he *was* his own invention. Germany had not yet come to terms with its Nazi experience. It had repressed it. Beuys's work is syncretic. He owes virtually nothing to the Formalesque. Manet, Matisse, Picasso were not among his heroes. His dialogue is with Dada and all that is relevant to twentieth-century modernism. He took the playful, neo-Dada performances of Fluxus and gave them a metaphysical significance. From a rational viewpoint most of his concepts are naive and strikingly unoriginal. But rational criticism misses the point of his art. He sought to revive the traditional metaphysical preoccupations of the German culture deeply trauma- tised by World War II, using all the available avant-garde devices at his disposal. For this reason he has been accused of showmanship. But as Kuspit argues, he was a shaman not a showman. Since Shamanism is a performance designed to produce awe and fear even while it heals, there is a component of showmanship in all shamans.

By contrast with Warhol's ironic and complacent cynicism, Beuys exposed himself as a vulnerable scapegoat for his nation. It was this act of witness that provided German art with a revitalised integrity just when, in New York particularly, it was succumbing (with Warhol as adman) to market values.[39]

Shot down as a Stuka pilot over the Crimea in 1942, Beuys later mythologised his fate at the hands of Tatars who wrapped him in fat and felt, enabling him to survive. Fat and felt together with other soft and melting substances such as wax and honey became, with contrasting hard 'crystalline' substances such as iron and rock, prime sources for Beuys's immensely complex personal mythology. His art centred upon an ethical and educational programme that was also mystical. Like William Morris and Eric Gill (1882–1940),

[36] 'The Twilight of the Idol', *Art Forum* 18 (Jan.), pp. 35–43.

[37] Kim Levin, 'Joseph Beuys and the New Order', *Arts Magazine* (April 1980); reprinted in Levin 1988, pp. 173–84.

[38] 'Beuyspeak', in Thistlewood 1995, pp. 165–76.

[39] On this, see the Introduction to 'The Decline of the City of Mahagonny', in Hughes 1990.

he proclaimed that all humankind could be artists, while he performed solemnly among his fetishised accoutrements. They became an inalienable aspect of his art. Like Picasso he turned to 'primitive' art, in his case to the art of Celtic Europe – and not, as with Picasso, to its forms but to its 'mythologising' content. For by the 1970s Europe, no longer master of the world, was turning increasingly to the shadowy sources of its cultural originary.[40] It was the kinship of such notions to the ideology of National Socialism that gave Beuys's critics cause for unease. But we must remember that he was raising the Nazi spectre in order to exorcise it. His performances were homoeopathic. He sought to heal others with the poisons used to heal himself. Like Kandinsky he owed much to his readings in Rudolf Steiner, but unlike Kandinsky his art 'works' cannot be separated from the artist and enjoyed in their own right. They are, in Kosuth's sense, traces. In this, Beuys comes even closer to re-creating the shaman as artist than Kandinsky himself. Europe is now older by almost a century and one avant-garde conception of art is divorced even more completely from craft. After Beuys's death curators have had difficulty in displaying the material relics of his art. They were so much a part of his personal performance that, lacking his presence, they lose their aura. In thus promoting the idea of the genius bereft of craft skill, Beuys promoted the immanent geniusism at the root of so many modernisms. Although ethical and didactic elements were strong in Kandinsky's art, Beuys devoted himself even more strenuously to spreading his beliefs, such as the need to reform art education and care for the natural environment. He was one of the founders of the Green Party in Germany.

Despite the apparent showmanship, there was an agonistic humility in all Beuys's performances. In this it was in marked contrast to the market-driven work of American artists such as Jeff Koons (b. 1955) and Julian Schnabel (b. 1951). Nevertheless Beuys's achievement was recognised from the beginning as Eurusan. In December 1964 he enacted a Fluxus performance in Berlin that was performed simultaneously by Robert Morris in New York.[41] In the excellent critical forum on Beuys held at the Tate Gallery, Liverpool, David Thistlewood gives unwitting support to the Eurusan circumscription of the discourse on Beuys. The aim, he stated, was to 'bring together scholars from around the world, to

[40] For Beuys's relation to the Celtic Renaissance, see Tisdall 1995, pp. 107–28, and Kockel 1995, pp. 129–47.

[41] Levin 1988, p. 184n19.

create an unconventional forum for the sharing of ideas'.[42] Predict-
ably, the world he spoke of consisted of Britain, Holland, Germany
and the United States.

Although the Eurusan visual culture conspicuously ignored the
rest of the world, it did, within its own confines, attain at times a
high measure of artistic achievement. This was most evident when
the two poles around which it circled, post-war western Germany
and the United States, established a creative interaction in the work
of Anselm Kiefer (b. 1945). Born in the year World War II ended,
his work has developed as a powerful and enduring witness for the
moral conscience of his generation. The vigour and scale of Abstract
Expressionism (European in origin but transformed and invigor-
ated on U.S. soil during the 1940s) is put to revitalising the rich
legacy, historical and critical, of traditional German culture. In his
paintings, the spectres of *Entarte Kunst*, particularly in their *neue
Sachlichkeit* mode, are to be seen riding out of the flames again. The
ghosts of Meidner, Grosz, Beckman and Dix, as we noted earlier,
certainly stretched and distended the aesthetic of the Formalesque
to its limits, yet never succeeded in escaping from its overarching
control. Manet, Matisse, Mondrian and early Picasso are returned
to their nineteenth-century ethos in Kiefer. Their search for a still
centre to their turning world – for a countervailing harmony, a
geometric transcendence, to contain their innovations – is pre-
sented in Kiefer as yet another misplaced arcadian vision. For he is
all for fragmentation, turning Europe's history to his creatively
destructive purpose. So he is best read as a twentieth-century
modern with his spiritual sources in Dada, the Neue Sachlichkeit
and Surrealism. His art is an exorcism of the Third Reich and its
historical precursors. Under his eye lies the ruins of Europe's grand
imperial project.

[42] Thistlewood 1995, p. 1.

11 The turn to meaning

Apart from puzzling over the nature of high art that preoccupied so many artists of the time, a deeper problem was beginning to unsettle the supremacy of the Formalesque. It may be described as the turn to meaning. Formalesque critics such as Bell, Fry and Greenberg had insisted that meaning in the visual arts was constituted by the relationships established between the formal components of art and the effect of the whole. In this, painting was like music. Art that was 'literary' was suspect. Of course content, subject matter, had continued to interest Formalesque artists. Picasso had assured Gertrude Stein that his portrait of her would eventually resemble her, and his *Guernica* owes its fame as much to its expression of his political attitude as to its formal achievement. Nevertheless during the hegemony of the Formalesque, content was regarded at most as a supplement to form but irrelevant to aesthetic assessment. When Herbert Read published his influential book *The Meaning of Art* in 1931 the meaningfulness of art was expressed in formal terms: 'beauty is a unity of formal relations among our sense perceptions'.[1] Aesthetic sensibility made it possible for our perceptions to respond to formal relationships. The sensibility of an epoch, in his view, creates its period style. 'There is little of value in the art of the period [third quarter eighteenth century] that does not in the end reveal itself as an aspect of the Rococo spirit.'[2] Even though, for Read, El Greco's *Burial of the Count Orgaz* 'reaches a depth of religious pathos' that was unknown to Shakespeare, he does not feel the need to discuss whether the painting's content has any effect upon its form. It is only when he discusses the work of Klee and Ernst that Read finds it necessary to consider the role of symbolism in art. Klee's art for Read is an expression of the preconscious, as Freud conceived it, a world of 'memory-residues, of disconnected images . . . fairy tales and myths . . . Klee's drawings have wit.'[3] It is at this point that Read's whole formalist aesthetic encountered the problem of meaning in art as it confronted the findings of psychoanalysis.

[1] Read 1936a, p. 19.
[2] *ibid.*, p. 143.
[3] *ibid.*, pp. 206, 203.

The reasons for the relative suppression of content in aesthetic assessment and artistic practice during the hegemony of the Formalesque are complex and have never been fully investigated. But they centre around the need for the visual arts to establish their autonomy at several levels: the level of practice, and the levels of theory, criticism and history. Here Habermas's reading of Kant is relevant in his description of Modernity, in which 'philosophy delimits from one another the cultural spheres of value – science and technology, law and morality, art and art criticism – under exclusive formal viewpoints, and it legitimates them within these limits'.[4] However, a special problem with this position in the case of the visual arts is that they are, in a literal sense, mute. They do not speak, they disclose, making themselves available to be seen. All discourse about them is thus a translation into a code of words, into an artist's or viewer's conversation, into criticism, into history of art, or aesthetic assessment. In a literal sense therefore the autonomy of visual art is a second-order autonomy, for it depends upon the verbal arts to convey its intentions into the public domain. The immanent drive of the Formalesque aesthetic, there-fore, in alienating art from language and literature, was to reduce it to an ever-increasing minimalist position.

The turn to meaning that we shall now consider under a number of heads was developed somewhat apart therefore from the actual practice of art, as a para-critical activity, until its combined effect began to challenge the hegemony of the Formalesque during the 1960s. In this the long-term trend towards the return to meaning may be compared with the long-term trend by means of which Formalesque theory and practice, since the time of Winckelmann and Flaxman, gradually eroded the art practice of the European academies, in their maintenance of post-Renaissance naturalism from the sixteenth to the nineteenth century, as the natural way of teaching art at the professional level.

ICONOGRAPHY

During the period within which the Formalesque rose to influence and power, all aspects of the art field did not develop in unison. Although, as we have seen, the development of style-critique in art history from Winckelmann to Wölfflin favoured the development of the aesthetic, there were other aspects of art history that devel-

[4] Habermas 1987, p. 19.

oped on semi-independent lines. Consider the study of imagery, the modern study of which may be said to have begun in the late sixteenth century with the publication of Cesare Ripa's *Iconologia* (1593), essentially a technical manual for the use of artists producing images as symbols, emblems or allegories. Such a use of images could not be suppressed even at the height of the Formalesque. The use of emblematic imagery was central to the creation of *Guernica*. But that example proves the rule. The Formalesque did not take kindly to the use of the visual for symbolic expression. It was felt to compromise the autonomy of art with that of literature.

The modern study of iconography may be said to begin with Émile Mâle's *L'Art religieux du XIII^e siècle en France* (1902). In the preface to his book Mâle declared that as the result of the invention of printing, the symbolism of Gothic art, the *biblia pauperum*, was lost to the social memory from the sixteenth to the nineteenth century. Mâle quoted some famous misreadings, such as Dupuis's reading of the Zodiac at Notre Dame, as evidence for the solar origin of all religions. The understanding of Gothic symbolism was submerged by the growth of a reading public. Four centuries later, the symbolic values of art were further suppressed by the Formalesque aesthetic's abrogation of literary values from art, for the social function of art changed radically from medieval to modern times. Gothic art was essentially didactic; modern art during the hegemony of the Formalesque developed as an anti-didactic, post-Kantian, relatively autonomous experience. The result was that books like Mâle's had little affect upon the ways in which modern art was practised or seen. Iconographical studies were seen as contributions to history, not to aesthetic appreciation.

PSYCHOANALYSIS

In order for the symbol and image to emerge once again in modern art as a significant aspect of aesthetic assessment it was necessary for a theory of symbolism to develop that could be shown to be central to modern art – not a mere literary supplement, but a formative part of the creative process. This became possible with the publication of Freud's *Interpretation of Dreams*. For Freud, symbolism was a basic component of the dream process. Dreams were distorting comparisons by means of which the dream work transformed latent elements of the dream into visual images present in the manifest content of the dream. One's parents might appear as king and queen or one's body as a house. All such symbols were

sexual in origin. Parallels might be found in fairy-tales, myths, folklore, buffoonery and jokes. Such symbolism was unconscious to the dreamer but was drawn nevertheless from a universal archaic archive. However, Freud made no mechanical comparison between dreams and the artistic process itself. Though for him the artist tended to be an introvert 'not far removed from neurosis', the artistic process was a creative path from phantasy to reality. In a famous statement he put it this way:

> He [the artist] understands how to work over his day-dreams in such a way as to make them lose what is too personal about them and repels strangers, and to make it possible for others to share in the enjoyment of them. He understands, too, how to tone them down so that they do not easily betray their origin from proscribed sources. Furthermore, he possesses the mysterious power of shaping some particular material until it has become a faithful image of his phantasy . . . he has thus achieved *through* his phantasy what originally he had achieved only *in* his phantasy – honour, power and the love of women.[5]

Freud did not identify the dream process with creative artistic activity, but his revolutionary account of the mental processes eventually shifted the neo-Kantian emphasis upon the reception of the completed art work to a renewed interest in the artistic production process. Although, like Mâle, his work remained for years on the periphery of aesthetic discourse, it eventually became the bridgehead by means of which that discourse moved from a receptionist to a productivist aesthetic. The move was instigated, of course, by the Surrealists. In his first Surrealist manifesto of 1924, Breton stated that 'we must give thanks to the discoveries of Sigmund Freud'.[6] Freud showed a path that could lead to the recovery of the imagination (suppressed by formalist theory) for poetry and art. 'The imagination is perhaps on the point of reasserting itself, of reclaiming its rights.'[7] It would do this by exploring meaning in those unconscious reaches of the mind that Freud had revealed. Nevertheless the Surrealists, as we have seen, were marginalised by the dominance of the Greenberg aesthetic during the late Formalesque. It was not until the 1960s that the full impact of Freudian theory was felt again in art practice and theory.

Curiously enough, it was Freud's own imagination that succeeded in constructing a bridge between formalism and his own

[5] Freud 1953, vol. 16, pp. 376–77.
[6] Breton 1972, p. 10.
[7] *ibid.*

revolutionary account of the unconscious mind. Before he developed his novel psychoanalytical technique of free association he had read Giovanni Morelli,[8] the founder of modern connoisseurship, and was impressed by his inductive method by which a painting could be convincingly attributed to a particular artist as the result of a close examination of the ways in which minor details, noses, ears, hands, etc., were drawn. 'His method of enquiry', Freud wrote (in his study of Michelangelo's *Moses*), 'is closely related to the technique of psycho-analysis. It too is accustomed to divine secret and concealed things from despised or unnoticed features, from the rubbish heap as it were of our observations.'[9] Thus it was that in Morelli, the creator of one of the most powerful formal tools, connoisseurship, in the art historian's armory, Freud discerned a new path back to meaning.

WARBURG STUDIES

The turn to meaning privileged image and symbol over earlier preoccupations with style. The roots of this change may also be traced back in art history to the turn of the century. In 1893 Aby Warburg published his dissertation on Botticelli's *Birth of Venus* and *Primavera*. What particularly fascinated him was the late Quattrocento's fascinated interest in elaborate drapery. Instead of treating the problem in the traditional way as another moment in the development of naturalism, influential since Vasari, he sought the answer in the literary interests of Botticelli's patron Poliziano, in Ovid and the ancients. In the wide range of texts that he consulted he found parallel interests in the 'fluttering garments and flowing locks which he had noted in the art of the Quattrocento'.[10] This led to a lifelong interest in the study of visual imagery from the standpoint of pageantry, gesture, and the collective psychology of the period under investigation. Although his approach did not supplant the stylistic studies dominant from Winckelmann to Wölfflin, it added a new sophistication to the art history that was pursued vigorously by Warburg's younger colleagues, Fritz Saxl and Erwin Panofsky, and the generations of scholars who worked at the Institute built around his great library. Because the studies of the Warburg Institute centred upon the transmission of the after-life, the traces and relics of the culture of classical antiquity to

[8] Under his pseudonym Lermolieff.
[9] From *Imago* 3 (1914), pp. 15–36; quoted in Freud 1953, vol. 13, p. 222.
[10] Gombrich 1970, p. 57.

medieval, Renaissance and post-Renaissance Europe, they played no part in the *institutionalisation* of the aesthetics of the Formalesque during the 1920s, developing instead an alternative version of art history from that pursued at the Museum of Modern Art, New York. The Formalesque, as we have seen, driven by the predilections of generations of avant-garde artists, developed a powerful critique of academic classicism, whereas Warburg studies developed sophisticated historical techniques in order to understand the persistence of classicism and the transformations of its afterlife.

Perhaps it was yet another case of an archaistic return of the repressed, in this case transformed into Warburg's notion of *pathosformel*. He viewed European civilisation as a process of conflict, 'psychological oscillations swinging uniformly between the distant poles of magico-religious practice and mathematical contemplation'.[11] The creative artist by the power of memory was able to transform the latent human energy of classical art into symbolic values apt for his epoch. Warburg brought an anthropological perspective to classical art. As a young man, not yet thirty when he completed his dissertation on Botticelli, he visited in 1895 the United States and spent four months in Pueblo and Navajo settlements in the Southwest. Years later he explained that the study of Navajo art attracted him because he had acquired 'an honest disgust of aestheticising art history. The formal approach to the image – devoid of understanding its biological necessity as a product between religion and art . . . appeared to me to lead merely to barren word-mongering'.[12] Warburg may possibly have been referring to the vogue for *l'art nègre* promoted by the dealer Paul Guillaume in Paris during the 1920s which was, of course, a crucial event in the emergence of the Formalesque. Warburg was not interested in the purely formal aspects of Amerindian art. He was impelled, doubtless, by that sense of urgency to see and record the art of 'primitives', common to the ethnology of the time, which viewed indigenes as peoples vanishing from the face of the earth and believed that they held the mystery of Europe's cultural origins within their creation myths and customs. The visit to New Mexico made a profound impression and provided a poignant dénouement. Between 1918 and 1923 he suffered from a mental illness which confined him to a number of nursing homes. When he began to recover he asked his doctors for permission to be released if he

[11] *ibid.*, pp. 262–63. In a fascinating article (Schade 1995, pp. 499–513), Sigrid Schade argues that Warburg's *pathos formel* concept, crucial for his own writings, was inspired by Freud's teacher, Charcot.
[12] Gombrich 1970, pp. 88–89.

proved his own self-control by means of a lecture delivered to the
patients of his home. They agreed and he lectured on the 'serpent
ritual' he had witnessed in New Mexico. His notes for the lecture
reveal that he believed that the origins of human thought (the
mythopoeic mentality) lay in the capacity for naming. In this he
followed a tradition established by Vico. Just as Vico argued that
thought began with primitive man conceptualising his fear of
thunder by naming it as the god Jove,[13] so Warburg noted that
when a Bafiote Indian tribesman compared a railway engine to a
hippopotamus it was for him an act of rational enlightenment. Fear
produced metonyms that stimulated conceptual thought. The
capacity for 'naming' fear creates an animistic cosmos, a world of
biomorphic creatures, in the primitive mind. At this stage there is
no understanding of an inorganic world. This only becomes pos-
sible from the use of tools. 'I regard man as a tool-using animal
whose activity consists in connecting and separating. In this activity
he is apt to lose the organic sensation of the ego.'[14] There, for
Warburg, lay the human tragedy. Through the use of tools man was
able to conceive of a structured universe but in the process had
alienated himself from the natural universe to which he belonged.
It was here that memory was crucial. It evoked not only the original
phobic reactions by means of which man created his mythical
universe, but it also held the key to the structured universe gov-
erned by laws. The human memory is stored as the archival records
of its experiences, in the form of language and of art. It was for this
reason that Warburg envisaged his own library as

> a collection of documents relating to the psychology of human
> expression . . . [I]t should make use of the psychology of primi-
> tive man – that is the type of man whose reactions are immediate
> reflexes rather than literary responses – and also take account of
> the psychology of civilised man who consciously recalls the
> stratified formation of his ancestral and his personal memories.
> With primitive man the memory image results in a religious
> embodiment of causes, with civilised man in detachment
> through naming.
>
> All mankind is eternally and at all times schizophrenic.
> Ontologically, however, we may perhaps describe one type of
> response to memory images as prior and primitive, though it
> continues on the sidelines. At the later stage the memory no
> longer arouses an immediate, purposeful reflex movement – be
> it one of a combative or a religious nature – but the memory

[13] Vico 1968, pp. 118–19.
[14] Gombrich 1970, p. 221.

images are now consciously stored in pictures and signs. Between these two stages we find a treatment of the impression that may be described as the symbolic mode of thought.[15]

However, the primeval reaction to the terror of existence is ever present. In his ritual, the Indian 'projects' the snake as the cause of natural phenomena, rain, thunder, lightning; by appropriating and controlling the snake he can himself control the weather. Modern man was still at it, trying to do something similar. In San Francisco, Warburg had seen 'Uncle Sam with the top hat', he who with 'Edison's copper wire has wrested the thunderbolt from nature'.[16] For although Warburg responded positively to modern art, to the Impressionists and Manet, he was no naive admirer of Modernity. Modernity was responsible for 'the destruction of distance'. Psychological distance was essential. 'The conscious creation of distance between the self and the external world may be called the fundamental act of civilisation. Where this gap conditions artistic activity, this awareness can achieve a lasting social function.'[17] The value of distance was nowhere better illustrated for Warburg than in Manet's *Déjeuner sur l'herbe*. The discovery that it was in part based upon a group of river gods in a print of the *Judgement of Paris* by Marcantonio Raimondi after Raphael, a composition itself based upon a classical Roman sarcophagus, gave Warburg the opportunity of distancing himself from what I have called the Formalesque aesthetic. Whereas that aesthetic had exalted Manet as a paradigmatic figure in the emergence of the Formalesque, Warburg seized upon it as a supreme example of the distancing role of tradition:

Today we may ask whether Manet in his stride towards the light really had to turn his back in this way and present himself as a faithful trustee of the heritage of tradition. After all, the immediate impact of his work could tell the world that it was only those who shared in the spiritual heritage of the past who had the possibility of finding a style creating new expressive values. Such values derive the power of their thrust not from the removal of old forms but from the nuance of their transformation.[18]

What then is Warburg's position vis-à-vis the Formalesque? Gombrich put it this way: 'Instead of seeing styles as evolving

[15] *ibid.*, pp. 222–23.
[16] *ibid.*, p. 225.
[17] *ibid.*, p. 288.
[18] *ibid.*, p. 274.

according to predetermined laws, he saw individuals involved in situations of choice and of conflict.'[19] In consequence he greatly widened the parameters of art history. Astrological and mythological manuscripts were catalogued for his library, and even postage stamps, of which he had a great collection, were found relevant to the art historian's field.

Like the formalists, Warburg was seeking universal concepts applicable to all humankind. But he was much less confident about modern man's relation to primitive society than they were. He felt it to be a relationship that might be redeemed through art from generation to generation, but its essentially *tragic* nature would always persist.

Since the studies of the Warburg Institute, founded in Hamburg in 1921 and transferred to London in 1933, were centred upon the history of the classical tradition, they developed, predictably, in a Eurocentric fashion. Warburg's own early interest in the arts of indigenous peoples remained a marginal concern. The Institute's studies brought the humanist interests of the Enlightenment to the scholarly pursuit of art history but did not seriously affect the development of taste in the visual arts during the first half of the twentieth century in the way that the Bauhaus and the Museum of Modern Art, New York, did. Its publications rarely covered subjects extending beyond nineteenth-century Europe. R. H. Jairazboy's article 'The Taj Mahal in the Context of East and West',[20] which traces the complex interrelationships in the development of centralised domical constructions in the Near East and Europe, was something of an exception. And it too came under the rubric of the diffusion of Europe's appropriated 'classical' tradition. Few papers concerned with twentieth-century art were published during the hegemony of the Formalesque. However, some influential ones began to appear in the 1960s when its dominance was beginning to be challenged on a global scale: notably the paper by Theodore Reff on 'Cézanne and Poussin', which revealed the way the relationship between these two artists was exaggerated by Bernard, Denis and their associates, during the decade following Cézanne's death, to reinforce their own case for a classical turn from the naturalism of Impressionism, championed by the Synthetists and Cloissonists.[21] Then in 1966 Sixten Ringbom published his seminal paper on the occult elements in the art of Kandinsky, Mondrian and Malevich. The significance of the occult, as we have noted, was suppressed in

[19] *ibid.*, p. 314.
[20] *Journal of the Warburg and Courtauld Institutes* 24 (1961), pp. 59ff.
[21] *Journal of the Warburg and Courtauld Institutes* 23 (1960), pp. 150ff.

Formalesque accounts of modern abstract art. The spirituality at the heart of early abstract art had been invariably referred to in accounts of twentieth-century abstraction, such as that by Michel Seuphor (1958), always in the most general of terms. It was as if the concrete origins of the movement inspired by the modern syncretic religions, were felt to be a form of indiscretion – by initiates transgressing, in releasing sacred knowledge to the public domain. Seuphor noted, for example, that Mondrian 'avoided religious topics and closed up at the slightest allusion to them'.[22] During the 1960s Gombrich returned to Warburg's interest in primitivism. Predictably, having regard for the Institute's charter, he found one of its significant sources in the classical tradition itself, the debate in ancient rhetoric between the 'Asian' style and the 'Attic' style, the former given to ostentation, the latter to simplicity and purity, conducted in Athens between Plato and the Sophists and in Rome between Cicero and the Atticists. As with Jairazboy's account of the historical sources of the Taj Mahal, interest in the exotic was thus folded over into a primitivistic mode of the classic.

Although the Warburg Institute's studies were directed at an exclusively academic audience, their influence was considerable. By developing powerful historical techniques for contextual study in the visual arts, they confronted the Formalesque aesthetic with a formidable intellectual alternative. The 1950s witnessed a massive growth of art history teaching at the tertiary level throughout the Eurusan world and its colonies. The influence of Warburg teaching filtered into these new faculties through teachers trained in art history rather than, as in former years, the manufacture of taste. In consequence the Formalesque itself became increasingly a subject of historical study. In 1950 Anthony Blunt, the director of the Courtauld Institute of Art, founded in 1932 along lines broadly similar to those of the Warburg Institute, gave a series of lectures on Picasso, placing him within a contextual tradition and presenting him as 'a great traditionalist as well as a great revolutionary'.[23] His insights were developed by his student Phoebe Pool and published in 1962.

MARXISM

Blunt in his early years championed social realism. Marxism left a strong influence upon his exemplary art historical research and

[22] Seuphor 1958, p. 41.
[23] Blunt & Pool 1962, p. 4.

Marxism too played a major role in the turn to meaning during the 1960s. Interpretation was central to its aesthetic, in describing the relationship of artistic production to production in general, to class and to ideology.

After Khrushchev's revelations to the 20th Congress of the Communist Party of the Soviet Union in 1956 about the depth and extent of Stalin's tyranny, the statist hegemony of Zhdanovite Socialist Realism collapsed. Since the early 1930s it had been officially insisted that art was no more than a transparent reflection of its contemporary economic base, Marx's base and superstructure metaphor being treated as a rigid mechanism. Soviet art was required to mirror Soviet 'reality'. The tyranny of Socialist Realism brought with it, as Maynard Solomon has noted, a high degree of sexual repression. Zhdanov's speech to the 1st Congress of Soviet Writers held in Moscow in August 1934, which determined Soviet cultural policy until 1956, 'coincided precisely with the cancellation of liberal abortion and divorce laws, with passage of strict laws against homosexuality . . . [and with] the arrest of a large number of homosexuals' accused of Nazi affiliations.[24] Under such censorship, exemplary studies of Marxian aesthetics, such as Mikhail Lifshitz's *The Philosophy of Art of Karl Marx*[25] (1933), could no longer be published.

In western Europe the further development, in what later became known as Eurocommunism, of unfettered Marxist studies in aesthetics and art history was delayed first by World War II and then by the Cold War. These studies only began to become widely available from the 1960s. For example the highly influential *History and Class Consciousness* of George Lukács (1885–1971), originally published in 1923, did not appear in a French translation until 1960 and in English until 1971. Lukács re-appraised Marx's Hegelian sources, revaluing the young Marx's concept of alienation under the conditions of capitalism developed in his *Economic and Philosophical Manuscripts* of 1844, first published in 1932, but not in English until 1959. Marx addressed the Hegelian concept of alienation (the 'unhappy consciousness' of the Roman world and the Christian Middle Ages) in the sociological form of reification (the separation of man from his own productions under capitalism). Lukács also stressed that a dialectical method is essential in order to grasp the 'totality' of historical development, the crux of the method being that 'concepts which are false in their abstract

[24] Solomon 1979, p. 239.
[25] trans. Ralph B. Wynn, ed. Angel Flores, New York, Critics Group, 1938.

one-sidedness are later transcended'; the dialectician 'is in the presence of a *social phenomena* and that by conceiving it as a sociohistorical phenomenon he can at once refute it and transcend it dialectically'.[26]

Like many Eurocommunists, Lukács was anti-modernist,[27] a classicist who developed an influential and controversial theory of realism in his famous work *The Historical Novel* (1937). Art for him was a de-fetishising activity which transcended the world of magic and religion. The realist defends social order against the onset of social chaos. What closed Lukács off from a positive view of modernism was his notion of decadence. The spectre of the end of (good) art in Modernity haunted him as it haunted Hegel, Marx and Theodor Adorno (1903–1969). In his view European art after the 1848 revolutions entered upon a period of bourgeois decadence.

Lukács's critique of modernism as decadence is developed most fully in the first chapter of his book *The Meaning of Contemporary Realism* written in 1956, first published in Hungarian in Budapest in 1957, in German in 1958 and in English in 1963. It is probably the most sophisticated defence of Socialist Realism and it appeared ironically when its hegemony in the 'East' and formalism in the 'West' were both beginning to dissolve.

> The distinctions that concern us are not those between stylistic 'techniques' in the formalistic sense. It is the view of the world, the ideology or *Weltanschauung* underlying a writer's work that counts . . . Man is *zoon politikon*, a social animal. The Aristotelian dictum is applicable to all great realistic literature. Achilles and Werther, Oedipus and Tom Jones, Antigone and Anna Karenina: their individual existence . . . cannot be distinguished from their social and historical environment . . . The ontological view governing the image of man in the work of leading modernist writers is the exact opposite of this. Man, for these writers, is by nature solitary, asocial, unable to enter into relationships with other human beings . . . With Musil – and many other modernist writers – psychopathology became the goal, the *terminus ad quem*, of their artistic intention, which follows from its underlying ideology . . . The protest expressed by their flight into psychopathology is an abstract gesture . . . Its content – or rather lack of content – derives from the fact that such a view of life cannot impart a sense of direction. These writers are not wholly wrong in believing that psychopathology is their surest refuge; it is the

[26] Lukács 1971; preface to the 1st edn (1922), pp. xlvi–xlvii.
[27] On this point, see Feher 1983, pp. 94–95.

ideological complement of their historical position . . . Freudian psychoanalysis is its most obvious expression.[28]

It was a view not altogether dissimilar, though expressed more strongly, from that with which Erich Auerbach had concluded his *Mimesis* three years before.

Lukács was antipathetic to psychological interpretations of culture and saw modernist literature as revealed in Robert Musil (1890–1942) as an expression of the psychopathological conditions of later capitalism. In this instance his dialectical 'totality' left no space for neurosis as a positive emergent element in contemporary culture. So the revolutionary aspects of Surrealism played no part in his view of an 'ethically' democratic utopian society. This was in sharp contrast to the view of his younger contemporary, the English poet W. H. Auden, who held the view that poetry under the conditions of Modernity was creatively engendered by neuroses.[29]

Lukács was not able to resuscitate Socialist Realism in the Eurusan culture, but his analysis of the class nature of alienation and reification under capitalism found fertile soil for the revision of both realism and formalism as dominant aesthetics during the cultural conditions prevailing in the United States during the Vietnam War and the Eurusan student revolts of the later 1960s.

The writings of the Italian communist Antonio Gramsci (1891–1937) were more influential in the development of Eurocommunist theory. Most were written during his years in prison (1926–37), in thirty-four notebooks not published until the 1970s. The growth of fascism, with its mass base in the Italian lower middle-classes, taught Gramsci that a revolution on the Soviet model was no longer possible in advanced capitalist societies. For him the role of the intellectual (which he defined in a broad sense) was crucial. Although all humans were curious and questioning, and thus potential intellectuals, intellectuals *per se* were professionally trained members of civil society. They were of two kinds: traditional intellectuals, such as notaries, priests and lawyers; and urban intellectuals, such as engineers, teachers and technicians. The former took their inspiration from philosophers such as Croce (who supported a liberal democratic version of capitalism); the latter were drawn (or could be drawn) to the support of the working class. Such intellectuals Gramsci called organic intellectuals. They were the critics of advanced capitalism. Their support and organisational capacities were essential for the transition to socialism. There is an interesting

[28] Lukács 1963; cited in Harrison & Wood 1992, pp. 675–78.
[29] Davenport-Hines 1995, p. 88.

Soviet Union, the neo-classicism of National Socialism, and the revolutionary innovations, aesthetic and political, of Surrealism. In Paris, in 1929, Michel Seuphor (b. 1901) and the Uruguayan Torres-Garcia (1874–1949) founded the group and periodical known as *Cercle et Carré*. Although it survived for only a few months, it brought together a considerable number of prominent artists, including Kandinsky, Léger, Mondrian and Le Corbusier, committed to Constructivism and abstraction, in order to create an opposition to the Surrealists. Then early in 1931 the Abstraction-Création (1931–36) group established by Auguste Herbin (1882–1960) and Georges Vantongerloo (1886–1965) extended the interests of Cercle et Carré. Its annual publication, *Abstraction-Création: Art Non-Figurative*, provided a platform for all the current modes of non-figurative art ranging through the late Cubism of Herbin and Gleizes, the Neo-plasticism of Mondrian and Vantongerloo, and the Constructivism of Gabo, to the biomorphism of Arp. As it conflated its diversities and institutionalised itself, it also made manifest the immanent drive within the Formalesque style towards abstraction. Abstraction-Création defended the autonomy of art and identified abstract art (in the light of the growing harassment and persecution of abstract artists in the Soviet Union and the Third Reich) with aesthetic liberation and political freedom. Figural vestiges gradually disappeared from the work of this circle. A preference also grew to secularise the case for abstraction, more in harmony with the technological drives of Modernity, in terms of material, geometry and design, than to seek transcendental justifications in occult belief and the fourth dimension.

In May 1937 the massive Exposition Internationale des Arts et des Techniques dans la Vie Moderne opened in Paris. It presented an unrivalled opportunity for the nations of Europe to display their artistic and political ambitions. It sought to celebrate national achievements in both art and technology, what I described earlier as art in the special sense and art in the general sense. It was in the general sense, of course, that the art displayed was all for Modernity, whether perceived as a fascist, communist or capitalist Modernity.

The German and Soviet pavilions confronted one another dramatically across the main pedestrian axis of the Exposition. Speer's lofty block of stripped classicism towered over Boris Iofan's Cubist, Art Deco Soviet pavilion. Perched on its top, a huge German eagle, clutching a swastika in its claws, glowered over Vera Mulhina's *Worker and Collective Farm Girl* on the top of the Soviet pavilion.

parallel here with Saint-Simon's call to scientists and artists for support in the transition from feudalism to modernity.

The role of the intellectual was integral to the nature of the state, which was, for Gramsci, the institutionalisation of force *and* consent.[30] The consensual aspect of state power depended upon hegemony, a somewhat ambiguous concept which combines the notions of force and consent, and which, in its duality, may be viewed as an anticipation of Foucault's power/knowledge conflation, except that in Gramsci's case the concept is fluid and historical rather than epistemological. Hegemonic power, when fully developed, rests upon active consent rather than force. Thus folklore and popular culture were seen by Gramsci to be of great significance in the development of a new hegemony sympathetic to socialism. Gramsci also developed the concept of passive revolution by means of which the political aspirations of the working class are confounded and diverted. Examples were fascism, reformism and Taylorism. Although Gramsci was cosmopolitan by disposition, his highly political, revisionary Marxism provided greater flexibility for national aspirations than the Soviet-grounded diktats of the Comintern had done. It was thus influential in the development, in the work of Edward Said and others, of the postcolonial discourse that began to get under way during the 1980s.

The great majority of the creative contributions to Marxism, as Maynard Solomon has noted, from Marx and Engels to Adorno and Herbert Marcuse (1898–1979), wrote their mature theoretical works in exile. Forced to leave their homelands because of their political convictions, nationalism and patriotism played little or no part in their thought, which tended to be international, cosmopolitan, universal and, because they were Europeans, Eurocentric, despite their universalism. This is true of the work of Walter Benjamin (1892–1940) who, during the 1920s, read Lukács's *History and Class Consciousness* and developed an informal association with the Marxian Institute for Social Research (Institut für Sozialforschung), of the University of Frankfurt, founded in 1923, and a close friendship with the radical playwright Berthold Brecht. A visit to Moscow in the winter of 1926/27 impressed him with the dynamic culture of the new socialist state, but he decided not to join the Communist Party. After Hitler's seizure of power he was compelled to leave Berlin and wrote his most mature essays in exile in Paris. With the Nazi invasion of France in 1940, he fled Paris, and on 26 September took his own life on the Franco-Spanish border

[30] See Buci-Glucksmann 1980, pp. 19–38.

when turned back by the Spanish authorities.[31] As with most of the major Eurocommunist thinkers, wide public knowledge of his work was delayed for decades. His reputation began to develop posthumously during the 1970s.

Benjamin possessed no lingering sympathies for what I have described as the Formalesque. For him it was an imperial expression of capitalism in decline. It was the consummation of *l'art pour l'art*, of art as an autonomous field of behaviour which rendered fascism aesthetic. The new modernism of the twentieth century is to be seen emerging, not in Cézanne or Manet, but in Dada and Surrealism, which herald the film.

For Benjamin took seriously Marx's view that it was the contradiction between the forces and relations of production that determined the dynamic of the capitalist mode of production. He examined this concept profoundly in his famous essay 'The Work of Art in the Age of Mechanical Reproduction',[32] which has developed something of a cult following since its publication. The forces, for Benjamin, behind the production of art, like everything else, are its changing technologies. It is in this respect that art is for him, as it was for Aristotle, ontologically mimetic. It ever seeks to reproduce the natural world and in so doing repeats its own world in the process. The Formalesque, on the other hand, in ever seeking to insulate itself, in a pseudo-autonomous field of activity, from the general forces of capitalist production, becomes increasingly elitist. This engenders its immanent drive towards abstraction.

Benjamin traces the technological means by which art has sought to reproduce itself through the ages, in woodcut, the printed word, etching, engraving and lithography, culminating in our time in photography and film. For him photography and film are the true modern arts of the twentieth century. They are progressively replacing the handcrafted arts of painting and sculpture and the reproductive arts that precede them. The high arts of sculpture and painting are distinguished by being unique. They produce originals to which their reproductions, whether in woodcut or photography, are subservient. They evoke an aura by virtue of their originality and authenticity. Benjamin's 'aura' is one of the most contentious of his concepts. He argues that reproduction detaches art from the

[31] The occasion and reasons for his suicide are considered in some detail by Hannah Arendt in her Introduction to Benjamin 1973.

[32] Written in Paris during the 1930s as part of his 'Arcades' project, a study of the roots of Modernity, for the Institute for Social Research, Frankfurt, but not published by the Institute until 1936 when it was operating in exile in New York; translated into English in 1968.

domain of tradition and thus deprives it of its aura. But if it is the nature of art to reproduce itself it follows that the deprivation of aura is immanent to art. For Benjamin, works which possess aura are sacred objects, conceptually indistinguishable from fetishes. In this regard the artistic process, for him as for Lukács, is a defetishising activity. The problem, however, for Benjamin is that reproductions, as he admits, may develop an aura with time as much as do unique works. Old family photographs may acquire a greater aura than a quick glimpse at the *Mona Lisa* over the heads of other tourists. It is arguable whether the fetishistic aspect of art is diminished by its immanent capacity for reproducibility. More interesting is Benjamin's insistence upon the prophetic nature of art.

> One of the foremost tasks of art has always been the creation of a demand which could be fully satisfied only later. The history of every art form shows critical epochs in which a certain art form aspires to effects which could be fully obtained only with a changed technical standard, that is to say, in a new art form. The extravagances and crudities of art which thus appear in the so-called decadent epochs, actually arise from the nucleus of its richest historical energies. In recent years, such barbarisms were abundant in Dadaism. It is only now that its impulse becomes discernible. Dadaism attempted to create by pictorial – and literary – means the effects which today the public seeks in the film.[33]

By making art the product of shock and scandal rather than aura and contemplation, the Dadaists introduced the public to a new form of perception apt for the film viewer.

> No sooner has his eye grasped a scene than it is already changed. It cannot be arrested . . . The spectator's process of association in view of these images is indeed interrupted by their constant sudden change. This constitutes the shock effects of the film, which, like all shocks, should be cushioned by heightened presence of mind. By means of its technical structure, the film has taken the physical shock effect out of the wrappers in which Dadaism had, as it were, kept it inside the moral shock effect.[34]

Thus, for Benjamin, art contained a prophetic, if not utopian, element, which presaged coming events and even coming tech-

[33] Benjamin 1973, p. 239.
[34] *ibid.*, p. 240.

nologies by articulating cultural needs. The technical forces of cultural production contained within capitalism the inherent possibilities both of subversion and revolution.

Much less optimistic was the 'critical theory' developed by the Institute for Social Research, Frankfurt, under Max Horkheimer (1895–1973), Adorno, Marcuse and others. The Institute was expelled from Germany in 1933 but found refuge in the United States during World War II and was re-established in Frankfurt in the early 1950s. Their revisionary Marxism, like that of Lukács and Gramsci, was long delayed in making public impact. In their *Dialectic of Enlightenment* (1947) Adorno and Horkheimer took issue with Benjamin's view that the capitalist mode of production could be regarded as an objective structure operating independently of human agency driven by an autonomous economic base. For Adorno, 'technology is congealed subjectivity'.[35] Contradictions between the forces and relations of capitalist production did not lead inevitably to revolution. They were resolved in one way or another by the intervention and mediation of social agents. The subjectivity of agency was present in both base and superstructure. In *The Authoritarian Personality* (1950) and *Negative Dialectics* (1966) Adorno advances even more pessimistic views for the possibilities of radical social change under the conditions of advanced capitalism. Effective radical criticism can only take place at the level of ideology, not at the economic base, and takes the form of a 'negative dialectic'. Auschwitz had destroyed the right to hope. 'In the concentration camps it was no longer an individual who died, but a specimen – that is a fact bound to affect the dying of those who escaped the administrative measure.'[36] '[N]egative dialectics calls for the self reflection of thinking . . . if thinking is to be true today . . . it must also be a thinking against itself.'[37] For Adorno, advanced capitalism turned citizens into reified consumers; the popular arts were nothing more than its ideological instruments. The only recourse was to perpetual criticism, a 'negative dialectic', 'without any preconceptions as to where it might lead'. Adorno's is a pessimistic, post-Auschwitz, metaphysic. The utopian dimension holds no place in his aesthetic. Yet Adorno, a student of Alban Berg and an eminent musicologist, defended the need for an avant-garde.

Surrealism . . . by deliberately defying the concept of art itself, has contributed something to authentic modern art which has

[35] Adorno 1984, p. 62.
[36] Adorno 1990, p. 362.
[37] *ibid.*, p. 365.

never been lost since. Yet art survived; it has remained art. How can this be explained? Presumably at the centre of the surrealist provocation was the perception that art is preponderant over the work of art . . . Something may appear wholly unsatisfactory from the vantage point of the individual work of art and still represent a valid impulse, an impulse that can no longer be objectified in a single work of art. Such impulses therefore point to the idea of an art that transcends individual creation.[38]

Adorno thus adopts a position not dissimilar to that of Schelling who maintained, as we have noted, that art itself was driven by a kind of idealistic immanence that transcended the work of individuals.

Here Adorno rejects Gombrich's empirical aphorism about art – 'There really is no such thing as Art. There are only artists'[39] – and claims the presence of a subversive immanence in art as a social process. But for Adorno art does not proceed in the terms of its formal autonomy but in a dialectical relationship to social change. This places meaning at the centre of his aesthetic agenda. 'Meaning is present even in the statement that there is no meaning.'[40] 'Meaning can never be a product of the synthesis of the art work alone; it can never be the epitome of what is being made by the work: meaning is constituted by the totality of the work; it is produced and reproduced aesthetically. Meaning therefore is legitimate only to the degree to which it objectively represents a surplus of meaning over and above what the work means by itself.'[41] The 'surplus' to which Adorno refers is gained by virtue of its social and temporal existence.

Lukács, Gramsci and the Frankfurt School were the most influential of the revisionary Marxists whose work became widely known during the 1960s and 1970s. Unlike the Zhdanovist realists whom they superseded, these theorists of a Eurocommunist aesthetic did not present a unified front. Apart from finding common ground in one form or another in historical materialism, their aesthetics varied from Lukács's defence of realism to Marcuse's spirited defence of art for art's sake.[42] Marcuse was the first of the Frankfurt School migrants to the United States to achieve the status of an intellectual guru – during the student revolts of the later

[38] Adorno 1984, p. 37.
[39] Gombrich 1955, p. 5.
[40] Adorno 1984, p. 154.
[41] ibid., p. 220.
[42] Marcuse 1978.

1960s. His aesthetic differs little from that of Greenberg while giving more thought to art's relationship to advanced capitalism. Championing art's autonomy, he viewed it as the one true liberating element in an unfree, reified modernity. 'Art fights reification by making the petrified world speak, sing, perhaps dance.'[43] Fine words, but Marcuse had no solution to changing the world he deplored. His position ultimately was as pessimistic as Adorno's.

Lukács, Gramsci, Benjamin, Adorno, Marcuse were cultural critics who did not confine themselves to aesthetics: they strove for a total vision of modern culture. During the 1960s and 1970s the turn to meaning which their Marxism reinforced was supplemented by the publication of work specifically devoted to the visual arts by Arnold Hauser, Frederick Antal, John Berger, Ernst Fischer, Frederic Jameson, Jack Lindsay and T. J. Clark, among others. The efflorescence of Marxist writings, particularly during the 1960s and 1970s, seriously challenged the dominance of the Formalesque in theory and practice.

ANTHROPOLOGY

Around 1960 the dominance of the Formalesque was also eroded by anthropology. The arts of exotic cultures raised persistent problems. Did not a purely formal approach to a Papuan mask endow it with a value other than that given it by its maker and the culture from which it took its being? Did not such a view hide one of the central strategies of cultural imperialism? Makers of exotic artefacts, it was assumed by the Formalesque aesthetic, were not in a position to assess the *aesthetic* value of their own productions. Ethnographical museums began to be established in Europe in quantity during the third quarter of the nineteenth century at a time when the European imperial project was moving towards its apogee. Britain's Great Exhibition of 1851, which featured the art and industry of all nations and from all parts of the globe, stimulated their establishment. Prior to that, exotic artefacts had featured in collections among clutters of other 'antiquities'. After World War I, aesthetic appraisals began to be applied increasingly to them. In 1923 an exhibition of the indigenous art of the French colonies was held in Paris, reflecting the fashionable vogue for *l'art nègre*. Exhibiting the 'best' pieces in a tasteful ambience began to be a feature of such museums during the 1930s. Whereas previously the emphasis

[43] *ibid.*, p. 73.

had been upon research and collecting, ethnographical museums now followed increasingly the taste of dealers, artists and collectors.[44]

Just how were the objects in ethnological museums to be assessed aesthetically? Were local values relevant or must all art [...]thetic values evolved by the [...]itive' art remained in ethno-[...] remained in art museums, the [...]antly cultural contexts and the [...]ntexts. But so soon as 'primi-[...]rimitive' art museums, as they [...]uoris, the issue had to be faced: [...] And if cultural values were still [...] 'primitive' art were they not [...]e was no easy answer to these [...]nt debate that arose had the [...] the Formalesque hegemony. [...]e' art museums reinforced the [...]oldwater put it:

[...]ogy, while [...]t neglecting documentation and [...]tional' considerations, have increasingly presented their objects (or at least some of them) as worthy of formal study. They have been willing to take the 'ethnocentric' risk of making judgements which separated the finer objects from the more everyday ones in their permanent exhibits, and have also organised exhibitions to call attention to these special products of material culture as works of art.[45]

The implication was that they (the exotics) cannot inform themselves, so the Eurusan culture must inform them.

Like aesthetics, art history and Marxist theory, the anthropological discourse had, from its beginning, sought to establish universals. Edward Tylor (1832–1917), deeply influenced by Darwin and widely regarded as the founder of cultural anthropology, developing an aspect of the philosophy of Leibniz, defined animism as the earliest form of religious belief. It endowed the inorganic world with spiritual significance, a view developed by Lucien Lévy-Bruhl (1857–1939) in his description of the nature of the primitive mind in his *Les Fonctions mentales dans les sociétés primitives* (1910), published three years after Picasso painted *Les Demoiselles*. Both

[44] A useful and succinct account of the development of ethnological museums is contained in Goldwater 1986, pp. 3–14.

[45] *ibid.*, p. 13.

Tylor and Lévy-Bruhl were confident that 'primitive' man was linked to civilised (that is to say European) man in an evolutionary continuum. Their ideas were given a geographical thrust in the diffusionist theories of Grafton Elliott Smith (1871–1937) and W. H. R. Rivers (1864–1922). Civilisation emerged in the Nile valley and was diffused throughout the world as a result of the migration of superior and conquering races. Each race held to a fixed cultural character, and cultural differences in a particular region were evidence of racial mixture.[46] The basic concepts of the diffusionist school were developed in the years immediately preceding World War I and were published in the early post-war years. They are, that is to say, homologous with European civilisation at the height of its imperial power and the emergence of the Formalesque style. Both evolutionists and diffusionists agreed that contemporary 'primitive' societies were survivals of stages of society that were akin to earlier stages of advanced societies. As Locke, who was at the root of their epistemology, put it, 'In the beginning all the World was America'.[47]

In opposition to Lévy-Bruhl, Franz Boas (1858–1942) maintained 'the fundamental sameness of mental processes in all races and in all cultural forms of the present day'.[48] The mystical and illogical elements that Lévy-Bruhl believed characterised 'primitive' man were also present among the peoples of the highest civilised societies. Boas's *Primitive Art* (1927) was the first authoritative work on the subject by an experienced field anthropologist. Written at a time when, as we have seen, the Formalesque was being institutionalised, it assembled from indigenous societies a great wealth of evidence to reinforce the Formalesque aesthetic. Previously most of the champions of the Formalesque, with the significant exceptions of Riegl and Semper, had drawn their evidence mainly from the high arts of architecture, sculpture and painting. Boas, in the nature of his discourse, and quoting Riegl and Semper, had no qualms in stretching the definition of art to cover all modes of material culture from basketry and chipped flints to indigenous song and dance. For Boas, the necessary but not sufficient requirement for the production of art is technique. But technique must achieve a quality capable of giving aesthetic pleasure. By reaching a high proficiency, techniques establish standards by means of which the artistry may thus be judged. 'The judgment of perfection of technical form is

[46] Kuklick 1984, pp. 66–67.
[47] *Two Treatises on Government*, ed. Pater Laslett, New York, 1965, p. 343. On Locke's contribution to the origins of 'functionalist' anthropology, see Zengotita 1984, pp. 10ff.
[48] Boas 1955, p. 1.

essentially an esthetic judgment. It is hardly possible to state objec-
tively just where the line between artistic and pre-artistic forms
should be drawn, because we cannot determine just where the
esthetic attitude sets in.'[49] A detailed empirical investigation of the
decorative arts of indigenous peoples world-wide led Boas to con-
clude that the essential elements in the plastic and graphic arts were
'symmetry, rhythm and emphasis of form'.[50] But because he was
addressing not the European only but a great diversity of cultures,
Boas was directly confronted, despite his formalist aesthetic, with
the problem of meaning.

> While the formal elements, which we have previously discussed,
> are fundamentally void of definite meaning, conditions are quite
> different in representative art. The term itself implies that the
> work does not affect us by its form alone, but also, sometimes
> even primarily, by its content. The combination of form and
> content gives to representative art an emotional value apart from
> the purely formal esthetic effect.[51]

Boas thus incorporates the problem of meaning within his formalist
aesthetic, but does not ask whether purely abstract patternings
possess cultural meanings also. Representations only become art, in
his view, when the technical and formal problems have been sur-
mounted and controlled sufficiently to provide pleasure in their
own right. His aesthetic is consistently Kantian. Representation
must be distinguished from realism, the problem of representation
being solved 'first of all . . . by the use of symbolic forms'.[52] To
emphasise the formal origin of symbolic art, Boas coined the term
'idioplastic' art.

For Boas, consistent with the Formalesque aesthetic of his time,
good indigenous art was 'pure' art. 'The appreciation of the esthetic
value of technical perfection is not confined to civilized man. It is
manifested in the forms of manufactured objects of all primitive
people that are not contaminated by the pernicious effects of our
civilisation and its machine-made wares.'[53]

Although structured firmly within the Formalesque aesthetic,
Boas's *Primitive Art* widened the categories of art dramatically. No
longer could art be discussed within guidelines imposed by high art
or male art. Boas was probably the first influential anthropologist to

[49] *ibid.*, p. 10.
[50] *ibid.*, p. 349.
[51] *ibid.*, p. 64.
[52] *ibid.*, p. 68.
[53] *ibid.*, p. 19.

note that much art was women's work, as when he observes: 'Basketmaking is an occupation of women and thus it happens that among the Californian Indians only women are creative artists.'[54]

But the very widening of the categories by the inclusion of 'primitive' and 'exotic' art revealed the vulnerability of the formalism that had embraced them. Ironically, just as it had been promoted by the 'discovery' of indigenous art by the Fauves and Cubists, so its very broadening of the concept of art threatened the authority of the aesthetic itself. Although Leonard Adam took many of his basic ideas and evidence from Boas in his popular *Primitive Art* published on the eve of World War II, he was much less confident about Boas's formalism. In criticising the aestheticist approach to indigenous art expressed by James Johnson Sweeney[55] when curating an exhibition of African art for the Museum of Modern Art in 1935, he questioned whether the 'aesthetic enjoyment of a work of art' could be 'achieved by deliberate disregard of the cultural background and especially of the religious meaning?' 'If we look, for example, at the "Venus of Willendorf" would not a merely formal approach leave us completely helpless, and is not our sensation entirely different when we learn that this is not a caricature of a fat woman but a goddess of motherhood?'[56]

The history of anthropology as a professional and academic discourse is strikingly homologous with the history of the Formalesque as a period and hegemonic style. Just as Lewis Morgan (1818–1881) used his analytical and formal studies of the 'universal' laws of kinship to support his views about the evolution of the family and society in *Ancient Society* (1877), so Alois Riegl used his analytical and formal study of the evolution of decorative art, in *Stilfragen* (1893), to support his concept of an innate, artistic 'will to form'. Biological survival established the laws of kinship; social volition, the laws of form. Both found crucial evidence in 'primitive' societies.[57] The academic institutionalisation of functionalist anthropology in the form of field work techniques under Boas and Bronislaw Malinowski (1884–1942) during the 1920s parallels the institutionalisation of functionalism in the Formalesque architecture of the Bauhaus school. The global triumph of the International Style after World War II parallels the post-war hegemony of functionalist anthropology established by the disciples and pupils of

[54] *ibid.*, p. 18.
[55] Sweeney 1935.
[56] Adam 1940, p. 48.
[57] On Riegl's use of the spiral in Maori art to support his concept of *Kunstwollen*, see Olin 1992, pp. 68–69.

Malinowski and Radcliffe Brown (1881–1955).[58] Just as the International Style 'dehistoricised' architecture of its nineteenth-century passion for period styles, so anthropology, in its passion for the deployment of empathic relationships between observer and indigene, dehistoricised historic and evolutionary concepts as it sought to reveal the social structures of indigenous societies synchronically. And just as the institutionalisation of the Formalesque critique of painting and sculpture during the 1920s distinguished and privileged formal values above the values of content, so during the same decade did the Boasian view that all human behaviour, including artistic behaviour, was the result of social conditioning, disrupt the inalienable links between biological and social conditioning.[59]

The height of such formalism is achieved in the structuralism of Claude Lévi-Strauss (b. 1908) which began to gain eminence in the 1950s. Inspired by Saussure's linguistics, he sought to reduce cultures to their structural elements and the relationships between them. The myths and totems of all cultures could be reduced in such a fashion, thus revealing the fundamental unity of articulated human thought. This reduction of the anthropological project to universal forms parallels Clement Greenberg's ambition to reduce all art to the relationships between its formal constituents.

The anthropological discourse then, like the Kantian aesthetic, had developed from the beginning along universalist lines. The central problem had been the search for what was common to all 'primitive' peoples. That contact with 'non-primitive' Europeans made 'primitives' less so was ignored as irrelevant.

However, around 1960, anthropologists began to become seriously interested in the history of their own discourse and to develop reflexive perspectives. George Stocking, the historian of anthropology, has put it this way:

Although doubtless variously motivated, the heightened retrospective interest of anthropologists reflects the special sense of disciplinary crisis that has developed since about 1960. With the withdrawal of the umbrella of European power that had long protected their entry into the colonial field, anthropologists found it increasingly difficult to gain access to (as well as ethically more problematic to study) the non-European 'others' who had traditionally excited the anthropological imagination – and who

[58] On the history of the functionalist tradition in British anthropology, see Stocking 1984b, pp. 131–85.
[59] See Freeman 1996.

seemed finally about to realise, through cultural change, the long-trumpeted anthropological prediction of the 'vanishing primitive'.[60]

Since classical times, primitivism had functioned as a psycho-sociological instrument by which aggressive societies had sought to interpret the cultures of vulnerable ones. But it was also an instrument by which such societies criticised their own institutions. The development of anthropology in Europe led to the institution-alisation of primitivism. It became the domain of specialists. Those who used primitivism as critique could be ignored as artists or amateurs. 'Primitives' now became the scientifically labelled 'others' of advanced civilisation. Their purity could be admired until they expired. However, the effects of anthropology upon Eurusan culture itself operated dialectically. As the museums of Europe and the United States were steadily filled with the objects of material culture, acquired by anthropologists from indigenous societies, so the desire to incorporate them into Kantian and neo-Kantian con-cepts of high art increased among artists, critics and the general public. On the other hand anthropologists continuously protested against such 'primitivising' of cultural artefacts, insisting that they should be appreciated with regard to their meaning and function in their original cultural contexts.

By 1976 Clifford Geertz, one of the leading anthropologists of his generation, was in a position to assert with some authority a defi-nition of art that was quite incompatible with the universalist assumptions of the Formalesque:

[T]he definition of art in any society is never wholly intra-aesthetic, and indeed but rarely more than marginally so. The chief problem presented by the sheer problem of aesthetic force, in whatever form and in result of whatever skill it may come, is how to place it within the other modes of social activity, how to incorporate it into the texture of a particular pattern of life. And such placing, the giving to art objects a cultural significance, is always a local matter; what art is in classical China or classical Islam, what it is in the Pueblo southwest or highland New Guinea, is just not the same thing, no matter how universal the intrinsic qualities that actualise its emotional power (and I have no desire to deny them) may be. The variety that anthropologists have come to expect in spirit beliefs, their classification systems, or kinship structures of different peoples, and not just in their

[60] Stocking 1983, pp. 3–4.

immediate shapes but in the way of being-in-the-world they both promote and exemplify, extends as well to their drummings, carvings, chants and dances.[61]

FEMINIST ART

Although it began somewhat later, the emergence of a highly committed feminist art during the 1970s probably eroded the hegemony of the Formalesque more than any of the other factors we have already considered. This may be due to the fact that it began to operate from a potentially greater and more closely involved constituency. By the 1970s the number of women art students in tertiary art colleges and universities engaged in art practice or taking art history and theory courses exceeded men throughout the Eurusan and Europeanised colonial worlds.[62] But unlike the hybridisation of art categories so common to innovative art of the 1960s and 1970s, feminist art was not so much an attempt to define or create new arts or new stylisms as to establish new valuing systems in opposition to the dominant masculine values that had prevailed for centuries in the production of art in the special sense.[63] The driving force of feminism art lay in the political activism stimulated by such basic texts as Simone de Beauvoir's *Le Deuxième Sexe* (1949), translated into English in 1953, Betty Friedan's *The Feminine Mystique* (1963), Kate Millett's *Sexual Politics* (1970) and Germaine Greer's *The Female Eunuch* (1971).

Feminists were quick to point out that H. W. Janson's definitive *History of Art* (1962) made no mention of any woman artist. As a result of their interventions, meaning and content were given priority over style and form.[64] By bringing a new sense of value to the crafts traditionally practised by women, they also effected (as had the Arts and Craft Movement) the further erosion of that long-standing distinction between art in the special and in the general

[61] Geertz 1983, p. 97.

[62] Lisa Tickner records that in 1971 WAR (Women Artists in Revolution) and Women Students and Artists for Black Liberation in a letter to the Human Rights Commission noted that women constituted 60–75 per cent of the art students but only 5 per cent of artists represented in galleries ('Feminism and Art', in Dictionary 1996, vol. 10, p. 878). Jonathan Culler has expressed the view that 'feminist criticism . . . has had a greater effect upon the literary canon than any other critical movement and . . . has arguably been one of the most powerful forces of renovation in contemporary criticism' (Culler 1983, p. 30).

[63] See Lippard 1976, pp. 10–11 et al.

[64] Broude & Garrard 1994, p. 16.

sense. The overall result was to promote diverse and plural values in opposition to the universalising values that had helped to sustain the masculine mastery of the art world. The history of art was rewritten increasingly from the point of view of gender. The female body became the subject rather than the object of art. Some feminists reclaimed the neolithic 'Great Mother' in images, rituals and performances. Others, by community participation, greatly increased the role and status of community and site-specific art.

Between 1969 and 1971 radical organisations such as the Women Artists in Revolution (WAR) organised the picketing of the Whitney Museum of American Art (1969), the Los Angeles County Museum of Art (1970) and the Corcoran Gallery of Art, Washington (1971), insisting upon a fairer representation of women's art in these major public collections. In 1970 Judy Chicago (b. 1939), a sculptor in Los Angeles, accepted a teaching post at Fresno State College, California, on condition that she be permitted to develop a women's art programme within its art department. It began against a background of anti–Vietnam War discontent. Faith Wilding has described the intellectual atmosphere of the time students were being interviewed for Chicago's programme:

> [T]he campus was in more than usual turmoil . . . bomb scares caused building evacuations, anti-war marches and demonstrations took place weekly, five professors had been fired for their political activism . . . [Chicago] challenged her prospective students 'Do you want to be an artist?' . . . [She] told them forthrightly that she was looking for women strong enough to become leaders – to give up make-up, 'girl-stuff', and traditional sex roles; and to challenge the male hierarchy of the Art Department.[65]

Fresno at that time was offering courses in 'Marxist politics, anarchist theory, and Black, Chicano, Armenian and Women's studies'.[66]

Much time was given in this pioneering class to 'consciousness raising', developed by class discussion of shared experiences and the subsequent analysis of female suppression and subordination within the masculinist art world. During one weekend in the spring of 1971 some hundred-odd women came from San Francisco, Los Angeles and elsewhere to witness a programme of performances, films, art history, lectures, environments and discussions. Later that

[65] *ibid.*, p. 34.
[66] *ibid.*, p. 32.

year Judy Chicago joined Miriam Schapiro to create a feminist art programme at the California Institute of Arts and established Womanhouse, 'a collaborative art-environment . . . highly successful in securing broad public visibility nationally for the idea of a feminist art'.[67] A return to mimesis became a significant instrument of Womanhouse in the construction of an art that identified, satirised and ironised the social construction of gender roles. Artefacts that shaped female identity – make-up, lingerie, dolls, clothing – were employed in parody. 'Mimicking the societally ordained forms of femineity proved to be the first step of separation, of gaining critical distance from that which is being mimicked.'[68] Just as the decorative arts of Asia had played a significant role in the creation of the Formalesque, so leading feminist artists such as Chicago and June Kosloff turned to the patterning in Islamic and Japanese craft in order to enhance the status of the decorative arts so long subordinate within the European tradition.

As Poststructuralism and Postmodernism became increasingly influential during the 1980s, the pioneering feminism of the previous decade came under fire as 'essentialist'. In March 1972 Chicago and Schapiro had argued that to feel like a woman was 'to be formed around a central core and have a secret place that can be entered and which is also a passage from which life emerges'.[69] They then asked how this grounded sensibility revealed itself in art, pointing to the fact that much women's art, such as the work of Georgia O'Keefe and others, was characterised by a central core imagery, 'a central orifice whose formal organisation is often a metaphor for a woman's body'.[70]

The 'essentialist' critique was largely a generational backlash developed by female artists influenced by Poststructuralism and tended to discredit the pioneering emancipatory nature of 1970s feminism. It foregrounded the social and political constructions of representations of the body. But the body is a biological not a social entity, however it is represented. To reduce its biology to its socialised reconstructions was to turn the feminist movement into a bird with a maimed wing. The Poststructuralist attack upon the concept of identity acted in a similar fashion. If 'identities' were little more than pragmatic strategies of survival constructed from time to time for special occasions, there was little point in talking about female identity with conviction. Such views reinforced the social deter-

[67] *ibid.*, p. 39.
[68] *ibid.*, p. 25.
[69] Schapiro & Chicago 1973, p. 14.
[70] Broude & Garrard 1994, p. 23.

minism that had dominated U.S. anthropology since the time of Boas. The biological was suppressed.

In 1972, the year that Chicago and Schapiro wrote their seminal article 'Female Imagery',[71] Karla Jay and Allen Young published their *Out of the Closet: Voices of Gay Liberation*.[72] Three years before, the Stonewall Riots in New York City had inaugurated a new epoch of homosexual militancy that also promoted the image of the body as a biological entity. Furthermore, a great deal of the best feminist art of the 1970s sought to reclaim the female body from the social constructions placed upon it by an overbearing masculine society. This in itself was not designed merely to substitute a feminist for a masculine social construction of the female body but to reclaim its biological nature and identity. However, the intellectual dominance of cultural determinism in the United States was not profoundly challenged until Derek Freeman published *Margaret Mead and Samoa: The Making and Unmaking of an Anthropological Myth* in 1983. This seminal work has led to an increased acceptance of an 'interactionist anthropology' grounded in evolutionary theory in which *both* biological and cultural factors are seen to be relevant for any adequate explanation of human behaviour. Seen in this light, the so-called essentialist feminists of the 1970s (who did not, in any case, deny the significance of culture in the construction of gender) can now be seen to have been a liberating discourse.

Arising within a context of political emancipation, the Feminist art movement promoted the slogan 'the personal is political'. It has been argued that its closest parallel is that of the Russian avant-garde (1914–30), since 'both movements were led by a utopian vision based on a euphoric ideological awakening that critiqued bourgeois modernist art as a site of political oppression'.[73]

LINGUISTICS

During the first decade of the twentieth century, while Freud was revolutionising the study of neurosis, the French linguist Saussure and the American philosopher C. S. Peirce were developing, inde-pendently, the rudiments of a new science: semiotics. It had the effect of marshalling a basic critique against the epistemology of formalist aesthetics. Saussure defined semiotics (or as he called it

[71] Schapiro & Chicago 1973, pp. 11–14.
[72] Jay & Young 1972.
[73] Cottingham 1994, p. 278.

'semiology') as 'a science that studies the life of signs within society'.[74] The study of language was, he said, a specific science within the more general science of semiotics. It followed that the visual arts were also a 'language' of signs to the extent that they communicated. We were back, in a sense, to Tolstoy, who defined art as 'a human activity . . . that one man consciously, by means of certain external signs, hands on to others feelings he has lived through, and that other people are infected by these feelings, and also experience them'.[75] But semiotics took Tolstoy's communication theory of art to a new level of sophistication. It argued that visual art like language was but another signifying activity. The components of the visual arts, shape and mass, colour, tone, line, and their infinite relationships, were not entities to which artist and viewer possessed immediate and transparent access. They were not accessible to an 'innocent' eye but were signs mediated through language. The blind person suddenly restored to sight may experience the colour yellow, but it is an experience that makes no cognitive sense to her and which she cannot relate to other experiences unless told that she is seeing 'yellow'. The so-called abstract relationships of the Formalesque aesthetic were thus reduced by semiotics to systems of mediating signs. Forms were seen because their like had been seen and comprehended before. It followed that the most abstract of art was also a re-presentation, even though it might well be an innovative re-presentation. The long-sustained distinction between abstract and representational art was thus seriously weakened. All art, it came to be increasingly accepted, was representational. Meaning was no longer regarded as a vicarious supplement to the visual arts but ontologically grounded in their nature. Semiotic theory developed at some remove from the Formalesque aesthetic during the first half of the twentieth century but by the 1960s the 'linguistic turn', as it was called, was profoundly influencing philosophy, anthropology and aesthetics.

A new development occurred when, in his *Elements of Semiology* (1964), Roland Barthes (1915–1980) argued, in opposition to Saussure (upon whom he greatly relied), that semiology was a part of linguistics, the part that covered 'the *great signifying unities* of discourse'.[76] Barthes sought to develop a semiology of clothing, food, vehicles, furniture and architecture analogously with Saussure's system. Language began to take the place of music as the

[74] Saussure 1966, p. 16.
[75] Tolstoy [1899], p. 50.
[76] Barthes 1968, p. 11.

art that provided the model for all the others. For Barthes, follow-
ing Jean Piaget (1896–1980), 'there is no perception without
immediate categorisation . . . [T]he photograph is verbalised in
the very moment it is perceived.'[77] Barthes thus inverted the
Formalesque hierarchy in which form was primary and the imagery
secondary. For him, drawings, paintings, cinema, theatre were all
conveyors of messages. But in addition to the analogical content of
the message, such as an object or a scene, they also conveyed a
supplementary message, 'what is commonly called style . . . In
short, all these "imitative" arts comprise two messages: a *denoted*
message, which is the *analogon* itself, and a *connoted* message, which
is the manner in which the society to a certain extent communi-
cates what it thinks of it.'[78] So Barthes inverted the formalist hier-
archy of style and meaning and opened out the closed and
relatively autonomous Formalesque discourse to the wider con-
cerns of sociology and anthropology.

Jacques Derrida (b. 1930) reinforced Barthes's position by dis-
tancing the visual arts still further from the 'metaphysics of pres-
ence' – the assumption that perception precedes cognition, the
philosophical grounding upon which the Formalesque aesthetic
rests. For Derrida, the visual arts, like speech, are a kind of writing.
For him there is nothing outside of the text (*il n'y a pas de hors-
texte*).[79] Seeing is thus reduced to reading, a linguistic *imperium*
offered to replace the imperial universality of the Formalesque. It is
pointless to argue, against Derrida, that a text has to be seen in
order to be read, pointless even to argue that a text can be seen and
not read because it cannot be understood. For Derrida, the primacy
of perception is put into question by the paradox entailed in the
contention that we cannot see without knowing what we see. It
would be futile to attempt to debate in any detail Derrida's highly
convoluted and complex thinking here; indeed the style by which
he conducts it was fittingly described by Michael Foucault as an
'*obscurantisme terroriste*'.[80] Derrida seeks to reduce the visual arts,
painting particularly, into his deconstructive schema of difference/
differance by means of which linguistic codes, following Saussure,
operate. But his project fails because the visual arts are not *linguistic*
codes. Although a painting differs from the world it inhabits by its
edge or frame, its *identity* does not depend upon such differences. It

[77] Roland Barthes, 'The Photographic Message', in Barthes 1984, p. 28. Originally
published as 'Le Message photographique' in *Communications* 1 (1961).
[78] Barthes 1984, p. 17.
[79] Derrida 1976, p. 158.
[80] In a conversation with John Searle; quoted in Searle 1993, p. 178.

establishes its identity by the ways in which it is constructed. A painting is a painting for the same reason that a rose is a rose. It does not need the concealed presence of a trait, or that which it is not, in order to establish its identity. Derrida himself appears, if I understand him correctly, to concede this when he writes in his highly convoluted thesis on the art of Valerio Adami (b. 1935):

> There had been for me, two paintings in painting. One, taking the breath away, a stranger to all discourse, doomed to the presumed mutism of 'the-thing-itself', restores, in authoritarian silence, an order of presence. It motivates or deploys, then, while totally denying it, a poem or philospheme whose code seems to me to be exhausted. The other, therefore the same, voluble, inexhaustible, reproduces virtually an old language, belated with respect to the thrusting point of a text which interests me.[81]

Even for Derrida then there are two aspects of a painting: painting as presence and painting as meaning. For him painting as presence evokes a code that 'seems exhausted'. He says that, apparently because for him painting without meaning is not possible. But what of an unfinished painting? Surely it cannot mean until it is finished – or taken to be finished.

Historically speaking, if we equate the Formalesque with painting as presence we might agree that by 1975[82] it was, in Derrida's word, 'exhausted'. But that is not to say that for practising artists a painting or any other work of art may be perceived as having a presence before it acquires meaning – the second aspect of painting to which Derrida refers. Indeed it can be argued that a painting has no meaning until it is made. The artist works in the presence of the unfinished painting which acquires meaning when the painting of it stops. Of course both meaningful intentions and unconscious mental activities may contribute to its production. But these do not constitute the meaning of the painting. A whole is more than the sum of its parts. Nothing can mean until it is made. If this is granted, then from an historical point of view the Formalesque style may live on, and doubtless does, into the post-Formalesque (Postmodernist) present as an ineluctable aspect of creative production. But even a cursory glance at Derrida's writings on painting indicates that the cast of his mind does not seriously involve the visual arts. He delights in reducing visual hermeneutics to unre-

[81] Derrida 1987, pp. 155–56.
[82] The text was originally published on the occasion of an exhibition of Adami's drawings in 1975.

solved epistemological puzzles. His real concern is to show that
European thought has been imperial since Parmenides. Finally it
must be noted that, if I have understood Derrida correctly, no text,
no work of art, can be shown to possess a determinate meaning,
nor can one meaning be shown to be superior to another. It follows
then that if I have understood Derrida correctly I can never under-
stand him correctly.

The attempts that have been made by Barthes and Derrida to
subordinate the visual arts to a linguistic imperium serve to remind
us of the great artistic achievements of the Formalesque style,
conducted on the assumption that presence is prior to meaning.
This does not necessarily involve a belief in the 'innocent eye' but
rather that the constructive (compositional) relationships by which
the visual arts are constituted are not to be identified with the
meaningful intentions that bring the component parts into exist-
ence. These visual relationships must be distinguished from the
syntactical relationships of language. They possess their own modes
of spatial ordering distinct from the temporal orderings of language.

These few brief comments on the theories of Barthes and Derrida
may also serve to remind us of the darker side of the turn to
meaning in which the visual arts, the arts of seeing, must suffer.
Martin Jay has drawn attention to a powerful trend in twentieth-
century French thought, from Bergson to Derrida, in his magisterial
Downcast Eyes.[83] It is a trend that closely accompanies what I have
described here as twentieth-century modernism with its roots in
Dada and Surrealism. Considered in relation to the dominance of
the Formalesque during the first half of the century, such a trend
was to be expected. However, its presence does suggest that the
visual arts cannot be accommodated comfortably within either an
epistemology of presence or an epistemology of meaning, that they
can exist creatively only within a dualism that endows an arresting
presence of form with infusions of meaning. It is by their forms that
they are constructed and by their meanings (when made) that they
enter the public realm of interpretation, a process to which there is
no end and no authoritative conclusion.

[83] Jay 1994.

12 Cultural imperialism and the Formalesque

With the exception of the United States of America, the Formalesque style did not begin to affect the art of regions beyond Europe in any significant way until the 1920s. By that time, as we have seen, it had moved beyond its avant-garde phase and was in the process of being institutionalised. As it was institutionalised it began to spread. The agents involved in the process were mostly young artists from countries beyond Europe and the United States who could afford to spend some time training within the Eurusan culture and could then act as couriers of the new style when they returned home. Most saw themselves as agents of modernisation whose function it was to help modernise a home culture enervated by over-dependence upon traditional values. The reception of the new style in their homelands depended upon many factors, such as the political conditions prevailing, the strength of the traditional culture, and the social status accorded to artists.

Since the Formalesque style was introduced largely by returning expatriates and not imposed directly by agents of the Eurusan culture, should we describe the spread of the Formalesque as a form of imperialism at all? I think we must, in light of the ways empires have spread their power and the influence of their cultures in the past. But we must distinguish cultural imperialism from other forms of imperialism, such as military and economic imperialism.

Military imperialism involves the subjection and subordination of other peoples by force; economic imperialism, the subordination of the material resources of others to the needs and interests of the imperial power. Cultural imperialism is the imposition of the culture of an imperial power upon the culture of other peoples. However, in their historical operation all three imperialisms are profoundly interconnected. Military imperialism is a primal, economic imperialism, a secondary, and cultural imperialism, a tertiary form, by means of which imperialisms dominate the subjected. Furthermore, all three forms manifest themselves as *uneven* two-way processes in which the military, economic and cultural might of the imperial centre is imposed until its military and economic power wanes. However, even when the military and economic power of an empire has ceased, its cultural influence may continue

to inform, as a revenant or norm, the cultures it once dominated. Consider, to quote but one example, the influence of the Spanish language, religion and culture in the Philippines. However, from the very beginnings of conquest an interactive process manifests itself by which the culture of the subjected begins to permeate the culture of the centre, transforming and, at times, eventually dominating it. Two closely related cases, of course, are the abiding authority that the cultures of the Greek and Roman empires have continued to exert upon the culture of Europe at so many levels.

It is a curious imperialism, cultural imperialism, one in which a complex dialectic is involved. It is a case of attraction and repulsion operating from the centre of empire in response to surges of desire and aversion from its colonies. The centre does what it can in ideological, financial and other ways to attract the most able, the most intelligent, and the most influential, from the colonial regions, not only in order to reinforce its own cultural supremacy, but also to acculturate the colonial in the ways of the centre. If they remain they contribute to the cultural vitality of the centre. If they return to their colonial homelands they bring with them the cultural values and strategies of the centre. That at least is how it normally happens during the first moment (which we shall discuss later) of cultural imperialism. But the centre does not attract unselectively, it establishes barriers by way of immigrant quotas, visas and the like, to ensure that colonial undesirables do not flood the centre.

These strategies of the centre activate a correlative response from colonies. Here the colonial elite, and their children, conscious of living in a culture that has been disempowered by virtue of its colonial dependency, yearn for the centre. For it reveals for them an image, often a utopian image, of Modernity and its culture, an image available under imperial conditions in colonies only in a diluted and disempowered form. So the desires of the elite, and not only the elite but those who have absorbed elite desires and ambitions, respond to the empire's substantial powers of cultural attraction. On the other hand, there are also those who by virtue of the disadvantages of class, gender or ethnicity are unable to make the essential voyage back to the centre, or are repulsed by the centre as undesirable migrants. So develops responses of aversion and resentment addressed to the culture of the centre. From them springs a desire to develop an independent colonial culture and, at the political level, a drive towards nationalism. This move in turn develops a powerful discourse about personal *identity* arising from the displaced situation of colonists and their descendants of European origin living out their lives in non-European natural and

social environments. It is a discourse that does not arise sharply in the centre itself until the implosion of empire sets in after the massive return of 'non-elitist', 'undesired' migrants.

Broadly speaking, the Formalesque style in its imperial diffusion affected two markedly distinct categories of culture: first, the cultures of Asia in which the arts, in the general sense, had developed largely under the sway of traditional religions such as Hinduism, Buddhism and Islam; second, the settler cultures, of which the United States of America, Canada, Latin America, South Africa, Australia and New Zealand are leading examples. Of course there are great differences between both Asian and settler cultures, but the establishment of the latter, unlike the establishment of the traditional cultures of Asia, involved the forcible suppression, by either displacement, slavery or extermination, of indigenous peoples expropriated from their lands. True, this distinction between traditional Asian societies and European settler societies is not as neat as my distinction suggests: the Chinese Han dynasty suppressed the Mongolian Hsiung-nu, and the Japanese empire suppressed the Ainu. But for our purposes, which is devoted to a modern imperialism, it will serve.

In order to provide a framing structure for our topic, I shall survey the course of the Formalesque in Japan, as a model of an Asian society, and in South Africa, as a model of a settler society. I shall not assume that either society is normal to its type. I use them only as models in which to consider the forms cultural imperialism may take in modern times as it affects the visual arts. It will not be possible to consider more than two countries in detail, but the results may be applied, I believe, to other Asian and settler societies with value.

I shall endeavour to show on the evidence presented that three distinctive *moments* of cultural imperialism may be discerned as the Formalesque style spread throughout the world. By a moment, in this context, I mean a cluster of events that recur in different places at different times. The first moment is usually succeeded by a second moment, and the third moment is often, as we shall see, conflated with the second.

The first moment of cultural imperialism champions art in the special sense as the natural mode of Modernity and leads to the devaluation and rejection of the traditional indigenous styles it seeks to supersede. The second moment, which is dialectically related to the first, brings the Formalesque style to the colonised and at the same time seeks to reinstate the status and values of the traditional indigenous styles which the first moment rejected. It

does this not by rejecting the first moment entirely but by assimilating it to its local needs and intentions. In so doing the second moment of cultural imperialism reveals an awareness of the origins of the Formalesque as a stylistic critique of Modernity that draws upon traditional, non-European arts, upon art in the general sense, for its own vitality and sustenance. In this the Formalesque in its imperial diffusion reveals a kind of homecoming, a return of art in the special sense to its origins in art in the general sense.

The first moment of cultural imperialism normally precedes the arrival of the Formalesque. It acts as the servant of military and economic imperialism as it takes material and spiritual control of the land and economies of the indigenes by using the arts of cartography and topography, and of picturesque, naturalistic and impressionistic landscape in order to master the newly acquired environment.

The initial move from the first to the second moment of cultural imperialism is usually inaugurated by expatriates, either colonial expatriates residing for varied lengths of time in Europe or the United States, or Eurusan expatriates who have migrated to the colonised cultures. A psychological drive is at the heart of the second moment. Expatriates usually depart, as noted above, from their home culture critical of its 'thinness', of its inability to supply their intellectual, professional, or economic needs. Political and religious refugees are, of course, extreme examples of such situations. Then, after a period absorbing Eurusan modernity, a change of heart and mind often discloses shortcomings in the imperial culture to which expatriates attach themselves. They become champions of the culture they formerly disavowed after experiencing it anew from a distanced light. This move has been identified in recent years as a kind of diasporic illumination and the cultures to which the 'reborn' expatriates now address their discourses are often seen as 'postcolonial'. But it may also be viewed as a second-order re-run of the primal Formalesque revelation – the potential, creative energy stored in exotic cultures. Of course not all expatriation is of this kind. Some expatriates deliberately attach themselves to the imperial culture from the beginning in order to empower themselves to oppose it.

A third moment of cultural imperialism may be discerned wherein contemporary indigenes responding to the challenge of the second moment, begin to create work that combines the traditional arts of their own culture with the techniques and aesthetic of the Formalesque. When this first appears it is usually regarded with disfavour by the champions of the Formalesque. For in practice, as

we have seen, the Formalesque aesthetic cherishes the purity, timelessness, antiquity and so-called authenticity of indigenous art. Indigenous art contaminated by Modernity is condemned as 'kitsch' or 'tourist' art. However, in their rejection of contemporary indigenous art they may also glimpse its reality as a product of a cultural imperialism and describe it as 'hybrid', apparently unaware that all art is in a powerful sense hybrid. There are no pure arts any more than there are pure 'races'. Yet it is only with the decline of the hegemony of the Formalesque that a 'postcolonial' aesthetic has begun to assess positively the 'hybrid' art of contemporary indigenes and their 'hybrid' descendants.

What is particularly characteristic of the second moment of cultural imperialism, in the guise of the Formalesque as it spreads world-wide, is that it tends to manifest itself as a generic style, not as a series of diachronic movements as in its Parisian avant-garde phase during the late nineteenth century. In this it supplements, internationally, what was happening to the style itself within the Eurusan culture as it institutionalised itself during the 1920s. Predictably, an enduring theme in all countries is the dialogue that develops between the inherent qualities of the Formalesque style and the overriding need to relate its practice and aesthetic to the local social and geographic environment. The whole process appears invariably to be a case of uneven but reciprocal development and interaction between the Eurusan and extra-Eurusan cultures. Finally it needs to be emphasised at this point that the imperial diffusion of the Formalesque was the last, in the sense of the most recent, of the visual imperialisms, to spread from Europe throughout the world. The first imperialisms began with the spread of the Portuguese and Spanish empires in the sixteenth century.

JAPAN

Let us now consider Japan in relation to the above. First, as to military imperialism. In 1543 Portuguese sailors were wrecked on the island of Tanega off southern Kyushu. They were the first Europeans known to arrive in Japan; others arrived later in Chinese junks. There they taught the locals the art of musketry construction. Three hundred and sixty-two years later the Japanese defeated the Russians in the war of 1904–05, and on 7 December 1941 bombed Pearl Harbor. Second, as to economic imperialism. In 1854 the U.S. Admiral Commodore Perry was able to enforce, by a display of naval power, an *unequal* economic treaty upon Japan.

Forced to abandon its isolationist policy, maintained for over two centuries under the Tokugawa Shoguns (1603–1868), Japan granted unequal trading privileges to the United States and, shortly afterwards, to Britain, France, Holland and Russia. Today the economic power of Japan is comparable to that of the United States itself. Yet at the level of *cultural* imperialism, Japan continues to subject its own culture to a continuing dialogue with the Eurusan culture forcibly introduced by the guns of Perry.

But to phrase it so strongly may be misleading, for Japan never at any time possessed a purely indigenous culture; and that perhaps has been its redemption. Like all cultures that survive, it has responded to historical contingencies while clinging to the traditions it cherished. Japan is long schooled in both the advantages and dangers of cultural borrowing. As early as the seventh and eighth centuries, when its culture was still in its infancy, it learnt how to blend its traditional Shinto religion with the Buddhist religion and the Confucianist ethics its rulers borrowed from China, which they perceived (as Rome had perceived Athens) as the true centre of civilisation.[1]

That early experience provided a powerful precedent for comparable action when, after the Meiji Restoration of 1868, and its isolation under the Tokugawa, the new Meiji emperor, keen to avoid the colonised fate of India and China, proclaimed: 'Knowledge shall be sought throughout the world so as to strengthen the foundation of imperial rule.'[2]

The modernisation of Japan may help us to understand the role the Formalesque played in the renovation and/or suppression of local cultures in its imperial spread throughout the world. It is significant that in Japan the ground for its reception was well prepared. Japan possessed well-developed traditions in architecture, sculpture and painting, in both a technical and an aesthetic sense. They provided Buddhism with a concrete visual, aesthetic and spiritual presence. The arrival of Spanish and Portuguese travellers after 1543, followed by Jesuit missionaries, at first resulted in a deep incursion of Catholic Christianity into southern Japan. Mounting resentment, incited by clan rivalry, saw it as a threat to Buddhism and the local way of life. So the Tokugawa proscribed all contact with the West apart from the Dutch traders (not regarded as Christians!) who were permitted to use the port of Dejima in Nagasaki Harbour. What information trickled through about Euro-

[1] See Beasley 1995.
[2] Quoted from Rimer 1987, p. 37.

pean science and culture came via China or through that tiny port. The resulting 'Dutch studies', as they were called, were addressed mainly to Europe's superiority in technology and science. European art was viewed in Japan not, in a Kantian sense, for its 'uselessness' but for its utility, for the very way indeed in which it had been used by Europeans ever since the Renaissance to map and describe the world and empower its users.

One of the first Japanese artists to admire European drawing and painting unreservedly was Shiba Kōkan (1747–1818), who wrote that 'The primary aim of Western art is to create a spirit of reality . . . By employing shading, Western artists can represent convex and concave surfaces, sun and shade, distance, depth and shallowness. Their pictures are models of reality . . . For this reason Western books frequently use pictures to supplement descriptive texts, a striking contrast to the inutility of the Japanese and Chinese pictures.'[3]

Kōkan, and artists such as Maruyama Ōkyo (1733–1795), the master of 'eyeglass' realism, who made use of chiaroscuro and one-point perspective, and Katsushika Hokusai (1760–1849), the master of *ukiyo-e* (pictures of the floating world) woodblock prints, as a result of their 'Dutch studies', were able to use European techniques for the attainment of visual realism, despite the proscription then obtaining upon European cultural contact. One of the pioneer teachers of this *yoga* (that is, 'Western style') art, Kawakami Tōgai (1827–1881)[4], was attached to the General Staff of the Japanese army to develop skills in cartography and the colouring of maps for military purposes.

Such artists may be viewed as modernisers seeking to modernise Japanese visual culture. But their work also served as a *critique* of traditional Japanese art, such as that of the Kano family whose Chinese-oriented, monochrome ink paintings had been in favour for centuries. The Kano provided a foil, broadly similar to that of the academic classicism of Europe, against which artists like Kōkan, Hokusai and Tōgai could exercise their dissent. In thus developing a critique of their own national traditions they may also be viewed, in our context, not only as modernisers but as modernists – or to put it another way, as utopian critics of their own culture.

The European-style painting advocated by Kōkan and his epigones was institutionalised as one aspect of Meiji policy by the establishment of the Technical Art School (Kobu Bijutsu Gakkō) in

[3] Quoted from Kawakita 1974, pp. 14–15.
[4] Rosenfield 1971, pp. 197–98.

Tokyo, in 1876. It taught drawing, oil painting and sculptural modelling, its set object being 'to improve various crafts by promoting the application of modern European techniques to traditional Japanese methods'.[5] The school's first foreign art teacher, Antonio Fontanesi (1818–1882), was from Turin and specialised in Barbizon-type landscapes. Although he stayed only two years (1876–78), he trained a group of enthusiastic students in the basics of European realism: perspective, modelling, chiaroscuro, and oil painting. It is significant that European-style art was introduced as the result of a perceived local need. From the 'Dutch studies' of Kōkan to the establishment of the Tokyo Technical Art School may be taken as a characteristic expression of the first moment of visual cultural imperialism in Japan. It was not imposed. It was the product of a local desire for what was attractively exotic.

But in Japan it created a backlash, spearheaded, oddly enough, not by patriotic Japanese artists defending the Kano-style art favoured by the Tokugawa, but by Ernest Fenollosa (1853–1908), an academic from Harvard. Arriving in Japan in 1878 to teach political science, philosophy and economics at Tokyo University, he developed a great passion for traditional Japanese art and Noh theatre, and in 1884 converted to Tendai Buddhism. Ably supported by his friend, the Japanese art critic and teacher Okakura Tenshin (1863–1913), Fenollosa effected a major change in local taste. In an influential lecture, 'The True Theory of Art' (1881), he advanced the claims of traditional Japanese art in opposition to the *yoga* being taught in Tokyo's Technical Art School: 'Why do you Japanese people strive to imitate European-style paintings when you have such excellent paintings of your own? European paintings are becoming more and more realistic and scientific and are declining artistically. The West in its efforts . . . to overcome this crisis, is actually turning its eyes to your traditional Japanese art to learn what it can.'[6]

Japanese arts and crafts were at that time represented in international exhibitions, following London's Great Exhibition of 1851 (and most notably in the London International Exhibition of 1862), as 'industries'. Though its crafts were much admired, the existence of Japanese architecture, painting and sculpture was largely ignored.[7]

There was probably an element of enlightened self-interest at

[5] Quoted from Takashina 1987, p. 22.
[6] Fenollosa, 'True Theory of Japanese Art'; quoted in Mitsugu, 1958, pp. 309–10.
[7] See the comments of Rutherford Alcock; quoted in Conant 1991, p. 81.

work in Fenollosa's activities.[8] He was not only seeking to instil in the Japanese a lost pride in their own 'art' but also seeking to advance its claims as antique collectibles on a world scale. In 1886 he sold his own magnificent collection of Japanese art through the agency of Charles Weld, a wealthy Boston doctor, to the Museum of Fine Arts, Boston.[9] Later, Fenollosa, from 1890 to 1895, was appointed curator of its new Department of Oriental Art.

Fenollosa and Okakura did not advocate the retention of a wholly traditional Japanese art, but rather a modern manner of painting 'in the Japanese style' executed in water-soluble pigments, often on silk. It became known as *nihonga* to distinguish it both from the practice of Western oil painting and from *Yamatoe*, the name for the older style traditional art.[10]

Fenollosa's ideas drew upon Hegelian metaphysics, Spencerian evolutionism and Emerson's transcendentalism. Both East and West, he felt, had exhausted their own traditions. A synthesis was required that would bring humankind to a higher cultural level; and an innovative *nihonga* art might act as its agent. His ideas soon aroused local patriotic sentiment.

It is clear from the views he expresses in *Epochs of Chinese and Japanese Art* (1912), the magnum opus he began writing after his return to New York in 1890, that Fenollosa was an early advocate of the Formalesque aesthetic. Like Wölfflin he structured his enquiry within a stylistic unity of epochs, conceiving 'the art of each epoch as a peculiar beauty of line, spacing and colour which could have been produced at no other time and which permeates all the industries of its day',[11] and the most important element of all was spacing.[12] So his aesthetic was opposed to realism, modelling and chiaroscuro. However, his historical method was rather primitive. It reveals the dangers of using style as a guide without adequate documentation. Things like the stylistic similarities between the Horiuji frescoes of Japan and those of Pompeii excited him so much that he argued a seventh-century Western influence on Japanese art.[13] This reliance on style determined the way he addressed his grandiose problem of the separate origins of art in the

[8] On this point, see Clark 1986, p. 229n13.

[9] Rosenfield 1971, p. 206.

[10] Its first appearance is said to have been as a translation of 'Japanese Painting' in a translation of Fenollosa's lecture 'The True Theory of Art' (1882).

[11] Fenollosa 1912, vol. 1, p. xxiii.

[12] After his return to the United States, Fenollosa developed with a colleague a system of art education known as the Fenollosa–Dow system. Gombrich has drawn attention to it as a possible influence on Mondrian. See Gombrich 1979, pp. 59, 310n.

[13] Fenellosa 1912, vol. 1, p. 94.

East and West. He posited a 'Pacific School of Art' unified by 'dispersion and contact throughout the vast basin of the Pacific'.[14] It covered the arts of Peru, Central America, Alaska, China and Japan and was marked off from the arts of the West by a 'longitudinal line drawn from Central China to Borneo'.[15] Oddly enough, he did not believe that China was the centre from which this vast stylistic corpus radiated but that its 'ancient centre lay in the south possibly in lands now submerged'.[16] This notion seems to have been stimulated by stylistic similarities he found between the Maori art of New Zealand and the ancient art of China. Then when describing the origins of Western art, in which he included the arts of Mesopotamia, the Nile Valley, the Greek Mediterranean *and* India, he argued that 'Egyptian art must have received ancient infusions from the south from African sources that yield us today the spirited drawings of the bushmen and Benin bronzes'.[17] So for both his Eastern and Western megastyles he sought what we would now describe as 'primitivistic' origins. Even so, it is the spread of ancient Greek art that becomes the leading player in his historical theatre. Although ancient Chinese art was first influenced by an archaic art proceeding possibly from a submerged Atlantis in the Pacific it was then 'overlaid by Graeco-Persian' art.[18] Thus we have the strange mingling of a 'primitivistic' account of art's origins and diffusionist concepts overlaid by an eastward spread of Greek art from the West.

All this may best be described as an early example of the second moment of cultural imperialism. It promoted, inter alia, the seizure, collection, and/or purchase of indigenous artefacts for Eurusan public and private collections. It also promoted the preparation of classifications, evaluations, and histories of non-European artefacts in terms of the universalising methods of art history and Kantian and post-Kantian aesthetics. Artefacts were transvalued from cultural particulars to aesthetic universals.

Fenollosa was seeking to develop a better understanding in the United States and Europe of Chinese and Japanese art; indeed he was one of the first scholars successfully to do so. As a member of the Fine Arts Jury of the Chicago World's Columbian Exposition of 1893, for example, he was responsible for having the Japan exhibits presented as 'fine art'. In previous expositions they had been clas-

[14] *ibid.*, p. 3.
[15] *ibid.*
[16] *ibid.*, p. 7.
[17] *ibid.*, p. 4.
[18] *ibid.*, p. 5.

sified, as we noted, as' industries'. But in so raising crafted, ritual artefacts to the status of fine art, he also stimulated the process of commodifying them. He thus stands out as a prime mover in the transvaluation of values by which the artefacts of China and Japan were disembedded from their original religious and ritual cultural roots and transformed into aesthetic objects for the delectation of the West. It is implicit in the method he used to assemble the artefacts discussed in his *Epochs of Chinese and Japanese Art*. Despite his own conversion to Buddhism, their ritual significance does not seriously interest him. They are assembled as objects of fine art according to the formalist aesthetic he embraced, already discussed above.[19]

It is of interest to note that Fenollosa's former student, close friend and collaborator, Okakura, denied that there were any Greek influences effecting Indian, Chinese and Japanese art. This was probably one of the reasons for their later estrangement. While supporting the status quo in his own country, Okakura became a militant anti-colonist so far as China and India were concerned, a friend of Rabindranath Tagore, and one who advocated guerrilla warfare tactics against the colonial oppressors. By contrast, Fenollosa, in his later years, championed the concept of a coming world art by the fusion of the arts of East and West, at a time when diffusionist views were becoming increasingly less congenial to his erstwhile colleague. Towards the end of his life he helped and encouraged Charles Freer (1856–1919) to lay the foundations of the first great private collection of Japanese and Chinese art in the United States, later bequeathed to the Smithsonian Institution, Washington.

The transvaluation of Japanese art values from cultural particulars into aesthetic universals launched by Fenollosa in 1881 finds an interesting parallel on the Indian sub-continent. There too modernisation resulted in second moment transvaluations of local artefacts in response to the foreign imperial presence. Like Japan, India possessed a traditional visual culture of enormous strength, resilience and beauty, an ancient heritage of architecture, sculpture and painting in the service of the major religions of the sub-continent, Hinduism, Buddhism and Islam. Art in the general sense flourished, and still flourishes, in textiles, ivory, jade, jewellery and metalwork.

[19] Fenollosa's work as an early pioneer in the transvaluation and commodification of Chinese and Japanese ritual objects to fulfil the commercial and aesthetic needs of Eurusan culture may be compared with Lynn Hart's brilliant exposition of the contemporary commodification of women's ritual art from the Kumaon region of Uttar Pradesh. See Hart 1995, pp. 127–50.

But, unlike Japan, the sub-continent experienced throughout its long history the violent penetration of many empires. This produced arts that, blending with many regional styles, became endemically eclectic. But, as we have already noted, taking a distanced view, this is true of the art of all times and all places.

Portuguese, Dutch, French and eventually British imperial incursions into the sub-continent from the early sixteenth century introduced European building styles – Renaissance, Baroque, Rococo, Palladian – wherever Europeans established their forts and factories. There was bound to be a response, even if it was unequal. By the middle of the nineteenth century Indian decorative design was coming to be judged by connoisseurs like Digby Wyatt, Gottfried Semper, Richard Redgrave and Henry Cole as far superior to contemporary British design.[20] Indian architecture even exercised a modicum of influence in Britain, in Cockerell's Sezincote, Gloucestershire (1805), and Nash's Brighton Pavilion (1815–21). Meanwhile neo-classical statues of empire builders, such as Lord Dalhousie (1812–1860), were erected in Calcutta, the headquarters of the English East India Company, and in Bombay, Madras and elsewhere. Oil painting styles were introduced by Johann Zoffany (1733–1810), who worked in Calcutta from 1783 to 1789. The need to represent Indian subject matter in the genres of topography, natural history and realistic portraiture led to the development of what is called 'company painting' in the eighteenth century. By the 1860s, with the growth of industrialism, there arose the need to establish local art schools in which to train Indian artists in the techniques of European-style naturalism.

All these developments, from the early sixteenth to the late nineteenth century, may be aptly described by what I have called the first moment of cultural imperialism. As a result, the arts of India, particularly its architecture and sculpture, came to be held in contempt, seen as the product of superstition, or as 'bazaar art' of little value.

This was true especially in Europe itself. The most influential thinkers had little time for it. For Hegel, Indian art was childish;[21] For Ruskin, Indian sculpture was idolatrous – 'non-progressive . . . diseased and frightful'.[22] But Hegel and Ruskin were thinking of the 'high' arts, arts in the service of religion. Ruskin, twelve years before he condemned Indian sculpture so vehemently,

[20] See Mitter 1977, p. 221.

[21] Hegel 1975, vol. 1, pp. 308–09.

[22] Ruskin, 'Aratra Pentelici' (Six Lectures on the Elements of Sculpture, 1870), in Ruskin 1903–12, vol. 20, p. 227.

when speaking at the South Kensington Museum in 1858 (at the opening of its architectural section), viewed examples of Indian *decorative* art and raved about them. They were being displayed there for educational purposes, for improving the standards of British industrial design. The artisans of India, Ruskin said, 'are, indeed, in all materials capable of colour, – wool, marble, or metal, – almost inimitable in their delicate application of divided hue, and the fine arrangement of fantastic line . . . [T]he love of subtle design seems universal in the race, and is developed in every implement that they shape, and every building that they raise.'[23]

In thus praising Indian decorative art on this occasion, Ruskin was contributing to the sources of the emerging Formalesque style. There is a delightful paradox at work here. Imperial India could teach English art students the Indian way in art manufactures while it taught Indian students in India the British way according to Ruskin's *Elements of Drawing* (1857) and *Elements of Perspective* (1859).

Not that Ruskin himself had any love for the British raj:

Every mutiny, every danger, every terror and every crime, occurring under, or paralysing, our Indian legislation, arises directly out of our national desire to live on the loot of India, and the notion always entertained by young English gentlemen and ladies of good position, falling in love with each other without immediate prospect of establishment in Belgrave Square, that they can find in India, instantly on landing, a bungalow, ready furnished with the loveliest fans, china and shawls, – ices and sherbet at command, – four-and-twenty slaves succeeding each other hourly to swing the punkah, and a regiment with a beautiful band to 'keep order' outside, all round the house.[24]

Ruskin wrote this in 1884 long after he had turned from a predominant interest in art to the social and political problems of his day. His influence is present in the work and writings of Ernest Havell (1861–1934), who played a comparable role in India to that of Fenollosa in Japan. With Havell, we witness the first moves from the first to the second moment of cultural imperialism at work in India.

Ernest Havell was the great nephew of William Havell (1782–1857), who had spent much of his life producing topographical and picturesque views in China, India and Sri Lanka – the kind of art

[23] Ruskin 1903–12, vol. 16, p. 261.
[24] *ibid.*, vol. 33, p. 473.

essential to the first moment of the European colonial project. After training at South Kensington, Havell accepted, in 1884 (the same year that Ruskin inveighed against punkah-wallah slavery), the post of superintendent of the Madras School of Industrial Arts. Here, like Fenollosa in Japan (also in the 1880s), he developed an intense passion for the exotic art he found around him and spent the rest of his life drawing attention to its unrivalled qualities.

Havell took a strong stand against the then widely prevalent claim that much Indian sculpture was 'a debased imitation' of Greco-Roman models,[25] and strongly criticised the introduction of European methods of art teaching into India, condemning the rigid distinctions that were then being maintained in Britain by Ruskin and others between art in the special and in the general sense. To make his point he quoted from the current official handbook for the Indian section of the Victoria and Albert Museum: 'The monstrous shapes of the Puranic deities are unsuitable for the highest forms of artistic representation; and this is possibly why sculpture and painting are unknown as fine arts in India . . . Nowhere does their figure sculpture show the inspiration of true art . . . It is only because their ivory and stone figures of men and animals are on so minute a scale that they excite admiration.'[26]

Havell was also critical of 'educated Indians' who preferred European culture to their own. They were 'entirely aloof from those vital movements in British art and craft which in the last half-century have derived so much from the study and exploitation of oriental art'.[27] He was referring of course to the Arts and Crafts Movement launched by Ruskin and Morris. 'The folly of the present educational system is that with such a tradition still alive, with numbers of such master craftsmen still obtainable, we allow Indian revenues to be spent in producing mechanical imitations of Gothic and Renaissance sculpture at ten or twenty times the cost of good Indian art, and this . . . because some western doctrinaires believe that Indian sculpture is not "fine".'[28]

In his campaign for the international recognition of Indian art, Havell was supported by highly influential friends such as the Japanese art historian Okakura Tenshin; the famous Indian writer and philosopher Rabindranath Tagore (1861–1941), his nephew Abanindranath Tagore (1871–1951), and the great scholar Ananda Coomaraswamy (1877–1947). It was Abanindranath Tagore, a

[25] Havell 1911, p. xiii.

[26] *ibid.*, p. xviii.

[27] *ibid.*, p. 143.

[28] *ibid.*, p. 179.

painter and writer, whom Havell was able to install as vice-principal of the Calcutta School of Art in 1905, and thus turn around the emphasis from a European (i.e. British) technical training to a modern approach to painting in and for India comparable to the *nihonga* of Japan. Coomaraswamy, the talented son of a Singhalese father and English mother, followed a path not dissimilar to Fenollosa. After amassing a great collection of Indian art, particularly of Rajput painting, he was able to move, with his collection, as curator to the newly established Indian section of the Museum of Fine Arts, Boston, where he continued to write prolifically on Indian art and philosophy. All these talented people were profoundly influenced by Ruskin, Morris and the Arts and Crafts Movement. Havell, in turn, influenced Roger Fry, and Coomaraswamy influenced Eric Gill.[29] At his influential centre, Shantinikitan, Rabindranath Tagore brought together artists and writers from the 'East' and the 'West', seeking to link art in the general with art in the special sense and so create a world art. In this he was greatly influenced by the Japanese experience.

As a result of their work, Indian artefacts from architecture to textiles came to be accepted world-wide as fine art, art in the special Eurusan sense. The breakthrough, of course, was achieved under the aegis of the aesthetics of the Formalesque, which had initially, as we have seen, been inspired by exotic, not by European, art. Thus the second moment of cultural imperialism must be clearly distinguished from its first moment forerunner, which involved the use of *European* art – mapping, topography, the picturesque and impressionist landscape – for the material, emotional and spiritual acquisition and securement of colonies beyond Europe and the establishment of European institutions such as art schools and museums in foreign lands.

Second moment cultural imperialism was addressed instead back to the Eurusan culture itself. Its essentially imperial nature is revealed by the gradual accession of Indian art into Eurusan collections and museums as the result of looting, and other forms of acquisition.[30]

But in India too, second moment cultural imperialism created a backlash that viewed it as an impediment to modernisation. The principals of the influential Jamshetjee Jeejheebhoy School of Art in Bombay objected to the trend developed by Havell and his circle.

[29] *ibid.*, pp. 283–84.
[30] See for example the sections on Collectors and Collections and Exhibitions in the article devoted to the Indian sub-continent in Dictionary 1996, vol. 15, pp. 740–46.

Equally, Fenollosa's advocacy of traditional Japanese art conflicted with Japan's artistic modernisers. There battle lines were drawn in 1882 when Shotaro Koyama (1857–1916), one of the most influential of the early *yoga* artists, wrote a challenging article entitled 'Calligraphy is not Art'. The European alphabet was beautiful because it was useful, efficient and clear. Calligraphy, he said, though it aspires to spirituality, does not contribute to learning. In responding, Okakura argued that Koyama had missed the point. The true aim of art was subjective, to give concrete expression to a mystical experience. This calligraphy did.[31]

Both Havell and Coomaraswamy had used similar arguments in their advocacy of Indian art against the materialism of Western values. Indian art, like European medieval art, was spiritual; modern European art, material. It did not point the way.

In response to the growing influence of Fenollosa's ideas, Tokyo's Technical Art School was closed down in 1883. Two years later the practice of drawing in line with pencil, established fifteen years before in elementary education, was abolished in favour of traditional ink and brush drawing. In 1887 a Tokyo School of Fine Arts was established to advance modern practice in traditional Japanese art. Two masters of Kano-style painting, Kano Hogai (1828–1888) and Hashimoto Gaho (1835–1908), friends of Fenollosa, were employed as teachers, and through their pupils a re-invigorated *nihonga* art was promoted. At the outset no department of oil painting, seen as a Western innovation, was established.

There is a fascinating reciprocity of art categories at work here. Although in the first instance artists like Kōkan had turned to the 'fine' arts of Europe, for their superior techniques as aids to science and technology, *nihonga* art championed the elevation of traditional Japanese art, formerly perceived as craft, to the status accorded in Europe to high art. A universalisation of the European concept of art was relentlessly in progress. It was institutionalised by the Japanese Ministry of Education's establishment in 1907 of a popular annual art exhibition, the Bunten, modelled on the French Salons. Prior to its establishment, Japanese arts and crafts had been exhibited as 'industries' in the Domestic Industrial Expositions, which had been held several times since the Meiji Restoration. The 1907 Bunten was the first occasion on which 'art' was exhibited independently.[32] In 1912 the exhibition attracted an audience of 160,000.[33]

[31] Rosenfield 1971, pp. 209–10.
[32] Bunten 1990, p. 11.
[33] Rimer 1987, p. 40.

Despite the work of Fenollosa and Okakura, interest in *yoga* art continued to grow. From the 1880s an increasing number of Japanese architects, sculptors and painters began to study and work in Europe, returning with new ideas and experience. This also reinforces the contention that cultural imperialism is a social condition stimulated by desire, and funded by *ressentiment*,[34] a drive to catch up with Modernity and reduce the sense of marginalisation and inequality pervading the homeland. Yet modernisation created traumatic upheavals in social life in Japan. 'Scores of old-style artisans – lacquer makers, potters, weavers, wood carvers, bronze casters – were being absorbed into mechanised industries and given entirely new skills. For painters and sculptors, a totally new system of training was devised to replace the master–apprentice method of traditional workshops.'[35]

Change affected all levels of society. By the time that Kuroda Seiki (1866–1924) returned to Tokyo in 1893 after ten years' study in Paris, the ground was well prepared for the acceptance of art on the European model. Kuroda had studied under Raphael Collin (1850–1916), a French Salon painter who specialised in painting young, nubile nudes reclining in arcadian landscapes, and whose style owed something to Impressionism. Socially well connected, Kuroda was appointed in 1896 to teach in the recently established Western Painting Section of the Tokyo School of Fine Arts, and became its director two years later. Although it had been set up under the influence of Fenollosa's advocacy of *nihonga* painting, ten years had wrought a change. A new generation of artists now preferred *yoga* art to *nihonga*. However, this did not mean an immediate leap into avant-garde attitudes on the Parisian model. Kuroda based his teaching on the methods of academic training to which he had become accustomed in Paris, introducing the study of the nude in his classes. He also composed history paintings in the manner of the Salons but based their content on Japanese history, myth and legend. A generation later Diego Rivera, returning to Mexico in 1921, performed a similar task for Mexican art, introducing not only modernism but a new version of Renaissance mural painting.

This raises a point of general interest. It would appear that a *recapitulation* of the European tradition had to be acclimatised, practised and enjoyed before an avant-garde critique of that same tradition could fully develop. To artists belonging to non-European

[34] For Nietzsche, resentment (*ressentiment*) is a mark of the 'slave morality' rejecting what is noble and exceptional. But for P. F. Strawson, it presupposes free will and for John Rawls, in his *Theory of Justice*, it presupposes equality and justice.

[35] Rosenfield 1971, p. 184.

cultures, like the Japanese and Mexican, all European culture, not only its latest phases, was exotic and, for that reason, equally enticing to appropriate. There is a sense in which they saw European art as timeless, just as Picasso's generation saw 'primitive' art as timeless. So when the Formalesque style did begin to emerge in Japan around 1910, it is not to be seen as an influence issuing directly from Europe so much as a local critique working, not against *nihonga* but against earlier modes of *yoga* art conceived as pure technique, practised by a preceding generation and its followers. Japanese history painting became a modernising critique of Japan's own Modernity.

Europe drew, as we have noted, upon the art of societies less technologically developed in creating the Formalesque. Japan, on the other hand, drew upon a Europe technologically more sophisticated in order to change the tenor of its life and art. It possessed no Cézanne to classicise its modernism by returning it to its traditional Buddhist culture. Instead it developed a modernising *nihonga* promoted by Okakura. So it is not possible to find a close analogy between the aesthetic function of the Formalesque in Europe and its operation in Japan. It emerged in a different cultural situation.

When *yoga* art got under way again under the influence of Kuroda after the dominance of *nihonga* subsided, Paris and Europe became the goal of his students. Asai Chū (1856–1907), who had studied under Fontanesi, arrived there in 1900 and returned in 1902; Fujishima Takeji (1867–1943) left in 1905 to study with Cormon in Paris and Carolus-Duran in Rome, returning in 1910. It was a generation skilled in Impressionist techniques modified by academic training under such salon painters as Raphael Collin, Jean-Paul Laurens (1838–1921), Fernand Cormon (1845–1924) and Carolus-Duran (1837–1917). And not only from Japan but from all over the colonised world came young artists to the French Salon teachers to be instructed in the conventions of academic classicism. On their return each in his own way acclimatised his styles to local themes and subject matter. To take but one example, the Canadian painter A. Y. Jackson (1882–1974) studied under Jean-Paul Laurens during 1907–08 and, returning, became one of the leading members of Canada's Group of Seven, which specialised in landscape painting.[36] In settler societies such as Canada's the second moment of cultural imperialism could not be faced until the local Canadian landscape had been emotionally addressed. A

[36] Robson 1938.

similar situation obtained in Australia towards the end of the century. In settler societies a landscape nationalism substituted for the symbiosis characteristic of Asian visual modernism as it addressed itself to the confrontation of its own art in the general sense with Europe's art in the special sense.

From 1890 to around 1915 Impressionism was the advanced style in Japan and continued to produce good art well into the 1920s.[37] How shall we describe, globally, such returning expatriates? They cannot be called avant-garde, at least in a supra-national sense, for the style had already been created in Paris in the early 1870s. They were *couriers of the new*, carrying the now accepted French style back to their homeland. It was a process that during the first decades of the century operated world wide, when in Europe itself the Formalesque was replacing Impressionism as the avant-garde style of the time.[38]

Around 1910 a new generation of couriers began returning to Japan. The painter Saitō Yori (1885–1959) and the sculptor Ogiwara Morie (1879–1910), inspired by Rodin, both returned in 1908, as did the sculptor Takamura Kōtarō (1883–1956) in 1909 and the painter Tsuda Seifū (1880–1978) in 1910. The artists Yamashita Shintarō (18881–1966), Arishima Ikuma (1882–1974) and Minami Kunzō (1893–1951) all returned in 1910 and set up the Nikakai (Second Divison Society) in opposition to the Bunten. They were soon followed by Umehara Ryūzaburō (1888–1986) and Yasui Sōtarō (1888–1955).

These were the artists and generation that introduced the Formalesque to Japan. The style seemed to appeal deeply to the Japanese sensibility of that time. Arishima Ikuma wrote of his response to the Cézanne retrospective of 1907 held at the Salon d'Automne: 'My eyes were opened . . . my soul was moved . . . I learned of a new way in which the great garden of art could be cultivated.' In Cézanne's art he found a 'world element' that 'could transcend a particular culture and so speak directly to any true believer in art'.[39] Umehara Ryūzaburō's first confrontation with the works of Renoir was not dissimilar: 'I shouted to myself. Yes these are the paintings I have been seeking, the paintings I myself want to paint. It is worth it to come so far across the sea, to have been able to see such paintings.'[40] Kishida Ryūsei (1891–1929), a pupil of Kuroda's who never left Japan, was equally moved by the repro-

[37] On Japanese Impressionism, see Rimer 1990, pp. 137–68.
[38] On the world spread of Impressionism, see Broude 1990.
[39] Rimer 1987, p. 46.
[40] Bridgestone 1991, p. 198.

ductions that he found in *Shirakaba*, the journal of the White Birch Society, which included illustrations of the work of Cézanne, Manet, Gauguin, van Gogh, Renoir, Matisse and Renoir. 'I would look', he wrote, 'at the paintings and I would be gasping with excitement. I was so overwrought there would be tears in my eyes. My paintings then, were not merely influenced by the Post-Impressionists, they were more like copies. I would unabashedly paint in the manner of Van Gogh.'[41]

That these artists found immediate emotional kinship with French Impressionist paintings is not surprising. The Impressionists, as we know, gained inspiration from the brilliant, colourful prints of the *ukiyo-e*. Even more than in Europe itself, the Japanese Formalesque is the child of Impressionism. It is Post-Impressionist and Fauve art, not Cubism, Expressionism or Futurism, that are most favoured by its couriers during those crucial years before World War I when the Formalesque style found a footing in Japan. To some extent it was a homecoming for the art as well as the artists. Cultural imperialism may indeed be seen here, if anywhere, as a two-way process, but even so, it remained an uneven two-way process. To the extent that Japanese art absorbed the changing substyles of the Formalesque and ceased no longer to be exotic to European eyes, to that extent the Eurocentred vision was able to ignore it. If Japan is mentioned at all in general histories of art it is in the form of a footnote about, say, Hokusai's influence on Manet and his circle.[42]

Japan was the first non-European culture to respond, with a nudge from Fenollosa, to Formalesque art enthusiastically, and yet selectively, favouring its Post-Impressionist and Fauvist modes. This was probably because there was a profoundly compatible, local aesthetic at hand to embrace it. Shinto, the native religion of Japan, is a religion of 'nature mysticism'; worship becomes aesthetic experience. The Japanese theologian Kishimoto Hideo informs us how a Japanese walking in the countryside might use the one word *samishii* (lonesome) to express his feelings. He does not say that 'I am lonesome' or 'the scenery is lonesome'. The language itself is structured to identify him directly and imperceptibly with it. This, in part, is the gift of Shinto. Kishimoto concludes that in Japan 'religious values and aesthetic values are not two different things. Ultimately they are one for the Japanese.'[43]

[41] Takashima & Rimer 1987, p. 152.

[42] e.g. Gombrich 1989, pp. 417–18. The situation has changed dramatically with the publication of Dictionary 1996, which provides an ample account of Japanese art.

[43] Kishimoto 1967, p. 117.

Yet that is only part of the modernising story. Kishida, who would unabashedly paint like van Gogh, found the direct influence of Formalesque art unfulfilling. 'I am beginning to feel more and more strongly that I am not what is called a Contemporary Man . . . I was confused as to which path I ought to take . . . this was inevitable. But I have always seen Nature in my basic desire.'[44] Nature drew him back to the old masters. 'I was first influenced by Rembrandt, Rubens, Goya, and the like, then I was influenced by Dürer, Mantegna and van Eyck. I admired Dürer most of all.'[45] But it was through his love for his small daughter, Reiko, that his passion for nature, filtered through the skills of the masters, enabled him, as he put it, to move from a ' "material beauty" towards a "spiritual beauty".'[46] So there is a sense in which Kishida repeated the experience of his teacher Kuroda who, after absorbing the lessons of Impressionism returned to Japan, as we noted, to promote history painting in the European manner. This reinforces the view that modern painters, working beyond the European culture, were not presented with the same kind of problem as their European contemporaries who felt closed off from the masters of their own culture by the very dynamics of Modernity and needed to resist its influence in order to 'make it new'.[47] But to modernise their own cultures, the twentieth-century artists of non-European cultures often felt that they had to master the whole of the European tradition, not only the avant-garde end of it, in order to produce good art. The situation was similar for Nakamura Tsune (1887–1924), a contemporary of Kishida's who, like him, never visited Europe: 'an artist who moved back and forth between many different styles while maintaining an earnest admiration for Rembrandt, Renoir, Cézanne and the European art of the time'.[48]

So the European project of Kōkan begun at the level of technical mastery, in the eighteenth century, became for Kishida and Nakamura a spiritual quest. The series of paintings of Kishida's small daughter 'has remained among the most popular of any works by any artist in modern Japan'.[49] In this way he succeeded in

[44] Takashima & Rimer 1987, p. 154.

[45] ibid.

[46] ibid., p. 156.

[47] What Gombrich has called 'the principle of exclusion' (Gombrich & Eribon 1993, p. 165). And compare the situation of David and his school, as assessed by Norman Bryson in Bryson 1984.

[48] Mizusawa 1988, p. 26.

[49] Takashima & Rimer 1987, p. 102.

relating his own culture to European innovation. The paintings of his daughter have become cultural icons.

The work of Kishida and Nakamura were the aesthetic rewards of modernisation, end products of Meiji Restoration art policy. They are not a critique of Japan's Modernity. This, when it came, arrived not from western Europe but from Russia and Berlin. In October 1920 David Burlyuk, friend and colleague of Kandinsky, Goncharova, Larionov and Mayakovsky, arrived in Tokyo. He was on his way to the United States, seeking to evade the civil war then engulfing the new Soviet Union.[50] Soon after he arrived he arranged *The First Exhibition of Russian Paintings in Japan*. It included a great deal of his own work and that of his Siberian colleague Pal'mov, but also a work by Malevich and two by Tatlin. A visitor, the artist Tai Kambara (b. 1898), described the effect it had on him: 'All the styles . . . grotesque, fantastic, and story book art, Realism, Dadaism, Constructivism, Futurism, and Cubism – were hung in disorderly array. I went back to the exhibition almost every day.'[51]

The exhibition introduced Constructivism to Japan and provided support to the Japanese Futurist Art Association already formed earlier that year. This small avant-garde group continued to promote Burlyuk's work after he left for the United States two years later. In 1923 one of them, Shuichiro Kinoshita (1896–1991), published jointly with Burlyuk *What is Futurism? An Answer*. By that time another Russian artist, Varvara Bubnova (1886–1983), had already arrived. She had been actively associated in Moscow with the debates on Construction and Composition held by Inkhuk between January and April 1921, and in Japan she played an important part in disseminating knowledge of Russian Constructivism and Futurism with her two articles 'On Contemporary Trends in Russian Painting'[52] and 'On the Death of Art'.[53] Her influence was greatly reinforced by the return of Tomoyoshi Murayama (1901–1977), who had come into contact with Dada and Constructivism during his months in Berlin, where he met Archipenko and Marinetti in Herwath Walden's Sturm Gallery and saw work by Klee, Picasso and Braque. It was the year of the Russian Constructivist exhibition in Berlin. He saw plays by Toller, and the dancing of Niddy Impekoven made a profound impression.

[50] See Omuka 1986, pp. 111–33.
[51] Mizusawa 1988, p. 28.
[52] Published in *Shiso* (Sept. 1922).
[53] Published in *Chuo Koron* (Nov. 1922).

Later he dressed as a dancer and dancing became an important part of his persona.

Murayama held his first Tokyo show in May 1923 shortly after his return to Japan. He had came from Berlin with a programme which he called called 'Conscious Constructionism', the logical successor, he said, of Dada and Constructivism. But it was more his Dadaist critique of Constructivism strongly influenced by Schwitter's *Merz* and the geometry of De Stijl. Murayama modelled his activity on Marinetti, spoke in the vein of Nietzsche and anticipated Rauschenberg:

> [M]y pictures have pieces of cloth swelling out from the surface of the canvas which are sewn on, real tousled blonde hair hanging down, and rope, nails, dolls, and tram tickets attached . . . All of my passion, thoughts, songs, philosophy and sickness take tangible form and boils over in a search for expression . . . I am at the peak of happiness. I am completely satisfied with my own pitifulness and perplexity. Who before me knew that pictures, that formative art was so great?[54]

'I hate', he wrote three months later, 'the present Frenchified, overly calm, self-centred, death-like, degenerate condition of Japanese art.'[55]

Murayama exhibited tirelessly and wrote scathing newspaper articles. Everything about modern art known in Japan, Expressionism, Cubism, Dadaism, Constructivism, was now dead and buried. He castigated the young artists who exhibited in the Nika Society: 'you are slavishly following the fashions of Europe . . . you are following the traditional concept of absolute beauty . . . you are serving a faulty society'.[56]

A new group, Mavo, developed around him a few months after his return. An exhibition was organised; a manifesto prepared. Denying that it would assert *any* position – thus in a sense anticipating Postmodernism – it stood by its denials and affirmations. 'We are standing at the front edge. And will probably stand at the edge permanently. We are not bound. We are radical. We are revolutionary. We are advancing. We are creating. We are continually affirming and denying. We are alive in every sense, to an incomparable degree.'[57] They experimented 'with lectures, plays, concerts,

[54] From his manifesto 'Expressionism Passing Away: Introductory Implementation of Conscious Constructivism', *Chuo Bijutsu* (April 1923); quoted in Omuka 1988, p. 21.

[55] Mizusawa 1988, p. 29.

[56] *Mizue* (June 1924); quoted in *ibid.*, p. 30.

[57] Mizusawa 1988, p. 31.

magazine publishing . . . show windows, book binding, stage sets . . . architectural design'.[58]

It must have sounded like a prophecy. A month after Mavo was formed, the great Kano earthquake of 1923 turned Tokyo into a ruin overnight. Over 400,000 dwellings were totally destroyed. It was Dada transcendent. 'Mavo moved furiously into action, designing and decorating barrack buildings.'[59] They held a 'scattered show' in coffee shops, restaurants, park benches, throughout the ruined city. They expanded their theatrical performances. Murayama danced to the accompaniment of an instrument made out of an oil can, logs and wire. Anticipating Jean Tinguely, they destroyed it at a final performance.

The circle of young Japanese artists associated with the Russians and Murayama active between 1920 and 1925 constituted the first distinctive Japanese avant-garde. The nature of their work varied between Futurist, Constructivist and Realist art and developed as a critique of the earlier generation of established Formalesque artists whose teachers had been trained largely in Paris. But the Constructivist heyday in Japan was brief. In 1927 a large exhibition of Russian art was brought to Tokyo (18–31 May) accompanied by the art historian Nikolay Punin. Most of the works shown (387) were of a realistic character. Punin explained that the absence of works by Malevich, Tatlin, Filinov and Larionov was due to a shipment delay from Moscow and other 'technical' reasons. But at the bottom lay the changed attitude of the Soviet authorities. In their view Constructivist works were no longer suitable for export. In this, the Soviet Union prefigured the United States' decision, three decades later, that modern figurative American art was not suitable for export during the Cold War years. But the Soviet decision was even more Draconian. A few years later Constructivism was unacceptable throughout the Union and Punin was, as noted earlier, sent to a concentration camp where he died.

The cultural climate changed dramatically after the Kano earthquake. *Shirakaba*, the journal of the White Birch Society, which had brought a new, liberating humanism to Japanese culture during most of the Taisho period (1912–26), ceased publication. The increasing power of the Mitsui and Mitsubishi industrial empires retarded the development of an independent labour movement. The Kato administration of 1924–26 was called the Mitsubishi Cabinet. Although universal *manhood* suffrage was achieved in

[58] *ibid.*
[59] *ibid.*

1925, under the 'peace-preservation' laws of 1928 a special police corps was established to seek out 'dangerous thoughts'. Avant-garde art, originally inspired by the achievements of the young Soviet Union, became more overtly political. Murayama turned his activities increasingly to left-wing theatre.

Surrealist painting, the work of Tōgō Seiji (1897–1978) and Fukuzawa Ichirō (1898–1992), began to be exhibited in Tokyo around 1929, the very year of the Wall Street Crash. It heralded the Great Depression and a deep depression in the Japanese rural silk industry. The political influence of the military developed rapidly after the Depression, spurred by resentment. Efforts by Japan and China to gain a racial equality clause in the League of Nations Covenant had been frustrated by European statesmen, and a popular desire developed for imperial expansion onto the Chinese mainland.

During these uneasy times Surrealist art together with social realism sought to develop a modernist critique of Japanese society. But its culture (despite its modernisation since the Meiji Restoration) had never developed a civil society stable enough to protect a secure, relatively autonomous, art world and make such a critique possible. The process of modernising art had been sustained by a series of transient groups, energised by generational change and substylar movements of the Formalesque from Post-Impressionism to Fauvism. Surrealism failed to develop a political programme as it did in France. It was drawn more to personal fantasy in the manner of Klee and Chagall, revealing little interest in the exploration of the automatism of Ernst or Masson. The Surrealist group of artists formed after Fukuzawa's return in 1931 was known as the Bijitsu Bunka Kyokai (Art Culture Society), and Tōgō Seiji's work was not confined to Surrealism but ranged over Cubism, Futurism and Expressionism. In 1960 he became a member of the Japanese Academy of Fine Arts.

This is not surprising. The political situation was far more oppressive than in Europe. By 1929 the Communist Party and its sympathisers were effectively suppressed and the proletarian art movement – about which more needs to be known – ceased to exist.

One thing that stands out from this brief survey of the reception of Formalesque art in Japan is that, as in Russia a decade earlier, it did not arrive as a distinct and successive series of substyles from Post-Impressionism to Surrealism but in conflated bundles determined largely by generational change and the return of couriers of the new – manifestations in which Post-Impressionism, Neo-

Impressionism and Fauvism, Dada and Constructivism and even Surrealism blend into eclectic forms of modernising art responsive to the local cultural climate.

Although Japan was one of the few foreign nations to avoid imperial occupation, it was itself an adept pupil of empire. After its success in the Russo-Japanese War of 1904–05, it annexed Korea in 1910, set up the puppet state of Manchukuo in 1932, and added Inner Mongolia in 1937. By 1942 it had conquered Burma, China, French Indo-China, the Netherlands East Indies, and the Philippines, and controlled the waters of the south-west Pacific.

After Japan's defeat in World War II the United States occupied the country and democratised it – forcibly. Thereafter its art has followed a path closely comparable to that of the Eurusan culture. It is a classic case of successful cultural imperialism.

SOUTH AFRICA

The present modern nation of South Africa, like the United States of America, Canada, Latin America, Australia and New Zealand, began as a settler society. Its military, political, social and cultural institutions were created by migrants from Europe. It thus affords a sharp contrast to countries such as Japan, China and south-east Asia, all of which possessed rich indigenous traditions in monumental architecture, sculpture and painting prior to European contact. It will be useful therefore to consider here the reception of the Formalesque style by the white settlers of South Africa living among black indigenes. It has been estimated that less than 17 per cent of the population are white, 13 per cent are coloured, and over 70 per cent black.

It is only in recent years that the artefacts produced by the black communities in metal, wood, stone, ivory, beads, fibre, and so forth, have come to be classified as art and discussed as such in encyclopaedias of art.[60] That this has occurred at all has been owing largely to the hegemony of the Formalesque style in practice and theory, originating, as we know, in the passionate interest of Fauve painters such as Derain and Matisse for African sculpture, and the revaluation of 'negro' art by critics like Roger Fry.[61] It is true, of course, that European travellers collected African artefacts at least from the sixteenth century. The Ulm Museum possesses West

[60] e.g. the article on 'African Cultures' by William Fagg in *Encyclopaedia of World Art*, 1959, vol. 1, pp. 130–41; and that in Dictionary 1996, vol. 1.

[61] Fry, 'Negro Sculpture', in Fry 1937.

African artefacts of the seventeenth century.[62] But such were considered, until the twentieth century, to be artificial curiosities rather than works of art. Many factors contributed to the change. The growth of ethnographic museums throughout the Eurusan world promoted a change in the way indigenous art was perceived, from artificial curiosities to works of art available for Kantian-type judgements. The capture of the city of Benin by the British punitive expedition of 1897 resulted in the seizure, and arrival in Britain, of thousands of items of Edo art that connoisseurs began to realise were sculpture of high quality.

The history of the Formalesque in settler societies like South Africa may be viewed as the protracted reversal of a repression. At the outset Dutch and British settlers sought to displace the indigenous inhabitants either by pushing them further inland, taking them as slaves or exterminating them. Their figurines were envisioned as fetishes possessed of satanic power to be destroyed or collected as evidence of idolatry. The appreciation of such artefacts as art did not begin among the settler communities but in metropolitan centres such as Paris and London. Even if the Formalesque style begins in practice with Picasso's traumatic interest in African sculpture, that was the very last aspect of the Formalesque that attracted white South Africans. They received it as a European style.

It is in the paintings of Pieter Wenning (1873–1921), influenced somewhat by *ukiyo-e*, and in the poster-like landscapes of the Transvaal of J. H. Pierneef (1886–1957) that the Formalesque first appears on South African soil. During a visit to Holland in 1925–26 Pierneef became attracted to the mathematical theories of composition advanced by the Dutch painter Willem van Konijnburg (1868–1943), and some of his work bears a spiritual affinity with the early landscapes of Mondrian. The Formalesque appears in architecture somewhat later, during the 1930s, in Johannesburg, in the designs of architects described by Le Corbusier as the 'Transvaal Group'. Its most prominent member was Rex Martienssen (1905–1942), who wrote with passion about 'early modern' architecture. However, the full impact of the Formalesque only appears with the paintings of Irma Stern (1894–1966). Born in the Transvaal to wealthy parents, she began her training at the Weimar Academy in 1909. In 1916 she met Max Pechstein, who helped organise her first exhibition, held in Berlin in 1919. After ten years in Europe she returned and held an exhibition in Cape Town in 1920, which

[62] Fagg in *Encyclopaedia of World Art*, 1959, vol. 1, p. 134.

introduced her expressionism to a highly incensed, colonial audience. Unquestionably one of South Africa's finest painters, Stern travelled widely in Europe and Africa (notably east Africa) and collected much indigenous art. It was indeed art to her. But it did not influence her practice, which may also be viewed, in our context, as exemplary of a late phase of what I have called first moment cultural imperialism. For her inspiration derives largely from her perception of African people as colourful exotica. In it the European vision moves from the cartographical, topographical and picturesque art of its earlier years, addressed to the land, to an emotional, indeed spiritual, appropriation of its people. Black Africans became the object of her white vision. It was not an unsympathetic vision but, given the cultural climate of the time, inevitably patronising.

The second moment of cultural imperialism begins in South Africa with the acceptance of the cultural artefacts created by black Africans as art in the special sense, and the recognition of black Africans as artists. Here a clear distinction must be sustained between artefacts classified as 'artificial curiosities' or 'material culture' on the one hand and as 'art' on the other. In this regard a useful distinction may be made between the 'aesthetic' vision of practising artists, with its ultimate origin if anywhere in Kant, and the historical methods of collectors and anthropologists.

In South Africa the aesthetic vision appears to have been first addressed to black art (or at least addressed influentially) in the empathy and practice of Walter Battiss (1906–1982). Born in Somerset East, Cape Province, he spent a great deal of his boyhood in two small villages in the Orange Free State, where he was shown San (Bushman) petroglyphs by William Fowler, a friendly engineer. They explored the banks of the Riet River and adjacent areas in search of prehistoric art. The experience was a revelation. In 1933, while teaching art in a Johannesburg school, he saw San rock paintings for the first time at Le Roux Farm at Molopodraai, in the Orange Free State. They left a lasting impression not only upon him but also upon his art. In 1936 Battiss became a founding member of the New Group, established to break from the conservatism of the South African Society of Artists. Two years later, aged thirty-two, he visited Europe and met the eminent French prehistorian Abbé Breuil.[63] A year later he published The Amazing Bushman, his first book on rock art.[64] His own art then became deeply involved with the paintings and engravings of the San.

[63] Skawran & Macnamara 1985, p. 219.
[64] Battiss 1939.

'I have a terrible feeling', he said to Elaine Davie, in a radio interview in 1981, 'that South Africa has got to start its art all over again and not imitate what's happening in Europe . . . to start right from the beginning and go through the whole primitive thing, finding its roots here.'[65]

So it was that Battiss, in South Africa, thirty years after Picasso in Paris, experienced a comparable revelation, that insight central to the Formalesque style – an all-prevailing urgency to return to a 'primitive' originary. Roger Fry had already written in positive terms about Bushman art in the *Burlington Magazine* in 1910 and had republished it in his famous book of essays *Vision and Design* in 1920. Battiss would surely have read it.

A convergent art that sought to conflate European and black experience also emerged at this time in the work of Alexis Preller (1911–1975). Born in Pretoria, he was able to visit Europe some years before Battiss and study in London and Paris. On his return in 1938 he exhibited work on black African themes influenced by Gauguin. Trips to Swasiland and the Congo deepened his interest in tribal life and by the later 1940s he was creating luminous, mythic compositions inspired by local ritual and African sculpture.[66]

In settler societies the aesthetic interest in indigenous art was closely associated with the development of nationalism. In the 1920s the American artist John Sloan (1871–1951) fostered an interest in Amerindian art, organising the pioneering *Exposition of Indian Tribal Arts* in 1931. In Australia, Margaret Preston (1875–1963), in the late 1930s, became deeply interested in the indigenous art of Australia and it began to influence her practice.[67]

As artists of European origin born in settler societies became increasingly aware of the fact that they were working, as emotionally displaced persons, under the colonial conditions of first moment imperialism, they began to mourn the cultural conditions of their displacement. Their colonial culture came to appear thin, lamely dependent upon Europe. All who could, made the expatriate move to the metropolitan centres: Paris, Rome, Madrid, London, New York. Many remained, comforted to be back in the heartlands of their own culture. Others returned and turned to the indigenous art of their birthplace for inspiration. The life and art of the Cuban Surrealist Wilfredo Lam (1902–1982) indicates the great complexities of the situation. Reared as a Catholic but introduced to African witchcraft at 'an early age', he studied art in Havana before

[65] Skawran & Macnamara 1985, p. 16.
[66] Berman 1993, pp. 156–61.
[67] On Preston's Aboriginalism, see McQueen 1979, pp. 140–64.

departing for Spain in 1923 to further his art studies. There he found himself fighting on the Republican side in the Civil War and defending Madrid. In 1937 he met Picasso; in 1938 he left Spain for Paris, met Breton in 1939 and joined the Surrealists. To escape the German invasion he fled to Marseilles, joined the other Surrealists there and with them left for Martinique in 1941. Seven months later he was back in Cuba. Here, Lam set out to express the spiritual beliefs of Cubans in such masterpieces as *The Jungle* (1942–44). In Haiti in 1946, he spent four months with Breton studying black rituals and voodoo ceremonies.[68] Lam's art is a classic example of second moment cultural imperialism: Surrealist insight addressed to Caribbean culture.

Walter Battiss's career flourished during the long apartheid years. In 1956 he held his first one-man show at the Imperial Institute, London. He has been described as an anarchist and he spoke up shrewdly and courageously against the local censorship laws, but he was not a political activist. He embraced the 'timeless-ness' of San art and adopted it as his own philosophy. Or as he put it: 'Life is today . . . yesterday becomes today, tomorrow becomes today.'[69] Yet his relation to contemporary black Africans troubled him. 'I am terribly fond of black people, Africans . . . They are a big mystery to me . . . I can't understand them and I am sure they don't fully understand me as a white person, but they are close to me through art.'[70] Battiss's obviously troubled conscience may serve to introduce the third moment of cultural imperialism, when indig-enous people become contemporary artists.

It was the Christian missions in South Africa that first debased black African art in fear and loathing of its pagan sculpture. Yet by the turn of the century there existed a mission-educated, black middle class, and permanent townships around the industrial cities, and it was the Christian missions – Lutheran, Wesleyan, Catholic and Congregational – that during the 1920s and 1930s established the training and support given to young black artists that provided the basis for the rebirth of black art during the 1940s. John Koenakeefe Mohl (1903–1985), after revealing his talents, was sent to Düsseldorf by the aid of the London Missionary Society and the Lutheran Church and studied there for five years. Ernest Mancoba, while training as a teacher at the Anglican Training College, Grace Dieu, near Pietersburg, received guidance in wood

[68] Ronald Alley, 'Wilfredo Lam', in Dictionary 1996, pp. 665–66.
[69] Skawran & Macnamara 1985, pp. 15–16.
[70] *ibid.*, p. 16.

carving.[71] In 1937 he graduated in arts from the University of South Africa. After a period teaching he was able, with the aid of grants, to study at the École des Arts Décoratifs, Paris. Gerard Sekoto (1913–1993), after training as a teacher at the Botshabelo Lutheran Mission Station and teaching for some years, moved to Sophiatown, near Johannesburg, in 1939, where he was assisted by Mohl. Predictably, most of his work was bought by whites.[72]

During the 1920s, contemporary black art was being produced both in rural villages and in the towns. Rapid urbanisation brought blacks increasingly into the cities, hawking grass baskets and hats, or clay pots – largely women's work – from the villages, to sell to white tourists. This shift from a black rural to a white urban market also marked the beginnings of a local distinction between craft and art. A craftsperson potted, an artist painted. Both Mohl and Sekoto began their careers as children moulding clay images of oxen by the riverside[73] and later turned to painting.

In the days before apartheid became official, Sophiatown, the black suburb of Johannesburg, was the main fountainhead of the new black art. After he returned from Düsseldorf, Mohl set up the 'White Studio' by his home and taught 'white' art (i.e. painting) there. Later, when Sophiatown was demolished because of apartheid, he moved to Soweto, became a founder member of the black art group there known as Artists under the Sun and died there in 1985. Sekoto also lived for some years in Sophiatown. His *Yellow Houses: A Street Scene in Sophiatown* (1940) was purchased by the Johannesburg Art Gallery from the 1940 exhibition of the South African Academy. It was a brightly coloured piece of social realism, the only style of painting that meant much to people living in such conditions. The gallery did not acquire another painting by a black artist for thirty-two years. In 1942 Sekoto paid his own way to Paris, lived a difficult, alienated life, becoming better known as a jazz musician. In Paris his painting moved from the social realism of his Sophiatown youth through the whole gamut of the Formalesque from Impressionism to Orphism. He never returned to South Africa, dying in Paris at the age of eighty.

It was in sculpture that twentieth-century black South African art, like traditional African sculpture, attained its greatest achievements. Here, Ernest Mancoba (b. 1904) was a distinguished

[71] On Mancoba and the history of South African twentieth-century sculpture in general, see Rankin 1989, and Miles 1994.

[72] See Lindop 1988, and Spiro 1989.

[73] Sack 1991, p. 11, to which this section is much indebted.

pioneer. Because of his training at Grace Dieu, his earliest work is in his religious carvings for churches. But by 1934 he had turned to African themes after reading *Primitive Negro Sculpture* (1926) by Paul Guillaume (1891–1934) and Thomas Munro. Lippy Lipschitz (1903–1980), a Lithuanian sculptor living in Africa who had worked with Bourdelle in Paris, called his attention to the book. Guillaume was the Parisian dealer who began selling African sculpture in Paris as early as 1911 and was as responsible as anyone for the 1920s vogue of *l'art nègre*. Thomas Munro became a leading United States aesthetician. In the emergence of modern African art the edge was never far from the centre. Mancoba left for Paris in 1938, married the Danish sculptor Sonja Ferlov (1911–1985) and became a naturalised French citizen in 1961. His marriage to a white woman had made it impossible for him to return to South Africa. Through her he had contact with the Cobra group (1948–51) and explored automatism in his drawings.

Mancoba, Mohl and Sekoto provided models for a generation. When Sophiatown was gutted in accord with apartheid policy, their achievements helped to inspire the young artists who worked at Polly Street, Johannesburg, under the direction of Cecil Skotnes (b. 1926). After serving with the South African forces in Italy during World War II, Skotnes studied drawing under Heinrich Steiner in Florence. On his return he completed a fine arts B.A. at the University of Witwatersrand in 1950, then visited Europe again in 1951 and was deeply impressed by the work of Picasso and Moore.

The Polly Street Art Centre was established by white liberals working in the Johannesburg Committee for Non-European Adult Education acting in concert with the Johannesburg City Council. Skotnes, who had long developed a deep interest in African art, was appointed as its Cultural Recreation Officer in 1952 shortly after his return from Europe. Thenceforth black art became a vigorous plant. 'Skotnes was able to launch himself . . . and a number of other artists into successful lifelong art careers . . . to put the centre . . . in touch with an array of contacts including many foreign visitors and dealers, as well as to acquire commissions from the church and City Council.'[74] At that time a professional art training in universities and colleges was closed to black students.

Polly Street stimulated the 'Township' art that had originated in Sophiatown and also a 'neo-African' style in sculpture and graphics inspired by traditional African sculpture. Skotnes's own practice after 1953 began to be affected by traditional African sources from

[74] *ibid.*, p. 15.

which he created original, wood panels, colouring the gouged spaces. Egon Guenther, a German migrant and successful dealer in traditional African art, introduced him to the work of Willi Baumeister, who in Germany had himself been deeply influenced by traditional African art. Polly Street thus began a creative synthesis between European and traditional African art. It reached its height in the sculpture of Sydney Kumalo (1935–1988) and the powerful graphics of Feni Dumile (1939–1991), who became known as the 'Goya of the Townships'.[75] In 1963 Guenther launched the Amadlozi (Zulu: 'spirit of our fathers group'; 1963–65). It included Skotnes, Edoardo Villa (b. 1920), Cecily Sash (b. 1925), Giuseppe Cattaneo (b. 1929) and Sydney Kumalo, the sole black (Zulu) member of the group. It was Kumalo who suggested the group name.[76]

As a result of the tightening grip of apartheid the Polly Street Art Centre ceased to function in 1960. The work went on at the Jubilee Social Centre until Skotnes resigned in 1966. As it became illegal for blacks to live in the city of Johannesburg, there was no reason, it was said, for a black adult education facility to exist there.[77] It is not without significance that as social conditions in townships such as Soweto became more oppressive, the synthesis between a white European and black South African art that had been developing at Polly Street was called increasingly into question. So too was the sentiment of the Township art that expressed the poverty and destitution of black living conditions created largely for the white liberal market. The Black Consciousness movement led by Steve Biko regarded such attempts at synthesis as romanticism and most Township art as self-pitying sentimentality. The political situation hardened. After the assassination of Prime Minister Hendrik Verwoerd in September 1966, his successor B. J. Vorster, of the extreme right of the Nationalist party, tightened restrictions and the segregation of blacks. Biko's South African Students' Organisation (SASO), established in 1968, called for a campaign of 'consciousness raising' inspired by music, poetry and art that empowered the political struggle with a sense of affirmation and hope, an activist realism for liberation – a kind of unofficial, unbureaucratic, Socialist Realism.

But in 1973 most of the groups associated with Black

[75] Responding to an invitation from the University of California (UCLA) in 1978 led Dumile to settle in the United States where, like George Grosz before him, his output lost 'the searing social content of his earlier work' (Steven Sack, Dictionary 1996, vol. 9, p. 385).

[76] Lissoos 1986, pp. 49–52.

[77] On Polly Street, see Sack 1991, pp. 15–19; and Lissoos 1986, pp. 52–54.

Consciousness had been banned. When the Vorster Government sought to make Afrikaans the compulsory language in African schools the worst race riots in the history of South Africa erupted in Soweto in June 1976. Biko was arrested (for the third time) in July 1977 and after atrocious torture died in police custody. Such events were not without their effect upon black art.

But by that sad time the main centre for black art had become the rural Art and Craft Centre established by the Evangelical Lutheran Church at Rorke's Drift. It was created by a committee established in 1961 in Stockholm. Peder and Ulla Gowenius were sent out to start it. They trained local women to teach art and craft as a therapy. Work by tuberculosis patients at Ceza Mission hospital in Zululand raised 6,000 rand and was used to establish the Centre at Umpumulo. A year later it moved to Rorke's Drift. Work centred upon weaving and fabric printing and was sold both in South Africa and abroad. The sales covered much of the Centre's financial needs during the 1960s.

One of the TB patients at Ceza was Azaria Mbatha (b. 1941). Peder Gowenius taught him linocut techniques and he moved with the Centre to Rorke's Drift, where he drew designs illustrative of the history of Zululand suitable for fabrics. Around Mbatha there developed a significant school of print-makers using relief and intaglio techniques. In 1964 Mbatha won a scholarship that took him to the Konst Fack Art School in Stockholm (1965–67). He returned to teach for two years at Rorke's Drift but then returned to Sweden to study fine art and social science at the University of Lund. As his art became widely known it was normally presented as a striking example of 'African' art in keeping with the Formalesque preference for ethnic purity, rather than what it was, the work of a twentieth-century artist using his skills to record his own history and redeem his culture.[78] Rorke's Drift did much to raise the quality of craft work during the 1970s, but the status of its fine art section under apartheid became more dubious. The section was closed in 1982 and the importance and influence of Rorke's Drift diminished.

The 1976 Soweto riots created a new aesthetic climate that gave rise to a flood of pictorial imagery. Graffiti of all kinds appeared wherever a viable surface was available – the work of anonymous artists. A powerful political realism animated the art of Robert Hodgins (b. 1920) and Paul Stopforth (b. 1945). The human savagery of the late 1970s energised Hodgins into the creation of an art

[78] On this point, see Rosen 1993, pp. 9–22.

of the grotesque, absurd and ironic. Inspired by Alfred Jarry (1873–1907), the great forerunner of Dada, Surrealism and the Theatre of the Absurd of the 1950s, Hodgins created his own Ubu Roi series in his endeavour to cope with the contemporary situation.[79] Stopworth, working through the radical Market Gallery, Johannesburg, produced life-size figures, after the manner of the American sculptor George Segal (b. 1924), but evocative, in his case, of extreme alienation and suffering. They were followed by his *Interrogators* (1979), etchings worked with powdered graphite to simulate a sinister form of photography. His *Biko Series* was among the many works banned from being shown at the Valparaiso Biennial in 1981 by the official censorship of the Publications Control Board.[80]

In 1979 the State of Art in South Africa Conference was held at the Michaelis School of Fine Art, University of Cape Town. It called for a boycott of all State-sponsored exhibitions, requested 'all colleges and schools of art to be opened to all people in South Africa', and noted that it was 'the responsibility of each artist to work as diligently as possible to effect changes towards a post-apartheid society'.[81] The conference was both a cause and a symptom, and its effect was considerable. More community art centres were established and more black teachers were trained in existing colleges and university art departments. The Federated Union of Black Artists (FUBA) and the Johannesburg Art Foundation, established in 1982 in the studio of Bill Ainslie, both played an important role during the 1980s in training both black and white artists and art teachers.

In 1979 the Standard Bank of South Africa, recognising the growing international interest in black art and the value of investing in it, established its Foundation for African Art at the University of Witwatersrand, Johannesburg. First it sought for so-called authentic pieces of black art, that is art allegedly 'uncontaminated' by 'foreign' contact. Later it gave institutional recognition to the fact that blacks were creating art that not only related to their traditional tribal arts but also expressed their contemporary experience. Such art was described as 'transitional'. Of course no one had described Picasso's art as 'transitional' when he drew upon Iberian and African sculpture for inspiration. But, as Elizabeth Dell has

[79] On Hodgins, an Englishman who had migrated to Africa in 1938, see Berman 1993, pp. 310–13.
[80] A British Council scholarship made it possible for Stopforth to study at the Royal College of Art, London, during 1984–85. See Berman 1993, pp. 305–10.
[81] Sack 1991, p. 24.

noted, there was a valid reason for the term. It described a shift in patronage from the black communities for which traditional art was produced to the white Euro-African market for which the art, often described as 'tourist' art, was produced.[82]

The next significant move came in 1985 when Ricky Burnett curated the *Tributaries Exhibition*, sponsored by BMW (Bavarian Motor Works). After its initial exhibition in Johannesburg it toured in Germany. It sought a complete coverage of all South African art: urban white, urban black, rural traditional and rural transitional. The exhibition created a sensation and led to a better understanding of all African art as art in the special sense. It advanced a concept further promoted in the exhibition entitled *The Neglected Tradition: Towards a New History of South African Art (1930–1988)*, held at the Johannesburg Art Gallery from November 1988 to January 1989. Here for the first time the origins of contemporary black art in South Africa were presented historically by its curator, Steven Sack. In the catalogue, Sack reminded his readers that no firm distinction could be drawn between white and black art: 'there are too many parallels and reciprocities for the history of black art to be seen as a separate category of art'.[83]

Meanwhile the tightening grip of sanctions isolated South Africa from the international art community. Yet the social pressures of the time inspired the most productive and creative decade in the nation's art. The conventional categories of art were challenged more severely than ever. Burnett's *Tributaries Exhibition* brought to light the work of sculptors living in the northern Transvaal, most notably Jackson Hlungwani (b. 1923), a spiritual leader of his own sect who created his own new Jerusalem on a hilltop in northern Transvaal. The unquestionable originality of his work set the local art world the task of deciding whether it was looking at 'naive art', 'folk art', 'transitional art' or just good art. The political and spiritual intensity of the decade, in this case, produced masterpieces from both black and white South African artists the quality of which is still little known outside of South Africa. I am thinking of the work of Johannes Maswanganyi (b. 1949) and Nelson Mukhuba (1925–1987), Penelope Siopis[84] (b. 1953), Helen Sebedi (b. 1943), Bill Ainslee (1934–1989), Karel Nel (b. 1955), Gavin Younge (b. 1947) and Pippa Skotnes (b. 1957), among others.

From this brief survey it should be clear that, from the buildings

[82] Dell 1989, p. 45.
[83] Sack 1991, p. 7.
[84] On Siopis, see Rankin [n.d.].

of Martienssen and the paintings of Wenning, virtually all of modern South African art falls under the generic style of the Formalesque. This is not surprising. It was the Formalesque style that from its beginning held out the promise, for the first time, of a world art and a world vision that might grasp it. In its travail under apartheid the creative artists of South Africa, black and white, sought desperately for a vision that would transcend racial classifications. Nelson Mandela, like Martin Luther King, held fast to an ethical humanism and multicultural vision born of the Enlightenment, and held to it at a time when Adorno and 'critical theory', appalled by the Holocaust, and Foucault and his epigones, dejected by the failure of the 'revolution' of 1968, were calling humanism and the Enlightenment project into question. We need mention only one example, Penelope Siopis's brilliant collage, *Patience on a Monument: A History Painting* (1988).

Even from this brief survey it becomes clear that cultural imperialism is an imperialism of desire and aversion, or to be more specific (and oxymoronic), an imperialism of imposed desire and stimulated aversion. It is clear too that its reception differs markedly in different regions. But in all cases a first moment occurs before the second moment can be experienced. The region must be colonised by Renaissance and post-Renaissance art, art in the special sense, before the local arts, the arts in a general sense, can be seen and experienced as desirable 'art'. This move, we noted, is often instigated by Eurusan colonists, their descendants, or returning expatriates inspired by the Formalesque and its aesthetic, a style which they perceive as essentially European. Because of this there is sometimes a hiatus between the second and third moment of cultural imperialism. Picasso's position must be understood before it is possible to admire *contemporary* art produced by indigenous people. Only then is it possible for indigenous communities, black Africans, Amerindians, or Aboriginal people in Australia, to grasp the Formalesque as an expressive vehicle for the contemporary redemption of their own cultures.

Finally it must be noted that although the Formalesque style began to spread imperially throughout the world after World War I, its immanent drive towards abstraction, which was achieved in Europe before that war in the work of Malevich, Rodchenko and others and which achieved a powerful return in the work of Ad Reinhardt (to name but one) in the United States during the 1940s, did not achieve full recognition in Asian and settler societies, for economic, political, cultural and other reasons, until the 1960s. This, ironically, was the very decade when the dominance of

abstraction was being effectively challenged in Europe and the United States by Pop Art and critics like Leo Steinberg. This suggests that while the Formalesque, as a generic style, was received in non-European societies as a 'homecoming', its immanent Eurusan drive towards abstraction was not. The conversion of cultural particulars into aesthetic universals – the transvaluation of arts in the general sense into arts in the special sense (strategies in the complex process of cultural imperialism) – was strongly resisted in order to maintain a plurality of practice and a degree of independence for art and artists working beyond the limits of Eurusan aesthetic jurisdiction.

Conclusion

We noticed at the beginning how the imperial hubris that quickened Virginia Woolf's little party on the slopes of Pentelicus was sustained by a fatal attraction for those 'original figures which . . . have resisted time', and took it to be both sign and portent. For the ambitions of empire demand that the lives and lands of those who live beyond the boundaries of civilisation be identified and described. It is this need that generated a new kind of art, an art addressed not to the practical and spiritual needs of local cultures but one capable of describing the lives and lands of others.

Perhaps it is no accident that the first philosopher to make the distinction between such an art and art in the general sense was Aristotle, the tutor of Alexander, the creator of the Hellenistic Empire. It was, furthermore, Ptolemy (fl. AD 127–45) of Alexandria who first mapped the oecumene, and it was in the Hellenistic and Roman world that naturalism and realism, its less attractive twin, first entered the house of art as permanent, if irascible, tenants.

It was this use of art in the special sense, art as a naturalistic mimesis, that Italy inherited from the Hellenistic world and first, during the fifteenth century, conveyed to the Portuguese and Spanish then, later, to the Dutch, French and British in order to describe the empires they established beyond the Pillars of Hercules – by means of maps, topographies and landscapes. There they also found the original figures that resist time, as enticing as the songs the Sirens sang to Ulysses bound to his mast. For over four centuries, from the fifteenth to the end of the nineteenth, Europe, like Ulysses, resisted the temptations of art in the general sense and remained faithful to the naturalism that had served it so well in the creation of its scientific and geographic projects. Then with the world discovered, mapped and partitioned, the long resistance to those who resist time could not be sustained. Europe returned to the art of its ancestors, to art in the general sense, and tried to begin again from the beginning.

That attempt constitutes the history of the Formalesque. It is the history of a universalising theory and practice that became in its final phase an imperialising project. It begins with the endeavour made by European historians and philosophers to isolate the

invariable factor in art. They found it in style and reduced style to form. It is also the history of European art practice as it succumbs to the exotic. It rejected the beauty of Aphrodite as reconstructed and cosmeticised by the nineteenth-century academy. The way was thus opened to admire not one but many beauties, to admire the unrestrained diversity of art in the general sense, world-wide, rather than conform to a classical ideal of beauty no longer considered relevant. Yet the old loyalty to the Grecian ideal lingered. As the Formalesque institutionalised itself during the 1920s, it transformed the exotic into a new kind of universal beauty by discarding the naturalistic mode upon which the Grecian original had been grounded. Though style became form and form became a system of abstract relationships, the Greek ideal was reconstituted in the fashion described by Plato and in the *Philebus*; 'the beauty of the straight line, the circle and the plane and solid figures formed from these'. For such a beauty could be found in the arts of all the cultures of the world, of art, that is to say, in the general sense. So it was that the Formalesque held out the promise of a new kind of global beauty as it appropriated indigenous cultures to its universalising aesthetic.

The Formalesque style, though universalist in its ambitions from the beginning, did not develop as an effective imperialising project beyond Europe until it was institutionalised during the 1920s. Here the history of twentieth-century art in Japan and South Africa has been surveyed briefly as typical case-studies of this project and a theory of cultural imperialism (that remains to be tested against other situations) advanced.

After World War II, when its dynamic centre shifted to New York, the Formalesque developed a syncretic Eurusan mode which embraced the advanced art of the United States and Europe. It experimented particularly in hybrid forms of art far removed from the trio originally sanctified by Alberti: architecture, sculpture and painting. In this way the twentieth century may be seen as a strobe-lit theatre in which the dialectic interaction of art in the special and the general sense was continuously played out throughout the world.

The basic energy behind these incessant interactions was provided by the resistance that developed against the universalising, imperialising practices of the Formalesque as it institutionalised itself after World War I, a resistance that came originally from Dada, Surrealism and the Neue Sachlichkeit. It took the form of an engagement with the Formalesque in which all four were radically transformed in the process. Out of this engagement has emerged

the hybridised, fragmented art of the so-called postmodern world. But Postmodernism is nothing but the mask which twentieth-century modernism adopted in its struggle with the institutional-ised Formalesque. It is high time that it was recognised for what it is: a twentieth-century modernism galvanised into action by the new face of Modernity revealed during the Great War of 1914–18.

References cited

Abrams 1953 M. H. Abrams. *The Mirror and the Lamp: Romantic Theory and the Critical Tradition*, New York, Oxford University Press, 1953

Adam 1940 Leonard Adam. *Primitive Art*, Harmondsworth, Penguin Books, 1940

Ades 1989 Dawn Ades. *Art in Latin America: The Modern Era, 1820–1980*, New Haven and London, Yale University Press, 1989

Ades 1993 Dawn Ades. 'Surrealism as Art', in *Surrealism: Revolution by Night*, Canberra, National Gallery of Australia, 1993

Adorno 1984 Theodor W. Adorno. *Aesthetic Theory*, trans. C. Lenhardt, London and New York, Routledge and Kegan Paul, 1984 (originally published in German in 1970)

Adorno 1990 Theodor W. Adorno. *Negative Dialectics*, trans. E. B. Ashton, London, Routledge and Kegan Paul, 1990 (originally published in German in 1966)

Andrews 1964 Keith Andrews. *The Nazarenes: A Brotherhood of German Painters in Rome*, Oxford, Clarendon Press, 1964

Apollinaire 1960 Guillaume Apollinaire. *Chroniques d'art (1902–1918)*, Paris, Gallimard, 1960

Apollinaire 1972 Guillaume Apollinaire. *Apollinaire on Art: Essays and Reviews, 1902–1918*, ed. Leroy C. Breunig, trans. Susan Suleiman, London, Thames and Hudson, 1972

Arnason 1968 H. H. Arnason. *History of Modern Art: Painting, Sculpture, Architecture*, Englewood Cliffs, N.J., Prentice-Hall, and New York, Harry N. Abrams, 1968

Ashton 1972 Dore Ashton. *Picasso on Art: A Selection of Views*, London, Thames and Hudson, 1972

Assouline 1990 Pierre Assouline. *An Artful Life: A Biography of D. H. Kahnweiler, 1884–1979*, New York, International Publishing Company, 1990

Auerbach 1953 Erich Auerbach. *Mimesis: The Representation of Reality in Western Literature*, trans. W. R. Trask, Princeton, Princeton University Press, 1953

Baer 1991 Nancy Van Norman Baer. *Theatre in Revolution: Russian Avant-Garde Stage Design, 1913–1935*, The Fine Arts Museums of San Francisco, and London, Thames and Hudson, 1991

Banham 1960 Reyner Banham. *Theory and Design in the First Machine Age*, London, Architectural Press, 1960

Barbican 1991
Barbican Art Gallery (London) and the Setagaya Art Museum (Tokyo). *Japan and Britain: An Aesthetic Dialogue, 1850–1930*, London, Lund Humphries, 1991

Barr 1936
A. H. Barr, Jr. *Cubism and Abstract Art*, New York, Museum of Modern Art, 1936

Barr 1951
Alfred H. Barr, Jr. *Matisse: His Art and His Public*, New York, Museum of Modern Art, 1951

Barrell 1986
John Barrell. *The Political Theory of Painting from Reynolds to Hazlitt*, New Haven and London, Yale University Press, 1986

Barthes 1968
Roland Barthes. *Elements of Semiology*, trans. A. Lavers and C. Smith, New York, Hill and Wang, 1968

Barthes 1984
Roland Barthes. *Image, Music, Text*, trans. S. Heath, London, Fontana, 1984

Bate 1971
W. Jackson Bate. *The Burden of the Past and the English Poet*, London, Chatto and Windus, 1971

Battcock 1969
Gregory Battcock, ed. *Minimal Art: A Critical Anthology*, London, Studio Vista, 1969

Battiss 1939
Walter Battiss. *The Amazing Bushman*, Pretoria, Red Fawn, 1939

Bauhaus 1959
Bauhaus, 1919–1928, ed. Herbert Bayer, Walter Gropius and Ise Gropius, Boston, Charles T. Brantford, 1959

Beasley 1995
W. G. Beasley. *Japan Encounters the Barbarian: Japanese Travellers in America and Europe*, New Haven and London, Yale University Press, 1995

Bell-Villada 1996
Gene H. Bell-Villada. *Art for Art's Sake and Literary Life: How Politics and Markets Helped Shape the Ideology and Culture of Aestheticism, 1790–1990*, Lincoln, Neb., and London, University of Nebraska Press, 1996

Benjamin 1973
Walter Benjamin. *Illuminations*, ed. Hannah Arendt, trans. H. Zohn, London, Collins Fontana, 1973

Benjamin 1993
Roger Benjamin. 'The Decorative Landscape: Fauvism and the Arabesque of Observation', *Art Bulletin* 75, no. 2 (June 1993), pp. 295–316

Berger 1969
John Berger. *Art and Revolution: Ernst Neizvestny and the Role of the Artist in the USSR*, Harmondsworth, Penguin Books, 1969

Berman 1993
E. Berman. *Painting in South Africa*, Johannesburg, Southern Book Publishers, 1993

Blavatsky 1987
H. P. Blavatsky. *The Key to Theosophy*, Pasadena, Calif., Theosophical University Press, 1987

Bletter 1981
M. Haag Bletter. 'The Interpretation of the Glass Dream: Expressionist Architecture and the History of the Crystal Metaphor', *Journal of the Society of Architectural Historians* 40 (March 1981), pp. 23–31

Bloom 1973 Harold Bloom. *The Anxiety of Influence*, New York
 and London, Oxford University Press, 1973

Blunt 1973 Anthony Blunt. 'From Bloomsbury to Marxism',
 Studio International 186 (Nov. 1973), pp. 164–68

Blunt & Pool 1962 A. Blunt and P. Pool. *Picasso: The Formative Years:
 A Study of His Sources*, London, Studio Books,
 1962

Boas 1955 Franz Boas. *Primitive Art*, New York, Dover
 Publications, 1955 (originally published in 1927)

Boime 1971 Albert Boime. *The Academy and French Painting in
 the Nineteenth Century*, London and New York,
 Phaidon Press, 1971

Bourdieu 1993 Pierre Bourdieu. *The Field of Cultural Production:
 Essays on Art and Literature*, ed. Randal Johnson,
 Cambridge, Polity Press, 1993

Bourdieu 1996 Pierre Bourdieu. *The Rules of Art: Genesis and
 Structure of the Literary Field*, trans. Susan
 Emanuel, Cambridge, Polity Press, 1996 (original
 French edn, *Les Règles de l'art*, Paris, Éditions de
 Seuil, 1992)

Bowlt 1986 John E. Bowlt. 'Esoteric Culture and Russian
 Society', in Weisberger 1986

Bown 1991 Matthew Cullerne Bown. *Art under Stalin*,
 Oxford, Phaidon Press, 1991

Brandes 1963 G. Brandes. *Michelangelo: His Life, His Times, His
 Era*, trans. H. Norden, London, Constable, 1963

Braun 1990 Emily Braun. 'Political Rhetoric and Poetic
 Irony: The Uses of Classicism in the Art of
 Fascist Italy', in Cowling & Mundy 1990

Breton 1936 André Breton. *What is Surrealism?* trans. David
 Gascoigne, London, Faber and Faber, 1936

Breton 1972 André Breton. *Manifestoes of Surrealism*, trans.
 Richard Seaver and Helen R. Lane, Ann Arbor,
 University of Michigan Press, 1972

Bridgestone 1991 Bridgestone Museum of Art (Tokyo). *Ishibashi
 Foundation: Masterpieces from the Collection*, Tokyo,
 Ishibashi Foundation, 1991

Bromfield 1987 David Bromfield. 'Japanese Art: Monet and the
 Formation of Impressionism: An Enquiry into
 Some Conditions of Cultural Exchange and
 Appropriation in Later Nineteenth-Century
 European Art', paper given at the Conference on
 Europe and the Exotic, Humanities Research
 Centre, Australian National University,
 Canberra, 1987

Brook 1975 Donald Brook. 'Flight from the Object', in Smith
 1975

Broude 1990 Norma Broude, ed. *World Impressionism: The
 International Movement, 1860–1920*, New York,
 Harry N. Abrams, 1990

Broude & Garrard 1994 Norma Broude and Mary D. Garrard, eds. *The
 Power of Feminist Art: Emergence, Impact and*

Triumph of the American Feminist Art Movement, London, Thames and Hudson, 1994

Bryson 1983 Norman Bryson. *Vision and Painting: The Logic of the Gaze*, London, Macmillan, 1983

Bryson 1984 Norman Bryson. *Tradition and Desire: From David to Delacroix*, Cambridge, Cambridge University Press, 1984

Buci-Glucksmann 1980 Christine Buci-Glucksmann. *Gramsci and the State*, trans. David Fernbach, London, Lawrence and Wishart, 1980

Bullough 1957 E. Bullough. 'Psychical Distances as a Factor in Art and an Aesthetic Principle', in his *Aesthetics: Lectures and Essays*, ed. Elizabeth Wilkinson, London, Bowes, 1957

Bunten 1990 Bunten Exhibition (Tokyo). *Masterpieces from the Bunten Exhibition, 1907–1918*, National Museum of Modern Art, Tokyo, 18 May–8 July 1990

Bürger 1984 Peter Bürger. *Theory of the Avant-Garde*, trans. M. Shaw, Minneapolis, University of Minnesota Press, 1984

Canaday 1962 John Canaday. *Embattled Critic: Views on Modern Art*, New York, Noonday Press, 1962

Cheetham 1991 Mark A. Cheetham. *The Rhetoric of Purity: Essentialist Theory and the Advent of Abstract Painting*, Cambridge, Cambridge University Press, 1991

Cheney 1934 Sheldon Cheney. *Expressionism in Art*, New York, Liveright, 1934

Chipp 1968 Herschel B. Chipp. *Theories of Modern Art: A Source Book by Artists and Critics*, Berkeley and Los Angeles, University of California Press, 1968

Clark 1949 Kenneth Clark. *Landscape into Art*, London, John Murray, 1949

Clark 1962 Kenneth Clark. *The Gothic Revival: An Essay in the History of Taste*, London, John Murray, 1962

Clark 1986 John Clark. 'Modernity in Japanese Painting', *Art History* 9, no. 2 (June 1986), pp. 213–31

Clarke 1992 David Clarke. 'The Gaze and the Glance: Competing Understandings of Visuality in the Theory and Practice of Late Modernist Art', *Art History* 15, no. 1 (March 1992), pp. 80–98

Clifford 1988 James Clifford. *The Predicament of Culture: Twentieth-Century Ethnography, Literature, and Art*, Cambridge, Mass., and London, Harvard University Press, 1988

Coetzee 1992 N. J. Coetzee. *Pieneef, Land and Landscape: The Johannesburg Station Panels in Context*, Johannesburg Art Gallery, and Johannesburg, C.B.M. Publishing, 1992

Compton 1974 Susan Compton. 'Malevich and the Fourth Dimension', *Studio International* 187 (April 1974), pp. 190–95

Conant 1991 Ellen P. Conant. 'Refractions of the Rising Sun:
 Japan's Participation in International
 Exhibitions, 1862–1910', in Barbican 1991, pp.
 79–92

Contreras 1983 Belisario R. Contreras. *Tradition and Innovation in
 New Deal Art*, Lewisburg, Penn., Bucknell
 University Press (London and Toronto,
 Associated University Presses), 1983

Cork 1994 Richard Cork. *A Bitter Truth: Avant-Garde Art and
 the Great War*, New Haven and London, Yale
 University Press, 1994

Cottingham 1994 Laura Cottingham. 'The Feminist Continuum:
 Art after 1970', in Broude & Garrard 1994

Cowling & Mundy 1990 E. Cowling and J. Mundy. *On Classic Ground:
 Picasso, Léger, De Chirico and the New Classicism,
 1910–1930*, London, Tate Gallery, 1990

Crary 1988 Jonathan Crary. 'Modernising Vision', in *Vision
 and Visuality*, ed. Hal Foster, Seattle, Bay Press,
 1988

Crowther 1993 Paul Crowther. *Critical Aesthetics and
 Postmodernism*, Oxford, Clarendon Press, 1993

Culler 1983 Jonathan Culler. *On Deconstruction: Theory and
 Criticism after Structuralism*, London, Routledge
 and Kegan Paul, 1983

Dahrouch 1993 Abdelali Dahrouch. 'The Neglected Side: Matisse
 and Eurocentrism', *Third Text* 24 (Autumn
 1993), pp. 13–14

D'Avennes 1989 Prisse d'Avennes. *The Decorative Art of Arabia*,
 with text by Jules Bourgoin and foreword by
 Charles Newton, London, Studio Editions, 1889

Davenport-Hines 1995 Richard Davenport-Hines. *Auden*, London,
 William Heinemann, 1995

De Guttry & Maino 1995 Irene de Guttry and Maria Paolo Maino. 'Forging
 Modern Italy: From Wrought Iron to
 Aluminium', in Kaplan 1995

Dell 1989 Elizabeth Dell. 'Transitional Sculpture', in
 Catalogue: Ten Years of Collecting, 1979–1989, ed. D.
 H. Tooke and A. Nettleton, Johannesburg,
 University of Witwatersrand, 1989, p. 45

Derrida 1987 Jacques Derrida. *Of Grammatology*, trans. G. C.
 Spivak, Baltimore and London, Johns Hopkins
 Press, 1976 (original French edn, *De La
 Grammatologie*, 1967)

Derrida 1987 Jacques Derrida. *The Truth in Painting*, trans.
 G. Bennington and I. McLeod, Chicago and
 London, University of Chicago Press, 1987

Dickstein 1977 Morris Dickstein. *Gates of Eden: American Culture
 in the Sixties*, New York, Basic Books, 1977

Dictionary 1996 *Dictionary of Art*, ed. Jane Turner, 34 vols.,
 London, Macmillan, 1996

Douglas 1986 Charlotte Douglas. 'Beyond Reason: Malevich,
 Matiushin, and Their Circles', in Weisberger
 1986

Duchamp 1975 Marcel Duchamp. 'Where do we go from here?' *Studio International* 189, no. 973 (Jan.–Feb. 1975), p. 28 (quoted from Symposium at the Philadelphia Museum College of Art, March 1961)

Eagleton 1990 Terry Eagleton. *The Ideology of the Aesthetic*, Oxford, Blackwell, 1990

Egbert 1967 Donald Drew Egbert, *Socialism and American Art in the Light of European Utopianism, Marxism and Anarchism*, Princeton, Princeton University Press, 1967

Egbert 1970 Donald Drew Egbert. *Social Radicalism and the Arts*, London, Gerald Duckworth, 1970

Erlich 1955 Victor Erlich. *Russian Formalism: History – Doctrine*, The Hague, Mouton, 1955

Fant 1986 Aka Fant. 'The Case of the Artist Hilma af Klint', in Weisberger 1986

Farr 1978 Dennis Farr. *English Art, 1870–1940*, Oxford, Clarendon Press, 1978

Favola 1984 Ramon Favola. *Diego Rivera: The Cubist Years*, Phoenix, Phoenix Art Museum, 1984

Feher 1983 Ferenc Feher. 'Lukács in Weimar', in Heller 1983

Fenollosa 1912 E. P. Fenollosa. *Epochs of Chinese and Japanese Art*, 2 vols., London, William Heinemann, 1912

Fischer 1969 Ernst Fischer. *Art Against Ideology*, Harmondsworth, Penguin Books, 1969

Flam 1973 Jack D. Flam. *Matisse on Art*, Oxford, Phaidon Press, 1973

Freeman 1983 Derek Freeman. *Margaret Mead and Samoa: The Making and Unmaking of an Anthropological Myth*, Cambridge, Mass., Harvard University Press, and Canberra, Australian National University Press, 1983

Freeman 1996 Derek Freeman. 'The debate, at heart, is about evolution', in *The Certainty of Doubt: Tributes to Peter Munz*, ed. M. Fairbairn and W. H. Oliver, Wellington, Victoria University Press, 1996

Freud 1953 Sigmund Freud. *The Standard Edition of the Complete Psychological Works of Sigmund Freud*, 24 vols., ed. James Strachey, London, Hogarth Press, 1953

Fry 1937 R. Fry. *Vision and Design*, Harmondsworth, Penguin Books, 1937 (originally published in the *Athenaeum*, 1920)

Gee 1979 Malcolm Gee. 'The Avant-Garde, Order and the Art Market, 1916–1923', *Art History* 2, no. 1 (March 1979), pp. 95–106

Geertz 1983 Clifford Geertz. *Local Knowledge: Further Essays in Interpretative Anthropology*, New York, Basic Books, 1983

Geist 1984 S. Geist. 'Brancusi', in *'Primitivism' in Twentieth Century Art*, 2 vols., ed. W. S. Rubin, New York, Museum of Modern Art, 1984

Gibbons 1981 Tom Gibbons. 'Cubism and the "Fourth Dimension" in the Context of the Late Nineteenth-Century and Early Twentieth-Century Revival of Occult Idealism', *Journal of the Warburg and Courtauld Institutes* 44 (1981), pp. 130–47

Gibbons 1988 Tom Gibbons. 'British Abstract Painting of the 1860s: The Spirit Drawings of Georgiana Houghton', *Modern Painters* 1, no. 2 (Summer 1988), pp. 33–37

Giddens 1991 Anthony Giddens. *The Consequences of Modernity*, Cambridge, Polity Press, 1991

Giedion 1959 S. Giedion. *Space, Time and Architecture: The Growth of a New Tradition*, Cambridge, Mass., Harvard University Press, 1959

Golan 1995 Romy Golan. *Modernity and Nostalgia: Art and Politics in France Between the Wars*, New Haven and London, Yale University Press, 1995

Golding 1954 John Golding. *Cubism: A History and an Analysis, 1907–1914*, London, Faber, 1954

Golding 1975 John Golding. 'The Black Square', *Studio International* 189 (March/April 1975), pp. 96–106

Goldwater 1979 Robert Goldwater. *Symbolism*, London, Allen Lane, 1979

Goldwater 1986 Robert Goldwater. *Primitivism in Modern Art*, 2nd enl. edn, Cambridge, Mass., and London, Harvard University Press, 1986 (originally published in 1938)

Gombrich 1955 *and* **1989** E. H. Gombrich. *The Story of Art*, 7th edn, London, Phaidon Press, 1955; 15th edn, Oxford, Phaidon Press, 1989

Gombrich 1960 E. H. Gombrich. *Art and Illusion: A Study in the Psychology of Pictorial Representation*, New York, Pantheon Books, 1960

Gombrich 1970 E. H. Gombrich. *Aby Warburg: An Intellectual Biography*, London, Warburg Institute, 1970

Gombrich 1979 E. H. Gombrich. *The Sense of Order: A Study in the Psychology of Decorative Art*, Oxford, Phaidon Press, 1979

Gombrich 1989 *see* **Gombrich 1955**

Gombrich & Eribon 1993 Ernst Gombrich and Didier Eribon. *Looking for Answers*, New York, Harry N. Abrams, 1993

Goodyear 1943 A. C. Goodyear. *The Museum of Modern Art: The First Ten Years*, New York, 1943

Gray 1962 Camilla Gray. *The Russian Experiment in Art, 1863–1922*, London, Thames and Hudson, 1962

Green 1976 Christopher Green. *Léger and the Avant-Garde*, New Haven and London, Yale University Press, 1976

Green 1987

Christopher Green. *Cubism and Its Enemies: Modern Movements and Reaction in French Art, 1916–1928*, New Haven and London, Yale University Press, 1987

Greenberg 1986

Clement Greenberg. *The Collected Essays and Criticism*, vols. 1–4, ed. John O'Brien, Chicago and London, University of Chicago Press, 1986

Guilbaut 1983

S. Guilbaut. *How New York Stole the Idea of Modern Art: Abstract Expressionism, Freedom, and the Cold War*, trans. A. Goldhammer, Chicago and London, University of Chicago Press, 1983

Gulbenkian 1964

Calouste Gulbenkian Foundation. *Painting and Sculpture of a Decade, 1954–1964*, London, Tate Gallery, April–June 1964

Habermas 1990

Jurgen Habermas. *The Philosophical Discourse of Modernity: Twelve Lectures*, trans. F. Lawrence, Cambridge, Polity Press, 1990

Halbfess 1988

Wilhelm Halbfess. *India and Europe: An Essay in Understanding*, Albany, State University Press of New York, 1988

Harrison & Wood 1992

Charles Harrison and Paul Wood, eds. *Art in Theory, 1900–1990: An Anthology of Changing Ideas*, Oxford, Blackwell, 1992

Harrison, Frascina & Perry 1993

Charles Harrison, Francis Frascina and Gill Perry. *Primitivism, Cubism, Abstraction: The Early Twentieth Century*, New Haven and London, Yale University Press, 1993

Hart 1995

Lynn M. Hart. 'Three Walls: Regional Aesthetics and the International Art World', in *The Traffic in Culture: Refiguring Art and Anthropology*, ed. George E. Marcus and Fred R. Myers, Berkeley and London, University of California Press, 1995, pp. 127–50

Haskell & Penny 1981

Francis Haskell and Nicholas Penny. *Taste and the Antique: The Lure of Classical Sculpture, 1500–1900*, New Haven and London, Yale University Press, 1981

Hassan 1982

Ihab Hassan. *The Dismemberment of Orpheus: Toward a Postmodern Literature*, 2nd edn rev., Madison, University of Wisconsin Press, 1982

Hassan 1987

Ihab Hassan. *The Postmodern Turn: Essays in Postmodern Theory and Culture*, Columbus, Ohio State University Press, 1987

Havell 1911

E. B. Havell. *The Ideals of Indian Art*, London, John Murray, 1911

Hayward 1995

Hayward Gallery (London). *Art and Power: Europe Under the Dictators, 1930–1945*, London, Hayward Gallery, 1995

Hegel 1975

G. W. F. Hegel. *Aesthetics: Lectures on Fine Art*, 2 vols., trans. T. M. Knox, Oxford, Clarendon Press, 1975

Heller 1983

Agnes Heller, ed. *Lukács Reappraised*, New York, Columbia University Press, 1983

Henderson 1971 Linda Dalrymple Henderson. 'The Fourth
 Dimension and Non-Euclidean Geometry
 Reinterpreted', *Art Quarterly* 34 (Winter 1971),
 pp. 410–33

Henderson 1983 Linda Dalrymple Henderson. *The Fourth
 Dimension and Non-Euclidean Geometry in Modern
 Art*, Princeton, Princeton University Press, 1983

Heron 1971 Patrick Heron, letter in *Studio International* 183,
 no. 937 (Oct. 1971), p. 124

Heskett 1995 John Heskett. 'Design in Inter-War Germany', in
 Kaplan 1995

Hildebrand 1932 Adolf Hildebrand. *The Problem of Form in Painting
 and Sculpture*, trans. Max Meyer and Robert
 Morris Ogden, New York, Stechert, 1932

Hillier 1968 Bevis Hillier. *Art Deco of the 20s and 30s*, London,
 Herbert Press, 1968

Hinz 1980 Berthold Hinz. *Art in the Third Reich*, Oxford,
 Blackwell, 1980

Hirschfeld-Mack 1963 Ludwig Hirschfeld-Mack. *The Bauhaus: An
 Introductory Survey*, Melbourne, Longmans, Green
 and Co., 1963

Hitchcock 1958 Henry-Russell Hitchcock. *Architecture: Nineteenth
 and Twentieth Centuries*, Harmondsworth, Penguin
 Books, 1958

Hitchcock 1959 Henry-Russell Hitchcock. 'Art Nouveau
 Architecture', in *Art Nouveau: Art and Design at
 the Turn of the Century*, ed. Peter Selz, New York,
 Museum of Modern Art, 1959, pp. 122–47

Hobsbawm 1995 E. Hobsbawm. *Age of Extremes: The Short Twentieth
 Century, 1914–1991*, London, Abacus, 1995

Hogarth 1955 William Hogarth. *The Analysis of Beauty*, ed.
 Joseph Burke, Oxford, Clarendon Press, 1955
 (originally published in 1753)

Hughes 1990 Robert Hughes. *Nothing If Not Critical: Selected
 Essays on Art and Artists*, London, Collins Harvill,
 1990

Huyghe 1963 René Huyghe. *Delacroix*, trans. Jonathan Griffin,
 London, Thames and Hudson, 1963

Irwin 1979 David Irwin. *John Flaxman, 1755–1826: Sculptor,
 Illustrator, Designer*, London, Cassell, 1979

Iverson 1993 Margaret Iverson. *Alois Riegl: Art History and
 Theory*, Cambridge, Mass., MIT Press, 1993

Jacobs 1961 Jane Jacobs. *The Death and Life of Great American
 Cities*, New York, Random House, 1961

Jameson 1971 Frederic Jameson. *Marxism and Form: Twentieth-
 Century Dialectical Theories of Literature*, Princeton,
 Princeton University Press, 1971

Jameson 1984 Frederic Jameson. 'Postmodernism, or the
 Cultural Logic of Late Capitalism', *New Left
 Review* 146 (1984), pp. 53–92

Jay 1994 Martin Jay. *Downcast Eyes: The Denigration of
 Vision in Twentieth-Century French Thought*,

Berkeley, Los Angeles and London, University of California Press, 1994

Jay & Young 1972 Karla Jay and Allen Young. *Out of the Closet: Voices of Gay Liberation*, New York, World Publishing, 1972

Jones 1856 Owen Jones. *The Grammar of Ornament*, London, Day and Son, 1856

Jones 1895 H. Stuart Jones, ed. *Select Passages from Ancient Writers Illustrative of the History of Greek Sculpture*, London and New York, Macmillan, 1895

Kamakura 1988 Museum of Modern Art, Kamakura. *Dada and Constructivism*, Tokyo, Tokyo Shimbun, 1988

Kandinsky 1889 Wassily Kandinsky. 'From Materials on the Ethnography of the Sysol- and Vechegda-Zyrians: The National Dieties (According to Contemporary Beliefs)', *Etnograficheskoe Obozrenie* (Ethnographic Review) 3 (1889), pp. 102–10

Kandinsky 1955 Wassily Kandinsky. *Concerning the Spiritual in Art*, trans. Michael Sadleir, New York, Wittenborn, 1955 (originally published in German in 1912)

Kant 1952 Immanuel Kant. *The Critique of Judgement*, trans. J. C. Meredith, Oxford, Clarendon Press, 1952

Kaplan 1995 Wendy Kaplan, ed. *Designing Modernity: The Arts of Reform and Persuasion, 1885–1945: Selections from the Wolfsonian*, Miami and London, Thames and Hudson, 1995

Kaufmann 1971 Walter Kaufmann, ed. *The Portable Nietzsche*, London, Chatto and Windus, 1971

Kawakita 1974 Michiaki Kawakita. *Modern Currents in Japanese Art*, trans. Charles S. Terry, New York, Weatherhill, and Tokyo, Heibonsha, 1974

Kemp 1981 Martin Kemp. *Leonardo da Vinci: The Marvellous Works of Nature and Man*, London, J. M. Dent, 1981

Kishimoto 1967 Kishimoto Hideo. 'Some Japanese Cultural Traits and Religions', in *The Japanese Mind: Essentials of Japanese Philosophy and Culture*, ed Charles A. Moore, Honolulu, University of Hawaii Press, 1967

Kitching 1988 Gavin Kitching. *Karl Marx and the Philosophy of Praxis*, London, Routledge and Kegan Paul, 1988

Kockel 1995 Ullrich Kockel. 'The Celtic Quest: Beuys as Hero and the Hedge School Master', in Thistlewood 1995

Krauss 1986 Rosalind E. Krauss. *The Originality of the Avant-Garde and Other Modernist Myths*, Cambridge, Mass., MIT Press, 1986

Kuhn 1962 Thomas S. Kuhn. *The Structure of Scientific Revolutions*, Chicago and London, University of Chicago Press, 1962

Kuklick 1984 Henrika Kuklick. 'Tribal Exemplars: Images of Political Authority in British Anthropology, 1885–1945', in Stocking 1984a

Lasch 1967 Christopher Lasch. 'The Cultural Cold War', *The Nation* (1 Sept. 1967), pp. 198–212

Leja 1993 Michael Leja. *Reframing Abstract Expressionism: Subjectivity and Painting in the 1940s*, New Haven and London, Yale University Press, 1993

Levin 1988 Kim Levin. *Beyond Modernism: Essays on Art from the 70s and 80s*, New York, Harper and Row, 1988

Levitine 1978 George Levitine. *The Dawn of Bohemianism: The Barbus Rebellion and Primitivism in Neoclassical France*, University Park, Pennsylvania State University Press, 1978

LeWitt 1967 Sol LeWitt. 'Paragraphs on Conceptual Art', *Art Forum* 5, no. 10 (1967), pp. 79–83

Lindop 1988 Barbara Lindop. *Gerard Sekoto*, Johannesburg, Randburg, 1988

Lindsay 1966 Jack Lindsay. *J. M. W. Turner: His Life and Work: A Critical Biography*, London, Cory, Adams and Mackay, 1966

Lindsay 1975 Jack Lindsay. *William Morris: His Life and Work*, New York, Taplinger, 1975

Lippard 1976 Lucy Lippard. *From the Center: Feminist Essays on Women's Art*, New York, Dutton, 1976

Lissoos 1986 Sheree Lissoos. *Johannesburg Art and Artists: Selections from a Century*, Johannesburg, Johannesburg Art Gallery, 1986

Listowel 1933 Earl of Listowel. *A Critical History of Modern Aesthetics*, London, Allen and Unwin, 1933

Lloyd 1991 Jill Lloyd. *German Expressionism, Primitivism and Modernity*, New Haven and London, Yale University Press, 1991

Lloyd, Gott & Chapman 1993 M. Lloyd, T. Gott and C. Chapman. *Surrealism: Revolution by Night*, Canberra, National Gallery of Australia, 1993

Lodder 1983 Christina Lodder. *Russian Constructivism*, New Haven and London, Yale University Press, 1983

Logan 1950 Frederick Logan. 'Kindergarten and Bauhaus', *College Art Journal* 10, no. 1 (Fall 1950), pp. 36–43

Long 1986 Rose-Carol Washton Long. 'Expressionism, Abstraction, and the Search for Utopia in Germany', in Weisberger 1986

Lucic 1991 Karen Lucic. *Charles Sheeler and the Cult of the Machine*, London, Reaktion Press, 1991

Lukács 1963 George Lukács. *The Meaning of Contemporary Realism*, trans. John and Necke Mander, London, Merlin Press, 1963

Lukács 1971 George Lukács. *History and Class Consciousness: Studies in Marxist Dialectics*, trans. R. Livingstone, London, Merlin Press, 1971

Lukács 1972 Lukács, G. *Studies in European Realism*, London, Merlin Press, 1972

McQueen 1979 Humphrey McQueen. *The Black Swan of Trespass*, Sydney, Alternative Publishing Cooperative, 1979

Marcuse 1978 Herbert Marcuse. *The Aesthetic Dimension: Towards a Critique of Marxist Aesthetics*, Boston, Beacon Press, 1978 (originally published in German in 1977)

Marquis 1989 Alice Goldfarb Marquis. *Alfred H. Barr, Jr, Missionary for the Modern*, Chicago and New York, Contemporary Books, 1989

Martin 1968 Marianne W. Martin. *Futurist Art and Theory, 1909–1915*, Oxford, Clarendon Press, 1968

Matejka & Pomorska 1978 L. Matejka and K. Pomorska, eds. *Readings in Russian Poetics: Formalist and Structuralist Views*, Ann Arbor, University of Michigan Press, 1978

Medvedev & Bakhtin 1978 P. N. Medvedev and M. M. Bakhtin. *The Formal Method in Literary Scholarship*, trans. Albert J. Wehrle, Baltimore, Johns Hopkins University Press, 1978

Miles 1994 Elsa Miles. *Lifeline Out of Africa: The Art of Ernest Mancoba*, Capetown, Human and Rousseau, 1994

Milner 1966 John Milner. *Kazimir Malevich and the Art of Geometry*, New Haven and London, Yale University Press, 1996

Mitchell 1974 Charles Mitchell. 'Very Like a Whale: The Spectator's Role in Modern Art', in Smith 1974

Mitchell 1989 W. J. T. Mitchell. 'Ut Pictura Theoria: Abstract Painting and the Repression of Language', *Critical Inquiry* 15, no. 2 (Winter 1989), pp. 348–71

Mitchell 1994 W. J. T. Mitchell. 'Imperial Landscape', in his (ed.) *Landscape and Power*, Chicago, University of Chicago Press, 1994, pp. 5–34

Mitsugu 1958 Hisatomi Mitsugu. 'Ernst F. Fenollosa and Japanese Art', *Japan Quarterly* 5 (1958), pp. 307–14

Mitter 1977 Partha Mitter. *Much Maligned Monsters: History of European Reactions to Indian Art*, Oxford, Clarendon Press, 1977

Mizusawa 1988 Tsutomu Mizusawa. 'Japanese Dada and Constructivism: Aspects of the Early 1920s', in Kamakura 1988

Moffitt 1986 John F. Moffitt. 'Marcel Duchamp: Alchemist of the Avant-Garde', in Weisberger 1986

Moffitt 1996 John F. Moffitt. 'Marcel Duchamp's Étant Donnés: How Walter Arensburg Explained Its Alchemical Iconography', *Cauda Pavonis* (Fall 1996), pp. 1–13

Mondrian 1986 Piet Mondrian. *The New Art – The New Life: The Collected Writings of Piet Mondrian*, ed. Harry Holtzman and Martin S. James, Boston, G. K. Hall, 1986

Morise 1924 Max Morise. 'Les Yeux enchantés', *La Revolution surréaliste* 1 (Dec. 1924), pp. 15–16

Morris 1889 William Morris. *Hopes and Fears for Art: Five Lectures Delivered in Birmingham, London and Nottingham, 1878–1881*, 4th edn, London, Reeves and Turner, 1889

Motherwell 1981 Robert Motherwell. *The Dada Painters and Poets*, 2nd edn, Boston, G. K. Hall, 1981 (originally published in 1951)

Nadeau 1967 Maurice Nadeau. *The History of Surrealism*, Toronto, Collier-Macmillan, 1967

Newhall 1964 Beaumont Newhall. *The History of Photography*, New York, Museum of Modern Art, 1964

Nochlin 1971 Linda Nochlin. *Realism*, Harmondsworth, Penguin Books, 1971

Olin 1992 Margaret Olin. *Forms of Representation in Alois Riegl's Theory of Art*, University Park, Pennsylvania State University Press, 1992

Omuka 1986 Toshiharu Omuka. 'David Burliuk and the Japanese Avant-Garde', *Canadian-American Slavic Studies* 20, nos. 1–2 (Spring–Summer 1986), pp. 111–33

Omuka 1988 Toshiharu Omuka. 'To make all of myself boil over: Tomoyoshi Murayama's Conscious Constructionism', in Kamakura 1988

Omuka 1991 Toshiharu Omuka. 'Vavara Bubnova as a Vanguard Artist in Japan', paper given at the International Conference on Cultural Contact and Interaction: Russia and Japan, 1868–1926, Hitotsubashi University, Tokyo, 27–29 May 1991

Orton 1993a Fred Orton. 'Action, Revolution and Painting', in Thistlewood 1993

Orton 1993b Fred Orton. 'Footnote One: The Idea of the Cold War', in Thistlewood 1993

Osborne 1968 Harold Osborne. *Aesthetics and Art Theory: An Historical Introduction*, London and Harlow, Longmans, Green and Co., 1968

Pächt 1963 Otto Pächt. 'Art Historians and Art Critics – VI: Alois Riegl', *Burlington Magazine* 105 (May 1963), pp. 188–93

Paulson 1990 Ronald Paulson. *Figure and Abstraction in Contemporary Painting*, New Brunswick, N.J., and London, Rutgers University Press, 1990

Plato 1961 Plato. *The Collected Dialogues of Plato, Including the Letters*, 2nd printing, with corrections, ed. Edith Hamilton and Huntington Cairns, New York, Bollingen Foundation, 1961

Podro 1982 Michael Podro. *The Critical Historians of Art*, New Haven and London, Yale University Press, 1982

Poggi 1992 Christine Poggi. *In Defiance of Painting: Cubism, Futurism and the Invention of Collage*, New Haven and London, Yale University Press, 1992

Pollock 1992	Griselda Pollock. *Avant-Garde Gambits, 1888–1893*, London, Thames and Hudson, 1992
Popper 1972	Karl R. Popper. *Objective Knowledge: An Evolutionary Approach*, Oxford, Clarendon Press, 1972
Popper 1975	Frank Popper. *Art – Action and Participation*, London, Studio Vista, 1975
Potts 1994	Alex Potts. *Flesh and the Ideal: Winckelmann and the Origins of Art History*, New Haven and London, Yale University Press, 1994
Proudfoot 1994	Peter R. Proudfoot. 'Geomancy in Modern Architectural Theory', *Architectural Science Review* 37, no. 2 (June 1994), pp. 81–91
Rader 1939	Melvin Rader. *No Compromise: The Conflict Between Two Worlds*, London, Victor Gollancz, 1939
Rankin 1989	Elizabeth Rankin. *Images of Wood: Post-War Sculptures and Assemblages in South Africa: The Baby and the Bathwater*, Johannesburg, Johannesburg Art Gallery, 1989
Rankin [*c.* 1990]	Elizabeth Rankin. *Penelope Siopis*, Grahamstown, S.A., Standard Bank National Arts Festival, [*c.* 1990]
Rankin & Powell 1986	E. Rankin and I. Powell. *Robert Hodgins: Images, 1953–1986*, Grahamstown, S.A., Standard Bank National Arts Festival, 1986
Rawls 1971	John Rawls. *A Theory of Justice*, Cambridge, Mass., Harvard University Press, 1971
Read 1936a	Herbert Read. *The Meaning of Art*, 2nd edn, London, Faber and Faber, 1936
Read 1936b	Herbert Read, ed. *Surrealism*, London, Faber and Faber, 1936
Rewald 1943	John Rewald. *Paul Gauguin: Letters to Ambroise Vollard and André Fontainas*, San Francisco, Graham Press, 1943
Richardson 1991 *and* **1996**	John Richardson. *A Life of Picasso, Vol. 1: 1881–1906*, London, Jonathan Cape, 1991; *Vol. 2: 1907–1917*, New York, Random House, 1996
Richter 1965	Hans Richter. *Dada Art and Anti-Art*, trans. David Britt, London, Thames and Hudson, 1965
Rimer 1987	J. Thomas Rimer. 'Tokyo in Paris/Paris in Tokyo', in Takashina & Rimer 1987
Rimer 1990	J. Thomas Rimer. 'The Impressionist Impulse in Japan and the Far East', in Broude 1990
Ringbom 1966	Sixten Ringbom. 'Art in the "Epoch of the Great Spiritual"', *Journal of the Warburg and Courtauld Institutes* 29 (1966), pp. 386–418
Robson 1938	Albert H. Robson. *A. Y. Jackson*, Toronto, Ryerson Press, 1938
Rose 1988	Margaret A. Rose. 'The Concept of the Avant-Garde: From the Modern to the Post-Modern', *Agenda* (Melbourne) 1, no. 2, spec. suppl. (Aug. 1988), pp. 23–24

Rosen 1993 Rhoda Rosen. 'Art History and Myth Making in
 South Africa: The Example of Azaria Mbatha',
 Third Text 23 (Summer 1993), pp. 9–22

Rosenbaum 1994 S. P. Rosenbaum. *The Early History of the
 Bloomsbury Group, Vol. 2: Edwardian Bloomsbury*,
 London, Macmillan, 1994

Rosenberg 1961 H. Rosenberg. *The Tradition of the New*, New
 York, Grove Press, 1961

Rosenberg 1964 H. Rosenberg. 'Action Painting: Crisis and
 Distortion', in *The Anxious Object: Art Today and Its
 Audience*, London, Thames and Hudson, 1964,
 pp. 39–47

Rosenblum 1976 R. Rosenblum. *The International Style of 1800: A
 Study in Linear Abstraction*, New York, Garland,
 1976

Rosenfield 1971 John M. Rosenfield. 'Western-style Painting in
 the Early Meiji Period and Its Critics', in
 Tradition and Modernisation in Japanese Culture, ed.
 D. Shiveley, Princeton, Princeton University
 Press, 1971

Rubin 1968 W. S. Rubin. *Dada, Surrealism and Their Heritage*,
 New York, Museum of Modern Art, 1968

Rubin 1984 W. S. Rubin, ed. *'Primitivism' in Twentieth Century
 Art*, 2 vols., New York, Museum of Modern Art,
 1984

Ruskin 1903–12 John Ruskin. *The Works of John Ruskin*, 39 vols.,
 ed. E. T. Cook and A. Wedderburn, London,
 George Allen, 1903–12

Ryabushin & Smolina 1992 A. Ryabushin and N. Smolina. *Landmarks in
 Soviet Architecture, 1917–1991*, New York, Rizzoli,
 1992

Sack 1991 Steven Sack. *The Neglected Tradition: Towards a
 New History of South African Art, 1930–1988*,
 Johannesburg, Johannesburg Art Gallery, 1991

Said 1985 E. W. Said. *Orientalism*, Harmondsworth,
 Penguin Books, 1985

Saint-Simon 1976 Louis de Rouvroy, Duc de Saint-Simon. *The
 Political Thought of Saint-Simon*, ed. Ghita Ionescu,
 Oxford, Oxford University Press, 1976

Salmon 1920 André Salmon. 'L'Art nègre' (1920), in his
 Propos d'ateliers, Paris, G. Grès et Cie., 1922

Sandler 1970 Irving Sandler. *Abstract Expressionism: The Triumph
 of American Painting*, London, Pall Mall Press,
 1970

Saussure 1966 Ferdinand de Saussure. *Course in General
 Linguistics*, trans. with int. by W. Baskin, New
 York, McGraw-Hill Book Co., 1966

Sawin 1995 Martica Sawin. *Surrealism in Exile and the
 Beginning of the New York School*, Cambridge,
 Mass., MIT Press, 1995

Schade 1995 Sigrid Schade. 'Charcot and the Spectacle of the
 Hysterical Body: The "Pathos Formula" as an
 Aesthetic Staging of Psychiatric Discourse – A

Blind Spot in the Reception of Warburg', *Art History* 18 (4 Dec. 1995), pp. 499–513

Schapiro 1978 Meyer Schapiro. *Modern Art, 19th and 20th Centuries: Selected Papers*, New York, George Brazillier, 1978

Schapiro & Chicago 1973 Miriam Schapiro and Judy Chicago. 'Female Imagery', *Womanspace Journal* 1 (Summer 1973), pp. 11–14

Scharf 1968 Aaron Scharf. *Art and Photography*, London, Allen Lane and Penguin Press, 1968

Schiller 1967 Friedrich von Schiller. *On the Aesthetic Education of Man*, ed. and trans. E. M. Wilkinson and L. A. Willoughby, Oxford, Clarendon Press, 1967

Sepetys 1977 Lionginas Sepetys. *Mikalojus Konstantinas Ciulionis*, Vilnius, Leidykla Vaga, 1977

Searle 1993 John R. Searle. 'The World Turned Upside Down', in *Working Through Derrida*, ed. G. B. Madison, Evanston, Ill., Northwestern University Press, 1993

Seuphor 1958 M. Seuphor. *Dictionary of Abstract Painting*, New York, Paris Book Center, 1958

Skawran & Macnamara 1985 Karin Skawran and Michael Macnamara, eds. *Walter Battiss*, Johannesburg, A. D. Donker, 1985

Silver 1989 Kenneth E. Silver. *Esprits de Corps: The Art of the Parisian Avant-Garde and the First World War, 1914–1925*, London, Thames and Hudson, 1989

Simpson 1984 David Simpson, ed. *German Aesthetic and Literary Criticism*, Cambridge, Cambridge University Press, 1984

Smith 1950 Bernard Smith. 'European Vision and the South Pacific', *Journal of the Warburg and Courtauld Institutes* 13 (1950), pp. 65–100

Smith 1974 Bernard Smith, ed. *Concerning Contemporary Art: The Power Lectures, 1968–1973*, Oxford, Clarendon Press, 1974

Smith 1985 Bernard Smith. *European Vision and the South Pacific*, 2nd edn, New Haven and London, Yale University Press, 1985

Smith 1992 Bernard Smith. *Imagining the Pacific: In the Wake of the Cook Voyages*, New Haven and London, Yale University Press, 1992

Smith 1993 Terry Smith. *Making the Modern: Industry, Art and Design in America*, Chicago and London, University of Chicago Press, 1993

Solomon 1979 Maynard Solomon, ed. *Marxism and Art: Essays Classic and Contemporary*, Brighton, Sussex, Harvester Press, 1979

Spate 1979 Virginia Spate. *Orphism: The Evolution of Non-figurative Painting in Paris, 1910–1914*, Oxford, Clarendon Press, 1979

Spate 1992 Virginia Spate. *The Colour of Time: Claude Monet*, London, Thames and Hudson, 1992

Speer 1976 Albert Speer. *Spandau: The Secret Diaries*, New York and London, Macmillan, 1976

Spiro 1989 Lesley Spiro. *Gerard Sekoto: Unsevered Ties*, Johannesburg, Johannesburg Art Gallery, 1989

Steegmuller 1986 Francis Steegmuller. *Cocteau: A Biography*, London, Constable, 1986

Stein 1947 Leo Stein. *Appreciation: Painting, Poetry and Prose*, New York, Crown, 1947

Stein 1950 Leo Stein. *Journey into the Self: Being the Letters, Papers and Journals of Leo Stein*, ed. Edmund Fuller, New York, Crown, 1950

Steinberg 1972 Leo Steinberg. *Other Criteria: Confrontations with Twentieth-Century Art*, London, Oxford and New York, Oxford University Press, 1972

Steiner 1984 Peter Steiner. *Russian Formalism: A Metapoetics*, Ithaca and London, Cornell University Press, 1984

Stocking 1983 George W. Stocking, Jr, ed. *Observers Observed: Essays on Ethnographic Fieldwork*, Madison, University of Wisconsin Press, 1983

Stocking 1984a George W. Stocking, Jr, ed. *Functionalism Historicized: Essays on British Social Anthropology*, Madison, University of Wisconsin Press, 1984

Stocking 1984b George W. Stocking, Jr. 'Radcliffe Brown and British Social Anthropology', in Stocking 1984a

Striedter 1989 Jurij Striedter. *Literary Structure, Evolution and Value*, Cambridge, Mass., Harvard University Press, 1989

Sutton 1963 Denys Sutton. *Nocturne: The Art of James McNeill Whistler*, London, Country Life, 1963

Sweetman 1987 John Sweetman. *The Oriental Obsession: Islamic Inspiration in British and American Art and Architecture, 1500–1920*, Cambridge, Cambridge University Press, 1987

Sweeney 1935 James Johnson Sweeney. *African Negro Art*, New York, Museum of Modern Art, 1935

Tafuri 1976 M. Tafuri. *Architecture and Utopia: Design and Capitalist Development*, Cambridge, Mass., and London, MIT Press, 1976

Takashina 1987 Shuji Takashina. 'Eastern and Western Dynamics in the Development of Western-Style Oil Painting During the Meiji Era', in Takashina & Rimer 1987, pp. 21–31

Takashina & Rimer 1987 Shuji Takashina and J. Thomas Rimer, with Gerald D. Bolas. *Paris in Japan: The Japanese Encounter with European Painting*, Tokyo, The Japan Foundation, and St Louis, Washington University in St Louis, 1987

Tatarkiewicz 1970 Wladyslaw Tatarkiewicz. *History of Aesthetics, Vol. 1: Ancient Aesthetics*, ed. J. Harrell, trans. Adam and Ann Czerniawski, The Hague and Paris, Mouton, 1970

Taussig 1993

Michael Taussig. *Mimesis and Alterity: A Particular History of the Senses*, New York, Routledge, 1993

Taylor 1996

Brandon Taylor. 'Photo Power: Planning and Iconicity in the First Five Year Plan', in Hayward 1996, pp. 249–52

Thistlewood 1993

David Thistlewood, ed. *American Abstract Expressionism*, Liverpool, Liverpool University Press and Tate Gallery, 1993

Thistlewood 1995

David Thistlewood, ed. *Joseph Beuys: Diverging Critiques*, Liverpool, Liverpool University Press and Tate Gallery, 1995

Tillett 1982

Gregory Tillett. *The Elder Brother: A Biography of Charles Webster Leadbeater*, London, Routledge and Kegan Paul, 1982

Tisdall 1995

Caroline Tisdall. 'Beuys and the Celtic World', in Thistlewood 1995

Tolstoy [1899]

Leo Tolstoy. *What is Art?* trans. Aylmer Maude, London, Walter Scott, [1899]

Toynbee 1934–61

Arnold Toynbee. *A Study of History*, 12 vols., London, Oxford University Press, 1934–61

Tuchman 1986

Maurice Tuchman. 'Hidden Meanings in Abstract Art', in Weisberger 1986, pp. 17–62

Van Gogh 1959

Vincent van Gogh. *The Complete Letters*, 3 vols., New York, New York Graphic Society, 1959

Varnedoe 1984

Kirk Varnedoe. 'Gauguin', in Rubin 1984, pp. 179–209

Vasari 1963

Giorgio Vasari. *The Lives of the Painters, Sculptors, and Architects*, 4 vols., ed. W. Gaunt, London, Dent, 1963

Vico 1968

Giambattista Vico. *The New Science of Giambattista Vico*, rev. trans. of the 3rd edn of 1744, trans. Thomas Goddard Bergin and Max Harold Fisch, Ithaca and London, Cornell University Press, 1968

Watson 1991

Steven Watson. *Strange Bedfellows: The First American Avant-Garde*, New York, Abbeville Press, 1991

Watts 1986

Harriett Watts. 'Arp, Kandinsky, and the Legacy of Jacob Böhme', in Weisberger 1986

Weisberger 1986

E. Weisberger, ed. *The Spiritual in Art: Abstract Painting, 1890–1985*, Los Angeles County Museum of Art and New York, Abbeville Press, 1986

Weiss 1990

Peg Weiss. 'Kandinsky: The Artist as Ethnographer', in *Münchner Beiträge zur Volkerkunde*, vol. 3, Munich, Hirmer, 1990

Weiss 1994

Jeffrey Weiss. *The Popular Culture of Modern Art: Picasso, Duchamp and Avant-gardism*, New Haven and London, Yale University Press, 1994

Weiss 1995

Peg Weiss. *Kandinsky and Old Russia: The Artist as Ethnographer and Shaman*, New Haven and London, Yale University Press, 1995

Welsh 1986 Robert P. Welsh. 'Sacred Geometry: French
 Symbolism and Early Abstraction', in Weisberger
 1986

Whitford 1972 Frank Whitford.' The Work of Ludwig Meidner',
 Studio International (Feb. 1972), pp. 54–59

Whyte 1982 Iain Boyd Whyte. *Bruno Taut and the Architecture
 of Activism*, Cambridge, Cambridge University
 Press, 1982

Whyte 1996 Iain Boyd Whyte. 'National Socialism and
 Modernism', in Hayward 1996, pp. 258–69

Williams 1977 Raymond Williams. *Marxism and Literature*,
 Oxford, Oxford University Press, 1977

Wimsatt & Beardsley 1976 W. Wimsatt and M. Beardsley. 'The Intention
 Fallacy', in D. Newton de Molina, ed. *On Literary
 Intention*, Edinburgh, Edinburgh University Press,
 1976

Winckelmann 1881 Johann Winckelmann. *The History of Ancient Art*,
 2 vols., trans. G. H. Lodge, London, Sampson
 Low, Marston, Searle and Rivington, 1881

Wittkower 1958 Rudolf Wittkower. *Art and Architecture in Italy,
 1600 to 1750*, Harmondsworth, Penguin Books,
 1958

Wölfflin [1929] Heinrich Wölfflin. *Principles of Art History: The
 Problem of the Development of Style in Later Art*,
 trans. M. D. Hottinger, New York, Dover
 Publications, [1929]

Wollheim 1965 Richard Wollheim. 'Minimal Art', *Arts Magazine*
 (Jan. 1965); reprinted in Battcock 1969, pp.
 386–99

Wood et al. 1993 P. Wood, F. Frascina, J. Harris and C. Harrison.
 Modernism in Dispute: Art Since the Forties, New
 Haven and London, Yale University Press, 1993

Woolf 1987 Virginia Woolf. 'A Dialogue upon Mount
 Pentelicus', *Times Literary Supplement*, 11–17 Sept.
 1987, p. 979

Woolf 1989 Virginia Woolf. *The Complete Shorter Fiction of
 Virginia Woolf*, 2nd edn, ed. Susan Dick, London,
 Hogarth Press, 1989

Worringer 1957 Wilhelm Worringer. *Form in Gothic*, London, Alec
 Tiranti, 1957

Yates 1964 Frances A. Yates. *Giordano Bruno and the Hermetic
 Tradition*, London, Routledge and Kegan Paul,
 1964

Zengotita 1984 Thomas de Zengotita. 'The Functional Reduction
 of Kinship in the Social Thought of John Locke',
 in Stocking 1984a

Zweíté 1989 Armin Zweite. *The Blue Rider in the Lenbachhaus,
 Munich*, Munich, Prestel-Verlag, 1989

Index